A HISTORY OF BASKETBALL IN FIFTEEN SNEAKERS

RUSS BENGTSON

Foreword by
Bobbito Garcia

WORKMAN PUBLISHING · NEW YORK

To Dad, who would have loved to see this.

Library of Congress Cataloging-in-Publication Data is available.

ISBN 978-1-5235-1028-3

Design and cover by Becky Terhune
Illustrations by Nick Maloy
Photo research by Aaron Clendening
Complete photo credits can be found on page 241.

Workman books are available at special discounts when purchased in bulk for premiums and sales promotions, as well as for fundraising or educational use. Special editions or book excerpts can also be created to specification. For details, please contact special.markets@hbgusa.com.

Workman Publishing Co., Inc., a subsidiary of Hachette Book Group, Inc.
1290 Avenue of the Americas
New York, NY 10104

workman.com

WORKMAN is a registered trademark of Workman Publishing Co., Inc., a subsidiary of Hachette Book Group, Inc.

Printed in China on responsibly sourced paper.
First printing October 2023

10 9 8 7 6 5 4 3 2 1

A HISTORY OF
BASKETBALL
IN FIFTEEN
SNEAKERS

Contents

Foreword by Bobbito Garcia

vi

Intro

viii

Chapter 1

The Birth of the Cool: Converse Chuck Taylor All Star

1

Chapter 2

Tougher Than Leather: adidas Superstar

21

Chapter 3

New York State of Mind: PUMA Clyde

37

Chapter 4

The Shape of Sneakers to Come: adidas Top Ten

51

Chapter 5

It's the New Style: Nike Air Force 1

67

Chapter 6

Cult of Personality: Nike Air Jordan

81

Chapter 7

Yo! Bum Rush the Show: Reebok Pump

97

Chapter 8

Bad Boys for Life: Nike Air Force Max

113

Chapter 9
All Hail the Queen: Nike Air Swoopes
129

Chapter 10
A Love Supreme: Nike Air Jordan XI
143

Chapter 11
The Strength of Street Knowledge: AND1 Tai Chi
159

Chapter 12
Watch the Throne: Nike Air Zoom Generation
175

Chapter 13
The Low-Cut Theory: Nike Zoom Kobe IV
189

Chapter 14
Three the Hard Way: Under Armour Curry One
205

Chapter 15
Future Shock: Nike Adapt BB
221

Outro
235

Sneaker Anatomy
238

Bibliography
239

Photo Credits
241

Acknowledgments
242

About the Author
244

Bobbito Garcia

"So . . . how many sneakers do you have in your collection?"

I get this question, oh, just about every interview that I've done since my book *Where'd You Get Those? New York City's Sneaker Culture: 1960–1987* dropped 20 years ago.

"I only own five pairs of kicks," I respond. "I'm not a collector. Never have been . . ."

And then the interviewer's jaw drops. Every time! You see, I'm a historian. An author. A documentary filmmaker. A TV/radio personality. I've designed sneakers in collaboration with Nike, adidas, PUMA, PRO-Keds, and smaller brands. But not one of these careers would have happened, bar none, had I not been a ballplayer first.

In 1980, I was 14 years old and caught the fever to play b-ball every single day like nobody's business. Luckily for me, I lived in NYC, where our outdoor courts were the breeding grounds for both a burgeoning hip-hop movement and a steadily evolving sneaker culture. Air Force 1s, PUMA Clydes, adidas Shell Toes, and PRO-Ked 69ers were the hot kicks that the b-boys coveted. Each of these models, though, were originally designed for ballplayers and didn't become cool on the street, or I should say linoleum, until cats with crossovers and no-look passes made them their preferred equipment.

I once read that something like 80 percent of all sneakers purchased were *not* used for their intended performance. So only 20 percent of people buying ball kicks were actually lacing up and calling, "I got next!" Yet every brand, still to this day, will spend millions and millions on research and development, design, marketing, seeding, promo, advertising, yadda yadda specifically for the basketball category, more so than any others. You know why?

You think the NFL, NHL, MLB, World Cup (with its record-breaking viewing audiences recently), the Boston or NYC Marathon, cricket in India, Wimbledon, or any other sporting event determine what's cool on people's feet the way basketball has, and always will? Do you even know what brand Lionel Messi wears? Do you care? Pele (RIP) wore Pumas. Do you think that had any impact on sales in New York, the undisputed sneaker center of the world?

I'm not trying to diss any other sports, endorsements, athletes, or brands. It's just that push comes to shove, ain't nothing stepping on the toes of basketball when it comes to importance in the footwear game. Nike founder/CEO Phil Knight even once said that the Swoosh was a running shoe brand, but its soul was basketball.

So, when you consider all the hoopla over kicks, from the reseller market to the lines for exclusive drops, just know that the firm roots of that tree date back to the '60s, '70s, and '80s, when a roundball and a rim drove people in New York insane trying to figure out what to wear when playing. Sneakers became a multibillion-dollar industry because of basketball—this book is the story of how.

The journey you're about to take is guided by Russ Bengtson, who I consider not only a friend, but also a source for footwear/basketball knowledge and perspective. I've trusted, followed, and admired Russ for over two decades now since his days as editor in chief of *SLAM* magazine to his on-camera work at Complex.

"Uncle" Russ (as DJ Clark Kent and I have nicknamed him) gave me the most unexpected and unique interview for *KICKS* magazine during the press campaign for my sneaker book back in 2003. I'll never forget it. Instead of asking me the same questions that every writer was posing, the supreme sneakerhead pulled out joints from the '80s from his personal closet and then asked me for my impression of each. When he showed me the Nike Air Ships, I lost my mind! I hadn't seen them since the winter of '84-'85 when they released. And I didn't know another soul who knew that Michael Jordan had worn the Ships during his rookie season before Air Jordan Is came out. But Russ knew.

Of course he did.

And that's why he's *that dude* who should write this book. I hope your read is as unforgettable as that time he interviewed me 20 years ago.

Mic drop . . .

And do me a favor—please go outside and play ball after you've finished flipping through these pages! That's the right thing to do.

The Genesis: Where It All Began

If you ever want to get a good look at the history of basketball, just go to a sneaker store. Most of it will be right up there on the walls, from Converse Chuck Taylor All Stars to the latest Nikes for LeBron James and Kevin Durant, Under Armours for Steph Curry, and PUMAs for Breanna Stewart. There'll likely be Air Force 1s and Air Jordan 1s, adidas Superstars and Top Tens, Reebok Questions and PUMA Clydes. Let's face it: For so many people, turning on a basketball game means looking at players' feet. Sneaker history *is* basketball history.

Hoops has its roots in America's Northeast, starting with Dr. James Naismith's YMCA gym in Springfield, Massachusetts. Converse, the brand that created some of the first footwear for indoor basketball, had the same regional roots. Over the ensuing century, the sport and the shoes worn to play it became globe-spanning, multibillion-dollar businesses (Statista put the 2022 number at $72.7 billion for sneakers sales as a whole). Pro basketball went from games being shown on tape delay to a 24/7 spectacle you can watch on your phone, and *reselling* sneakers is now its own multibillion-dollar industry.

I'm not new to all of this. I've written about sneakers and hoops for a long time, my first such piece being a single column on obscure '80s basketball shoes I wrote in the early '90s for *The Review*, the University of Delaware's student-run newspaper. I joined the *SLAM* magazine crew in 1996, where I eventually took over sneaker coverage and became editor in chief. I wrote a monthly sneaker column for *Mass Appeal* (following in the footsteps of legendary digger and collector Chris Hall), had an NBA column in Japan's *DUNKSHOOT,* wrote for *HOOP*, and was hired by *Complex* to be their first sneaker editor. All along the way I was getting interviewed myself: I've appeared on many podcasts and panels over the years and was part of Thibaut de Longeville's *Just for Kicks* documentary, as well as a bunch of other sneaker docs. Before all that, though, I was just a kid who was into sneakers.

The initial idea for this book came from a memory of sneakers and basketball that I could never untangle. I know I got my first pair of Nikes—a pair of blue-on-white Bruins—in fourth grade, which was absolutely before I started following hoops. But

while I distinctly remember wanting the first Air Jordans when they came out in 1985, I can't for the life of me recall whether Michael Jordan got me into Jordans or whether it was the other way around. Either way, a few years later I got my first pair and was taking the train from Long Island to Madison Square Garden to see the man himself play.

I undoubtedly am not alone in this. The stories of basketball and basketball shoes are so intertwined it hardly makes sense to try to separate them. The game was invented, sneakers were developed, and each grew the other. Teaching the game helped sell the shoes; selling the shoes helped spread the game. For a half-century, a gentleman by the name of Chuck Taylor crisscrossed the country (and later the world) for Converse doing both. They eventually put his name on the shoe. And those shoes dominated the sport, despite remaining virtually unchanged for decades. They were made from either white or black canvas, with a rubber toe-cap, steel eyelets, and vulcanized rubber soles. When the NBA was established in 1949 in a merger of predecessor leagues, that basic sneaker design was already fifty years old. Chucks were just a piece of the uniform, as essential and as exciting as socks.

But by the time Taylor died in 1969, a revolution was brewing, one that would finally usher his long-lived eponymous shoe out of the game. The young scion of a German brand and an eager American hoops fiend thought they could do basketball shoes better—and they did, with the adidas Superstar. By then, the game had grown up, too. Now, more than a half-century later, shoes are the primary means of expression for the most individualistic players in team sports. This book is an attempt to explain how (and why) that has happened.

Let me try to get ahead of a few questions: Why 15 sneakers? More to the point, why *these* particular 15? Some sneakers are obvious choices (the aforementioned Chuck Taylor or first Air Jordan); others perhaps not so much (the adidas Top Ten or Nike Adapt BB). Undoubtedly you will have favorites that won't even earn a mention—an inevitability when you consider just how many shoes there have been over the past decade or two alone. But taken together, the 15 featured within these pages tell a story. And if you look at the arc of basketball sneakers and the arc of basketball itself, they follow a similar—albeit not quite identical—pattern. Both are more like a bell curve, with a long steady period of slow change followed by a burst of experimentation and innovation and

just trying stuff before settling back down into a generally agreed-upon style. But while you can track those stories separately, they're really best told in one narrative.

Over the past few years there have been quite a few books published about sneakers, to say nothing of the countless tomes on the subject of basketball. Each has touched on the other—how could they not—but to me, raised fully in both worlds, it just isn't enough for a sneaker book to dabble in basketball, or a basketball book to dabble in sneakers. To unwind either of those stories and present them as independent of one another is unfair to both and leaves out crucial elements. In fact, one provides a window into the other.

Sneakers enhanced and even helped create true basketball superstardom, from Walt Frazier's PUMA Clydes taking NYC by storm in the '70s to Air Jordans exploding globally in the '80s and '90s. They played a huge role in marketing leagues (NBA, WNBA, and ABA alike) before the leagues even knew how to market themselves. They trace the evolution of the game on court, from a center-dominant sport full of "big shoes for big men" to one run by fire-from-anywhere sharpshooters in lightweight lowtops. And they gave players new means to express themselves: from Dee Brown in Reebok Pumps to Sheryl Swoopes in a signature Nike sneaker of her own. For someone like Kobe Bryant, who approached his game and his shoes the same way—all in, immersing himself in every single detail no matter how small, seeking every possible advantage he could—each aspect reinforced the other.

I'll finish here by returning to the sneaker store, where 100 years of sneaker technology and marketing are on display. One thing that always bothered me—something I would bring up again and again to sneaker companies and friends within the industry, who were undoubtedly tired of hearing it—was the lack of context. "Retro" had just become a way to put product back on shelves without any real effort to explain the what and the why and the when of all of these shoes: how they fit into the bigger picture of basketball or even the bigger picture of sneakers. You could buy the shoes, but you could never get the full story. It's about time someone told it.

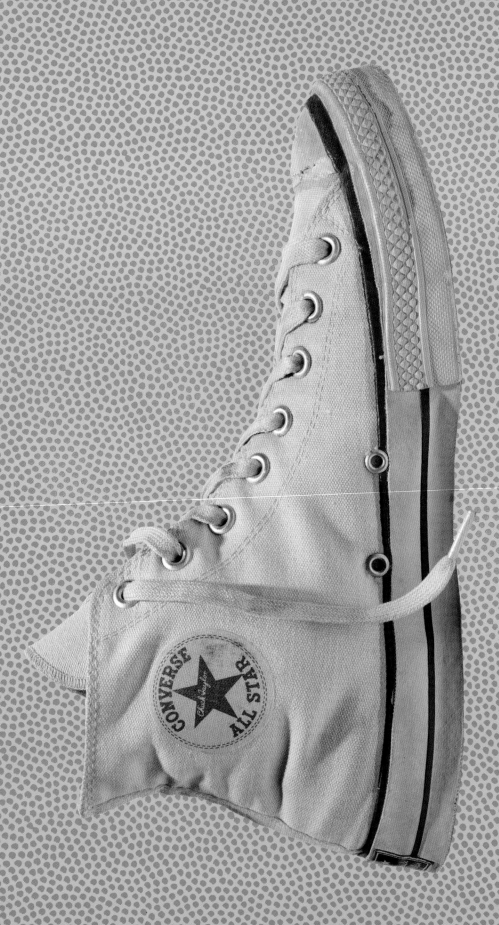

Converse Chuck
Taylor All Star
1917

Adidas Superstar
1965

PUMA Clyde
1971

Adidas Top Ten
1979

Nike Air Force 1
1982

Nike Air Jordan
1985

Reebok Pump
1989

Nike Air Force
Max
1993

Nike Air Swoopes
1995

Nike Air Jordan XI
1995

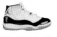

AND1 Tai Chi
2000

Nike Air Zoom
Generation
2003

Nike Zoom
Kobe IV
2009

Under Armour
Curry One
2015

Nike Adapt BB
2019

Chapter One

The Birth of the Cool:
Converse Chuck Taylor All Star

When Dr. James Naismith drew up 13 rules for a new indoor game back in 1891, there was no such thing as a "basketball sneaker." There's no chicken-or-the-egg riddle to solve here—it was a brand-new sport meant to be played with what was already on hand (and on foot). Naismith grabbed a soccer ball and set his players out on the wooden gymnasium floor. He had nailed some peach baskets to the lower rail of the elevated running track that circled the perimeter. As it turned out, their 10-foot height was perfect.

Naismith used basketball to keep his YMCA charges active and fit during cold New England winters, not to sell shoes, balls, or any other equipment. He was a teacher, not a designer or an entrepreneur. Someone else—many someone elses, as it turned out—would fill those roles.

THE ARCHITECT

Marquis Mills Converse's future was also shaped by New England's harsh winters. Born in New Hampshire, Converse had managed other footwear companies in the Northeast before starting his own at age 47. He founded his eponymous company in Malden, Massachusetts—not far from basketball's Springfield birthplace—in 1908 to manufacture winter boots. In 1912, the company began to produce automobile tires under the "Triple Tread" name that also graced their footwear.

The first Converse basketball sneaker, the Non-Skid, was introduced in 1917 both to outfit players of the increasingly popular sport and to keep factory employees working year-round. Renamed the All Star in 1919, the Non-Skid wasn't the very first basketball shoe—Connecticut's Colchester Rubber Co. makes that claim—but it quickly became the industry standard. Rubber companies produced the earliest sneakers: U.S. Rubber (now known as Uniroyal) created Keds in 1916 and B.F. Goodrich Co. introduced PF Flyers in 1937. Keds was the first brand to attach a canvas upper to a rubber sole, marking a significant milestone in sneaker history and establishing the next half-century of sneaker technology, but they didn't make a serious move into basketball until launching PRO-Keds in 1949. By that point, Converse had a substantial head start.

Key aspects of the Non-Skid are still visible in the Chuck Taylor All Star today. Major features like the ankle patch, the "bat wing" rubber toe bumper, and even the diamond-shaped tread pattern would look familiar to those who wore Converse's earliest basketball offerings. As for the game of basketball itself, well, the main goal has always been to put the ball in the basket, just as Naismith intended—only it happens a lot more often nowadays. (And there's no need to retrieve the ball from a peach basket.) Back in 1917, games were physical,

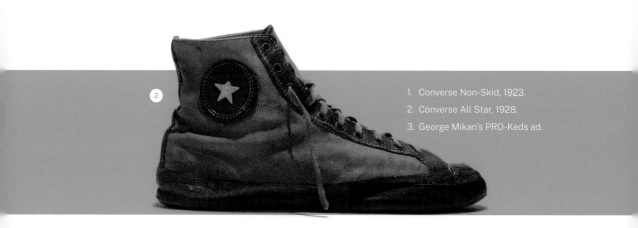

1. Converse Non-Skid, 1923.
2. Converse All Star, 1928.
3. George Mikan's PRO-Keds ad.

low-scoring slogs with center jumps after every field goal. Teams that took early leads literally fought to keep them. There was no shot clock, and the first jump shot was still decades away. Venues that held early pro contests installed netting to separate the spectators from the court, which is why basketball players are still sometimes called "cagers."

PRO-Keds

U.S. Rubber launched PRO-Keds in 1949 — the same year the NBA was born — on the feet of the game's biggest star. That was George Mikan, 6'10" center of the Minneapolis Lakers, who was the leading scorer in the National Basketball League (NBL) in 1948, the Basketball Association of America (BAA) in '49, and then the NBA (the merger of the NBL and BAA) in '50 and '51. In 1952, Mikan had a game with 61 points and 36 rebounds. U.S. Rubber eventually outfitted his teammates, too.

The Lakers were basketball's first modern professional dynasty. Minneapolis had won the 1948 NBL championship, then jumped to the BAA and won another title in 1949. They clinched the inaugural NBA title in 1950, lost to the eventual-champion Rochester Royals in 1951, and then ran off the NBA's first three-peat from '52 to '54. Ballplayers may not have recognized the shoe in the ad, but they definitely would have identified the bespectacled Mikan.

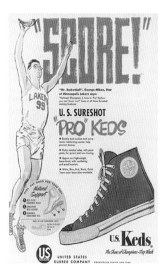

The PRO-Keds were familiar-looking canvas high-tops, but they did offer something new. Colors, for one thing — black, white, blue, red, and gold — when Converse was still releasing All Stars in only black or white. There were canvas reinforcements on the sides that provided extra support, "double" cushioning in the heels, and a "Caterpillar" tread pattern with a pivot pad on the forefoot. But upon Mikan's retirement, PRO-Keds lost some of their luster. No matter — they'd be back.

Naismith's new game spread quickly. The very first, short-lived professional leagues were established before the turn of the 20th century. The Amateur Athletic Union (AAU), founded in 1888, oversaw the earliest college games. Naismith himself launched the basketball program at the University of Kansas. And the sport soon made its way overseas. The formation of the International Basketball Federation (FIBA) in 1932 cemented global competition and led directly to basketball debuting as an official Olympic sport—for men only—at the 1936 Summer

Games in Berlin. (The United States won gold, defeating Canada 19–8 in a muddy outdoor game. Naismith, by then 74 years old, presented the gold medals.)

Throughout the Midwest, rubber companies like Firestone and Goodyear fielded semipro teams, while ballrooms like the Renaissance in New York and the Savoy in Chicago served as home bases for teams that would achieve regional—and eventually national—dominance. The Savoy team, promoted by an entrepreneur named Abe Saperstein, would become the Harlem Globetrotters, which competed with (and beat) the best white teams. The Globetrotters were never actually based in Harlem, but they did live up to the latter part of their name, traveling the world and spreading the hoops gospel. In the early days of basketball, these traveling players would prove essential.

THE SALESMAN

In 1921, Converse's Chicago office hired a 20-year-old semiprofessional ballplayer from Indiana named Chuck Taylor to be a regional salesman. The following year, he put on his first basketball clinic at North Carolina State University. Taylor's résumé included unconfirmed stints with legendary professional teams like the Original Celtics and the Buffalo Germans, but his talents as both player and salesman were real enough. And any would-be salesman's first product is always themselves. "He was a showman," said Taylor biographer Abe Aamidor. "It's not that he was lying—it was just part of the act. The important thing is he may have been the first person who understood that a person could be a brand."

Taylor became so synonymous with Converse that in 1934 his name was added to the All Star's ankle patch. All Stars would soon be known simply as

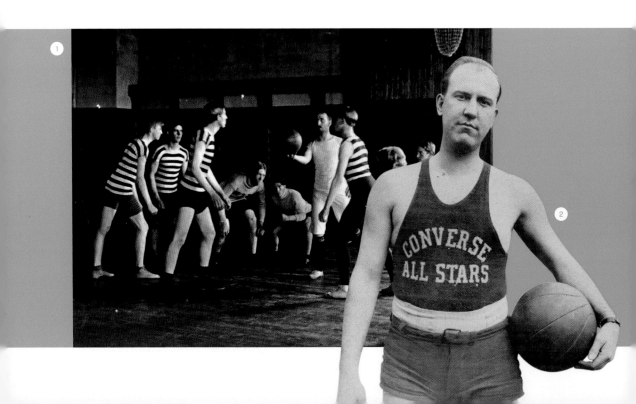

Chuck Taylors. While only in his thirties, the man had become a shoe. The recognition did not come with any additional financial windfall; he never received any bonus or royalties. But he did make full use of an unlimited expense account. Living out of hotels and traversing the country in increasingly nicer cars, Taylor put on clinics that spread the game and sold shoes. The more people got into basketball, the more they got into Converse, and over time, the two became virtually interchangeable.

Taylor made well over 100 stops per year at colleges and high schools from the 1920s through the 1950s. News reports described him as "one of the nation's best teachers of basketball fundamentals" (*Charlotte News*) and, in a particularly over-the-top bit of hyperbole, "one of the greatest hardwood performers ever known" (*Montgomery Advertiser*). "Everything in Taylor's repertoire is fundamental," wrote the *Chattanooga News* in 1935. "His technique is based on the professional idea of simplifying hoop tactics to the 'nth degree."

While only in his thirties, the man had become a shoe.

Coaches who attended his popular clinics seemed to bear this out: "Taylor has no trouble holding his audience," said H. S. Morgan, director of city athletics in Milwaukee. "After his demonstration the persons in attendance here would not let him leave the floor for 45 minutes as they plied him with questions," wrote the *Quad-City Times*. His clinics were free and generally pitted two teams against each other (with Taylor playing for one of them), thus assuring at least two local squads would attend. Adding to the momentum, in 1922 Converse had introduced the *Converse Basketball Yearbook*, an annual publication featuring the nation's best teams. And of course, those teams all wore Converse.

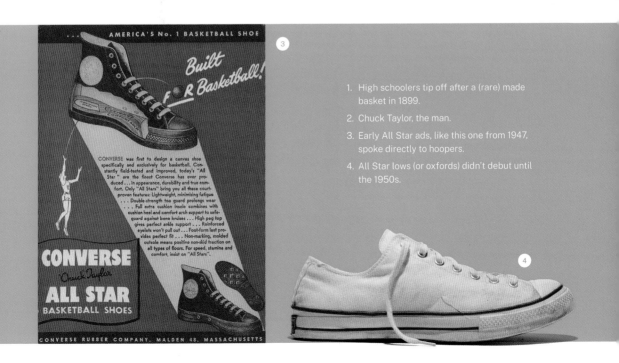

1. High schoolers tip off after a (rare) made basket in 1899.
2. Chuck Taylor, the man.
3. Early All Star ads, like this one from 1947, spoke directly to hoopers.
4. All Star lows (or oxfords) didn't debut until the 1950s.

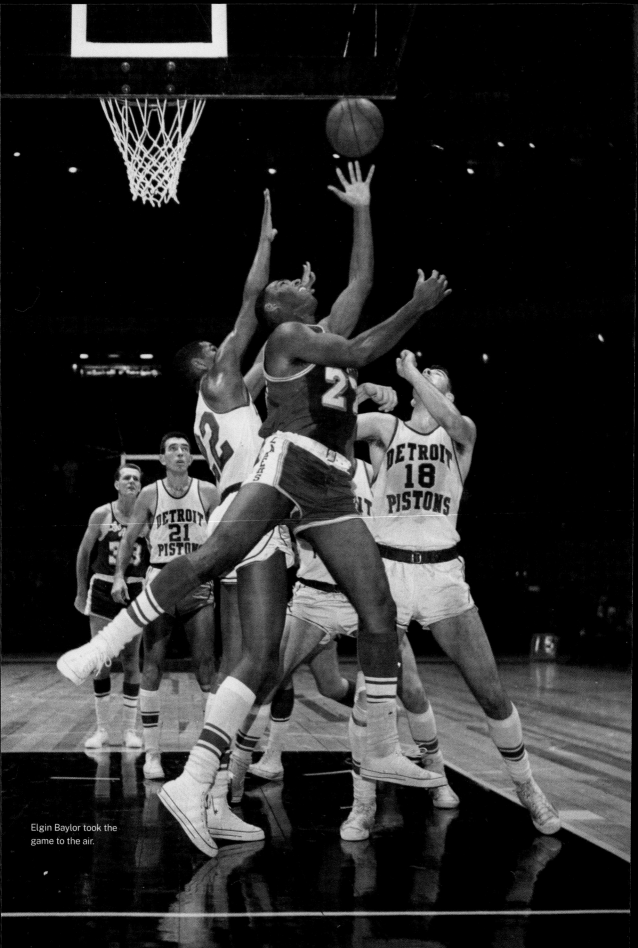

Elgin Baylor took the
game to the air.

Taylor, ever the consummate pitchman, hawked more than just shoes; he also sold his own model Wilson basketball and kneepads. But some of his ideas weren't so strong. One such innovation was a weighted pair of All Stars to wear in practice, used much like a batter in an on-deck circle taking swings with a baseball doughnut. The thought was that when players laced up their normal pairs for games they would feel lighter and quicker, but players mostly seemed to suffer injuries instead.

After the itinerant salesman finally established a home address in Florida in the 1960s, he wouldn't have much time to enjoy retirement. Taylor left Converse in 1968, was inducted into the Basketball Hall of Fame as a contributor in April 1969, and died in June of that year, the day before his 68th birthday.

BEAUTIFUL SIMPLICITY

It may be hard to believe, but there was a time when the Converse Chuck Taylor All Star was legitimate performance basketball footwear. The game grew up in Chucks. The double-layered canvas upper fit snugly, the steel eyelets assured the laces tightened evenly, and the thin, vulcanized rubber soles provided some light cushioning and arch support. The patented diamond tread pattern was eventually fortified with a "pivot button" on the forefoot, increasing traction and longevity. Grooves in the insole were meant to increase airflow. The upper also featured a "peg top," slightly elevated at the rear, that was intended to place less pressure on the Achilles tendon, even when the shoe was laced tightly to the top.

There was a time when Chucks were legit performance basketball footwear.

"There's a beautiful simplicity and purposeful design in the original Chuck," said Nike sneaker designer Eric Avar at the 2019 relaunch of Converse's performance basketball program. Much like Levi's 501 jeans, another timeless American classic, the Chuck Taylor has matured from staple to archetype. Form followed function; both are products with a purpose and very few embellishments.

Throughout the 1920s and '30s, the All Star evolved along with the game. There was a leather version, a women's model, and a crepe-sole model called the Hickory. But the All Star remained the All Star. Across industries throughout the first half of the twentieth century, there was no push to introduce new models every year just for the sake of it: The Ford Model T stayed in production for two full decades, from 1908 to 1927, and the Levi's 501 has been in production since 1873. Planned obsolescence was still in the distant future.

Even aesthetic changes were slow in coming. First the All Star was brown, then black. Converse designed a white model (with patriotic red and blue stripes on the midsole foxing) for the US team to wear at the 1936 Olympics in Berlin—the same games that Jesse Owens dominated in a pair of handmade spikes by German shoemaker Adi Dassler. (If that person is unfamiliar, reread the first six

letters of his name.) The Chuck Taylor would remain the official shoe of the US men's Olympic basketball team right through 1968. Low-cut "oxford" models weren't developed until the 1950s, when the Harlem Globetrotters literally cut down high-tops at Converse headquarters to figure out what worked and what didn't. And if you wanted any color other than black or white, you were dyeing them yourself until 1971.

THE BIRTH OF THE NBA

Professional basketball found its groove in 1949 when the three-year-old BAA and 12-year-old NBL merged to form the National Basketball Association. Establishing itself as the premier league, the NBA sliced through the Gordian knot of pro and semipro leagues that had defined basketball's first decades. But there was still a long way to go. In the beginning, the NBA was a professional sports afterthought, a way for arena owners to fill seats when their hockey teams weren't playing. Games were still aggressively physical, relatively low-scoring, and played in industrial cities by mostly white men who held down regular jobs in the off-season. Travel was bad, schedules were worse.

The NBA drafted its first Black player in 1950 when the Celtics selected Chuck Cooper with the first pick of the second round, although it took some time for the league to drop its unofficial racial quotas limiting the number of Black players per team. This development did not please Globetrotters owner Abe Saperstein. Up to that point he had gotten his pick of the best Black players and, given that he didn't need to follow the NBA's rules, would poach talent at times. Before heading to the NBA in 1959, Wilt Chamberlain skipped his senior year at Kansas and spent a gap year with the Globetrotters, earning $50,000 and touring the Soviet Union. Underclassmen wouldn't be eligible to play in the NBA until the 1970s.

Starting in the mid-fifties, the NBA made huge strides. The addition of a 24-second shot clock in 1954 sped up gameplay, and the arrival of generational talents like Bill Russell, Oscar Robertson, Elgin Baylor, and Chamberlain suffused the sport with unprecedented basketball intelligence and athleticism. Russell and Chamberlain redefined the center position, Baylor took the game above the rim for the first time, and Robertson set the standard for the prototypical big guard. But even as the sport improved, the league's talent would further concentrate.

Ten years post-merger, in 1959, the original seventeen teams had contracted to just eight, and the Western Division reached no farther west than Minnesota. There wouldn't be as many as seventeen teams again until 1970. But when the Minneapolis Lakers moved to Los Angeles before the 1960–61 season, the NBA became a continental league, spanning the country from coast to coast. Two years later, the Philadelphia Warriors moved to San Francisco and joined the Lakers out west. Basketball may not have become the national pastime, but, at last, it was truly national.

DOMINANCE

Most of the game's new stars played in Converse. Hell, most everyone did, from kids to pros and all hoopers in between. By the time the NBA was founded, the Chuck Taylor shoe—thanks to Chuck Taylor himself—had been *the* basketball footwear for decades. Only now, the sneaker was being elevated by pro players. While first developed for a ground-bound game, Chucks proved equally capable when the sport took to the air.

Converse-shod athletes blew apart the NBA record books in the 1961–62 season. Oscar Robertson averaged a triple-double in Cons in just his second NBA season. (That wouldn't be done again until Russell Westbrook, 55 seasons later.) Chamberlain, who wore All Stars throughout his career, scored 100 points in a game against the Knicks and averaged 50.4 points and 25.7 rebounds in just his third season. But neither of them won MVP—that went to Bill Russell, the 27-year-old leader of the 60-win Celtics.

Between 1960 and 1968, Russell and Chamberlain split eight of nine NBA MVP awards (Robertson won it in 1964). Russell won 11 rings in 13 seasons, and Chamberlain set unbreakable records in both points per game (50.4) and minutes per game (48.5—keep in mind a regulation NBA game is 48 minutes long) in 1961–62. Both stars logged a lot of playing time in Chuck Taylors.

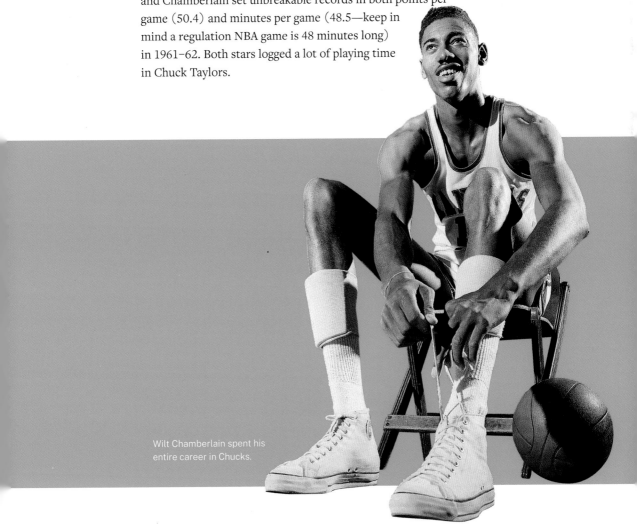

Wilt Chamberlain spent his entire career in Chucks.

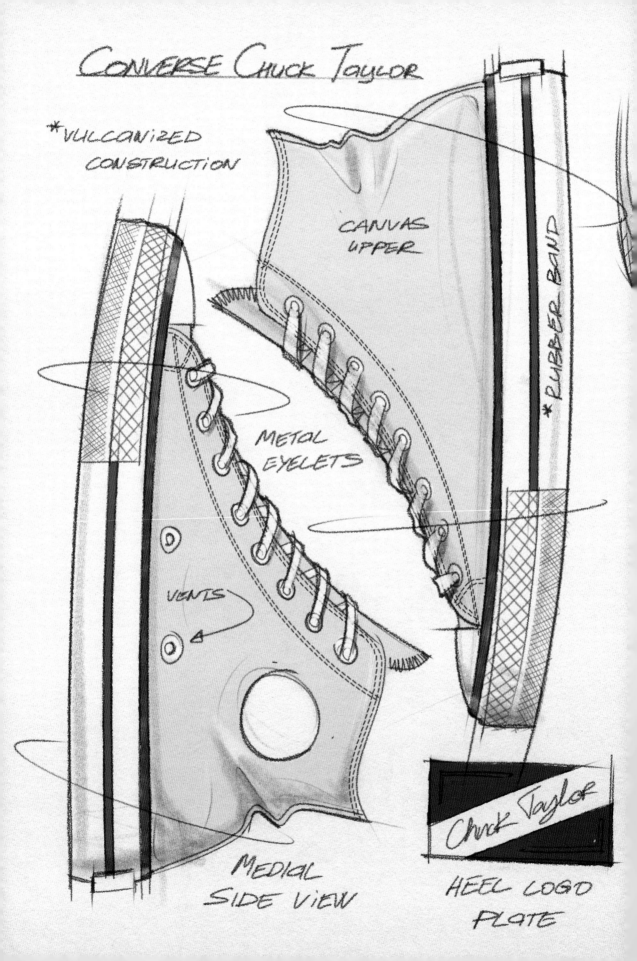

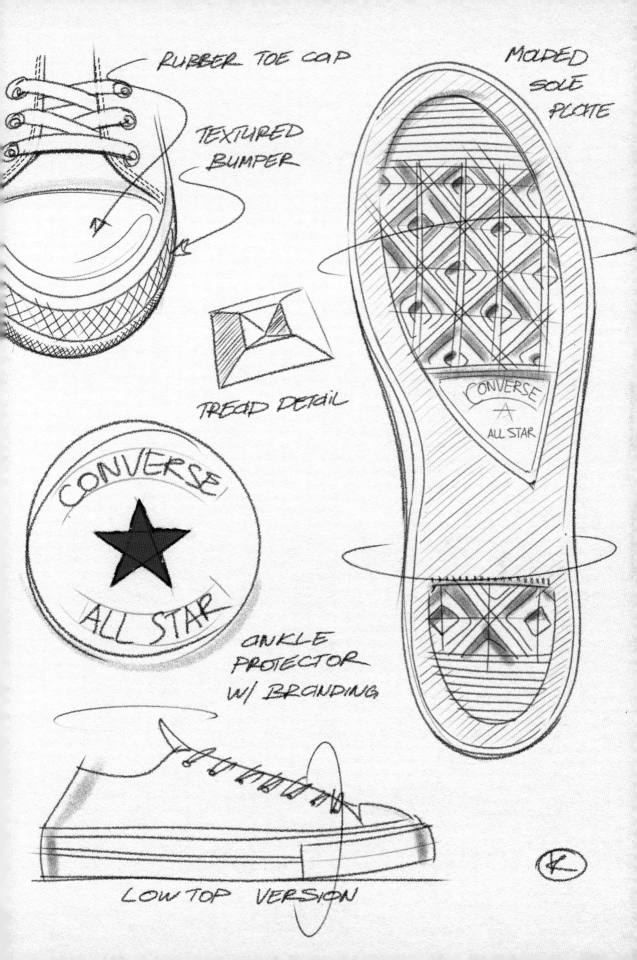

RUBBER TOE CAP

TEXTURED BUMPER

MOLDED SOLE PLATE

TREAD DETAIL

CONVERSE
ALL STAR

ANKLE PROTECTOR W/ BRANDING

CONVERSE
ALL STAR

LOW TOP VERSION

Doctors' Warnings

Back in 2016, *The Huffington Post* spoke to a series of podiatrists about the Chuck Taylor, and all thought the shoe would be an on-court disaster. Dr. Alex Kor, then the president of the American Academy of Podiatric Sports Medicine, went so far as to say, "I'm not convinced that I would suggest them for Wilt Chamberlain or Bill Russell, . . . It is absolutely amazing that [they] were able to complete an NBA season without sustaining major foot problems." Chucks might indeed spell doom for modern feet, accustomed as they are to being coddled in cutting-edge performance footwear. But the American-made, basketball-ready Chucks of the 1950s and '60s were more substantial than the flimsy fashion shoes of the 2010s and beyond.

For his career, Chamberlain averaged an NBA-record 45.8 minutes per game over 14 seasons and led the league in minutes played in each of his first five seasons (and nine times overall). Number two on the all-time minutes per game list? Bill Russell, at 42.3.

Despite all that wear and tear, their Chucks didn't seem to hurt them much. As of this writing, six of the top 11 single-game scoring performances in NBA history were done in All Stars—five by Chamberlain (including his 100-point masterpiece in 1962) and Elgin Baylor's 71-point stunner against the Knicks in 1960. Chucks didn't hold any of the immortals back—or down. "I was six-foot-ten, two hundred pounds, with quickness, agility, and impeccable timing—all of it self-trained," Russell wrote. "I was also on the track team. . . . As a very competitive high jumper, I could touch the top of the backboard, if I needed to, and be looking *down* at the rim."

The Big O., 1958.

None of them were paid to wear Chucks or appear in advertisements. Robertson expressed contempt for the lack of compensation in his 2003 autobiography: "When they contacted me [for a retro campaign], I said I did not want to be involved. When I was a star, they never came to me or asked another black person for an endorsement." True

enough, but when Robertson was a star, Converse didn't ask *anyone* to endorse Chuck Taylors. They wouldn't pay a player for their endorsement until Julius Erving in the mid-seventies.

In fact, Converse was such a dominant force in the world of basketball sneakers that pro players were essentially only paid to *not* wear Converse. Among them were Lakers center George Mikan, who became the face of the Keds brand upon the introduction of the PRO-Keds line in 1949. PF Flyers signed Celtics point guard Bob Cousy to promote the Bob Cousy All American sneaker in 1958. And Wilson paid Celtics forward Tommy Heinsohn to wear their canvas shoes in the 1960s—but they certainly didn't pony up very much.

PF Flyers

The "PF" in PF Flyers stands for "Posture Foundation"—it's understandable why the name was shortened. The brand was founded in 1937 by Benjamin Franklin "B.F." Goodrich, who two years earlier had put out an eponymous shoe for badminton player Jack Purcell. You may have heard of them. Converse's parent company later bought out B.F. Goodrich's sneaker business in 1972 and folded the Jack Purcell into the Converse line.

In 1958, PF Flyers developed the Bob Cousy All American, a familiar-looking canvas high-top with a rubber toe cap and a circular-patterned sole to emphasize pivoting. Or, as they put it, "quick positive traction for 'STOP and GO' fast action in all directions." Cousy, the MVP in 1957, was the most recognizable NBA player after George Mikan had retired. And he was a prolific endorser; the point guard did ads for Seamless basketballs, Jantzen sportswear, and even Kent cigarettes.

Unless you read the ankle patch or noticed that Cousy's shoes had two stripes on the foxing rather than just one, they were virtually indistinguishable from his Celtics teammates' black Chuck Taylors. But it was the ads and endorsement that made a difference. As companies sought to take down Converse, signing up players took on greater importance. They just needed to develop better shoes.

Cousy's kicks.

For most players, though, shoes were simply another piece of team equipment, and those shoes were Chucks. When Heinsohn dressed in his first Celtics uniform in 1956, the rookie power forward didn't just put on a jersey, shorts, and warm-ups—he also laced up black Chuck Taylors. "We got two pairs of shoes for the season," he remembered some sixty-odd years later. "And if you needed a third pair, you had to buy them yourself."

Celtics coach Red Auerbach designated black Chucks as the team's official shoe because they showed less dirt than white pairs and would need to be replaced less often. Auerbach made that penny-pinching decision back when teams traveled by car and bus to places like Rochester, New York, and the Tri-Cities of Illinois and Iowa. The Celtics, in those pre-championship days, were operating on a shoestring budget. Players didn't earn all that much, either. Heinsohn, as thrifty as Auerbach, made his two pairs last the season.

CELTIC PRIDE

Like Marquis Converse, Tommy Heinsohn was a local product—raised in Jersey City but a 1956 territorial draft pick after starring at Worcester, Massachusetts's Holy Cross, the alma mater of teammate Bob Cousy. (Unlike Heinsohn, though, Cousy wasn't wanted by the C's; Boston literally drew his name out of a hat in the 1950 dispersal draft. All Cousy did was make the All-Star team in 13 straight seasons and lead the league in assists in nine of them.) Heinsohn would become a Hall of Famer, but it was the other player the Celtics got in the '56 draft that would put the final—and most important—piece in place for Auerbach's basketball revolution.

Defense sparked Coach Auerbach's fast break offense.

Bill Russell didn't join the Celtics until late December after competing in the Olympics in Melbourne, Australia, where the undefeated US team easily vanquished the Soviet Union in the gold medal game. By the time the 6'10" center with a 7'4" wingspan arrived in Boston, the Celtics were already 16-8 and on their way to their second-best season in franchise history. Russell made an immediate impact—he grabbed 34 rebounds in just his fourth professional game—but he still had some lessons to learn.

"The first thing you faced was getting banged around," Heinsohn said. "He wasn't used to that, and guys all tested him because he looked like if you hit him his bones would rattle." Russell may have disagreed with this assessment. "My attitude when I arrived in Boston was: 'I am the best basketball player on the planet. Every game we play, I am, and I will be, the best basketball player in the building,'" he wrote in his 2009 memoir, *Red and Me*. "I believed that and I played like I believed it."

Russell's tenacious D proved as revolutionary as Cousy's dribbling wizardry: Defense sparked the offense, and the Celtics were literally off and running

in Auerbach's fast break. The entire game changed, and God help you if you couldn't keep up. "Neil Johnston, who was the league-leading scorer the year before, he had a hook shot and Russell blocked almost every hook he took," Heinsohn recalled. "He ran Neil Johnston and those type of players out of the game." Johnston, the earthbound Philadelphia Warriors center who led the league in scoring for three consecutive seasons from 1953 to 1955 and played in six straight All-Star Games, retired in 1959 at age 30. "People still ask me today, 'Who taught you to do that?'" Russell wrote of his defense. "Well, nobody! I had never seen a blocked shot in a basketball game before I did it!"

Heinsohn wasn't so bad himself. That rookie season, Tommy Gun made the All-Star team and finished third in team scoring behind Cousy and Bill Sharman, dropping a season-best 41 on March 5, 1957. He'd contribute mightily to the Celtics first NBA championship, posting 37 points and 23 rebounds in a double-overtime Game 7 win against the St. Louis Hawks in the Finals. Russell, by then fully acclimated to the pro game by anyone's standards, added 19 points and 32 boards in 54 minutes. Heinsohn was named Rookie of the Year, and Cousy won MVP. But the Celtics were just getting started. After losing to the Hawks in a Finals rematch the following season, Boston won eight championships in a row. They finished out the '60s having won 11 titles in 13 seasons, an accomplishment that is as unlikely to be matched as any in the sport.

The Celtics (left to right: Tommy Heinsohn, Bob Cousy, Red Auerbach) contemplate making two pairs last a whole year.

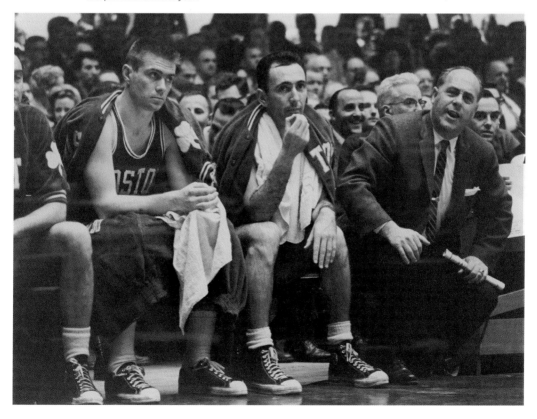

THE BEGINNING OF THE END

The Celtics weren't the last dynasty to launch in Chucks. UCLA coach John Wooden was a meticulous basketball mind who turned his Bruins into the Celtics of college basketball. They won 10 titles in 12 seasons and went undefeated four times. You could do things the Wooden way, or you could play somewhere else. He gave his charges precise instructions for everything, starting with the proper way to put on their socks. His players wore Chuck Taylors, albeit ones Wooden had modified with a razor blade, slicing out an inner seam he thought would give them blisters.

Wooden kept the Bruins in Converse until the late '60s, when he made the switch to adidas, a German company that had finally entered the basketball market and would soon dominate it with a superior product. Even a personal appeal to the coach from fellow Indiana native Taylor, by then retired, wasn't enough. The Celtics would soon move on to adidas, too. Auerbach and Wooden were coaches on opposite coasts who had diametrically opposed personalities, but each sought out the best players and equipped them with the best of what was available. By 1969, that was no longer the Chuck Taylor.

For decades, all the greats had started their basketball journeys in Chucks. "Main Street was my home turf, the place where I became a player and beat all comers," Magic Johnson wrote in *Magic*, his 1983 autobiography. "I also set fashion trends there by wearing red Chucks . . . and multicolored shoelaces." Dr. J set himself apart as a rookie in the American Basketball Association (ABA) by wearing red Chuck Taylors with the Virginia Squires. Charles Barkley wrote in one of his memoirs about being the first kid in his neighborhood to get a pair of Chucks. Hall of Fame Knicks guard Walt Frazier started out in Chucks, too: "That was the only shoe. In high school, college, and the first two or three years in the pros. Converse was it," he said. Hawks center Tree Rollins was the last NBA holdout in the early '80s, his canvas Chucks emblazoned with Converse's Star Chevron logo.

But there would be a final postscript. Mickey Johnson was a fleet-footed, slender-built, 6'10" Chicago native out of little-regarded Aurora College. In 1974, Johnson was

Bill Russell grabs a board, 1964.

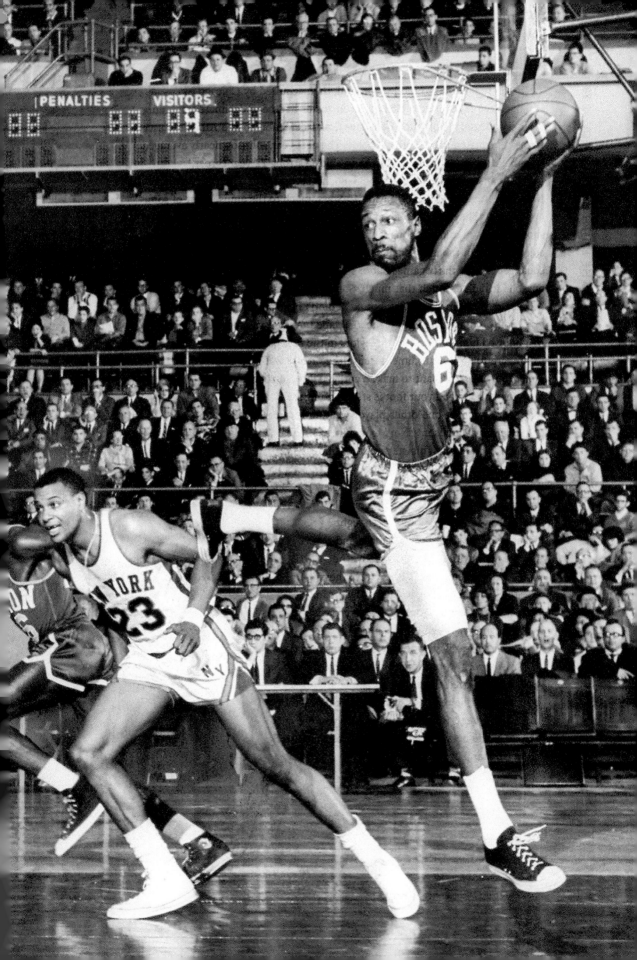

drafted in the second round by Portland, then acquired by Chicago in a trade. He made the Bulls after their preseason roster had been decimated by injury (Cliff Pondexter), holdout (Bob Love), and defection to the ABA (Maurice Lucas) and played sparingly as a rookie. The next year, Johnson nearly averaged a double-double, and he would go on to enjoy a strong 12-year career.

In Johnson's final season in 1985–86, his second stint with the New Jersey Nets, he wore leather Chuck Taylor All Stars, much to the amusement of some opponents. "They would laugh at me and ask me why I'm wearin' these dated shoes," Johnson said. "I thought they were awesome. They were very comfortable." And even though Converse sent him plenty, he made pairs last. "Oh, I could get twenty, thirty games out of a pair," Johnson said. "They were just that durable. It didn't stretch that much. Some people had to have insoles in there because the bottom was so flat, but me, I didn't need any of that."

Johnson didn't even get his ankles taped. And it was those strong ankles that allowed him to wear Chuck Taylors in the first place. "You had to prepare to stop on a dime because they really *will* stop on a dime," he said. "You want to make a cut, you'll end up leaving the rest of your body, and your foot is still standing still."

There was just one other player wearing leather Chucks in 1986: one of Johnson's Nets teammates. Micheal Ray Richardson had gotten his start on the Knicks before being traded to the Golden State Warriors for Bernard King. From there he was dealt to New Jersey, where he had his last of four All-Star seasons in 1985. Johnson thought Richardson had seen him in Chucks and adopted the style; Richardson claims he was wearing them first. Either way, they were the final two playing in Chuck Taylors for a 39-43 Nets team in front of sparse crowds at the Brendan Byrne Arena.

Whoever was first, whoever last, Johnson and Richardson both wore them for the same reason: because they loved them. "I had the white ones, the gray ones, the red ones, and the dark blue—they were all leather," Richardson said. "If you ask me, it's one of the best shoes ever made, was that Chuck Taylor All Star."

1. The young Dr. J already had swag.

2. Mickey Johnson wore leather Chucks on the Nets . . .

3. . . . and so did Micheal Ray Richardson.

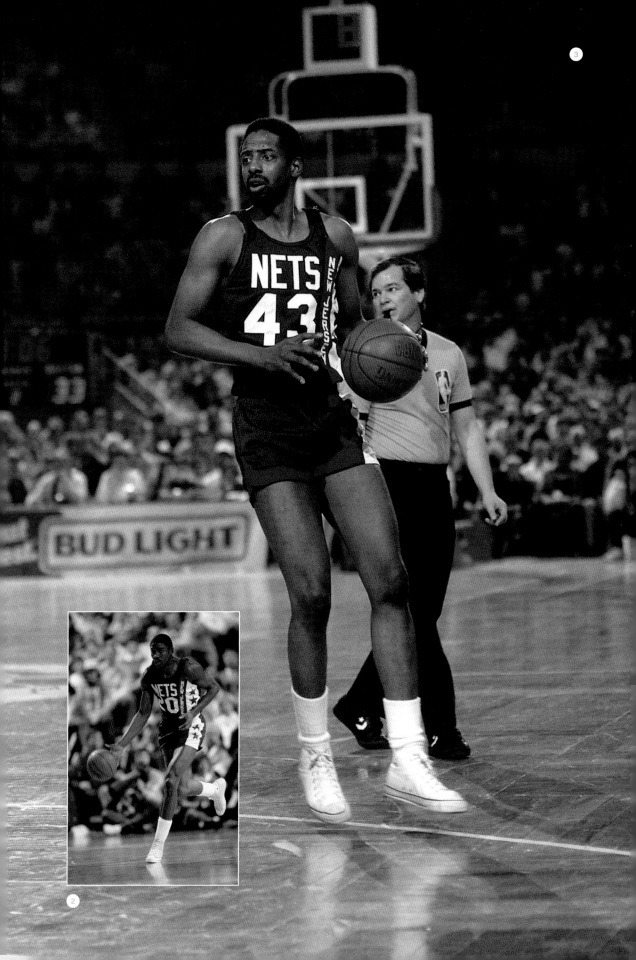

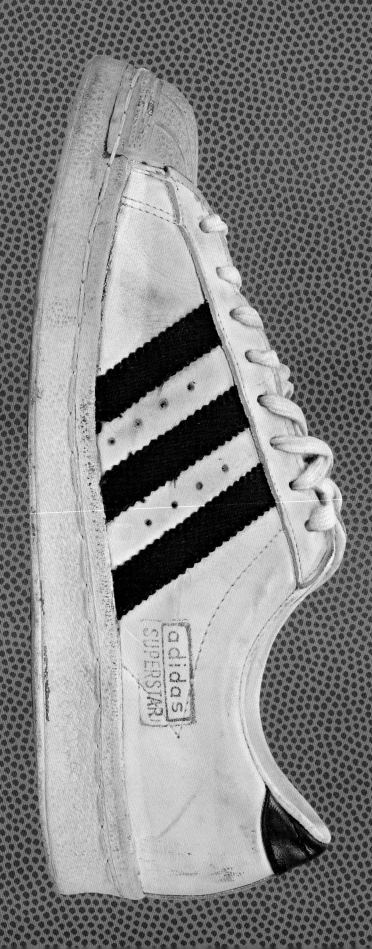

Chapter Two

Tougher Than Leather: adidas Superstar

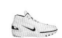

In 1960, a German sneaker company began plotting its takeover of American basketball with a shoe manufactured in France . . . because of a team selected to play in Italy. That US Olympic team still wore All Stars, and they would go on rocking Converse through 1988. But the group of players the United States assembled for the Summer Olympics in Rome was one of the best basketball squads of all time—and the world was watching closely.

The amateur team featured the likes of Oscar Robertson, Walt Bellamy, Jerry West, and Jerry Lucas, each of them future Hall of Famers who would go on to dominate in the NBA. In all there were seven NCAA players, four from the Amateur Athletic Union (then a semipro league), and one, Adrian Smith, from the military. They went undefeated en route to a gold medal, winning by a margin of 42 points per game, a dream team before most of the '92 Dream Team were even born.

A SUPERSTAR IS BORN

Among those observing the Americans dominate was Horst Dassler, the 24-year-old son of adidas founder Adi Dassler. At the time, adidas was the premier shoe company in the two most important sports outside of the United States, soccer and track and field. Jesse Owens had worn a pair of Adi's handmade track spikes while winning four gold medals at the 1936 Olympics in Berlin, and the company understood the importance of the Games for their brand. They even started a tradition of naming shoes after each Olympic city (the ROM trainer, for instance, was introduced for the 1960 Rome Games).

Adidas was synonymous with sport, especially in Europe. But as for basketball, the company had no pressing interest. "A lot of it had to do with the mentality within the Dassler family," said adidas distributor and designer Chris Severn. "They didn't really want to focus on or recognize basketball; they saw it as an American sport."

Severn was born in California to South African parents in 1935. He grew up playing cricket and discovered basketball in junior high. It was love at first shot. After competing through high school, he joined Los Angeles city leagues, playing point guard and coaching. He'd been introduced to adidas shoes by happenstance at his family's sporting goods import business, receiving a single pair of adidas spikes accidentally stowed away with a shipment of cricket equipment. The lightweight, white-and-green soft leather shoes intrigued him and his brothers, and they became adidas's West Coast distributor. Though adidas didn't make

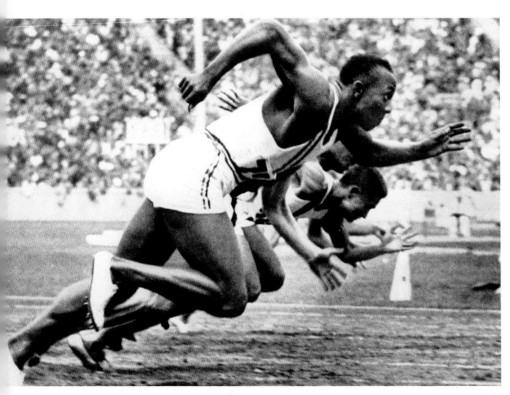

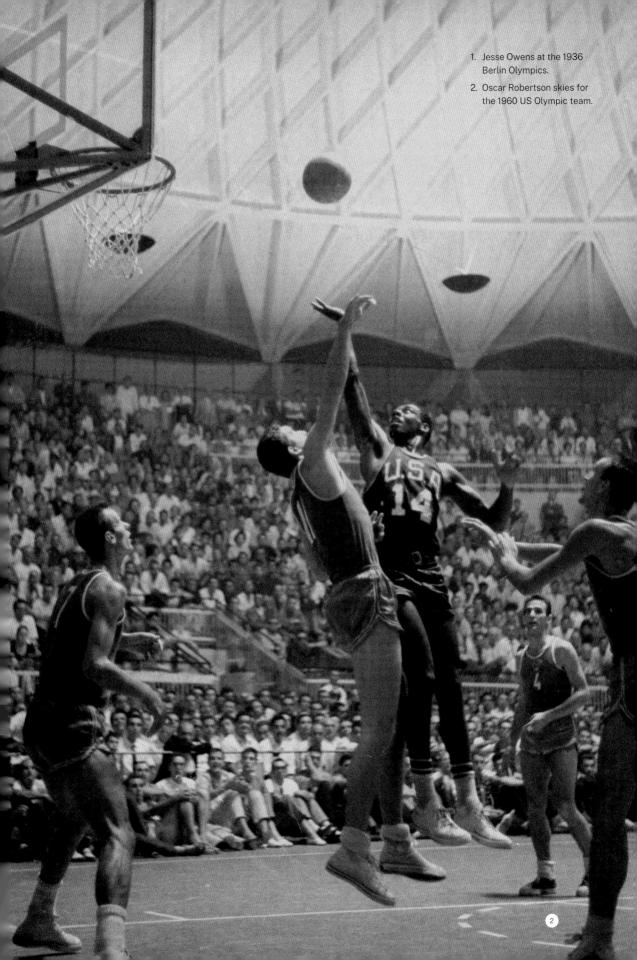

1. Jesse Owens at the 1936 Berlin Olympics.
2. Oscar Robertson skies for the 1960 US Olympic team.

sneakers for Severn's favorite sport, he would soon play a pivotal role in their creation and eventual popularity.

Severn had made Horst Dassler's acquaintance through sporting goods shows in the United States, but the American's early efforts to get the young German interested in creating an adidas basketball shoe had gotten nowhere. That all changed after the 1960 Olympics. It wasn't the Converse sneakers that caught Dassler's attention, but the sport itself. "That's the first time in his life that he saw very talented players and how beautiful the game was—he kind of fell in love with the game," Severn said.

Severn was Dassler's human cheat code into the world of basketball. The American had definitive ideas about how to make shoes better, as well as the connections (or at least the potential to forge them) to get adidas sneakers onto the feet of premier US players. Horst Dassler had seen the light, but his parents, Adi and Käthe, were far from convinced. As long as they were skeptical—and in charge of the company—adidas would never commit to developing and releasing a basketball shoe. So Dassler and Severn got to work behind the scenes.

Severn was Dassler's human cheat code into basketball.

They started their clandestine partnership by exchanging letters and phone calls, working from separate continents until Severn began making trips to Europe. The timing could not have been better. Dassler's parents deployed him to France, where the company had established a new manufacturing facility that could produce shoes cheaper than in Germany. For all practical purposes, Dassler had his own sneaker factory. It was there, an eight-hour drive from adidas headquarters in Herzogenaurach, Germany, that the first adidas basketball shoes would take shape.

Severn, being the one with the real hoops experience, had long considered ways to advance the standard basketball sneaker. Improvements were long overdue, given that the state-of-the-art basketball shoe of the 1950s wasn't all that different from the state-of-the-art basketball shoe of the 1920s. Converse had made incremental upgrades to the Chuck Taylor All Star over the decades, but the current sneaker was still based on a Marquis Converse design rooted in turn-of-the-century manufacturing techniques. Other brands had attempted to compete, but most simply copied Converse.

A "basketball shoe" was still just a canvas high-top with steel eyelets, a reinforced rubber toe cap, and a vulcanized sole. You could have put the image in the dictionary. But that's not what adidas made. Adidas sold leather shoes, and their new basketball sneaker would be leather as well. "PF Flyers and PRO-Keds and Bata, they all tried to make a shoe exactly like a Converse All Star," Severn said. "My outlook was, we need to make a shoe *better* than a Converse All Star— otherwise we will not succeed."

Given that the first adidas basketball shoe was effectively a black-ops project, Severn and Dassler had the luxury of taking as long as they needed to refine the product. It ended up being an eight-year process. One feature that required consistent tweaking was the toe cap, which started as a rough, unfinished-looking

piece of rubber that curled back over the toes. The problem, as they discovered through testing, was that it deformed quickly and gave players blisters. So their first sneaker ended up featuring a soft leather toe. They eventually stitched on a bumper for reinforcement—the near-mythical, pro-player-only "Half Shell"— before it evolved into the familiar full-coverage, six-ribbed "shell toe" that would give the shoe its colloquial name.

Gaining Traction

If you're looking for the most revolutionary aspect of the adidas Superstar, flip it over. That herringbone pattern may be awfully familiar now—the exact same pattern adorns the soles of many shoes from many brands, Nike included. But before Chris Severn put it on the sole of the Supergrip, it hadn't been seen on a basketball court. He remains justifiably proud of it. "It is the go-to traction pattern," Nike designer Leo Chang told *Sports Illustrated* in 2016. "We are always trying to one-up herringbone."

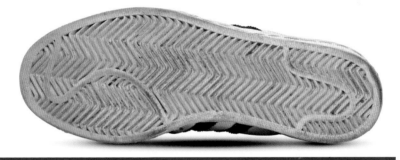

Severn felt that traction was one of the Chuck Taylor's weakest performance features, and he spent considerable time developing a new zigzagging outsole pattern to outdo it. This would become adidas's main selling point for the low-cut shoe they dubbed the Supergrip in 1965. They also developed a high-top version called the Pro Model, fully aware that some players were not prepared to accept a low-cut hoops shoe. And then, in 1969, the refined Supergrip was rechristened the Superstar. The reason for the name change came down to one question: What's better than an All Star?

CHANGING HEARTS AND FEET

Getting the shoe to work was only half the battle. Severn had to get adidas sneakers on the feet of American basketball players. Doing so would not only prove the Supergrip's worth as a superior basketball shoe, but also convince American stores to stock it. At first, retailers questioned both the $15 price per pair—a full 50 percent higher than Chuck Taylors—and whether it was even a basketball shoe at all. So Severn went about creating converts.

Going Low

The earliest basketball shoes were high-tops for just one reason: It was the style of the times. In the late 1800s, men wore ankle boots, and basketball shoes reflected that. It took nearly 60 years for Converse to introduce a low-top Chuck Taylor in 1957. They needn't have waited. Multiple studies over the years have found that whether one wears high-tops or low-tops, there is no discernible difference in preventing ankle injuries. In fact, high-tops are heavier, restrict range of motion, and — in extreme cases — can transfer that energy to the knee instead. Few would argue that a blown-out knee is better than a rolled ankle.

Stability starts at the base — it's all down to the sole and the way the heel is held in place. Ankle tape and balancing exercises help, too. Kobe Bryant and Nike discovered as much in 2008 when they developed the Zoom Kobe IV. They could have just asked adidas, whose Superstar lit the way 40 years earlier.

One of his first was John Block, a 6'9", third-round Lakers pick out of USC whom Severn had met at a summer pro league prior to the 1966 draft. Block had battled foot problems in college but found they cleared up when he wore the adidas shoe. Unfortunately, Lakers coach Fred Schaus shared American distributors' skepticism. Schaus disapproved of the shoe so much that he forbade Block from wearing it. But following a rookie season in which he averaged just 5.4 minutes per game, Block was selected in the 1967 expansion draft by the San Diego Rockets, who permitted more footwear freedom. Coach Jack McMahon, a 40-year-old from Brooklyn, tolerated the newfangled leather shoes as long as they made his players comfortable. A former coach with the Cincinnati Royals, McMahon also convinced Oscar Robertson to try adidas.

Block was such an enthusiastic convert to the Supergrip that by the start of the 1967–68 season, the entire Rockets team was sporting three stripes.

1. John Block wore adidas before you.
2. The Supergrip eventually evolved into the Superstar.

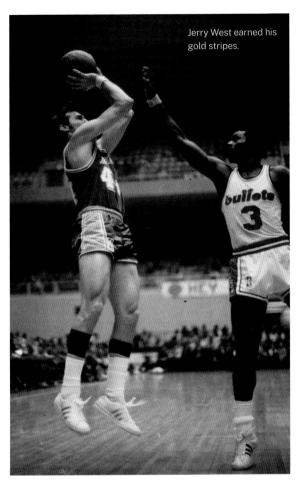
Jerry West earned his gold stripes.

When Severn saw the Rockets play in canvas shoes in the preseason, he thought he had failed. But the opposite was true: The San Diego players were saving their adidas for games that mattered because they didn't know if they could ever get replacements. Severn himself had trouble receiving enough pairs from overseas.

The Rockets proselytized with their feet, even as they struggled on the court, limping to a 15-67 inaugural-season finish. "The Converse reps were spreading the word that the adidas shoes were so lousy that [the Rockets] could barely win a game," Severn remembered. Little did they know that the world of basketball sneakers was changing right before their eyes. "It turned out that the Rockets were the leaven in the loaf," Severn continued, "because back in those days, everybody had to play everybody at least once. And then the players on all the other teams saw up close and personal what the Rockets were wearing."

Any remaining doubt faded quickly after the 1969 National Sporting Goods Association show in Houston. Headlining the convention was a double-header of NBA exhibition games (Cincinnati Royals vs. Detroit Pistons and San Diego Rockets vs. Boston Celtics) played on a court set up inside the four-year-old Astrodome. What Severn knew and the attendees didn't was that most of the players would be in Superstars or Pro Models. It was a wake-up call for American distributors, who now saw the best hoopers in the country wearing adidas of their own accord, while playing the game at the highest level. Maybe the shoes *were* better.

From one man to one team, from one team to squads across the country, adidas did a find-and-replace on the Chuck Taylor. Severn would supply a pair to a player, who in turn would reliably intrigue his teammates. Operating with a minuscule budget, Severn traveled only sparingly; the adidas proselytizer worked mostly in Southern California, where players from East Coast teams learned through word of mouth that they could get those new leather shoes, too. "[Knicks guard] Dick Barnett used to wear adidas because he used to live on the West Coast," said Walt Frazier. "So, when he came to New York, guys were like, 'Hey, man, where'd you get those sneakers?' So, when we went to play the Lakers, the guys would get some adidas to wear."

For the first few years, adidas sneakers were one of b-ball's best-kept secrets. The elite players had them—even streetball guys like New York's Joe "The Destroyer" Hammond and an up-and-comer from Roosevelt, Long Island, named Julius Erving. You could spot Superstars on the court at Rucker Park in Harlem, but you weren't going to find them in shops. Dedicated sneaker stores weren't even a thing yet—global retailers like The Athlete's Foot set up shop in 1971, and Foot Locker wouldn't open its first store until 1974. Sneakers were mostly found in Army-Navy stores, general sporting goods stores, and importers like Carlsen Imports on Broadway in New York City's SoHo. Those in the know could ride a freight elevator to the third floor and find themselves in sneaker nirvana.

"My last year, somebody wore adidas shoes and they didn't have to pay for them," remembered Celtics Hall of Famer Tommy Heinsohn, who retired in 1965. "They gave out a bag and it was part of their merchandising, their promotion. People who wore adidas would carry a bag with them through the airports. So everybody kept saying, 'What's adidas?'"

Eventually, the whole Boston team switched over. In 1968–69, player-coach Bill Russell's final season for the C's, Boston finished fourth in the East but beat Los Angeles in seven games in the NBA Finals, famously forcing Lakers owner Jack Kent Cooke's celebratory balloons to remain in the Forum rafters. In their official '69 team photo, the Celtics squad are all wearing black adidas low-tops. The next season, Jerry West, whose win-at-all-costs nature made Michael Jordan seem carefree and well-adjusted, would wear adidas, too: white Superstars with shiny gold stripes.

A major tipping point came when the UCLA Bruins switched to adidas in 1969—John Wooden held off until his old friend Chuck Taylor had passed away. The following year, when UCLA faced off against Jacksonville in the 1970 NCAA Championship, both squads wore adidas—a first in the college game. The shoes themselves eventually became a Bruins selling point. "That was just part of the whole UCLA awe," forward Marques Johnson said, "those powder-blue Pro Models that we wore at UCLA—and it was no shell toe—the toe was leather." Johnson received his first pair of Pro Models for a high school exhibition game against the Brazilian national team. "It was my shoe of choice from that point."

KAREEM OF THE CROP

Lew Alcindor had already graduated by the time the Bruins officially switched to adidas, but the big man had gotten a taste of the new leather shoes at UCLA and wanted to continue wearing them in the pros. He'd be Severn's biggest get. Alcindor was a transcendent star from the moment he stepped onto UCLA's Westwood campus. In his first college game in 1965, he led the freshmen squad to an easy win over the UCLA varsity—who were, keep in mind, the defending national champions. The freshmen team went on to post a 21-0 record.

The following season, Alcindor broke UCLA's single-game scoring record with 56 points in his varsity debut, a win. After he led the Bruins to a 30-0 national championship season as a sophomore, the NCAA banned dunking. Slams wouldn't return

to the college game until 1977, but Alcindor responded to the ban by perfecting his hook shot and winning two more national championships. He was named College Player of the Year all three seasons on the varsity team, from 1967 to 1969, and didn't just make the cover of *Sports Illustrated*—he was on the cover of *Newsweek*. *Inside Basketball* asked: "Is Lew Alcindor the Greatest College Center Ever?"

Fake It 'Til You Make It

Much like Converse in the '50s and '60s, adidas was what you wore if you weren't getting paid to wear something else. Or, if you were Washington Bullets forward Kevin Grevey, even if you *were* getting paid to wear something else. An All-American at Kentucky, Grevey made it to the NBA fully intending to play in adidas—he'd gotten a pair back when he was in high school and loved them. But Converse's Atlanta-based rep, Larry Conley, knew Kentucky was a Converse school and paid him to wear Cons in the pros.

The checks Grevey liked—the shoes, not so much. So, he didn't wear them. "I could not stand that shoe," he said. "So what I did was I took a razor blade, and I took the three stripes off [the adidas] with the razor. And then I took the stripes and the star off a Converse shoe. And then I had my girlfriend sew those onto the leather, and now I'm playing with adidas with the Converse logo. I did it for a year and a half. Nobody ever said a word." When his Converse deal finally ended, Grevey signed with adidas.

Unsurprisingly, the 7'2" center was the first overall pick of both the 1969 NBA and ABA drafts. (The Suns and Bucks, both in their second seasons as NBA franchises, flipped a coin to see who would get the first pick, and Milwaukee won.) Alcindor decided there would be no drawn-out negotiations; both leagues and both teams—the NBA's Bucks and the ABA's New York Nets—were informed in no uncertain terms that they should make their best offer. ABA commissioner George Mikan, the former PRO-Keds endorser and Hall of Fame center, went into his meeting with Alcindor and adviser Sam Gilbert with a four-year offer and a certified check for $1 million in his pocket. But he held back the check for a second round of negotiating that never came. Alcindor signed with the Bucks for $1.4 million over four years, and Mikan resigned as commissioner.

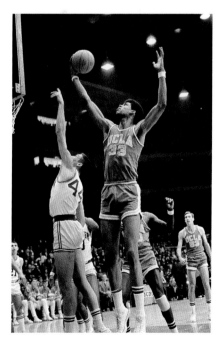

Young Kareem was a PROBLEM.

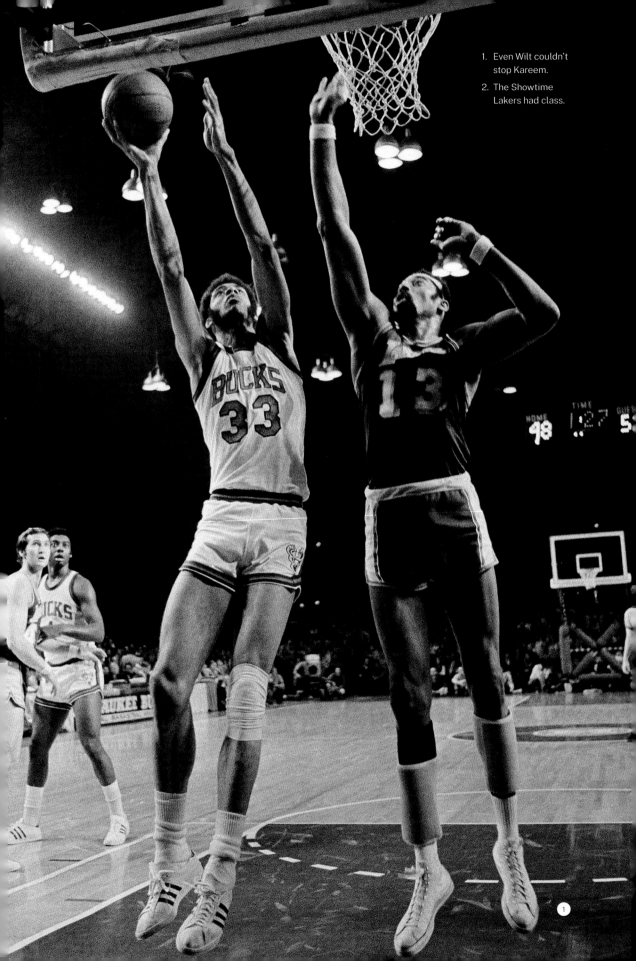

1. Even Wilt couldn't stop Kareem.
2. The Showtime Lakers had class.

When Alcindor made his much-anticipated NBA debut, he immediately became adidas's most prominent basketball athlete. He wore low-top Chucks already, so the big man needed no additional convincing to lace up a pair of Superstars. That first season he finished second in scoring and rebounding and was named Rookie of the Year. But as easy as it seemed on the court—at least as far as putting up monster numbers—it was difficult off it. Milwaukee was unfamiliar to the broody and contemplative star, and everyone seemed out to get him, from the referees to the media. "Sounds whiney, like sour grapes," he wrote in his 1983 autobiography *Giant Steps*, "but my rookie year as a pro drove me pretty deep into myself where I couldn't be visited, couldn't be bruised."

Before his second season, however, the Bucks traded for Oscar Robertson. They posted the best regular-season record, and Alcindor won more or less everything an NBA player could win: the scoring title, MVP, a championship, Finals MVP. He had an unstoppable shot and a Hall of Fame teammate. Alcindor turned 24 on the day of Game 4 of the Western Conference Finals against the Lakers and celebrated with 31 points and 20 rebounds in a 23-point win. The Bucks closed out the Lakers in Game 5, then swept the Baltimore Bullets in the Finals. That summer he made his 1968 conversion to Islam public and officially changed his name to Kareem Abdul-Jabbar.

Kareem served as the ultimate proof of concept for adidas. He was the best player in the NBA, the heir to both Chamberlain and Russell, and he chose to wear Superstars. There was no money involved—yet. But his choice helped change the entire sneaker landscape. Between UCLA, the Celtics, and Abdul-Jabbar, adidas swept through the pro and college ranks—Severn estimated that at the time they had 70 to 80 percent of players in three stripes—just off the strength of the shoe itself. Converse and other brands had to pay to get (or keep) people in their shoes.

Adidas eventually had to pay their stars, as well. Abdul-Jabbar himself would abscond to PRO Keds for a couple of seasons. In 1974, they signed him back with

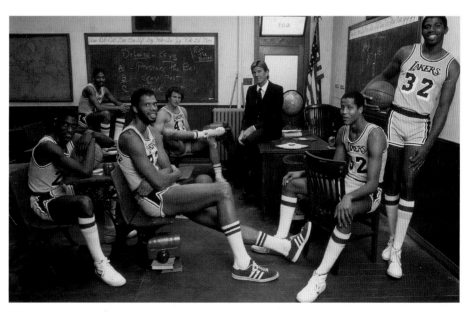

a $25,000 deal, and Kareem became the first player to get an adidas signature basketball shoe: the Jabbar. But as Severn tells it, the center was so enamored with the Superstar that he continued to wear them instead of his own signature product. He was *still* wearing the Superstar as late as 1987.

Abdul-Jabbar wouldn't finish his 20-season Hall of Fame career in adidas, but he'd give them plenty of prime placement along the way. Look no further than *Sports Illustrated*'s 1981 NBA preview issue titled "The NBA Goes Back to School": The opening spread featured defending-champion Los Angeles Lakers in uniform with a bow-tied coach Paul Westhead at the chalkboard. Front and center was a grinning Abdul-Jabbar, resplendent in his gold and purple and a pair of massive red adidas low-tops.

ABA: THE ADIDAS BASKETBALL ASSOCIATION

By the time adidas was outfitting 80 percent of pro players, the NBA had expanded rapidly. The league added the Chicago Bulls in 1966, the San Diego Rockets and Seattle Supersonics in 1967, the Phoenix Suns and Milwaukee Bucks in 1968, the Cleveland Cavaliers, Buffalo Braves, and Portland Trail Blazers in 1970, and the New Orleans Jazz in 1974. Teams got custom colorways—Seattle wore green with yellow stripes, while the Washington Bullets and Detroit Pistons got white with red and blue stripes. "It was always a challenge to meet deadlines," Severn remembers. "We tried to make each team feel that they were special. And that was through the use of color."

Then there was the ABA, an 11-team league that started play in 1967 with the unspoken goal of eventually merging with the NBA. The explosion of professional basketball teams meant a whole lot more people could make a living as a pro player—and they all needed shoes.

A fly-by-night operation from the start, the ABA offered enormous player contracts by deferring large sums of money through annuity payments. But as news headlines focused on those hefty numbers, the NBA was forced to adjust its own salary structure to match the ABA's inflated offers. The difference was that the NBA didn't defer payments, and player salaries would skyrocket.

Even with that on-paper advantage, however, ABA franchises moved or folded during each of the league's nine seasons. All-time talents such as George Gervin and Julius Erving (both of whom started their professional careers with the Virginia Squires before moving to the San Antonio Spurs and the New York Nets, respectively) couldn't make the league viable on a long-term basis. From the jump, the upstart league was Morpheus desperately leaping to a helicopter in *The Matrix*—an NBA merger was the ABA's only way to escape inevitable insolvency and dissolution.

The ABA could never hope to compete with the NBA on a level playing field, so they did their best to tilt it. By instituting looser eligibility rules, they drafted

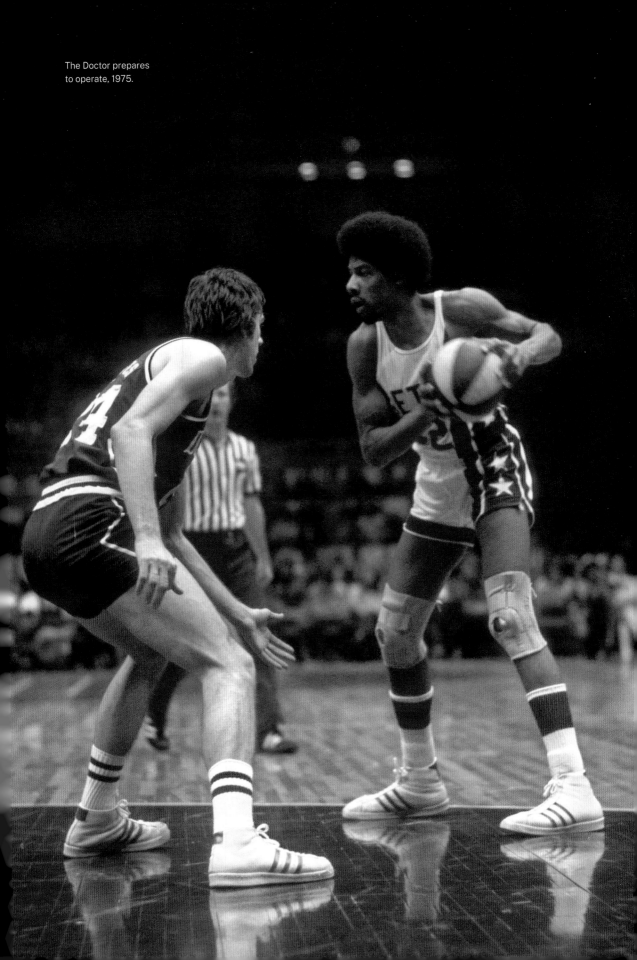

The Doctor prepares
to operate, 1975.

players before the NBA could, including stars like Erving, George McGinnis, and Spencer Haywood. The latter joined the ABA in 1969, two years before winning a landmark antitrust case against the NBA that led to underclassmen earning the right to enter the draft as "hardship" cases. In 1974, a blue-chip high school center by the name of Moses Malone spurned Lefty Driesell and Maryland to sign with the Utah Stars, who drafted him in the third round. Malone, the first modern prep-to-pro player, would eventually become a three-time NBA MVP.

The ABA also tried showmanship, despite playing before sparse crowds. The league used a red, white, and blue ball, its hypnotic spin making it an instant playground staple; they put cheerleaders in bikinis (shout-out to the Miami Floridians); and they cribbed the three-point line from Abe Saperstein's defunct ABL—although not its Curryesque 25-foot distance. "It was so Mickey Mouse it was unbelievable," Hall of Famer Rick Barry said of his transition from the NBA to the ABA. "I remember one time there were more people sitting on the benches and on the court in uniform than there were sitting in the stands."

Had the ABA been able to lure Abdul-Jabbar away from the NBA—a feat they managed to pull off with Barry—things might have gone quite differently. At worst, the ABA would have received media attention and gained leverage over their rivals; at best, they could have gotten their own TV contract. The ABA may not have signed Kareem, but they did get their own shoe: the adidas Americana. A short-lived Superstar takedown that Severn both created and named, the 1971 release featured an autoclaved white mesh with alternating red and blue stripes. It was advertised in posters and beyond as the official sneaker of the ABA.

In 1976, the ABA finally got their wish and merged with the NBA, although only four of six teams—the Denver Nuggets, New York Nets, Indiana Pacers, and San Antonio Spurs—made the cut. The rest of the ABA's talent from the Kentucky Colonels and the Spirits of St. Louis were distributed via dispersal draft, infusing

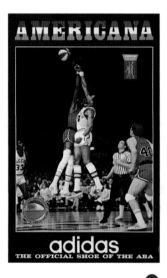

1. Adidas Americana, 1972.
2. Americana poster, early 1970s.
3. Adidas Pro Model, circa 1965.

the NBA with more athleticism and talent. The Nets, needing money to pay the Knicks for infringing on their territory in New York, sold Dr. J's contract to the Philadelphia 76ers.

Erving, who'd started his ABA career in Chucks before switching to adidas, became Converse's first official paid endorser in 1974. He wore the Pro Leather, which a North Carolina freshman named Mike Jordan would sport on his way to an NCAA title in 1982. But Jordan had played in adidas Pro Models in high school and liked the German brand so much that he continued to wear adidas at college practices, despite UNC being a Converse-sponsored school, and desperately wanted to wear them as a pro. (Erving also didn't give up adidas entirely; Severn remembers his brother, Ernie, sending Dr. J the occasional pair of Pro Models even after Erving became a Converse athlete.)

Converse now found themselves in an unusual position: as the underdog. Up until that point, basketball shoes had only improved incrementally. The adidas Superstar changed all that. Converse not only had to develop leather shoes of their own but also had to pay players and programs alike to wear what was now seen as an outdated product.

Chris Severn and Horst Dassler—who tragically passed away from cancer at age 51 in 1987—reshaped adidas, transforming the European company into a major American player. Even more impressive, they fast-forwarded basketball shoe evolution. The name was an important part of it. "Superstar" was simultaneously reactive and proactive, prophecy and fulfillment of same. With a name like Superstar, you needed real superstars like Kareem Abdul-Jabbar to wear them. And with the advent of the ABA, expanded television coverage, and skyrocketing salaries, the modern basketball superstar was born.

Debuting at a time when adidas's early distribution consisted of word of mouth and inside connections, the Superstar was both a validation of your status and an indicator of it. The sneakers quickly spread far and wide across the basketball universe. Even after Superstars began to disappear from the courts, they were adopted by leaders of the burgeoning hip-hop movement and became a status symbol for different kinds of superstars. The game had changed, but the shoe remained the same.

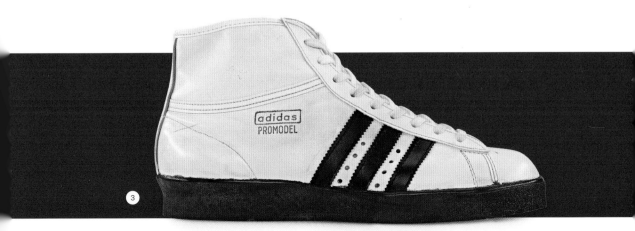

3

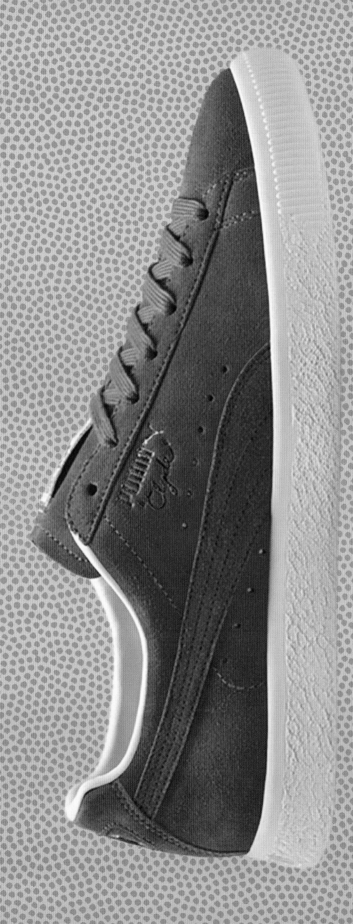

Chapter Three

New York State of Mind:
PUMA Clyde

Adidas didn't have to look far to find their biggest global competitor in the 1960s. Just down the road in Herzogenaurach, Germany, PUMA was originally founded as Ruda by Rudi Dassler, brother of adidas founder Adi Dassler. Formerly partners, they'd had a falling out and each established their own footwear companies in 1948. PUMA and adidas competed in the same arenas and strived to shod the same elite athletes, primarily in track and field and soccer. They were each other's fiercest competition as only brothers can be, and their headquarters still stand opposite each other like warring medieval fortresses. Once adidas went full-bore into basketball in the mid-sixties, it was only a matter of time before PUMA would respond in kind.

Converse Chuck
Taylor All Star
1917

Adidas Superstar
1965

PUMA Clyde
1971

Adidas Top Ten
1979

Nike Air Force 1
1982

Nike Air Jordan
1985

Reebok Pump
1989

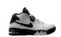
Nike Air Force
Max
1993

Nike Air Swoopes
1995

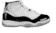
Nike Air Jordan XI
1995

AND1 Tai Chi
2000

Nike Air Zoom
Generation
2003

Nike Zoom
Kobe IV
2009

Under Armour
Curry One
2015

Nike Adapt BB
2019

BATTLE OF BROTHERS

Adi and Rudi's sons, Horst and Armin, respectively, deepened their fathers' rivalry and expanded each company's reach. Things came to a head in Mexico City for the 1968 Summer Olympics, where both brands had their representatives running around and paying athletes to wear their shoes—in some cases on an event-to-event basis—and sabotaging each other's efforts wherever and however they could.

American long jumper Bob Beamon, who had been wearing PUMA throughout the preliminaries, donned adidas for his record-shattering gold-medal leap. German sprinter Armin Hary raced his preliminary heats in adidas, broke an Olympic record and won gold in PUMA, and then changed *back* to adidas before taking the medal stand. American sprinters Tommie Smith and John Carlos ran the 200m in PUMA spikes and finished first and third, respectively. Each set a single white-on-black PUMA on the podium during their silent, black-gloved, medal-stand protest. They stood in their socks. It was—and still is—the image of the '68 Games. By this time, adidas had launched the Supergrip (later renamed the Superstar) and Pro Model in 1965, and PUMA introduced a hoops shoe called the Suede in Mexico City. But basketball was still less of a pressing concern.

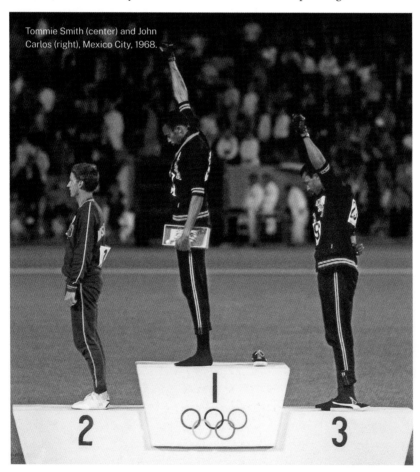

Tommie Smith (center) and John Carlos (right), Mexico City, 1968.

Broadway Joe.

While adidas sought to get their shoes on the feet of as many professional athletes as possible, PUMA was more interested in signing the most charismatic athletes in each sport. They signed young Oakland Athletics slugger Reggie Jackson and flamboyant New York Jets quarterback Joe Namath. "Broadway Joe" guaranteed a win in the 1969 Super Bowl, then went out and did it in white PUMA cleats. Sales soared, as did his quarter-a-shoe royalties.

As the start of the 1970 World Cup drew near, PUMA and adidas made a gentlemen's agreement not to sign Pelé, the greatest footballer of them all. But when the Brazilian star openly wondered why his teammates were getting shoe deals and he wasn't, PUMA gave him one. The company got an immediate return on their investment: Pelé paused before the start of the final match against Italy to tie his shoelaces, giving everyone a good look at his PUMA Kings. Brazil won 4–1, with Pelé scoring the first goal 19 minutes in. Not every PUMA athlete was Pelé or Namath, but it was clear that the right personality could do wonders for business.

NEW YORK, NEW YORK

A month earlier in New York City, the Knicks faced a daunting Game 7 in the 1970 NBA Finals against the Los Angeles Lakers. Knicks captain and NBA MVP Willis Reed had missed Game 6 with a serious leg injury, and New York suffered a crushing 22-point loss. Wilt Chamberlain had gone virtually unchecked, putting up 45 points (on 20 of 27 shooting) and 27 rebounds, while Jerry West added 33 points and 13 assists. Right up to tip-off in Game 7, no one knew whether Reed would play. If the Knicks were to join the Jets and Mets—both champions in 1969—as New York heroes, they would need a miracle. But they didn't get one. They got two.

Most of that game's lore still centers on Reed, whose gutsy return stunned both fans and players alike. The hobbled center hit the opening two shots and gave the Knicks momentum they would not relinquish. New York went on to take Game 7 at home and win their first NBA championship. Reed, already named regular-season and All-Star MVP, added Finals MVP to complete the trifecta. But it was Knicks point guard Walt "Clyde" Frazier, averaging 43 minutes per game in the Finals, who got them across the finish line.

Frazier posted an absurd 36-point, 19-assist, 7-rebound stat line in the clincher. "My mentality when the game started [was] to get the ball to the open man," Frazier remembered. "But as the game progressed, I was the open man."

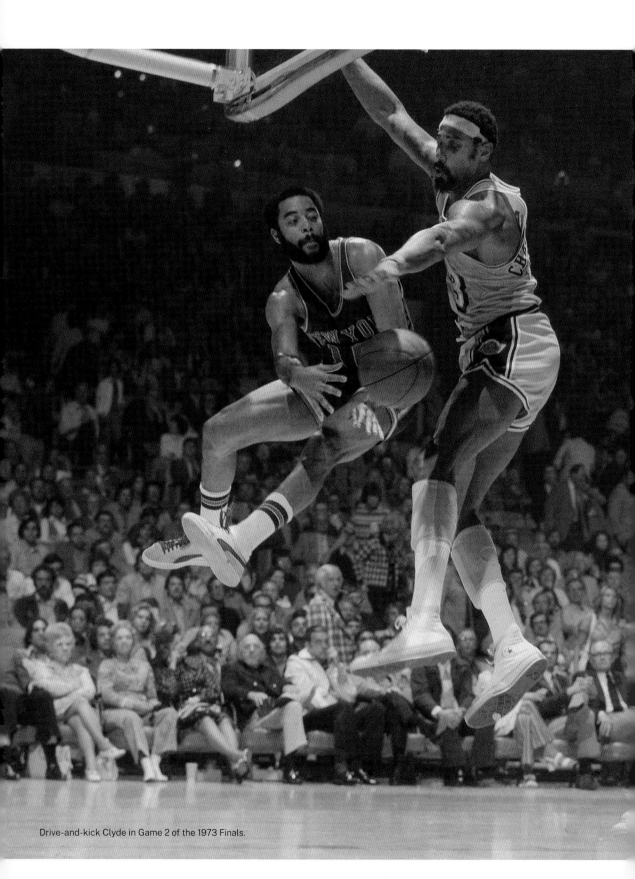

Drive-and-kick Clyde in Game 2 of the 1973 Finals.

Fifty years later, Frazier can still recite his exact stat line—including steals, which weren't even an official statistic yet.

Even on a team built on egalitarianism, it was readily apparent that the 25-year-old Frazier was a rising superstar. He was becoming as well-known off the court as he was on it, earning the "Clyde" nickname after his wide-brimmed hat reminded teammates of Warren Beatty's headwear in 1967's *Bonnie and Clyde*. Frazier fully enjoyed the New York nightlife and drove a two-tone Rolls-Royce, still a car reserved mostly for movie stars and royalty. By 1970, he already had the style, attitude, and presence to be a star—now he had the championship ring to match.

PUMA approached Frazier to be their premier basketball athlete following the NBA Finals. Like Namath, Frazier was a magnetic New York team leader with a penchant for fur coats and pretty women. But while Namath enjoyed broad appeal, his footwear wasn't for every-one—you couldn't wear cleats to class. Ditto for Reggie Jackson. PUMA really needed a basketball player and offered Frazier the same deal as Namath: $25,000 and a royalty on sneakers sold. Clyde accepted, but it wouldn't be as simple as slapping his name on an existing shoe.

PRO-Keds in New York

In 1971, PRO-Keds made a push for the Big Apple. Their canvas Super, also known as the 69er, was the first sneaker to be dubbed the Uptown or the Uptowner (Nike Air Force 1s would later get that nickname) and became popular among those not ready or able to step up for leather or suede. Meanwhile, the Royal, a.k.a. the Super PRO-Keds, found its way onto a bunch of NBA feet, including those of New York legends Kareem Abdul-Jabbar and Nate "Tiny" Archibald.

Kareem had played his high school ball at Power Memorial on West 61st Street, while Tiny played at DeWitt Clinton in the Bronx. In 1971, Kareem won MVP, a championship, and Finals MVP. In '72, Tiny averaged 28.4 points per game; the following season he led the league in points and assists.

PRO-Keds put their diagonal red and blue logo on some other All-Star players, too: Celtics point guard Jo Jo White, Bulls forward Bob Love, and Hawks guard Lou Hudson. They later added "Pistol" Pete Maravich, a rookie with the Atlanta Hawks. Even the Harlem Globetrotters went PRO-Keds. The company got a solid decade out of the shoe even though Kareem eventually jumped back to adidas — proving there are worse things you can do than market to NYC.

NEW SUEDE SHOES

PUMA had decades of experience with soccer players and soccer boots dating back to the pre–World War II Adi-Rudi partnership days, but basketball was still relatively new to them. Their leather shoe, the Basket, didn't impress Frazier, who found them to be heavy, clunky, and very un-Clyde. But PUMA didn't want him wearing the Basket (or the Suede for that matter). They wanted the basketball star to help them design something new.

Together, PUMA and Frazier developed the Clyde, a sleeker and wider-lasted take on 1968's Suede, with "Clyde" embossed in gold script on the sides. They started simple: blue or red stripe on white suede, and quickly produced a rainbow's worth of colors. This not only gave Frazier on-court styles that better reflected his off-court persona, but also vastly increased his earnings through royalties. Within a few years, he was making six figures off his feet.

At $20–$25 per pair, Clydes represented a serious investment when canvas Keds or Cons were going for $10. But they had more curb appeal than the leather adidas that were still primarily marketed to basketball players. And PUMA knew their off-court market, advertising their product in places like *Boys' Life*. On rainy days, the kids (or their parents) who could afford them wore bags over their Clydes so the suede wouldn't bleed. But bag or no bag, kids wore out sneakers quickly, either outgrowing or wrecking them in a matter of weeks. They burned through Clydes at basketball camp and on playgrounds and then needed new pairs, maybe in different colors. And in New York City, sneakers were becoming a status symbol. Even Frazier's Knicks teammates were intrigued.

"The guys were always teasing me, 'Hey, man, Clyde, you think you're hot, you got your own shoe, man,'" Frazier said. "[Then] they were like, 'Hey, man, can you get me some shoes?'" The point guard happily gave sneakers away to his fellow Knicks, but none wore them on court. Reed played in PRO-Keds, Bill Bradley continued to lace up Chuck Taylors, and Phil Jackson wore adidas his entire career. "Primarily, the guys didn't see it as a basketball shoe," Frazier said, "more of a fashion shoe."

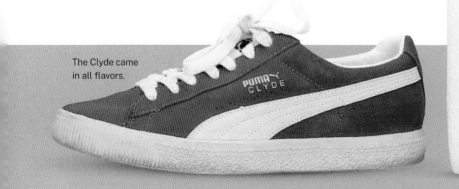

The Clyde came in all flavors.

Frazier had fashion sense from when he was young, but he wasn't always a New Yorker. Born in Atlanta as the oldest of nine children, he excelled at every sport he played. He chose basketball and led the Southern Illinois Salukis to the NIT championship at Madison Square Garden as a senior and was drafted fifth overall by the Knicks in 1967. Frazier started his pro career in the Chuck Taylors that the team trainer issued to him, although he soon switched from highs to lows.

"Once I got to the Knicks, the backcourt guys wore low-cuts. In college, our coach wouldn't allow us to wear low-cuts. But I learned how to tape my ankles, so I started wearing low-cuts, too." And Clyde being Clyde, he gave his Chucks a little twist: "I used to jazz my sneakers up with a blue lace and an orange lace. The thick ones, the thick laces. Just a way to add a little pizzazz."

The PUMA Clyde was one of the first basketball shoes to have that off-court pizzazz built in. PUMA shot a poster with Frazier posing beside his Rolls-Royce in full-on "Clyde" mode, sporting a wide-brimmed hat, mink coat, and, of course, his Clydes. And as Frazier tells it, the sneaker was so big in the Tri-State area they didn't need to sell pairs anywhere else. Basketball was smaller then and more regional, even for a marquee team like the Knicks.

THE CITY GAME

In the early 1970s, suiting up for the Knicks got you more prestige (and more ink) than being an NBA All-Star. Not only was there no All-Star Weekend, but the All-Star Game itself wasn't even *on* a weekend. The Tuesday night showcase was a low-rent affair run by the host team, not the league, so players had to sort out flying in and out themselves. Even the players' banquet the night before was on the chintzy side. For the 1973 All-Star Game at Chicago Stadium, Frazier's fourth, there was no pregame show, and the halftime show was unceremoniously bumped by an address from President Nixon announcing the end of the Vietnam War. Needless to say, tunnel fits and one-off shoes were still far in the future.

Even so, hoops were alive and well in the Big Apple. Basketball may have been born in Massachusetts, but the game came of age in New York City. There were the college powerhouses of the 1950s—eventually brought down by point-shaving scandals—and the much-celebrated Knicks teams of the 1960s and '70s. Then there were the playgrounds, feted in books like Rick Telander's *Heaven Is a Playground* and Pete Axthelm's *The City Game*, which placed streetball heroes and Knicks stars on much the same level.

Streetballers forged their legends by competing against pros on the asphalt in the summers. Ironically, Frazier, the veritable basketball king of New York, wasn't as enchanted by famed city courts like Rucker Park as others of his generation. He grew up in Atlanta learning to dribble on dirt courts and didn't see the need to prove himself against the best of New York City the way Erving and Chamberlain had before him—Frazier *was* the best of New York City. Plus, there were other considerations: "During the summer I like staying out late at night too much," he wrote in his 1971 autobiography, *Clyde*. "The Ruckers play around

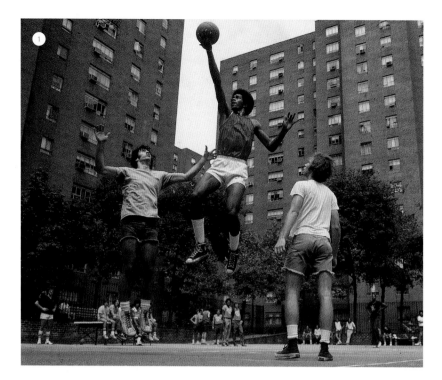

three o'clock. I don't like to get up until maybe two or two-thirty and I don't feel like rushing to a game right then."

Clyde embodied the concept of "look good, play good." An impeccable dresser off the court, he had to look right on court, too. (Tune in to any Knicks game, where Clyde remains the color commentator, and observe his bespoke sartorial splendor to this day.) You wouldn't catch him in beat-down PUMAs—he preferred a tight, crisp pair. "Every two or three games I might go through a pair of shoes," he remembered. "Sometimes they stretched and I didn't like the way they felt—they were too loose."

PUMA had their American offices in Yonkers, and Frazier would roll up there from his 54th Street penthouse to get more shoes. From the beginning, the slick suede sneakers with the red or blue stripe stood out among the predominant white canvas Cons and PRO-Keds and white leather adidas of the time. He laced up pairs in red or with orange and blue strings, just as he did with his Chucks. They were the Air Jordans of the '70s, instantly recognizable and worn on court by only one man.

For all his individuality, Frazier operated within a larger system on the Knicks. They were a sum greater than their parts. An all-time great team, New York was stacked with leaders Frazier and Reed, guards Bill Bradley and Dick Barnett, and forwards Dave DeBusschere, Jerry Lucas, and Cazzie Russell: each of them stars in their own right, but even better together. At the start of the 1971–72 season, New York then traded for All-Star guard Earl Monroe, forming the famed "Rolls-Royce Backcourt" with Frazier. "Earl the Pearl" knew he'd have to tone down some of the one-on-one flair that made him a star on the playgrounds of Philadelphia, at Winston-Salem State, and with the Baltimore Bullets, but he

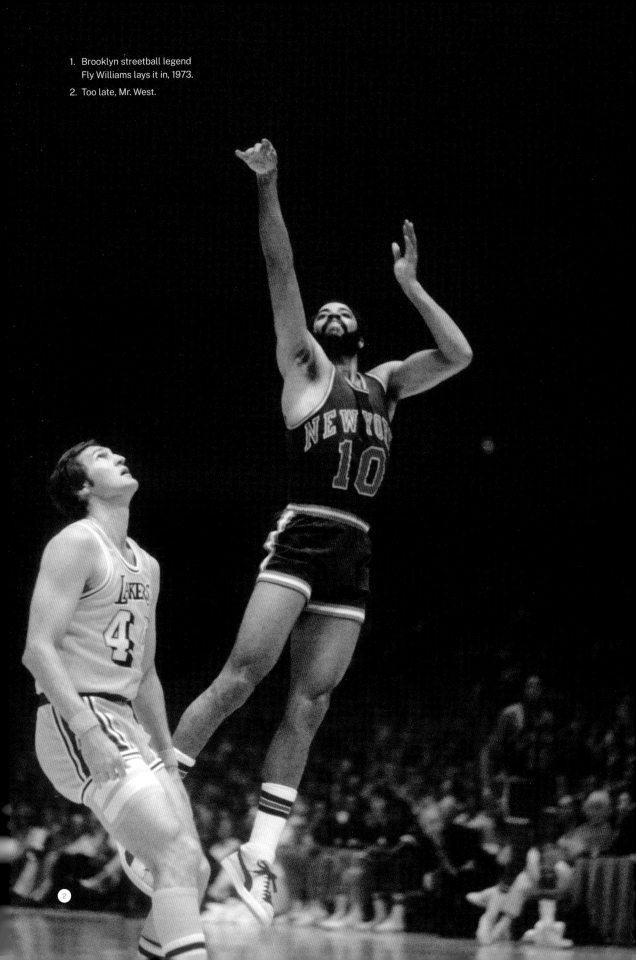

1. Brooklyn streetball legend
 Fly Williams lays it in, 1973.
2. Too late, Mr. West.

2

wasn't too worried. Monroe immediately signed an extension with the Knicks, who bounced back from an off-kilter start to reach the '72 Finals, then won their second championship in 1973.

From '69 to '74, New York made six straight Eastern Division or Conference Finals, playing in the NBA Finals three times and winning a pair of titles. They weren't the Russell-led, 11-championship Celtics—no one was—but the Knicks achieved a level of dominance that they have been seeking to duplicate ever since. (Suffice it to say that the quest continues, much to the consternation of Knicks Nation.)

But the early-70s Knicks had something going for them that the Celtics didn't: They were nearly universally beloved in their own city. New Yorkers were buying Frazier drinks and meals—they still do—not driving him out of his own neighborhood like Bostonians did to Russell. "What that Knicks team did create was a personality on and off the court," said NBA Commissioner David Stern in 2009, "and connected with a city in a way that professional basketball really hadn't seen before."

AHEAD OF HIS TIME

Frazier was a precursor for what Air Jordan would later become even beyond the shoe. Like Michael Jordan, Frazier not only transcended his sport, but he transcended sports, period. Frazier's "Clyde" persona, while a lot less blatantly commercial than Michael's "Air Jordan," became a pop-culture phenomenon. He

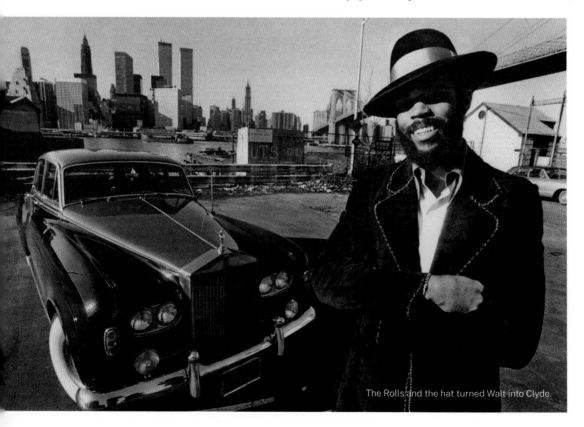

The Rolls and the hat turned Walt into Clyde.

appeared on the cover of *Esquire* in August of 1972—the same month *Super Fly* came out—in an all-white suit with matching hat, basketball in hand, floating above an anonymous Sixers defender. Frazier had some Wilt Chamberlain in him—the round bed with the mirror overhead, the penchant for big-city night-life. A 1975 *New York Times* profile reeled off mentions of his $20,000 Rolls, his $10,000 mink, his $300,000 salary, and his new $130,000 57th Street co-op. Just being Clyde was a full-time job.

Frazier was a precursor of Air Jordan.

Off the court, Walt may have evoked Wilt, but on it he was more like Bill Russell. Both prided themselves on using their stifling defense to generate offense, Russell through blocks and Frazier through steals—neither of which would even be officially recorded until the 1973–74 season. Frazier was a steadying presence as an offensive floor general and the ulti-mate disruptor on defense. And like Russell, who sometimes refrained from blocking shots early in games to ensure he could get them later in crunch time, Frazier might allow opposing guards to get complacent before relentlessly ripping away their dribbles down the stretch. (Look no further than his PUMA ad for the Basket sneaker, provocatively titled, "I steal for a living.")

In 1974, Bill Russell penned the introduction to Frazier's second book, *Rockin' Steady: A Guide to Basketball & Cool.* Basketball players had written books before—or had ones written for them—but *Rockin' Steady* was different. Clyde was different. It begins with Frazier waxing nostalgic about sneakers: "I remem-ber when I was a kid of 10 or 11 and I'd wash my sneakers with soap and brush almost every night so they would be bright and white and dry by morning," he wrote. "I remember being very exact how I laced them up when I went to play basketball in the dirt schoolyard in Atlanta. That was when my sneakers were the hottest item in my wardrobe. I can remember [...] how prideful I felt to wear the sneakers, and how I dug looking down and watching me walk in them."

Had PUMA not pursued him, he may very well have pursued them. A signa-ture shoe for $25,000 a year and all the sneakers he could ever want? You can just imagine a young Frazier asking to whom he'd have to make out the check.

NEVER CHANGE

After the success of the Clyde sneaker, PUMA saw no need to expand their bas-ketball reach right away. They signed ABA star George McGinnis in 1973, and in his very first game in PUMAs he tore straight through the top of his shoe and finished the night in one PUMA and one Converse. McGinnis wasn't going to sell a lot of sneakers anyway—the ABA was even more regional than the NBA and far less visible. But PUMA had Clyde, and Clyde was enough. One cool cat selling another.

The Dassler brothers had approached basketball sneakers in different ways—adidas created the Superstar and got the best basketball players to wear it; PUMA signed the best basketball player they could find and got his input to create a

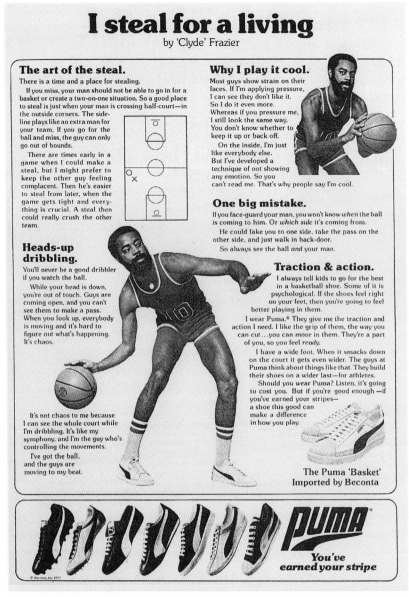

No secrets.

shoe. Then they both let it ride. In our current world of endless limited releases that are here one day and gone, well, that same day, it's a bit hard to imagine a time when you could put out one shoe in tons of colors and just keep selling it almost indefinitely. "New" was relative when canvas basketball shoes had been the standard for nearly seventy years.

First advertised in late 1971, the Clyde was produced for well over a decade. The line briefly expanded with a lower-priced Clyde III all-purpose shoe in the early seventies (there doesn't seem to be any record of a Clyde II) and a higher-priced Super Clyde in the mid-seventies. The original Clyde disappeared briefly in the early 1980s as Frazier's career drew to a close; the Knicks had traded him

to the Cleveland Cavaliers in 1977 and he endorsed Spalding sneakers after his PUMA deal ended. But the classic was revived shortly thereafter as b-boys (and the Beastie Boys, for one) clamored for older styles and scoured dusty sporting goods stores to dig out deadstock. As Frazier hung it up for good in 1979, the close of the decade marked the end of the Clyde as an on-court shoe.

Rebirth of Cool

If you watch *Beat Street*, one of a plethora of hip-hop-themed movies released in the mid-eighties, you might think that b-boys dipped head to toe in PUMA were the norm. But for that film at least, PUMA paid for the placement. "One of the biggest misconceptions about back in the day is that adidas and Pumas were popular to dance in," said Crazy Legs of the Rock Steady Crew. "PUMAs were too wide and flip floppy." Compare and contrast movies like 1984's *Beat Street* and *Breakin'* with 1983's *Style Wars*, the seminal hip-hop documentary in which Crazy Legs appeared. There are PUMAs, yes, but not a lot of coordinated outfits. Truth is messier than fiction.

But the Clyde never really changed. It didn't have to. Well, not that a casual wearer would notice anyway. "The only change they made to that shoe, they made the heel and the toe narrower," Frazier said. "That's the only tweak they've done to the shoe since I've been with them." And that's something you'd notice if, say, you were the shoe's namesake who wore them every single day and ran through hundreds if not thousands of pairs.

Why modify what worked? More important, why modify what sold? The Clyde was the Uptown, the Midtown, the Downtown—a way to show your Knicks allegiance in the days before team-branded apparel became readily available. It was PUMA's Superstar, only their superstar had a name.

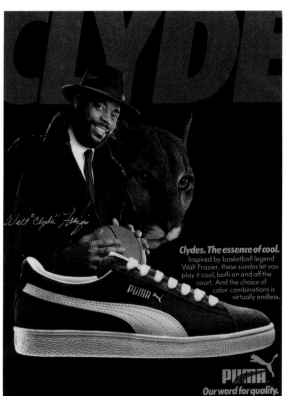

Clydes. The essence of cool.
Inspired by basketball legend Walt Frazier, these suedes let you play it cool, both on and off the court. And the choice of color combinations is virtually endless.

PUMA. Our word for quality.

Two cool cats.

Chapter Four

The Shape of Sneakers to Come: adidas Top Ten

Converse Chuck Taylor All Star
1917

Adidas Superstar
1965

PUMA Clyde
1971

Adidas Top Ten
1979

Nike Air Force 1
1982

Nike Air Jordan
1985

Reebok Pump
1989

Nike Air Force Max
1993

Nike Air Swoopes
1995

Nike Air Jordan XI
1995

AND1 Tai Chi
2000

Nike Air Zoom Generation
2003

Nike Zoom Kobe IV
2009

Under Armour Curry One
2015

Nike Adapt BB
2019

The modern NBA was born in 1979. It was a difficult coming of age, with many struggles and setbacks still to come. But there were signs of a brighter future. Two of them were obvious: Rookies Larry Bird and Magic Johnson joined the Celtics and Lakers, respectively. Here was a college rivalry between two of the best basketball players on earth, delivered ready-made to the pros in about as perfect a way as anyone could have dreamed. Bird immediately revitalized a Celtics team that rebounded from an abysmal 29-53 record in 1978–79 to an NBA-best 61-21 in 1979–80. Magic's boundless joy and creativity infused not only the champion "Showtime" Lakers, but the entire league.

The other signs of maturation were less readily apparent. The NBA adopted the three-point shot on a one-year trial basis (it stayed). It was also the year of the league's first cable TV partnership, with the fledgling USA Network signing a three-year, $1.5 million deal. And adidas introduced the Top Ten, the first truly modern basketball shoe. Unlike the arrival of Bird and

Magic, these three harbingers of the future would take more time to make an impact. Players were used to how they played the game and what shoes they played it in; the NBA was not yet the made-for-TV league it has since become. But change was coming.

THE FUTURE ARRIVES

Adidas's revolutionary Superstar and Pro Model were now more than a decade old, and other brands had caught up. As rookies, Bird and Magic both signed with Converse, whose current state-of-the-art shoe was the Pro Leather, a.k.a. the "Dr. J." Around since 1976, the leather sneaker featured a parquet-patterned outsole, though Bird's pairs were canvas with steel eyelets.

But then adidas introduced the Top Ten, with its suede reinforced toe, perforated vamp, steel eyelets like those of their Stan Smith tennis shoe, and an overstuffed ankle collar and tongue. Its herringbone-tractioned sole featured a pivot button on the ball of the foot. Put it all together and you had something completely different. In his 1991 "Confessions of a Sneaker Addict" feature for *The Source*, hip-hop jack-of-all-trades and b-ball connoisseur Bobbito Garcia contended that the Top Ten had ushered in a new sneaker era, one he dubbed "the complex, bugged, super duty, high octane moon boots period." Basketball shoes had been a tool—now they were finally getting more personality.

Back in the late '70s, fans had fewer issues with the sneakers than with the players who were wearing them. The NBA was suffering some growing pains. Many disgruntled sports fans, sportswriters, and potential sponsors were criticizing the league for a lot of things: being drug-ridden, permitting too much violence on the court, showcasing a less pure form of basketball than the college game. Others perceived those complaints as simply coded ways of saying "too Black." But in the seminal 1981 book *The Breaks of the Game*, which covered the Portland Trail Blazers' 1979–80 season, author David Halberstam posited that big money and increased TV exposure were the NBA's real problems—these developments brought in new owners, set players at a higher remove from their fans (and from one another), and put the game in front of a television audience that expected spectacle.

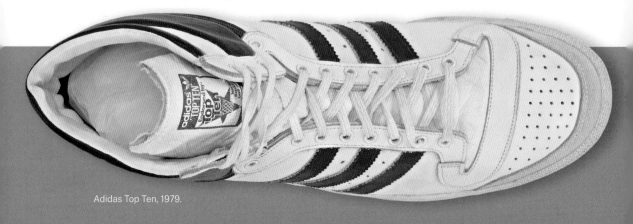

Adidas Top Ten, 1979.

Magic and Larry

Magic Johnson, the number-one overall pick of the 1979 draft, began his rookie year jumping into Kareem Abdul-Jabbar's arms after an opening night victory. He finished it by putting up 42 points, 15 rebounds, and 7 assists starting in Kareem's place in Game 6 of the NBA Finals in Philadelphia, winning a championship and the Finals MVP. It was the perfect rookie season. And he didn't even win Rookie of the Year.

Nope, Larry Bird — whose Indiana State team lost to Magic's Michigan State in the 1979 National Championship game, the most highly rated television game in the history of basketball — got that particular piece of hardware. Red Auerbach had drafted Bird a full year earlier with the number-six overall pick in 1978, and the college foes made their NBA debuts in '79 wearing Converse sneakers. On opening night at Boston Garden, someone released a dove as Bird was introduced. He dropped 14 in his first game, 28 in his second, and averaged 21.3 points, 10.4 boards, and 4.5 assists for the year. (Magic averaged 18.0, 7.7, and 7.3.) Bird and Magic redefined what big men could do. And while Magic won a title first, Bird earned three MVPs — back-to-back-to-back — before Magic got his first, in 1987.

But Magic and the Lakers won their first matchup, 123–105, on December 29, 1979. Sure, it was Lakers-Celtics, a pro hoops rivalry if there ever was one, but what people really wanted to see was Magic versus Bird. It was the first sellout at the Forum in over a year, their individual rivalry played up to Magic's delight and to Bird's chagrin.

"Tomorrow we'll forget this game," Bird said afterward. "We'll be so far from here." In another sense, though, they'd never be apart.

Rivals at the 1979 NCAA Championship game.

Maybe Halberstam was right. At least in the beginning, the new TV deals only magnified the league's problems rather than curing them. The season's start date shifted at the whim of CBS (still the league's primary television sponsor with cable in its relative infancy), and there were a lot of not-ready-for-prime-time players. Television required stars, and a fair number of NBA teams simply didn't have any. Plus, the networks didn't want basketball to interfere with ratings darlings like *Dallas* or *The Dukes of Hazzard*, even when those shows went into reruns. Games could just be broadcast later, right? The renaissance would be televised, but for the time being it was still on tape delay.

By 1979, the waves made by the ABA merger had not yet calmed. The 1976 agreement had brought in an influx of talent, but also four new franchises: the Denver Nuggets, San Antonio Spurs, Indiana Pacers, and New York Nets. That grew the NBA from 18 to 22 teams, the largest single-year expansion since 1949. As recently as 1966, there had been just ten. More teams meant more travel and fewer games against established rivals. The ABA superstars adapted easily enough—all Julius Erving, George Gervin, and David Thompson needed to do to find audiences was to start playing in front of them. Gervin took just one year to adjust, then led the NBA in scoring for three seasons in a row. But if they did find themselves needing any advice on their transition to the NBA, they could have talked to the one star who'd been there and back again.

THE INVENTOR

One way the ABA had hoped to become instantly viable upon its 1967 founding was to convince NBA stars to jump leagues. The biggest name they managed to pry away was San Francisco Warriors forward Rick Barry, the 1966 Rookie of the Year who led the NBA in scoring in '67. His father-in-law, Bruce Hale, had been named coach of the ABA's Oakland Oaks, which meant Barry didn't even need to move. Due to the NBA's reserve clause, however, he had to sit out the 1967–68 season entirely. That year the Oaks went 22-56 and Hale was fired, replaced by Barry's former Warriors coach Alex Hannum. Barry tore up his knee midway through his first ABA season, but the Oaks still went on to win the 1969 ABA title.

Unfortunately, winning didn't help Oakland's financial woes, and the team relocated to Virginia. Barry went on to play two seasons with the New York Nets, then reentered the NBA with the Warriors in 1972—which had to be at least a little awkward— and led them to a championship in 1975. By 1979, he was in the final season of his career, two years removed from his final All-Star appearance and

playing for the Houston Rockets. Nearing age 36, Hall of Fame status assured, Barry worked with adidas to develop the Top Ten. Taking design cues from Kareem Abdul-Jabbar's signature model, the Jabbar, the Top Ten's biggest performance advances weren't immediately noticeable—at least, not until you put the new shoes on.

Barry may not have been an obvious choice to sell a sneaker, especially at the tail end of his career, but he was the perfect choice to design one. He had

> *Barry may not have been an obvious choice to sell a sneaker, but he was the perfect choice to design one.*

zero qualms when it came to telling you what you'd done wrong and how you could do it better. That lack of a filter had infuriated teammates and opponents alike but was invaluable for adidas. Superstar creator Chris Severn talked to a lot of players about shoes, and Barry was one of his most valued resources. After visiting adidas in Germany, Barry didn't mince words and suggested two main improvements for the Top Ten.

The first was in the front of the sneaker, where it bends at the end of the laces. "They smoothed it out inside and it was really made to bend properly at that part of the shoe," Barry remembered. "It was so much more comfortable." The second innovation was to round off the edges of the sole. "A lot of times if you got over on the edge [of a Pro Model] it would be a hard, abrupt roll over," he said. "If you look at the way [the Top Ten] was designed, they rounded it. So it didn't have that abrupt edge, and so if you were to do something, it wouldn't snap off to the side as opposed to just gently rolling." Ankle sprains still vexed the small forward long after his career ended. Thirty years after adidas introduced the Top Ten, Barry worked with Ektio, an independent brand whose shoes were all about minimizing rollover.

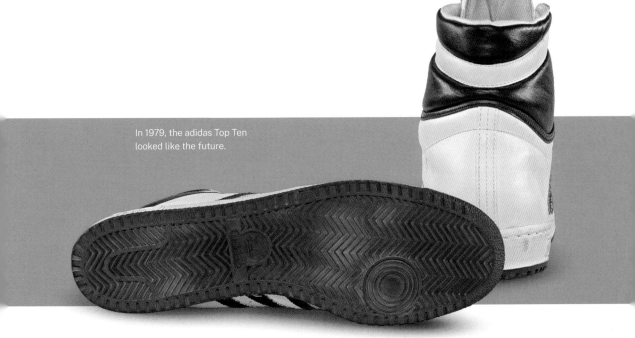

In 1979, the adidas Top Ten looked like the future.

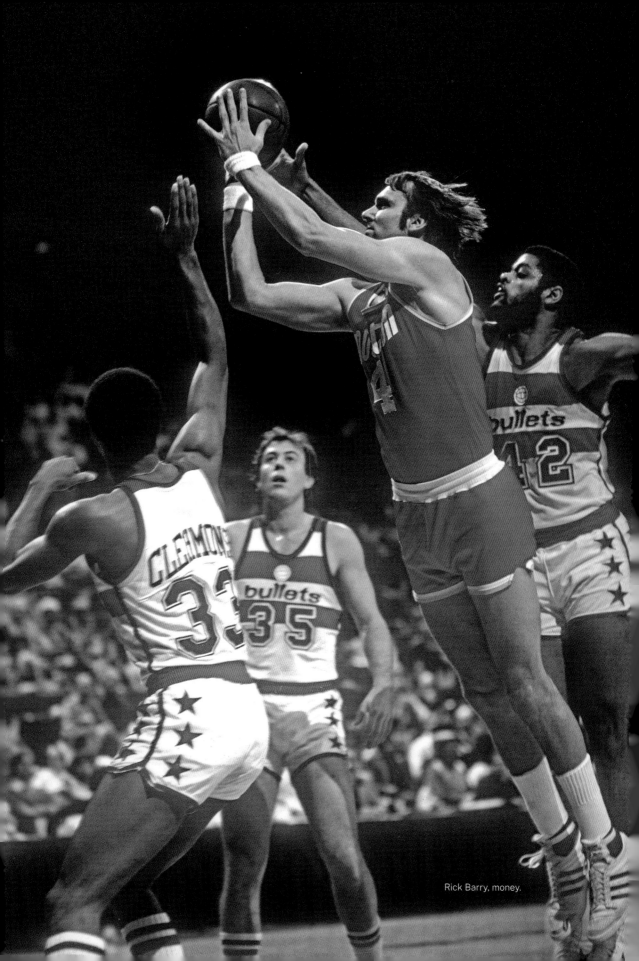

Rick Barry, money.

THE TEN

National ads featured a 1950s-posed (and coiffed) Barry as the Top Ten's "inventor," but the shoe wasn't a Rick Barry signature sneaker. The "Top Ten" name referred to the ten NBA players whom adidas hoops guru Chris Severn had selected to wear it: Bucks forward Marques Johnson, Blazers forward Kermit Washington, Sixers guard Doug Collins, Jazz forward Adrian Dantley, Pistons center Bob Lanier, Sixers forward Bobby Jones, Pacers swingman Billy Knight, Clippers forward Sidney Wicks, Bullets forward Mitch Kupchak, and Bullets swingman Kevin Grevey.

In Severn's reckoning, it was ten for the price of one, all while not expressly linking the shoe to any single player. "Top Ten" was wishful thinking—of those ten players, only Johnson, Dantley, and Washington wound up playing in the 1980 All-Star Game. Kareem Abdul-Jabbar, still adidas's premier athlete, was absolutely a top-ten player, if not the best in the league, but he already had a signature shoe of his own. Sometimes a name is just a name. (As it turned out, the Top Ten's street cred came less from who endorsed it and more from its high price tag—it was an early off-court status symbol.)

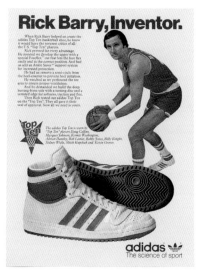

The Inventor in action.

For some of the "Top Ten" players, the agent side of the deal ran through a DC-based law firm that would flip the whole basketball sneaker world on its head. Dell, Craighill, Fentress & Benton's sports marketing arm, ProServ, was headed by Donald Dell, a former tennis pro and Davis Cup captain who represented everyone from Arthur Ashe to Stan Smith. Dell was adept at making his clients' product deals a viable secondary source of income that could outlast their on-court careers and provide a steadier paycheck than prize money. Tennis stars, unlike basketball players, had long enjoyed the financial boon of signature products: Wilson produced a signature racket for Jack Kramer in 1948 that would become the sport's bestseller for the next 35 years; Ashe and Smith got signature shoes from Le Coq Sportif and adidas, respectively. Now it was the hoopers' turn.

In 1975, Dell hired a persistent, young lawyer from Long Island named David Falk who simply refused to take no for an answer. Falk wasn't paid much—at first—and immediately earned his keep by helping with ProServ's basketball business. No firm was better equipped to bring the tennis shoe deal to basketball. At a time when only Abdul-Jabbar was making real money from adidas, the Top Ten deal created a new pool of revenue distributed equally among the ten players, in effect giving each of them a signature deal. At least one of those players, however, was talented enough to deserve a signature shoe all his own—and he happened to hate Rick Barry's sneaker invention.

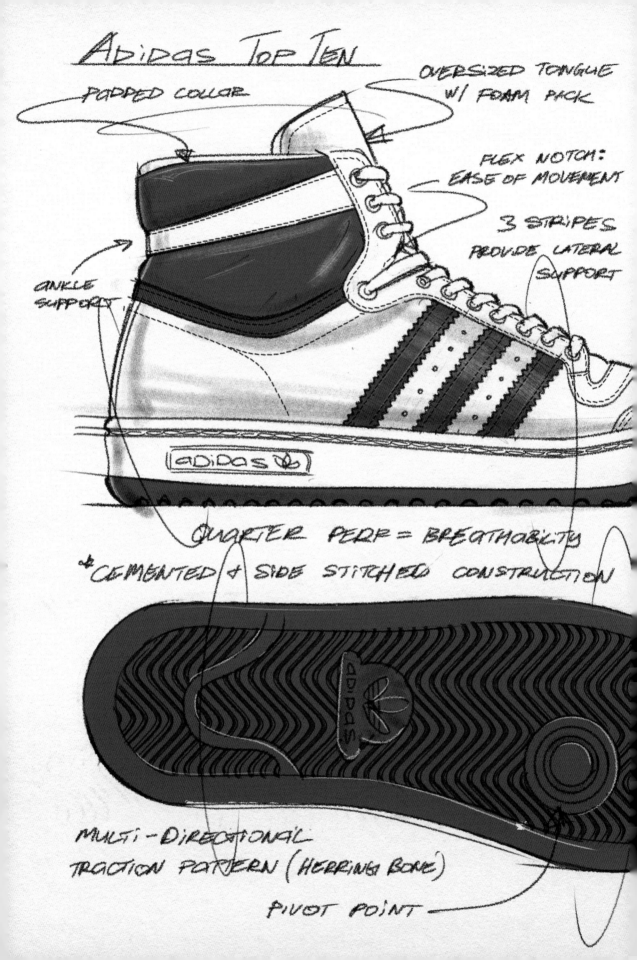

Adidas Top Ten

PADDED COLLAR

OVERSIZED TONGUE
W/ FOAM PACK

FLEX NOTCH:
EASE OF MOVEMENT

3 STRIPES
PROVIDE LATERAL
SUPPORT

ANKLE
SUPPORT

adidas

QUARTER PERF = BREATHABILITY

CEMENTED & SIDE STITCHED CONSTRUCTION

MULTI-DIRECTIONAL
TRACTION PATTERN (HERRINGBONE)

PIVOT POINT

HOW TO SOLVE FLEX POINT
PINCH PRESSURE ?

WIDE + OPEN VAMP,
SO THAT LESS MATERIAL
HAS TO GATHER DURING
FLEX MOTION

LACE
KEEPER

TRANSFER-PRINTED
LABEL

adidas
TOP TEN

TOP
TEN

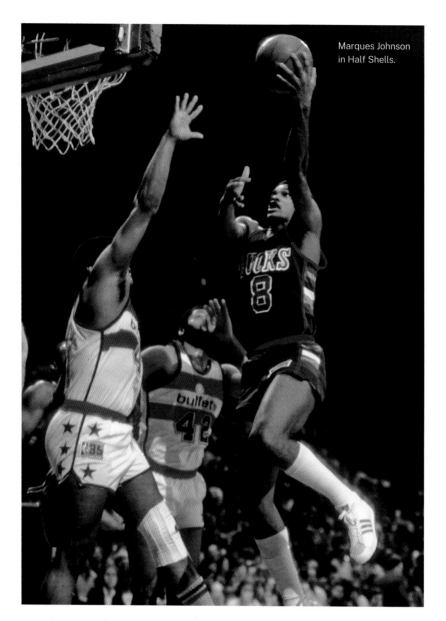

Marques Johnson
in Half Shells.

Marques Johnson was an LA kid whom some considered to be the best forward in the country while still playing for John Wooden at UCLA. In 1979, Johnson was just 23 years old and heading into his third year with the Milwaukee Bucks after an All-Star season where he had averaged 25.6 points per game. He'd signed with Bata out of college—they paid him handsomely to wear their canvas shoes—but he quickly realized he was more comfortable in adidas and took a pay cut to go back to the brand he had worn at UCLA.

Johnson loved adidas, but he didn't love the Top Ten. "I'm used to the Pro Model; sleek, not a whole lot of bells and whistles, pretty basic. The Top Ten had the big, leather ankle area padded, they had the big, padded tongue. They were rounder around the toe and a little wider, so my feet would slide around a little." Just talking about them forty years later gets Johnson worked up all over again. "I

couldn't *stand* 'em as a matter of fact—I hated playing in Top Tens . . . I told David Falk, 'Look, I can't wear these things, man, I feel slower, they feel cumbersome.'" Johnson soon made an unusual agreement with adidas that he would stay in the Top Ten club of players but be granted permission to wear the Pro Models.

Believe it or not, it's much easier to find photos of the Top Ten guys *not* wearing their signature shoe in games. Rick Barry appeared to wear them more often than any of the Top Ten themselves—save perhaps Bob Lanier—which made sense given that they were crafted to Barry's specifications. But it probably didn't matter much anyhow. Their names were in the ad, and the national TV schedule was thin, particularly so for Adrian Dantley, who was seemingly never photographed in Top Tens at all. Playing on the 24-58 Jazz in their first year in Utah, it was perfectly okay for him to stay in Pro Models—no one was going to see the games, much less his feet. In fact, the most prominent (and perhaps best) player to wear Top Tens may have been Indiana Hoosiers guard Isiah Thomas, whose whole squad rocked white-and-red pairs en route to the 1981 NCAA title.

The Real Top Ten

Adidas's "Top Ten" featured just two in the highest echelon of players during the 1979–80 season. Bucks forward Marques Johnson was an All-Star starter, made second team All-NBA, and posted the third-highest Box Plus/Minus (BPM) and eighth-highest Player Efficiency Rating (PER). Jazz forward Adrian Dantley also started the All-Star Game and ranked third in the league in PER.

So, who else was in the real top ten? One also wore adidas: Kareem Abdul-Jabbar, who was named MVP, made first-team All-NBA and ranked second in PER. Then there was Julius Erving, first in PER, second in MVP voting, and first-team All-NBA. Add the other three first-team All-NBA guys: George Gervin, who had just led the league in scoring for a third straight season and finished third in MVP voting; Larry Bird, who finished fourth for MVP and won Rookie of the Year; and Suns All-NBA First-Team guard Paul Westphal.

That leaves three spots, which is where the list gets more subjective. Moses Malone was second team All-NBA and fourth in PER — he's in. Sonics guard Dennis Johnson was sixth in MVP voting and made the All-NBA second team. (Coincidentally, he was traded straight up for Westphal that summer.) The tenth and final spot goes to Magic Johnson, who wasn't All-NBA or Rookie of the Year, and didn't receive a single MVP vote — but he was an All-Star starter and put up 42, 15, and 7 in Game 6 of the Finals, becoming the first rookie to ever be named Finals MVP. In alphabetical order:

1. Kareem Abdul-Jabbar
2. Larry Bird
3. Adrian Dantley
4. Julius Erving
5. George Gervin
6. Dennis Johnson
7. Magic Johnson
8. Marques Johnson
9. Moses Malone
10. Paul Westphal

Isiah Thomas blocks a shot en route to the 1981 NCAA Championship.

THREE FOR ALL

The Top Ten wasn't the only on-court development helping to modernize the game in 1979. Three years after the ABA merger, the NBA adopted the three-point shot on a trial basis. Not all members of the league's competition committee were on board. "We don't need it," said Red Auerbach. "I say leave our game alone." Portland coach Dr. Jack Ramsay agreed: "I don't think anything is wrong with our league to panic into change. What we need are some winning teams in New York, Chicago, and Boston." The old guard thought the three-pointer was just an ABA gimmick, but in time they'd grow to appreciate it. Others took to it right away.

Rick Barry, who had shot the three regularly only in his final ABA season, was one of the NBA's most fervent three-point converts. He wasn't going to pass up free points. (The man shot free throws underhanded, a silly-looking but undeniably accurate style, and hit 89 percent from the line for his career.) In the 1979–80 season, in just 25.2 minutes per game, Barry took 3.1 threes, hitting on 33 percent of them. His 221 total attempts were the second most in the NBA, where the league average for a team was 227. He took more than the rest of his Rockets teammates combined.

In a February game against the Jazz, Barry connected on 8, setting a single-game record that wouldn't be broken for over a decade. He had done the math: "To me, thirty percent is the cutoff," Barry said, reasoning that 30 percent on threes is equivalent to shooting 50 percent on twos. "If you can't shoot at least thirty percent, you have no business ever shooting a three unless the clock's going off."

Those slower to adjust wound up leaving a lot of points on the board. Larry Bird shot 40 percent on 143 attempts and didn't attempt more than 100 three-pointers again until five seasons later. There's an old joke that the only coach who could hold Michael Jordan under 20 points per game was his own, UNC coach Dean Smith. Well, the only team that could hold Larry Bird under 100 three-point attempts per year was the Boston Celtics.

While the C's eased into the three, other teams jumped right into the deep end. The San Diego Clippers—with new acquisition Bill Walton dealing with injuries yet again—were the least bashful, hitting 177 of 543 from distance. (Things have certainly changed: In 2021–22, 20 individual *players* attempted more than 543 threes.) Clippers point guard Brian Taylor, who got his start with the ABA Nets, led the 1979–80 NBA in makes (90) and attempts (239).

On the other end of the spectrum, you had the Atlanta Hawks, who went 13 of 75—as a team—for the season. (They still led the Central Division with 51 wins.) Somewhere in the middle were the New York Knicks, who took 191 threes despite shooting them at a 22 percent clip. Guard Micheal Ray Richardson was in his second season, one that would see him make his first All-Star Game and lead the NBA in assists and steals. He attempted 110 threes that year—more than half the Knicks' total. But shooting beyond the arc wasn't actively encouraged. The opposite, in fact: "We wouldn't dare take a three-point shot when I played," Richardson said. "If we did, the coach would look at us like, *What's wrong with you?*"

LIVE TOGETHER, PLAY TOGETHER

The Washington Bullets could have used a few more threes. Fresh off back-to-back Finals appearances in 1978 and 1979, the 1979–80 Bullets won just 39 games and were unceremoniously swept in the first round by a 59-win 76ers team who would go on to reach the Finals. (The Sixers would lose to the Lakers in the '80 and '82 Finals before deciding enough was enough, trading Caldwell Jones and a first-round pick for reigning MVP Moses Malone.) The two "Top Ten" Bullets, Kevin Grevey and Mitch Kupchak, weren't just teammates, they were roommates. When Kupchak was drafted out of North Carolina, he moved into Grevey's house. More than 40 years later they were still working together—Kupchak as general manager of the Charlotte Hornets and Grevey as one of his scouts. (They have their own houses, though.)

Grevey, like Marques Johnson, was happy to be part of the Top Ten but didn't particularly like the shoe. He too was accustomed to the adidas Pro Model and its narrower width. "I'd like my shoe to fit tight

The Top Ten was less an immediate game-changer than a glimpse of the future.

because I would sweat right through my shoe, and then the leather would stretch," Grevey said. "When I was wearing the Top Ten it was a little wider. So then I would add more socks, and I was wearing like, three, four pairs of socks in that Top Ten to try to make it snugger." Like Johnson, Grevey occasionally went back to the old model.

Adidas never got the Top Ten crew together—not even for an ad campaign, a poster, or, say, an off-season trip to the tropics like upstart Nike had been doing around the same time with their Pro Club of endorsers. This was probably for the best—the NBA was far less fraternal in those days. Asked whether the group ever got together, Grevey scoffed: "I mean, frankly, I didn't care for any of those guys," he said. "Bob Lanier, I couldn't stand him. He didn't like me. Rick Barry used to work out with Adrian Dantley; he was a knucklehead." The players he did get along with were Doug Collins and, of course, teammate Mitch Kupchak, who was drafted 13th overall by the Bullets in 1976, the year after Grevey.

When Kupchak got to the Bullets, the UNC star wasn't sure whether he would befriend his former opponent at rival Kentucky. But Kupchak needed a place to live, Grevey had an empty room, and—history be damned—the two hit it off. Grevey's house, already home to a few other young Bullets employees, became something of a pro hoops frat house. The young housemates meshed on the court, too—in Kupchak's second season and Grevey's third, the Bullets beat the Seattle SuperSonics in seven games to win their first (and thus far Washington's only) NBA title. The next year was a Finals rematch, but the Sonics beat the Bullets in Game 5.

Grevey and Kupchak were the only two "Top Ten" players who never made a single All-Star Game. Forty years on, Kupchak recognizes how fortunate he was. "For me, to be included in the Top Ten club, I wasn't anywhere near a top-ten

player," he said. "And you get to wear the shoe that's most comfortable, you're getting paid, and then on top of it, it's like Top Ten? Dell, Craighill, Fentress & Benton—they were good." Kupchak's personal connection at the firm was fellow Long Island native David Falk. They were both in their twenties, both working in DC, both coming up in the world. Three years later, in 1982, Falk would sign Lakers rookie James Worthy to New Balance in the largest rookie sneaker deal in history. Two years after that, Falk helped mastermind Air Jordan.

Like the three-point shot, the Top Ten was less an immediate game-changer than a glimpse of the future. The three-pointer didn't instantly transform the league like the arrival of Larry Bird and Magic Johnson had, but it laid the foundation for a more modern game. Similarly, the Top Ten previewed the shape of basketball shoes to come, both aesthetically and in terms of how—and by whom—they would be marketed.

It was a transitional shoe at a transitional time, a work in progress with some forward-thinking ideas that players weren't quite ready for. Many of those who had discovered adidas through the Superstar and Pro Model had grown used to those older models and, well, the feet want what the feet want. Any of the Top Ten's performance advantages—the rounded-off sole, the improved flexibility— were overshadowed by the desire to stay with what had been working all along. But the future had arrived and there was no stopping it. Just like the three-point line, even its detractors would eventually recognize its value.

Soon enough, basketball sneakers would start to look more like the Top Ten, with padded ankle collars, perforated vamps, and larger splashes of color becoming the norm. Gone were the days when you had to be a name to get a big shoe deal. Now a big shoe deal could help make you a name.

Mitch Kupchak (center) needed help with Kareem.

Chapter Five

It's the New Style:
Nike Air Force 1

Converse Chuck Taylor All Star 1917

Adidas Superstar 1965

PUMA Clyde 1971

Adidas Top Ten 1979

Nike Air Force 1 1982

Nike Air Jordan 1985

Reebok Pump 1989

Nike Air Force Max 1993

Nike Air Swoopes 1995

Nike Air Jordan XI 1995

AND1 Tai Chi 2000

Nike Air Zoom Generation 2003

Nike Zoom Kobe IV 2009

Under Armour Curry One 2015

Nike Adapt BB 2019

In 1972–73, the Philadelphia 76ers went 9-73, then the worst record in NBA history. Ten years later, in 1982–83, they won a league-best 65 games and were NBA champions. Here's how that transformation happened. They started by acquiring New York Nets star and three-time ABA MVP Julius Erving after the 1976 NBA–ABA merger. The Sixers ponied up $6 million for Erving and immediately went from first-round playoff losers to 1977 Eastern Conference champions. (The Nets immediately went from ABA champions to 25 years of NBA irrelevance.) But even with Dr. J—who was named NBA MVP in 1981—the Sixers remained only challengers, not champions. In the summer of 1982, after two more also-ran Finals trips, they got themselves another star and became the NBA's first superteam.

The Sixers signed the reigning MVP, Rockets center Moses Malone, and shipped center Caldwell Jones and their 1983 first-round pick to Houston as compensation. The very next season, Malone helped the Sixers sweep the Lakers for their first title since 1967 and repeated as MVP—all while wearing

a brand-new Nike shoe. That spring, the NBA averted a work stoppage by reaching a new labor agreement that included the league's first salary cap since the 1940s—partially in response to profligate spending by teams like the Sixers. But Philadelphia, for the moment anyway, was the center of the basketball universe.

SOMETHING COMPLETELY DIFFERENT

Around the same time, at Philly's Galleria Mall, a young hooper saw the Nike Air Force 1—the shoes Moses wore—on the wall of a sporting goods store. "I just remember thinking they were hiking shoes," Bobbito Garcia said. "I didn't really think they were basketball shoes." But those thick soles seemed ready-made for long summer days on outdoor courts. He took them off the wall to get a closer look, saw the hefty price tag, and promptly put them back. It wasn't until he got a pair through his Lower Merion High School squad—later Kobe Bryant's team—that he put them on his feet. Then he understood: "I never had an 'oh shit' moment playing ball in a sneaker until the Air Force 1." For Garcia, who would later become a consultant for Nike, the Air Force 1 ended up being one of his favorite shoes ever.

Garcia's initial impression wasn't far off. Designer Bruce Kilgore was inspired in part by Nike's Approach hiking boot, which had a distinctive front-to-back sloping cut that provided high-cut ankle support with less restriction of movement. Nike's previous high-top basketball shoes—the Blazer, the Legend, the Franchise— had all featured a straight-across cut. The removable strap—sorry, the "proprieceptus belt"—provided both an extra hit of color and helped you better sense your ankle's position.

And then there was the cushioning. The "air" in Nike Air wasn't oxygen—a TPU plastic bladder contained a synthetic gas called sulfur hexafluoride (since replaced with nitrogen). Unlike foam, it wouldn't break down, and as long as the TPU remained intact, the level of cushioning would stay the same. The technology wasn't an in-house development, either. A former aeronautics engineer named

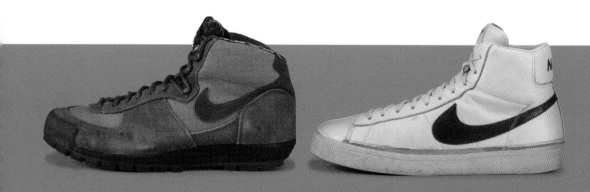

The Air Force 1 took more from the Approach hiking boot (left) than the Blazer basketball shoe (right).

Frank Rudy had shopped the technology to several sneaker companies before knocking on Nike's door. Company co-founder Phil Knight tried it on a run and loved it. They introduced the new feature in the Tailwind runner, which debuted at the 1978 Honolulu Marathon. Nike Air wasn't yet something you could see but rather something you could feel. A running shoe was just the beginning—Nike sought to put Air into their entire line. But basketball shoes, which absorb forces from all directions, are a whole different animal from running shoes, which primarily just need to go fast in a straight line.

'Nike Air wasn't yet something you could see but rather something you could feel. A running shoe was just the beginning.

Kilgore had started off as a sculptor before switching to industrial design. He worked on appliances and the Chrysler K-car project before taking a job with Blue Ribbon Sports—Nike's parent company until 1978—in Exeter, New Hampshire. There he found himself working alongside Jeff Johnson, Nike's first employee. Despite having never before designed a basketball shoe, Kilgore's background in both art and engineering made him the perfect person to take on what would become the Air Force 1.

Kilgore's primary task was to build a shoe around the Air unit. It added cushioning but also height, which led to instability. He created midsole structure with buttressing—inspired by Paris's Notre Dame cathedral—and added the raised AIR lettering to the sides to break up that vast white space. "I generally take a very minimalistic approach," he said. "If you don't need it, don't put it in the product."

It's only fitting that the Air Force 1 ended up hitting big in the Northeast, where it was created and later tested at schools like Boston College and the University of New Hampshire. "Usually when you take wear-test shoes out to people," Kilgore said, "you give them some time to play in the shoes and then you go and collect them. When people won't give you their shoes back, you know you're on to something."

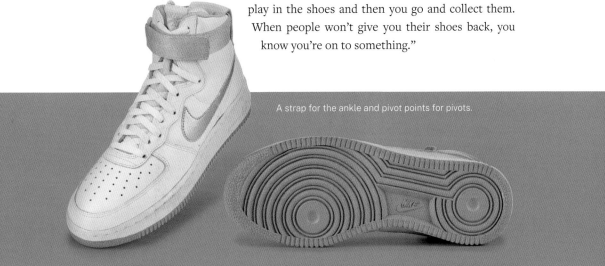

A strap for the ankle and pivot points for pivots.

Those first shoes were different—not only from all that had come before, but from the product that would wind up on store shelves. One wear-tester who loved the prototype was Tinker Hatfield, then a young corporate architect for Nike in Oregon. And while he wasn't primarily a basketball player—the world-class pole vaulter had competed on Nike co-founder Bill Bowerman's Oregon track team—the shoe samples made an impression that would resonate long into his own storied sneaker design career.

"I never felt anything that was so responsive," Hatfield said. "That pair of shoes actually had a steel shank running through it—the shoe itself was fairly rigid until you got up to speed, and then it would flex just enough and resiliently sort of spring back, and I just thought it was the best basketball shoe that I had ever had on." Unfortunately, liability issues won out over performance and the steel component didn't make it into the final design. But Hatfield never forgot those early samples. In 1995, while designing a futuristic patent leather Air Jordan XI for the then-retired Michael Jordan, he incorporated a carbon shank that would serve the same purpose as those steel plates.

Those early Air Force 1 samples that Hatfield played in were primarily a mesh shoe with a little leather to provide some support and abrasion resistance on the toe reinforcement, the Swoosh, and the heel foxing (much like Nike's 1981 Dynasty model). That evolved into all leather with a mesh panel behind the Swoosh for the very first retail pairs, and then into a full-leather build with a perforated vamp. The switch in materials wasn't for performance reasons—mesh was lighter and more breathable—but rather a marketing decision based on the expectation that no one would pay $89.95 for a mesh shoe. (Close to a hundred bucks was a lot of money for a pair of sneakers in 1982, when the bestselling car in America, the Ford Escort, had a base price of $5,500.) Nike named it the Air Force 1 after the President's Boeing 707—what better way to signify both luxury and security?

Flight Club

It wasn't until 1987 that the Detroit Pistons became the first NBA team with their own plane. In 1982, teams still flew commercial — even superstar-laden franchises like the Lakers. Center Mychal Thompson, who joined the Lakers in 1986, said, "People would notice these tall guys walking through the airport, and obviously people would notice Kareem and Magic and they would run up to try and get autographs. They were two of the most recognizable humans in the world."

Stars enjoyed privileges beyond some of the other everyday players — like first-class seats. Maybe one or two others would get that luxury. The rest of the team were left to fend for themselves in coach. If they were lucky, they got three seats between two guys. And if they weren't? Well, you could always do some extra stretching before the game.

THE ORIGINAL SIX

The NBA players whom Nike picked to initially promote the Air Force 1 became known as the "Original Six": 76ers Moses Malone and Bobby Jones, Trail Blazers Mychal Thompson and Calvin Natt, and Lakers Jamaal "Silk" Wilkes and Michael Cooper. Why those six? Cooper's theory is that they were all top-tier defenders, an explanation that holds up except for the more offensively minded Wilkes. Maybe there was no overarching reason other than who could make it to the poster shoot that day.

Nike flew the six players out to Long Beach to pose for Seattle-based photographer Chuck Kuhn. They stood in front of a plane at sunset, donning white flight suits and white AF1s with silver Swooshes. It was perhaps a little less of a role-playing stretch than the "Supreme Court" poster that put Nike's entire Pro Club of endorsees in black justices' robes, but not by much. It didn't matter. Back in the '80s, Nike posters were a big deal, both to the brand and to the athletes who adorned them. The George Gervin "Iceman" poster—featuring the Hall of Famer clad in a silver tracksuit and sitting atop a throne of ice blocks—is still iconic.

The finished Air Force 1 poster was the result of hundreds of shots taken before the sun went down, and then the players went their separate ways. The Original Six didn't get a chance to hang out and trade war stories, but Cooper recalls one anecdote from the shoot itself: "I kidded him to death about this, the late Moses Malone, because we would talk at least once a week: I'd say, 'Moses, what the fuck did they do to your space suit?' Moses was so big they had to cut his suit in half and just put it together by paper clips. He's so wide—you look at that poster and look around the collar of his neck and you'll see where it's pulled apart."

Nike posters began as in-store promos before becoming a consumer item in their own right; they were affordable, aspirational, and most every sports-obsessed kid wanted them hanging on their wall. And before signature shoes

The Original Six.

proliferated, this was how a player knew they'd made it to the next level. "Oh yeah, man, everyone was hoping to be on a poster someday," said Thompson. "To this day players love that [Air Force 1] poster. Even my sons think it's cool." (The sons he refers to, of course, are NBA players Klay and Mychel and MLB outfielder Trayce.)

The posters were a primary duty of creative director Peter Moore, who connected with Nike in 1977 after their shoes caught his eye in a photographer's studio. "Nike in 1977 had no clue about advertising or posters or anything other than shoes and how to make them, and even that was a little sketchy," he said. "The one thing they all had in common was they were all sports freaks—they know more about running and runners and tennis players and tennis than damn near anyone."

Moore's first poster featured Jazz guard Darrell Griffith as Dr. Dunkenstein, dressed in a lab coat and holding two smoking half-basketballs. In 1982, when PONY poached Sixers backboard-breaker Darryl Dawkins in the middle of the playoffs, Nike sued for breach of contract, in part because he'd requested and received a $20,000 advance on his $50,000 deal, but also because of the 20,000 "Chocolate Thunder" posters they'd printed and were now stuck with.

Getting the timing right required photo shoots before shoes were ready—which is how Bobby Jones managed to play in a pair of Air Force 1s that didn't have Air in them at all. As Moore remembered, they put pre-production samples on the Original Six for the poster shoot and asked for them back afterward. Everyone returned them except Jones, who wore his for the following night's game. "He played great, one of his best games ever," said Moore, "and then boasted about the new Nike Air shoes in the press." Jones also had his own individual Nike poster as the "Secretary of Defense," which had him seated on a massive desk in a natty three-piece suit, American and Nike flags behind him, white-and-silver Air Force 1s on his feet. There was a gilt shoe on the corner of his desk, mounted the same way as a model aircraft—just in case you were unsure why it was called Air Force 1.

Beyond the classic player posters, advertising for the Air Force 1 focused on how the shoe performed, not what it looked like or who wore it. One of the first ads didn't even show the sneaker at all, just the shoebox with a ball placed on top, as well as the declaration, "STARTING THIS SEASON, AIR WILL BE SOLD BY THE BOX." There was also a point-of-purchase poster that featured the shoe in cutaway form—it was more like a car ad than anything fashion-related, explaining exactly what customers were getting for their ninety bucks. It ran down all the performance features from top to bottom, from the proprieceptus belt (that removable strap) to the concentric circle outsole, a basketball-specific design so different from the standard herringbone. It was a diagram that leaned toward the technical; basketball shoes were being sold to basketball players.

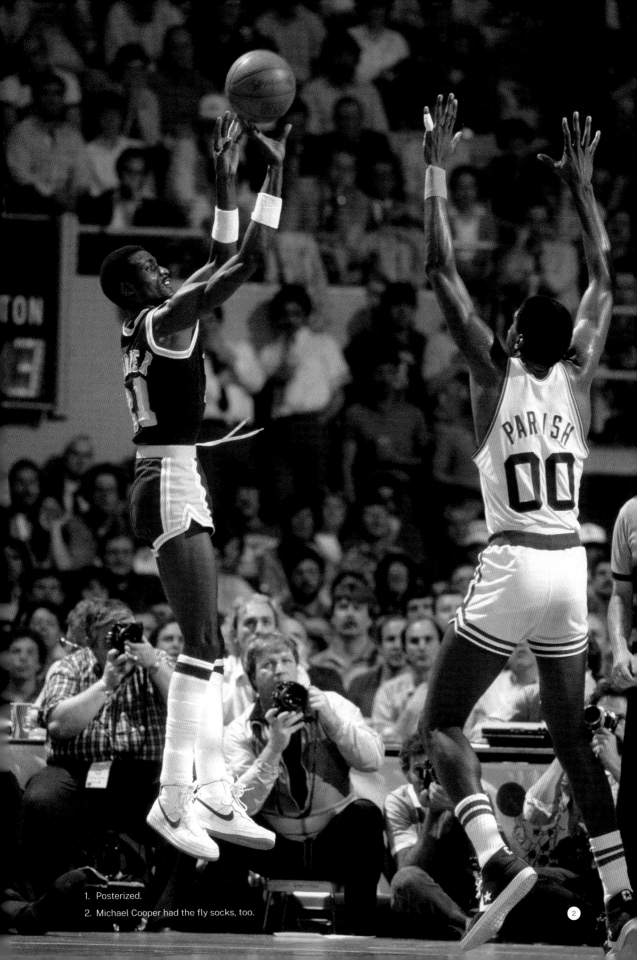

1. Posterized.

2. Michael Cooper had the fly socks, too.

ON THE COURT

Once Air Force 1s started hitting NBA floors they were hard to miss. The shoe made players look like superheroes, with that tall sole and equally high upper creating the same effect as boots worn by the likes of Funkadelic or KISS. "I definitely felt a difference because I came in the league at six-six and, after I wore those, all of a sudden, I was six-seven and a half," joked Cooper. "That shoe was almost two inches thick, it looked like." It was athletic wear but also stage wear. These were larger-than-life players in larger-than-life sneakers—Artis Gilmore must have looked about nine feet tall—amplified further by Nike's posters and commercials.

Air Force 1s loomed even larger when seen on basketball courts next to the suddenly antiquated-looking footwear being produced by other companies; even the rest of Nike's basketball line paled in comparison. The sloping cut made them really stand out, while the only visible indication of the major change inside was that big AIR lettering on the midsoles. This was a futuristic shoe made for a league striving for a better future itself. If part of an athlete's transformation from superstar to superhero was costuming, Nike played an oversized role in that. It was, as someone later said, the shoes.

Air Force 1s loomed even larger when seen next to the suddenly antiquated-looking footwear being produced by other companies.

Moses Malone got low-tops years before they were commercially available—one of the benefits of being the MVP. Everyone else wore the highs. Michael Cooper rocked a black-on-white pair sans strap in the '84 Slam Dunk Contest. Jamaal Wilkes not only wore his strapped up, but he also had WILKES embroidered on the strap itself. Meanwhile, other Nike guys, like Spurs guard Johnny Moore and Bullets forward Charles Davis, wore the basic white-and-gray retail version, with their Swooshes painted black and red, respectively. With the gray outsole, strap, and sockliner unchanged, they were tri-color Nikes before that became a regular thing.

Most other Nike athletes and college teams eventually wore Air Force 1s, too, from centers Jeff Ruland and Artis Gilmore to Celtics guards Danny Ainge and Dennis Johnson—who got their pairs in Boston-approved white-on-green in time for the '84 NBA Finals. Moses Malone understudy Charles Barkley wore a white-and-red pair as a Sixers rookie, while All-American Len Bias wore them at Maryland. Even George Gervin, the face of Nike's Blazer, transitioned into Air Force 1s and wore them through the end of his NBA career in 1986. Like virtually all the basketball shoes that came before it, the Air Force 1 was designed to be an all-purpose, all-position shoe. But thanks to the Original Six's biggest star, AF1s came to be perceived more as a big man sneaker. Forces for a force of nature.

The Final "1"

Four-time All-Star Rasheed Wallace grew up in Philadelphia along the I-95 corridor — it's only natural he got into Air Force 1s. His older brother copped a pair in '83 when Sheed was nine, and a year or two later he got a pair of his own. As one of the best high schoolers to ever come out of Philly, Sheed balled out at the University of North Carolina before getting drafted fourth overall by the Washington Bullets in 1995. But here's what's unusual: Once he got to the NBA, more than a decade after the sneaker's debut, all he wanted to wear was "Airs."

Wallace tried out some different sneaker styles on his way back to AF1s; he wore Jordans at UNC, various Air Maxes in the NBA, and even outdoor-specific Gore-Tex Air Terra Ptarmigans in a couple of games with the Blazers. But throughout the majority of his 16-year career you found Sheed in Air Force 1s, always highs, usually with the straps hanging off the back. His game was old-school, too: more post-ups than posterizations. Eventually Nike blessed him with his own logo and his own Airs, making it more like the Original Six Plus One.

Sheed, '00.

Moses Malone sends
back an Otis Birdsong
shot, 1982.

MAN-CHILD IN THE PROMISED LAND

Moses Malone was easily the most prominent player among the Original Six, as his rebounding exploits won a championship and back-to-back MVPs in 1982 and '83 and were heralded in national commercials. Combine that with the idea that "force" implied strength, and the AF1 eventually spawned the AF2, AF3, and an entire "Force" line—balanced out with a "Flight" line for guards and swingmen anchored by Air Jordan. (When Patrick Ewing entered the NBA as the number-one pick by the Knicks in 1985 and agent David Falk approached Nike marketing director Rob Strasser about signing the big man, Strasser thought of Air Jordan. He said, "Let me guess: 'Air Ewing.'" Falk demurred, thinking Ewing should anchor a Force line. He ended up with adidas instead.)

Back in 1974, Malone was the most sought-after teenage athlete in the country. The center didn't say much, especially around people he didn't know, and many mistook him for being a country bumpkin rather than simply quiet. But Malone let his game speak for itself: He averaged 36 points and 19 rebounds as a high school senior, scored 31 in the Dapper Dan all-star game, and was recruited by about 300 schools. He received all sorts of offers—including a bizarre promise from televangelist Oral Roberts that he would heal Moses's mother's ulcer if he committed to the eponymous university. Malone instead committed to Lefty Driesell and Maryland.

But not for long. The Utah Stars also selected him in the third round of the ABA's "open draft." NBA scout Marty Blake, who'd later declare Kobe Bryant not ready for the pros, was all-in on the youngster: "A lot of baseball players turn pro right out of high school," he told the *New York Times*. "Why can't a kid like Malone?" Moses wasn't as sure, but once the Stars began talking real money—a seven-year deal worth up to $3 million—he came around. Was he ready? Oh, he was ready. Moses started in his first game, a loss to the Nets in which he posted a double-double and blocked Julius Erving twice.

As a rookie, Malone averaged 18.8 points and 14.6 rebounds in 83 games for Utah. In the playoffs, the Stars lost in six to the Denver Nuggets, but Moses put up 30 points and 32 rebounds in one of Utah's two wins. The ABA being the ABA, the Stars folded the following season and Malone's contract was off-loaded to the Spirits of St. Louis, where he played a single season before the ABA–NBA merger.

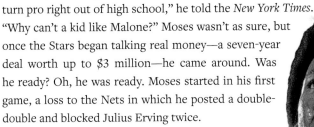

Rookie Moses, 1974.

Selected in the expansion draft by the Portland Trail Blazers, Malone was traded to the Buffalo Braves, who then dealt him to the Houston Rockets just a week later (after playing him a grand total of six minutes in two games). In Houston, Moses was a perennial All-Star and won the 1979 MVP, cementing himself as a low-post demigod. In 1981, the Rockets finished a mediocre 40-42, yet managed to claw their way to the NBA Finals, where they lost to Larry Bird's Celtics in six games. The next year, Houston regressed, the team was sold, and Malone—despite winning his second MVP—was off to Philadelphia, where he'd win an NBA title and another MVP. He'd eventually play 21 seasons with nine different teams, finishing with the most offensive rebounds in NBA history. He suited up for his first professional game when Michael Jordan was 11 years old and was still playing when Jordan retired the first time.

Had Malone come along in the mid-nineties rather than the mid-seventies, he would have never been a third-round pick. His high school team didn't lose a game in two years, and an apocryphal story following his untimely death in 2015 told of him and some Petersburg High School friends beating the Maryland varsity squad in a pickup game. At 6'11" and 200 pounds, young Moses was as pro-ready as any prep-to-pro guy has ever been. And he absolutely would have signed a shoe deal. Instead, he started with adidas, switched to Converse when he came over to the NBA, and eventually started wearing Nike. Which he did for the most prosaic of reasons: Converse wouldn't give him matching warm-ups and sneakers. "I didn't go to Nike for any contract," he said. "My negotiation was for a warm-up suit. I've been wearing Nike ever since." Pretty good deal.

He got more than just that warm-up suit. Malone was part of Nike's Pro Club—an exclusive group who vacationed on sponsored trips together in the off-season—and shot a poster of his own as his berobed Biblical namesake, holding a Swoosh-shaped staff and parting a sea of basketballs. Malone's final Nike commercial appearance would be in the late '90s as a yellow-trench-coated member of the Fun Police, a squad enforcing, yes, fun. The Fun Police leader was Kevin Garnett, whose jump to the league from high school in 1995 was inspired in part by Malone's own leap 21 years prior.

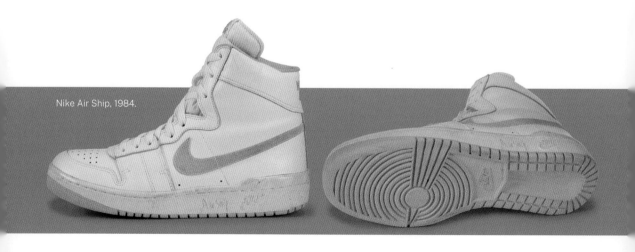

Nike Air Ship, 1984.

By the time Malone hung up his Nikes for good, the Air Force 1 had gone from performance shoe to icon. This was not by design. AF1s were never intended to be the "1" in an ongoing line, and they also weren't meant to stay in Nike's line forever. The shoe was discontinued in 1984 in favor of new Air models like the Air Ship and the Air Train. Those both did away with the strap, although they kept the AF1's sloping, front-to-back high cut and the thick Air sole. The Ship featured a splash of color across the top of the ankle, where the strap would have been; the Train was more like the Air Force 1 prototype, being a primarily mesh shoe.

> *By the time Malone hung up his Nikes for good, the Air Force 1 had gone from performance shoe to icon.*

But neither the Ship nor the Train were quite as special as the Air Force 1, which had developed a devoted following off the court, particularly along the I-95 corridor from NYC down to DC. A couple of shops in Baltimore raised enough of a ruckus that the shoe was back in limited production by 1986—it's been in stores ever since.

In 1982, technology was the best way for a still-young Nike to differentiate themselves from Converse and adidas, both of which had bigger stars and deeper rosters. The Air Force 1 didn't convert everyone right away, but it established what Nike Basketball could be and would become. It showed that a running shoe company could also lead in basketball. In 1984, adidas responded to the Air Force 1 with the Forum, a strap-equipped high-top priced even higher. But by then Nike had already moved on. And with the prodding of an agency that had helped build individual star power in tennis, they'd turn the basketball endorsement world upside down.

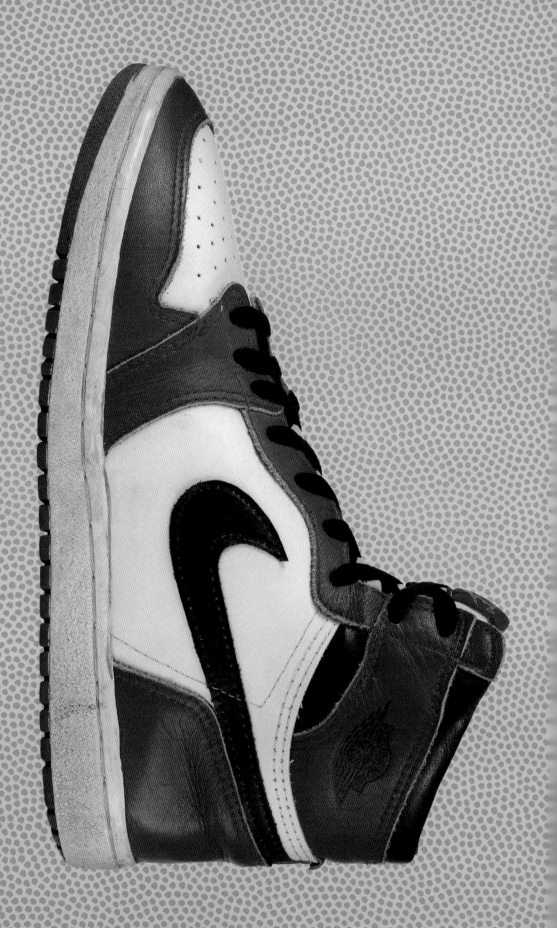

Chapter Six

Cult of Personality:
Nike Air Jordan

Converse Chuck
Taylor All Star
1917

Adidas Superstar
1965

PUMA Clyde
1971

Adidas Top Ten
1979

Nike Air Force 1
1982

Nike Air Jordan
1985

Reebok Pump
1989

Nike Air Force
Max
1993

Nike Air Swoopes
1995

Nike Air Jordan XI
1995

AND1 Tai Chi
2000

Nike Air Zoom
Generation
2003

Nike Zoom
Kobe IV
2009

Under Armour
Curry One
2015

Nike Adapt BB
2019

At the end of the 1983–84 NBA season, with the Summer Olympics just around the corner, Nike was at a crossroads. They may have been at the cutting edge, but four years after taking the company public, revenue was down and expenses were up. For starters, they were outfitting half of the league. Though they had expensive star power—NBA First-Teamers and All-Stars like George Gervin, Moses Malone, and Artis Gilmore—none were quite the equal of Converse's Magic Johnson, Larry Bird, and Julius Erving. Malone was a three-time MVP, but the taciturn big man was a spokesperson sans spoke. Heading into the 1984 NBA draft, Nike was looking to pare down their roster and refocus, even allowing players under contract to seek richer deals elsewhere. Maybe a rookie would be the answer.

THE FUTURE

The guy Nike wanted most had just finished his junior season at the University of North Carolina, his number-one-ranked Tar Heels having been upset by Indiana in the NCAA regional semis. Senior star Sam Perkins was headed to the NBA, but Michael Jordan wasn't so sure about making the leap. Well, Dean Smith was. The Carolina coach always did his due diligence by reaching out to his NBA connections, and if his players were projected to go high, then they went. In 1982, James Worthy had turned pro following his junior year and went first overall to the Lakers. And so Jordan, who wasn't going to fall past third, was leaving, too.

Just five years earlier, Jordan had been left off his Wilmington, North Carolina, high school varsity team with the thought that he would get more playing time on JV. Once he made varsity, it still didn't lead to a blizzard of recruiting mail. Then, in the summer of 1980, Jordan tore up Howard Garfinkel's Five Star Basketball Camp, busting heads by day and busing tables by night. By the time he drew national attention, he was already well on his way to becoming a Tar Heel. As a freshman, Jordan hit the biggest shot of the 1982 National Championship Game, a feathery jumper from the wing to beat the Georgetown Hoyas and give Dean Smith his first NCAA title. The ACC Freshman of the Year, Jordan earned All-American nods the next two seasons and was the consensus national player of the year as a junior.

The night Jordan's shot downed Georgetown, a Nike exec named Sonny Vaccaro was in the building. Vaccaro, a basketball lifer who founded the Dapper Dan high school all-star game in the 1960s, had pitched Nike on a line of shoes and got a job instead. Sent out as a wolf amid the sheep, he used his connections to sign prominent college coaches and get their teams in the Swoosh. (Coaches were amazed that Nike would both pay them *and* send shoes to their teams.) Vaccaro was now all-in on Jordan, willing to bet his job on it and stake Nike's entire half-million-dollar rookie budget to one guy. "Adidas and Converse didn't want to pay him, so I said, 'Give him all the money,'" Vaccaro remembered. "If we gave him $100,000 or $200,000, we definitely wouldn't have signed him."

Nike exec Rob Strasser had made it clear that his company was interested in Jordan, even before the college star finished his junior season. Once Jordan declared for the draft and signed with ProServ, agent David Falk told Strasser what they really wanted for their newest client: "I said, 'You'd have to do something really different for him . . . you'd have to treat him like a tennis player—I want his own line of shoes and clothes.'" Strasser didn't balk. Falk suggested the Air Jordan name, and Nike creative director Peter Moore came up with a winged basketball logo inspired by a pin that an airline had given to kids on the flight back to Portland after a meeting at ProServ. Moore then went about designing a line, everything in Bulls red and black.

Once samples were completed, Nike invited Jordan and his parents to their Oregon headquarters for a presentation. Smitten with adidas, the young player didn't want to go, but his mom made sure he did. Nike spared no expense to impress the Jordan family, and in Beaverton they showed MJ a personal highlight

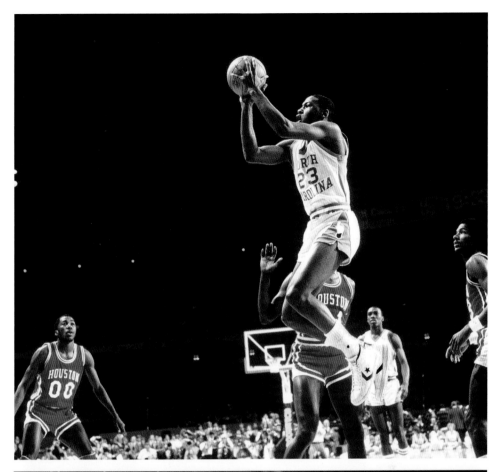

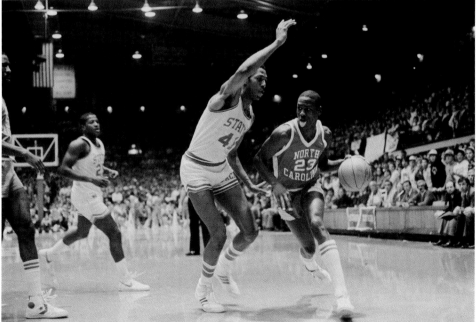

In 1982, young Mike Jordan already had the flair (and the tongue).

reel—set to the Pointer Sisters' "Jump (For My Love)"—and the sneaker and apparel line they had come up with. The colorway was not his first choice—"devil colors" as he called them, because UNC rivals NC State wore red and black. But Nike was offering opportunities the other big brands weren't.

Jordan still dreamed of adidas and just wanted them to match Nike's sizable offer—$500,000 per year for five years with royalties on pairs sold. But no dice. Adidas wasn't prepared to put the same kind of marketing push behind a rookie. Neither was Converse, who "had the imagination of a wall," according to Falk. Spot-Bilt, an American brand founded in 1898 that eventually became Saucony, actually offered Jordan the most money, and was Falk's second choice behind Nike. It's almost too bad it didn't work out—Spot-Bilt's parent company, Hyde, made the boots for the first American astronauts.

THE RISE AND RISE

Even with all of Jordan's potential, he wasn't going to be drafted first overall. For a league still built around big men, University of Houston center Akeem (no "H" yet) Olajuwon was the top prize. Portland picked second, but they were loaded at guard—which shouldn't have mattered. "We begged 'em to draft Michael, and they didn't," remembered guard Clyde Drexler. "Management is gonna do what they want to do." So the Blazers selected another seven-footer in Kentucky's Sam Bowie after Olajuwon went first to the Rockets, and Jordan fell to the Bulls at number three. "We wish he were seven feet, but he's not," said Bulls GM Rod Thorn afterward, in what turned out to be history's most unnecessary mea culpa.

Jordan missed out on the draft itself, as he was busy with the Olympic Trials in Indiana, where coach Bobby Knight called him "the best basketball player I've

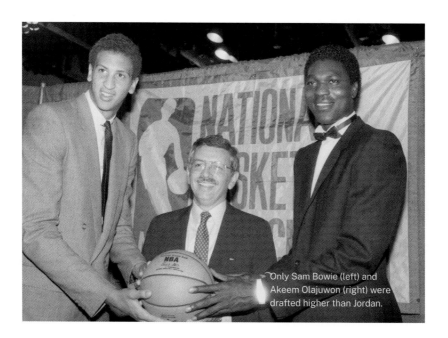

Only Sam Bowie (left) and Akeem Olajuwon (right) were drafted higher than Jordan.

ever seen play." Shortly thereafter, Jordan was competing in exhibition games against NBA players and then went off to Los Angeles for the Olympic Games. "If someone is going to beat the United States," said Canadian coach Jack Donohue, "they're going to have to figure out a way to keep the kid from jumping over the world." No one could. Team USA went 9-0 in foul-heavy exhibitions against NBA competition, then went 8-0 en route to Olympic gold.

Jordan hit the NBA just as sneaker deals were becoming a huge part of a rookie's earnings; two years earlier, Falk had gotten James Worthy a record million-plus-dollars signing with New Balance. But a shoe deal was just one component of a larger marketing portfolio. Falk wanted his Olympic-hero client to have a slew of complementary national endorsements with the most all-American companies, and Jordan would soon sign deals with McDonald's, Chevrolet, Coca-Cola, and Wilson.

After the Olympics, Jordan headed to Chicago. The Second City had long been a hoops town—it was home to the basketball world championships back in the pre-NBA days—but all its pre-Bulls professional franchises, like the Stags, Packers/Zephyrs, and Majors, had either folded or moved. The Bulls, established just 18 years earlier in 1966, had lasted longer than any of them. But by 1984, they'd made the playoffs just once in the previous seven seasons despite six straight top-ten picks. In 1983–84 they finished 27-55. Chicago Stadium, the "Madhouse on Madison," had been a state-of-the-art facility (and the very first stadium with air-conditioning) when it opened in 1929, but by 1984 it was the second-oldest NBA arena and usually two-thirds empty. The Bulls needed help.

Jordan's arrival in Chicago was marked by a Nike poster shoot. Peter Moore's go-to Seattle-based photographer, Chuck Kuhn, shot it in Nike's typical guerrilla fashion with no permits or extra security. With the sun setting over the Chicago skyline, the result was an iconic—*the* iconic—photo of Jordan, ball held aloft in his

How a man becomes a brand—the 1984 Jumpman poster (left) and the Jordan X's heel counter (right).

left hand, legs and fingers splayed. He was wearing his Jordan gear and a prototype pair of Air Jordan shoes.

Later on, after the resounding success of the first sneaker, Moore would trace the outline of Jordan's "Jumpman" image from the shot and leave it in a slim folder for his successor, designer Tinker Hatfield. "I told him the Jumpman was really the Polo Player and that the shoe should fit more with that than with Nike," Moore said. From that traced image, Hatfield would create the Air Jordan III and eventually turn the man into a brand.

As the 1984–85 season drew closer, Nike was racing to finalize Jordan's shoe. Moore asked what Jordan required from a performance perspective, and the young player would get exactly what he wanted. The Air bag was smaller even than that of the Air Force 1—Jordan had requested a shoe that played close to the ground to lower the risk of ankle sprains. The sneaker wasn't completed in time for the preseason, so he started out in a modified black-and-red version of the Air Ship, the successor to the Air Force 1, with "Air Jordan" emblazoned across the back.

The NBA famously sent Strasser a letter prohibiting Jordan from wearing the red-and-black shoes—league rules mandated that players' footwear be at least 51 percent white and match their jersey colors (unless the shoes were all black, like those of the Celtics). After some initial panic, Nike saw a golden opportunity and offered to pay the fines. As Falk described it, "Strasser calls me and said, 'We're fucked.' I told him, 'God, that's the best thing that could ever happen. You're going to advertise the shoe's so special that the league had to ban it.'"

As part of the initial Air Jordan marketing push, Nike had their Chiat\Day ad agency produce a series of commercials. One panned slowly down Jordan's body as a voiceover kicked in: "On September fifteenth, Nike created a revolutionary new basketball shoe. On October eighteenth, the NBA threw them out of the game. Fortunately, the NBA can't stop you from wearing them. Air Jordans— from Nike." When the camera reached his shoes, black bars appeared over them with two loud clangs. The Better Business Bureau called out Nike for potentially misleading advertising—the league had banned the color, not the shoes themselves. But by that point the commercial was off the air and the message had spread: Michael Jordan couldn't wear these, but *you* could. "He wore the black-and-red shoe like two or three times in the preseason and they're still making money off it," Vaccaro said.

The NBA still can't stop you from wearing them.

INSTANT OFFENSE

Nike needed Jordan to become a star so his signature shoe would be a success; the Bulls needed Jordan to shine to keep the team from going nowhere (or, given the fate of Chicago's previous basketball franchises, moving somewhere else). The NBA, with Magic Johnson in the West and Larry Bird in the East, would benefit from a Midwest megastar. And Jordan himself stood to make a lot more royalty money from his Nike deal if the brand sold more shoes.

Fortunately, they'd all chosen to tie their fortunes and futures to not only the best player in the draft, but the most competitive person on earth. "The first day of practice he was obviously the best player," said teammate Rod Higgins. "He was the type that if you didn't compete, he was going to bury you and he's going to talk shit. He's going to talk trash to you if you don't at least stand up and try to compete with him. That started as soon as he got to Chicago."

Higgins grew up on the South Side of Chicago and was a fellow Nike guy. Jordan spent a lot of time at his townhouse, spinning records and playing pool, and the rookie would buy a townhouse of his own just fifty yards from Higgins's back door. The Bulls waived the forward before the start of the 1985–86 season, but he remains extremely tight with Jordan. He still gets regular shipments of Air Jordans.

Jordan's teammates were relieved when the young guard finally got to unleash his fury against other NBA teams, not just against them in practice. He shot 10-for-11 from the floor and 11-for-13 from the line for 31 points in just his second

> *Jordan's Bulls teammates were relieved when the young guard finally got to unleash his fury against other NBA teams, not just against them.*

preseason game as fans chanted his name in Madison Square Garden. Jordan played in front of new commissioner David Stern not once but twice. "Why am I in Chicago? The same reason everyone else is—to see Michael Jordan," Stern said. "If the Bulls are successful, it would sure make our life a lot easier." On October 21, the *New York Times* ran a long piece entitled, "Jordan Makes People Wonder: Is He the New Dr. J?" The TL;DR answer was "Not yet, but . . ."

The Bulls opened the regular season on October 26, 1984, against the Bullets. A near-sellout crowd of 13,913 was on hand to see not only Jordan's debut, but a promoted appearance by ubiquitous, roving baseball mascot the San Diego Chicken. With his signature Air Jordans still not game-ready, MJ came out in white-and-red Air Ships and made the wrong kind of impact; before even scoring a point, he drove and attempted to dunk on hulking center Jeff Ruland. The 6'11" Ruland went straight up and Jordan went straight down, crashing awkwardly to the deck. He'd finish the game with 16 points on just 5-of-16 shooting.

Bulls coach Kevin Loughery kept his faith in Jordan's otherworldly ability and continued to put the ball in the rookie's hands. In his third game, he

scored 37. In his ninth, 45. By the time MJ wore the Air Jordan in a game for the first time in November, he was one of the NBA's hottest commodities—this despite CBS not airing a single Bulls game all season. (WTBS aired one, on November 1; Jordan scored 17 in a 16-point loss to the Nuggets.)

Even with the lack of national TV coverage, he was getting plenty of press. Jordan had landed on the front of *Sports Illustrated* as both a collegian and an Olympian, and as a Bull he scored the December 10, 1984, cover, shooting over three Milwaukee Bucks. "A STAR IS BORN" went the cover line. The piece spelled out how the Jordan effect had already been felt just three months into his young career: doubled home attendance, awestruck teammates, effusive opponents. Jordan himself came off as modest, in some cases ridiculously so. He outlined his goal of winning a couple of championships, but also made an understatement for the ages: "I'd like," he said, "to play in at least one All-Star game."

The Freeze-out

The story that persists to this day is that Michael Jordan's lackluster 1985 All-Star debut was the result of a freeze-out by jealous veterans like George Gervin, Magic Johnson, and Isiah Thomas. Even if there had been a conspiracy, it most likely wasn't personal. But Jordan took it that way. "He was freaking so pissed about how he was treated at the All-Star Game," Higgins remembered. In his next game, against Thomas's Pistons, Jordan sought revenge and exploded for a then-career-high 49 points in a 13-point Bulls win.

Frozen moment.

This much is indisputable: Some vets were just fine with a flashy youngster showing some growing pains in a rough first All-Star Game. "Michael is a rookie, and he has a lot to learn," Gervin said afterward, "just like we all did." Thomas was decidedly unhappy about the accusation: "What is all this talk about him being froze out, not getting any shots?" he asked. "Did he think he was the only player out there?" Jordan got the ball and got shots; he just left some short. Early in the second half, Thomas even lofted Jordan an alley-oop that was broken up.

Adding fuel to the conspiracy theory fire, Dr. Charles Tucker—an adviser to both Magic and Isiah—was spotted laughing with Thomas and Gervin at the airport after the game. When asked about it, Tucker said, "We were talking about how good they got Jordan. I got together with a bunch of the guys Saturday and talked about it. . . . But I think some of them thought we overdid it some." Fishy. So the freeze-out passed into Jordan lore, yet another motivating slight—whether it was real or not.

On January 24, 1985, Jordan was announced as an All-Star starter. He'd also compete in Saturday night's Slam Dunk Contest. Jordan walked out onto the Market Square Arena floor in Indianapolis for the contest in the "banned" black-and-red Air Jordan shoes and matching Air Jordan warm-up gear, a pair of gold chains glittering around his neck. Some thought it arrogant and took offense; Falk said it was Nike's idea. Jordan finished second to Dominique Wilkins, who had no issue with Mike wearing his own non-sanctioned Nike gear: "You tryin' to find an edge, you coming out there trying to set the tone," 'Nique reasoned. "It just sets up for a great show—and one thing we didn't do is take shit personal. It was all about the competition." Easy for Wilkins to say—he won.

The next day, Jordan started the All-Star Game and put up two points and two boards in the first minute—but it went downhill from there. He posted a disappointing seven points and six rebounds in 22 minutes, shooting just 2-of-9 from the floor in a 140–129 Western Conference win. He was still the talk of the broadcast—as were his Air Jordans. "Look at those shoes Michael Jordan wears, it's gotten a lot of attention around the league," play-by-play man Dick Stockton remarked to color guy Tommy Heinsohn.

But Jordan was tireless, breaking through the rookie wall like the Kool-Aid Man. He started all 82 games and, in his last 20 games, including the postseason, played fewer than 40 minutes in just three of them. The Bucks ousted the Bulls from the playoffs in four games, but Jordan scored 35 in Chicago's first postseason win since 1981, averaging 29.3 in the series.

He finished sixth in MVP voting, even receiving two first-place votes. Seagram's presented their algorithm-driven Seven Crowns of Sports Award for basketball to Jordan. He handily won Rookie of the Year honors over first-overall-pick Olajuwon, the only other player to even get a vote. Then MJ was off to Europe with Nike for a series of exhibitions against professional competition, where he stood to make $50,000 for every game he wore Air Jordans.

GREAT EXPECTATIONS

When the Air Jordan released to the public in April 1985, the $65 shoe sold out almost immediately. The line first launched in just six markets, including Lexington, Kentucky, home to that year's Final Four (in which all four teams wore Nike). Jordan's five-year deal included an opt-out clause—if he didn't sell $3 million worth of Air Jordan product over the first three years, Nike could walk away from the final two. They wouldn't need it. The shoe sold ten times that amount even before its wider release in July. Nike did $126 million in Air Jordan business in the first year alone; in the first nine months of 1985, all Converse sneakers sold just $175 million total.

Nike hedged all of their bets. They not only released the Air Jordan in a multitude of colors (along with two lowtops), they even offered a cheaper canvas version, the Air Jordan KO (for knock-off), figuring they'd beat would-be imitators to the punch. It was a good idea—seemingly every shoe brand with a sneaker

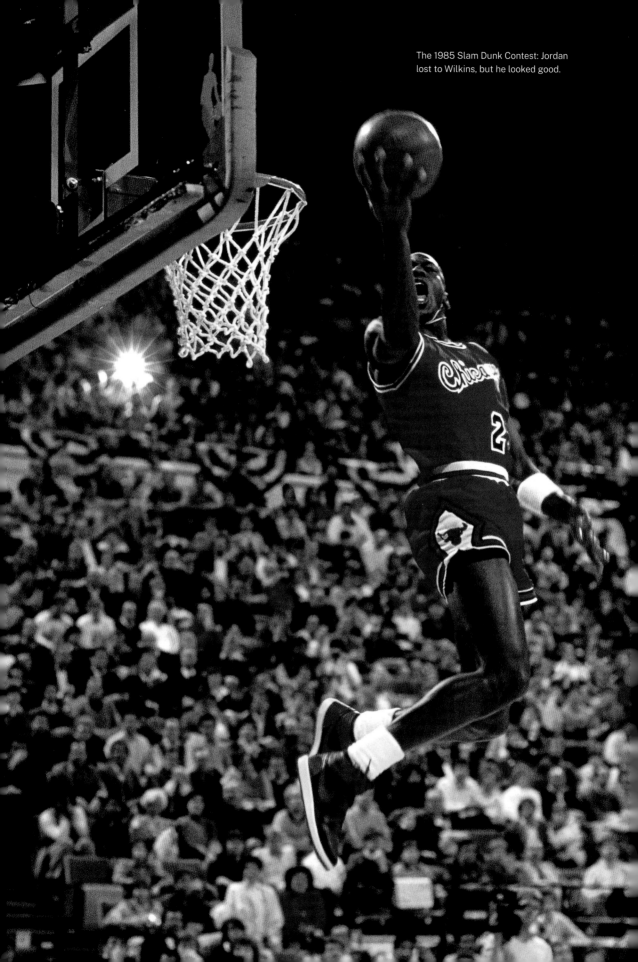

The 1985 Slam Dunk Contest: Jordan lost to Wilkins, but he looked good.

line would release a red, black, and white look-alike. Retailers blew through their Air Jordan stock and pestered Nike for more. But eventually, supply exceeded demand, and Air Jordans wound up being heavily discounted. They found their way onto the feet of skateboarders and punk rock singers and heavy metal guitarists. Air Jordans were everywhere.

"We caught lightning in a bottle, there's no question," Vaccaro says now of the sneaker. "Everything broke right. The advertising broke right, he came out of the gate, he was a great talent. Shit, they didn't win a world championship or nothing, but he was unbelievable."

In the summer of 1984, corporate America may not have been ready for a young, Black spokesperson, but clearly the kids were. Air Jordan released into a quickly changing culture that had been primed for it. In March 1983, Michael Jackson's "Billie Jean" performance on Motown's 25th Anniversary special had kids of all races trying to learn how to moonwalk. Early in 1984, Run-DMC's "Rock Box" became the first rap video to get regular play on MTV, itself just three years old. *Raising Hell*, Run-DMC's third album, was released in May 1986 and two months later became the first rap album to go platinum. LL Cool J wore a pair of black-and-red Air Jordans on the back cover of *Radio*, his 1985 debut.

As Jordans spread, the NBA was growing, too. Stern, who was named the league's fourth commissioner on February 1, 1984, had brokered a new TV deal with CBS. Meanwhile, ABC had purchased controlling rights of a Connecticut-based sports cable TV operation called ESPN.

Had to Have It

In the summer of 1985, a young filmmaker named Spike Lee shot *She's Gotta Have It*, his feature film debut, in Fort Greene, Brooklyn. He spent part of the indie film's small $175,000 budget on a pair of black-and-royal Air Jordans for a character he'd play himself, a hyperkinetic bike messenger named Mars Blackmon. (Nike didn't send shoes, but they did give Lee a supersized cutout of Jordan in the Jumpman pose, which would show up on Blackmon's apartment wall.) Blackmon didn't even take off his Jordans while in bed with the titular "she," Nola Darling.

The movie did well, grossing a respectable $7 million at the box office. Watching in one Portland audience were Wieden+Kennedy advertising creatives Jim Riswold and Bill Davenport, who raced into the office the next morning to tell Dan Wieden what they'd seen — and pitch Spike Lee for an Air Jordan commercial. Riswold called Lee, whose only question was whether he'd get to direct. Starting with their first ad together in 1988, Spike and Mike brought Air Jordan to an even higher level.

Jordan and the Bulls were more than ready for Year Two. But Nike? Not so much. The Air Jordan II—a sleek, Swooshless model that would be made in Italy—was taking a long time to develop and produce. Jordan started his second season in his first shoe, and when he came down wrong and broke his left foot in just the third game, he'd end up missing an excruciatingly long five months. After rehabbing his foot back at UNC in pool workouts and clandestine pickup games, he returned to the Chicago lineup in mid-March on a tight minutes restriction. He helped the Bulls squeak into the final playoff spot in the East, and while the two Jerrys (GM Krause and owner Reinsdorf) would have rather had a shot at Brad Daugherty in the draft than a first-round playoff matchup against the top-seeded, 67-win Celtics, Jordan just wanted to win.

Boston had dropped just one game at home all year, but the Bulls handed the Celtics one of their 14 road losses back in December *without* Jordan. MJ had a year of pent-up frustrations to work out, and in the first game at Boston Garden, he exploded for a playoff-high 49 points. Three nights later, he eclipsed that personal best with 63 in a double-overtime loss. "I was watching the game," said Celtics coach K. C. Jones afterward, "and all I could see was this giant Jordan out there and everybody else in the background." Reigning three-time MVP Larry Bird said, "I would never have called him the greatest player I'd ever seen if I didn't mean it. He's God disguised as Michael Jordan." The Bulls were swept at home as the Celtics constantly swarmed the star with double-teams in the third game—they'd seen enough of what a single-covered Jordan could do.

On May 20, 1986, exactly a month after he had torched the Celtics for 63 points, Jordan went on *Late Night with David Letterman*, resplendent in a shiny red Air Jordan sweatsuit. Toward the end of Jordan's seven-minute appearance, Letterman pulled out a pair of black-and-red Air Jordans: "Is this the shoe that the NBA wouldn't let you wear? Now why wouldn't they let you wear it, just because it's ugly?" Some brief sparring ensued before Jordan got to the answer: "Well, it doesn't have any white in it." "Yeah," the host responded, turning the shoe in his hands before tossing it over his shoulder and delivering the coup de grace: "Well, neither does the NBA."

1. The Air Jordan KO featured canvas and a different sole pattern.

2. The original red-and-white AJ1s.

3. White on white.

4. Jordan's favorite color.

LIKE MAGIC

It's easy to wonder why someone like Magic Johnson, with his boundless charisma and instant stardom—in LA no less—hadn't years earlier become the same sort of nationwide pitchman who would kick off the sneaker revolution. For one thing, Johnson signed with Converse out of college and, as the dominant basketball brand of the time, they felt no need to shift the paradigm. They *were* the paradigm. And while Nike was a creative and energetic brand on the rise, even Air Jordan had no guarantee of success. "When you look at the convergence of all of these things aligning," longtime Nike and Jordan exec Howard White said in 2016, "I don't know if all of that could happen again."

Converse Weapon

Converse didn't change course for Michael Jordan, but Air Jordan's success forced them to adapt. In 1986, Bird, Magic, and the rest of Converse's NBA All-Star roster were outfitted in a new shoe called the Weapon. It came in a whole slew of team-specific colors, from Magic's Lakers' "Forum Blue" and yellow to Bird's Auerbachian black-and-white. But that wasn't all.

One Weapon commercial featured honest-to-god rapping from not only Magic and Bird (key line: "I walked away with the MVP") and the always charismatic Isiah Thomas, but also goofy Bird teammate Kevin McHale, a head-bopping Bernard King, and a clearly out-of-his-element Mark Aguirre. Despite the colors and the commercials and the edgy name, the Weapon was still a Converse shoe at heart—a basic high-top basketball sneaker with a straight-across cut, not all that different from its All Star predecessors. There was no high-tech cushioning or flashy new logo.

Even another commercial, in which a fully uniformed Magic pulls up in a black stretch limo to Bird's real Indiana home court for a game of one-on-one, was too little, too late. Their Lakers and Celtics were still dominant, but it already felt like the past. If nothing else came of that shoot, at least Magic and Bird, longtime rivals, finally became friends.

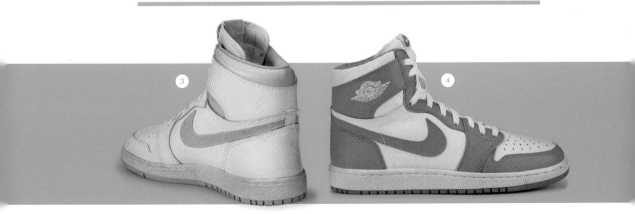

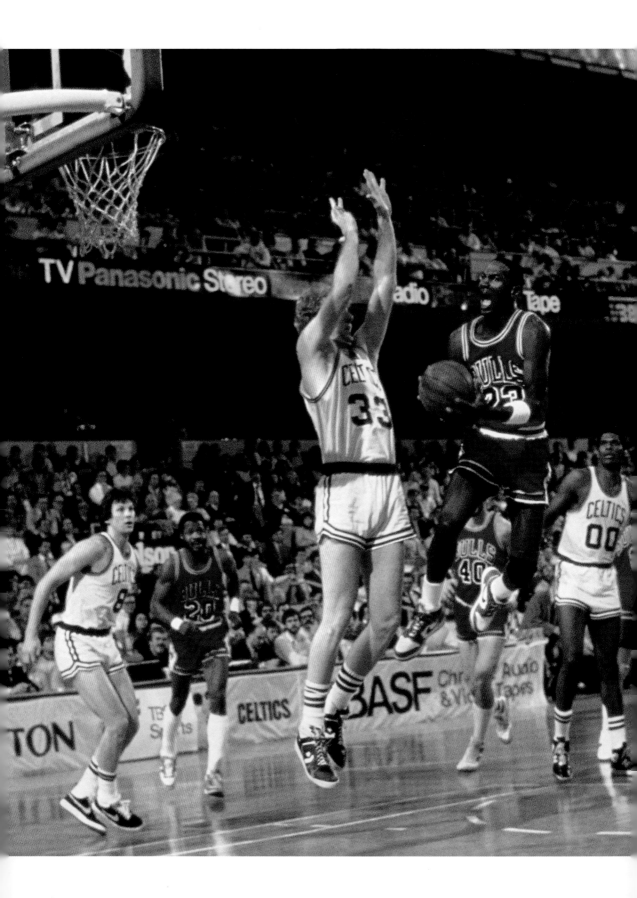

No one knew it could happen, period. Moore, Falk, Vacarro, Strasser, even Jordan himself—none could have predicted that a single player could end up being more popular than the sport itself. "No one had a clue, from me to Dean Smith to his parents, that he was going to become what he became," Falk said. "No one knew that."

Jordan was the perfect player at the perfect time presented in the perfect way, an icon for a burgeoning hip-hop generation who wasn't part of it himself—he famously preferred the sultry sounds of Anita Baker over the rappers wearing his gear—and who could equally appeal to the most middle of Middle America. His shoes and his brand became status symbols from city streets to suburban high school hallways.

But for some, the overzealous marketing and in-your-face branding was a step too far. Bobbito Garcia, in *Where'd You Get Those?*, his seminal book on New York sneaker culture, lamented the Air Jordan 1 as an ending. It marked a shift from needing to determine what was cool to having "cool" predetermined for you. "The worst thing about the Jordan was the wing logo on the high top," he wrote. "Neither fresh nor subtle. Magnify that by every herb in the world who wore these, and you have one of the worst signature shoes from the glory period of sneaker design."

Thirty-plus years later, you can certainly trace much of what is now untenable in sneaker culture—the endless hype, the top-down designation of desirability, seemingly everyone chasing the same releases—back to what Nike did with Air Jordan back in 1985. At the same time, Air Jordan is a big reason why there is a wider "sneaker culture" to begin with. Had Nike chosen someone else, or had Jordan broken his foot three games into his first season rather than his second, maybe everything today would be different. The shoe, the marketing, the defiant messaging, none of it works if Jordan wasn't out there putting up numbers and putting it down on opposing bigs.

Was some of it myth and marketing magic? Absolutely. Did Jordan himself live up to the hype? No question. Would the success of Air Jordan be easy to replicate? Oh, dear no. Would companies still try? Well, we know the answer to that.

God disguised as Michael Jordan.

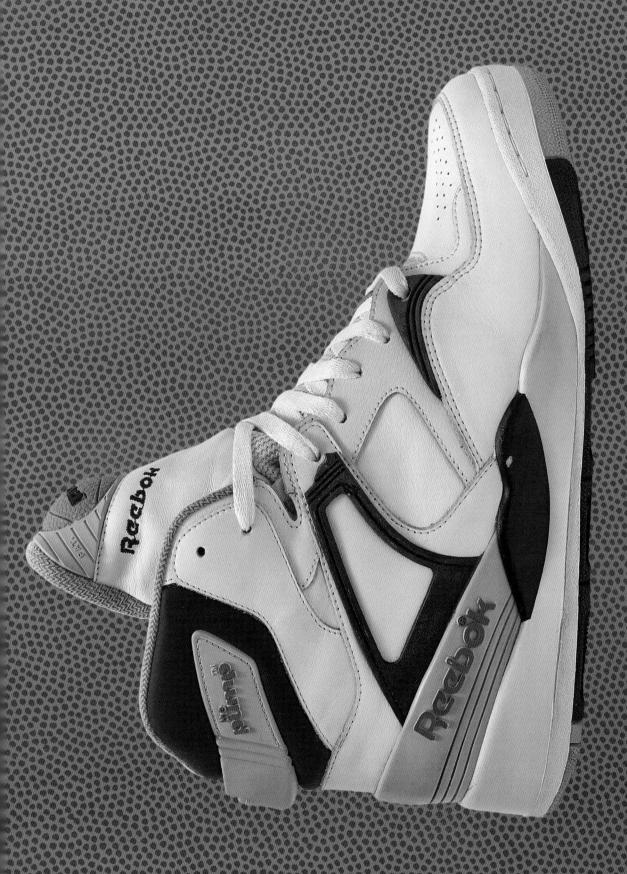

Chapter Seven

Yo! Bum Rush the Show: Reebok Pump

Converse Chuck Taylor All Star
1917

Adidas Superstar
1965

PUMA Clyde
1971

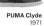
Adidas Top Ten
1979

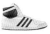
Nike Air Force 1
1982

Nike Air Jordan
1985

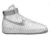
Reebok Pump
1989

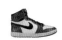
Nike Air Force Max
1993

Nike Air Swoopes
1995

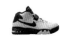
Nike Air Jordan XI
1995

AND1 Tai Chi
2000

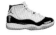
Nike Air Zoom Generation
2003

Nike Zoom Kobe IV
2009

Under Armour Curry One
2015

Nike Adapt BB
2019

F eet are complicated. Each one has 26 bones, 33 joints, and more than 100 muscles and ligaments. They not only support the entire body but propel it. For a basketball player, injuries to most body parts can be worked around—the foot is not one of those parts. Lose the foot, lose the player. Michael Jordan missed most of his second season with a broken foot, while more structural and intractable foot problems cut short the NBA careers of Hall of Famers Bill Walton and Yao Ming.

For all that anatomical complexity, though, sneakers are relatively simple. You can really just break them down into two parts: the sole unit and the upper. That's it. There's the part that goes under the foot, and the part that goes around the foot. Ideally, those two elements work together in harmony, while some footwear focuses primarily on one or the other. Reebok's 1989 Pump took the upper to its supportive, form-fitting extreme.

BIGGER AND BADDER

Early sneakers were simple and stable. A thin sole kept the foot close to the ground and allowed it to move naturally. Cushioning in a pair of Chuck Taylors was minimal, and the foot mostly relied on its own built-in suspension system. The canvas upper largely served to keep the sole underfoot, and even someone as big and dynamic as Bill Russell could play in low-tops. The high-cut adidas Pro Model was only made for those who didn't feel comfortable in the low-top Supergrip and Superstar. Lows remained a common sight on NBA courts well into the '70s.

What changed first were the soles. As companies moved away from vulcanized rubber and found ways to add more structure and cushioning via foam, plastic, and air, shoes got higher off the ground. Taller soles led to taller uppers, as more cushioning led to more instability. Solving one problem created others. And the biggest men had the biggest problems, as their joints bore more weight. Leaping resulted in exponentially greater landing forces; high-flyers came down harder. All that stress needed to go somewhere. And the more padded a shoe's upper became, the more difficult it was to make it fit well.

Tightening an upper made from two layers of canvas was easy. Build in leather, open-cell foam, a fabric lining, plastic reinforcements, and a massively padded tongue, and it gets more difficult. Features like speed lacing through plastic eyelets, Velcro straps, and round laces have helped. But what if you could do something more?

Air Jordan Revolution

In 1987, Air Jordan was at another crossroads. Rob Strasser and Peter Moore, the two Nike executives who'd done the most to shepherd Air Jordan into existence, had both left the company. They'd started a new brand called Van Grack and wanted Jordan to come with them. Falk was against it: "I persuaded Michael it would be a disaster. He created a brand; you stick with it and build it." And Nike did some persuading of their own.

Jordan was late to the meeting where they'd unveil the next Air Jordan. (He was off playing golf — where else?) But the shoe they presented got his attention. A three-quarter-cut floater leather shoe with elephant print trim and his new Jumpman logo on the tongue, the Air Jordan III had been sketched by Tinker Hatfield as the "Air Jordan Revolution," as it included the same sole unit as that of Nike's first Visible Air hoop shoe. Jordan liked what he saw and decided to remain with Nike. Wearing the Jordan III during All-Star Weekend in 1988 — in Chicago, no less — he won the Slam Dunk Contest, scored a record 40 points in the All-Star Game, and took All-Star MVP honors, and Nike released the first Air Jordan commercial featuring Mars Blackmon. Is it the shoes? Why, yes, it actually was.

When Tinker Hatfield opened up the midsole of 1987's Air Max runner, exposing the Air bag with a "Visible Air" unit, it was—as the Beatles song in the commercial went—a revolution. (Nike's Visible Air basketball shoe was even named the Air Revolution, and Hatfield's earliest sketches of the Air Jordan III referred to them as the "Jordan Revolution.") His Air Max design was inspired by the Centre Pompidou art museum in Paris, an inside-out building with external, color-coded piping that makes the functional visible.

Nike Air had been made clearly visible for the first time. Instead of needing a running shoe expert to explain it, the new design jumped off the display wall. It sold itself. There was no mistaking an Air Max shoe for anything else. Nike accentuated this visible quality in a two-page ad in which heavy backlighting shone through the sole of the running shoe. It looked almost biblical, both revolution and revelation. Nike put air under the foot—but what if it was possible to put air somewhere else?

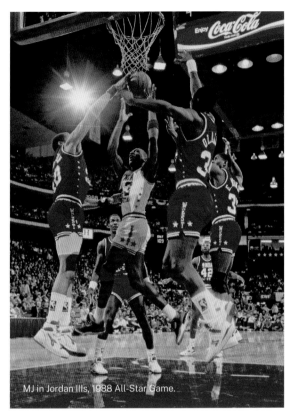
MJ in Jordan IIIs, 1988 All-Star Game.

PUMP IT UP

A few years earlier, Reebok had surpassed Nike when their wrinkly-toed, garment-leather aerobics shoes—met with derision at Nike HQ in Portland—became the most popular sneakers on the planet. For co-founder Phil Knight and the other Nike executives who had made it their life's goal to crush adidas, this was an entirely unexpected attack from an entirely unexpected direction. Reebok was a British company that had been distributed in the United States only since 1979, and less than a decade in they were doing a billion dollars in sales. Paul Fireman, the Boston-based CEO who had acquired the US rights, bought out the parent company in 1984 and overtook Nike by 1986.

Reebok had done extraordinarily well with the Workout, the Princess, and the Freestyle (informally dubbed the "5711" for the price with tax in NYC), but Nike still had Air Jordan and soon introduced the game-changing Air Max, regaining the lead by 1989. What Reebok needed was an Air Jordan of their own, a basketball shoe that would transcend the courts. They'd already begun to modernize their image, having updated their logo from a wordmark ending in the

British flag with the more noticeable Vector—Reebok's answer to Nike's Swoosh. The tier-priced garment-leather 4600, 5600, and 6600 basketball shoes were nice enough, but they needed something more.

At first, Reebok wanted some sort of advanced cushioning system like that of Nike Air. They soon introduced a heel-based, DuPont-developed energy return system called, well, Energy Return System, or ERS. But it wasn't seen as enough of a game-changer. Reebok's eventual solution would come out of a two-story building in suburban Boston, home to a consulting firm called Design Continuum.

Fireman had tasked Reebok engineer Paul Litchfield to develop a basketball sneaker, and Litchfield turned to the firm—itself only a few years old—for ideas. Design Continuum got creative, drawing inspiration from their previous work on medical products, including inflatable splints and IV bags. Meanwhile, Reebok had purchased the American trademark of Italian apparel and footwear brand Ellesse, which had prototyped a pair of ski boots that featured an inflatable fit system. The inflatable splint and ski boot gave them another idea. What if you could make a basketball shoe with a customizable fit? This would not only support the needs of athletes, but also help the sneakers fit longer on kids' rapidly growing feet. As it turned out, Nike was thinking the same thing; even as Reebok collaborated with Design Continuum to develop what came to be the Pump, designers in Beaverton were working on an inflatable shoe of their own.

Reebok's early Pump prototypes featured two kinds of inflation mechanisms: one a manual pump, the other self-inflating as the wearer walked. Litchfield preferred the latter, but wear-testing at high schools revealed that kids were enamored with the act of pumping up their own sneakers. Both companies' custom-fit shoes would debut at the same trade show, where Reebok's Pump got a warmer reception; Nike's Air Pressure was a sleeker shoe, but it came with a separate inflator.

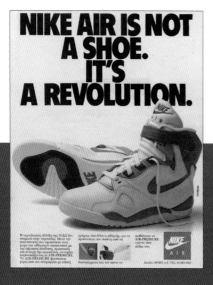

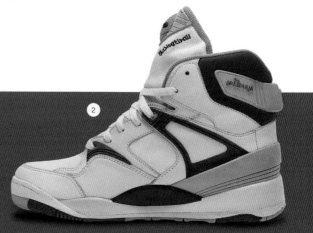

The Air Pressure didn't have a Visible Air bag, foreshadowing things to come. As improvements came to the thinner Air bags that provided the close-to-the-ground feel that Michael Jordan (and others) favored, high-end hoop shoes didn't always need to include Visible Air. But in 1989, with Air Max still seen as Nike's pinnacle tech, it was hard to market a cutting-edge product without it—even when poster ads called it a "revolution." Meanwhile, Reebok, at Fireman's urging, rushed the Pump toward a Black Friday release. Reebok designer Paul Brown worked the prototype shoe into retail shape, moving the inflation mechanism from the heel to the tongue, while Design Continuum's Jane Hathaway came up with the ingenious idea of making the Pump itself look like a basketball.

There was also something perfect about a shoe based in part on medical equipment hitting the market at the same time the Pistons were hitting their opponents. Detroit engaged in a particular brand of physicality perhaps better suited to the NFL—Raiders owner Al Davis felt an affinity with the "Bad Boys" and sent them some of his own squad's signature black-and-silver gear. Theirs was an approach perhaps best summed up as: "If you can't beat 'em, beat 'em harder." Faced with the daunting task of stopping, or at least slowing, Michael Jordan, the Pistons implemented "the Jordan rules" (not to be confused with Sam Smith's 1992 book of the same name), which boiled down to putting bodies on Jordan and putting Jordan's body on the floor. It helped Detroit reach three straight NBA Finals as they won back-to-back titles in 1989 and '90.

That first Pump shoe in 1989 represented a fairly direct trade-off of fit for weight. As anyone who eagerly entered a Foot Locker or Athlete's Foot to try on the $170 shoe could attest, the Pump hugged your foot like nothing else, but it was *heavy*. Breathability wasn't much of a consideration, either, what with the TPU-reinforced leather upper and industrial-strength bladders wrapping your feet. For, say, a 90-pound 14-year-old trying to make their junior high school team, a lighter—if less customizable—shoe may have made more sense. But that first Pump was essentially an experimental design pushed to market by a company that didn't want to wait.

1. Nike hoped the Air Pressure would spark a revolution.
2. The Pump was lot of shoe.
3. Pumping mechanism in the tongue.
4. Reebok's cushioning system, ERS, was visible through the sole.

BETTER CUSTOMIZED FIT,
BETTER SUPPORT

BBALL AS THE PUMP
MOLDED TPU INSERT, STITCHED

PUMP
REEBOK
REEBOK

PUMP TO FILL
THE BLADDER
WITH AIR

MOLDED ANKLE
LOCK DOWN

MOLDED TPU EYELET:
FOREFOOT LOCK

PERF → BREATHE

SKIING/AIR SPLINT TECH

AIR ENTERS THROUGH
THE PUMP AND FILLS THE
BLADDER FOR SNUG FIT

TOE BUMPER - STITCH DOWN
FLEX GROOVES

OMNI ZONE II

FOREFOOT
TRACTION

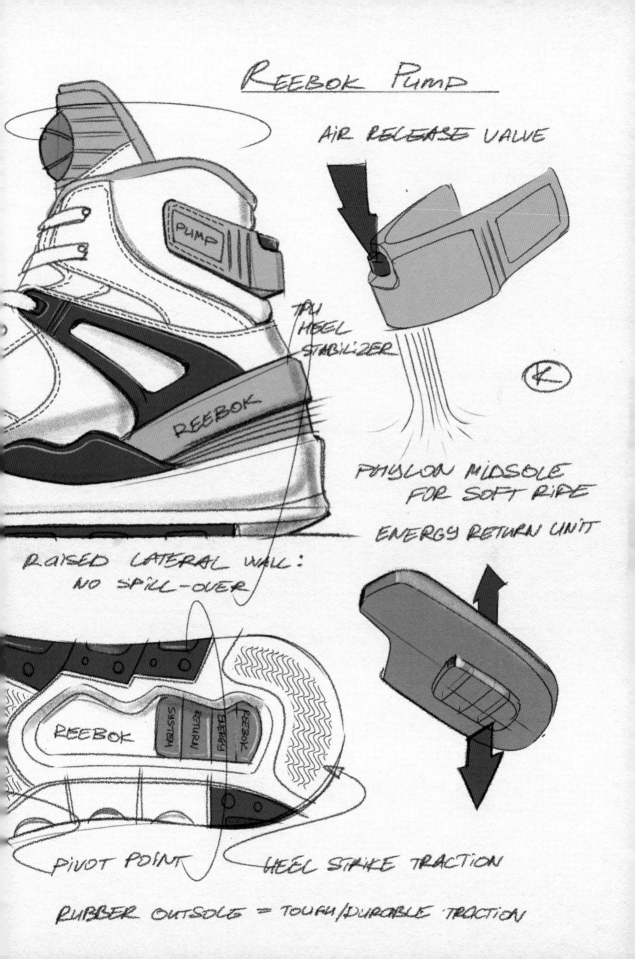

Not surprisingly, the rushed rollout was chaotic; the first batch of shoes came in from Korea with their US-made bladders malfunctioning. In order to get sneakers to retailers in time for the launch, Litchfield and his team replaced all 7,000 bladders by themselves. But it was worth it. The Pump easily outpaced the Air Pressure, which Nike soon discontinued.

The Pump drew in the kids, who pestered their parents for the new shoe. And by the late 1980s, a lot of hoops shoes were being sold to parents; Air Jordan had democratized basketball sneakers and spread them far beyond the courts. No one at Reebok needed to be tasked with convincing pro players to wear Pumps, like Chris Severn had done with the adidas Superstar back in the '60s. Paid endorsements and partnerships with college programs guaranteed that players would wear them. The Pump wasn't a signature shoe, it was a signature technology: The sneaker itself was the star, the astronomical $170 price tag both attraction and deterrent.

SNEAKER WARS

The Pump release coincided with Reebok signing Dominique Wilkins, their biggest star yet. Wilkins was a huge get for Reebok, whose roster was still primarily composed of Celtics (Dennis Johnson, Danny Ainge) and up-and-comers. 'Nique dueled Jordan in dunk contests—most notably in Chicago in 1988—and won the 1985–86 scoring title before Jordan started winning all of them. In '88, the Hawks took the Celtics to Game 7 in the Conference Semis, and it all came down to Wilkins and Larry Bird. Wilkins finished with 47 points, Bird with 34—including 20 in the fourth quarter—as the Celtics won a squeaker, 118–116.

Rather than gamble on a could-be next Jordan, Reebok signed his closest contemporary. Wilkins had originally signed with Converse as a rookie in 1982 after touring with Magic Johnson, Larry Bird, and Julius Erving on summer barnstorming teams. When that deal ended, he signed with Brooks, then primarily a running shoe company, which gave Wilkins a signature line, but nowhere near the exposure he'd get with a bigger company. So when that deal was up, Wilkins—by then represented by David Falk—chose Reebok.

The first Pump TV commercial was a big deal. Reebok flew their entire NBA roster to Los Angeles to film the spot on an outdoor court, and toward the end of the shoot, promotions manager Joanne Borzakian Ouellette asked the players to say what they really thought of the shoe for an internal video. Their responses were so entertaining they ended up becoming the commercial instead. "Some people like BMWs, I like gym shoes," said Hawks point guard Doc Rivers. "Somebody might sneak up behind me," said Lakers shooting guard Byron Scott, "push my release button, let all my air out." Cut to Wilkins cracking up.

History tends to remember Dominique Wilkins primarily as a dunker and a scorer, a guy who dueled with Jordan above the rim and could never quite get the Hawks over the top. But history can be stupid. In 1997, when the NBA put together their list of the 50 greatest players in league history, 'Nique wasn't

Dominique Wilkins at the
1990 Slam Dunk Contest.

included. It was not only an injustice, but a fundamental misunderstanding of the all-time player that Wilkins was (he would make the NBA 75 team in 2021). "My game was more than just dunking," he said decades later, still irate. "I was one of the greatest players to ever play this game because I played inside, outside, on the post, off the dribble, I had different aspects to my game . . . when you talk about my game [as just] 'He could really fly, he could dunk,' like come on, man, please."

Wilkins also had no qualms about going right after people. In a 1991 Pump commercial, he called out Jordan by name—"So, Michael, my man, if you want to fly first class, Pump up and Air out"—while throwing away a Nike Command Force (Nike's second-generation inflatable shoe, which had both an internal pump mechanism and Visible Air). "Pump Up and Air Out" became a whole series, with a Command Force being unceremoniously tossed at the end of commercials by not only Wilkins, but also by Dennis Rodman and Bill Walton. Those poor shoes.

"Mike got mad at me about that," Wilkins said. "I said, 'Mike, it's only advertising, man, it's not for real, I'm not serious. We're just trying to sell the shoe.'" By 1991, Pumps had become cheaper, lighter, and simpler, with the bladder relegated to the tongue alone, rather than wrapping all the way around the ankle. To sell real numbers and compete with $100 Air Jordans, the price had to be lower.

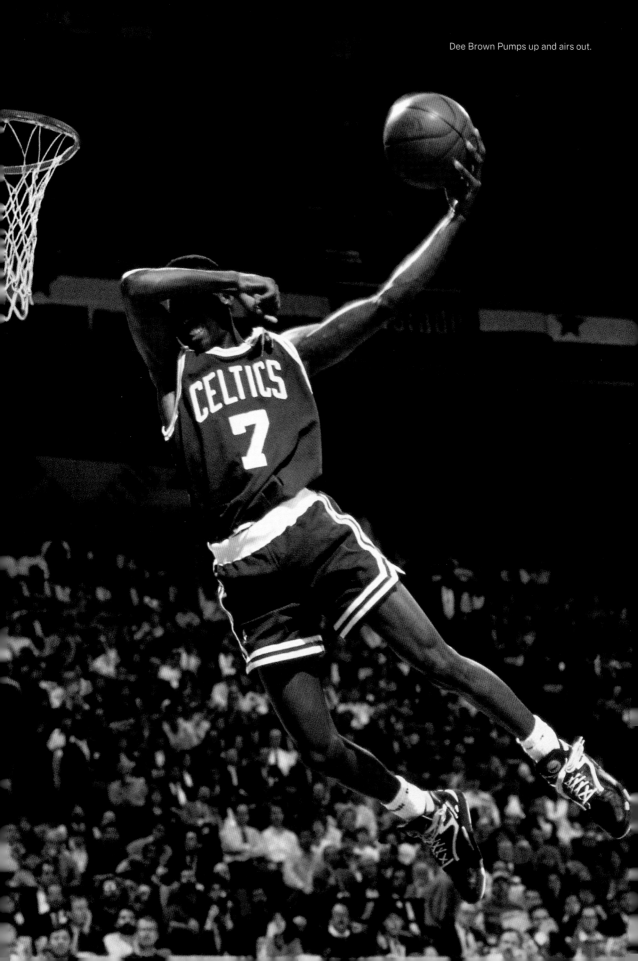

Dee Brown Pumps up and airs out.

Jordan had plenty of reasons to be irate about Reebok that year. In February, 6'1" Boston Celtics rookie Dee Brown crashed the 1991 Slam Dunk Contest party in Pumps. Before the event, he was enough of an unknown that some fans mistook him for fellow contestant Shawn Kemp's son. Afterward, no one would make that mistake again. Brown paused before several dunks to pump up his black Omni Zone IIs—the newest, more streamlined Pump shoe—which built up the drama and got Reebok valuable airtime.

Celtics rookie Dee Brown crashed the 1991 Slam Dunk Contest party in Omni Zone IIs.

Fireman, given a heads-up by Ouellette, was watching. The original plan had Brown performing his final, no-look dunk with a Pump ballcap pulled down over his eyes, but the NBA's "no props" rule quashed that particular marketing stunt. Instead, Brown ended by dunking with his head tucked into his elbow and won the contest. Later that night, Jordan confronted Brown, telling him he'd kicked off a "shoe war." Jordan knew better than anyone else what kind of sneaker stage the Slam Dunk Contest represented, as well as the impact a brash rookie could make. For MJ, forever seeking fuel for his competitive fire, it became personal.

Jordan didn't have the same reaction when Wilkins wore the original Pump a year earlier. Far from it. In the 1990 Dunk Contest, then-commentator Rick Barry mentioned during the CBS telecast that Reebok had paid the '85 champ $100,000 to enter—five times the $20,000 he'd make for winning. It was Wilkins's fifth and final contest, tying him with Clyde Drexler for the most appearances ever, and he took a businesslike approach to a business deal, throwing down a series of his signature windmills. There was a moment where he bent down, put down the ball, and briefly pumped up his shoes, but the announcers didn't even mention it, and the cameras never focused on his feet. The 29-year-old didn't milk it, either—he wasn't there for theatrics, he was there to win. As for Jordan, who'd stopped entering dunk contests after his back-to-back wins in '87 and '88, he was right there behind the bench in a white Air Jordan tee, laughing it up with Wilkins.

GENERATION NEXT

As Brown was winning the Dunk Contest, 7'1" LSU center Shaquille O'Neal was enjoying a dominant sophomore season in which he'd average 27.6 points, 14.7 rebounds, and 5.0 blocks per game. Had he turned pro that year, he likely would have gone in the top two—and not two—but his father, Sgt. Phil Harrison, wasn't having it. Shaquille was in school to get an education; NBA money and glory could wait. That's where O'Neal was bound regardless, if not from the moment LSU coach Dale Brown discovered him as a 13-year-old Army brat, then certainly when he enrolled in Baton Rouge as a business major.

The business he intended to run was himself. Inspired by Michael Jordan's Jumpman logo, O'Neal trademarked his own "Dunkman" silhouette, a knees-up, two-handed slam that he could license to would-be endorsees. Had today's Name, Image, and Likeness (NIL) rules been in effect, Shaq would have been a millionaire before he even left school. He played his junior season, posting similarly mind-boggling numbers against even more stifling (and fouling) defenses before forgoing his senior season. He'd eventually earn his degree in 2000, taking a day off from the Lakers to receive it.

Dunkman in the making.

While Michael Jordan's slew of endorsements coming out of college followed an agency's plans for a guy who was mostly just focused on playing basketball, the Selling of Shaquille O'Neal was a joint project between agent Leonard Armato and O'Neal himself.

Shaq grasped from the start what being a modern superstar entailed—both on court and off. He wanted it all, but some thought his image was confused. "He was trying to be the Terminator for Reebok and the gentle giant for Pepsi like Mean Joe Greene," said David Falk. "You have to have one image."

Shaq did pretty well for himself anyway, considering that even thirty years later he appears in every third TV commercial, along with his regular gig on *NBA on TNT*. He never tried to hide his commercial aspirations, either. "I'm tired of hearing about money, money, money, money, money," he joked as a rookie. "I just want to play the game, drink Pepsi, wear Reebok."

Reebok was the sneaker brand O'Neal met with first, and it went well enough that, although he would keep his subequent meeting with Nike, he chose to wear Reebok to their Beaverton campus. Phil Knight was not amused. That ended O'Neal's chances of signing with Nike then or ever, but the young superstar had already made his decision. His size-20 feet would be in Pumps, the perfect shoe for an overgrown kid. When he was introduced as an endorsee to Reebok's employees at their Boston-based headquarters, they all wore T-shirts that read LOVE SHAQ as the B-52's song played.

O'Neal was a supersized next Jordan, entering the NBA like a good-natured Thanos: a funny, playful giant who could obliterate half the universe without even trying. He averaged 23.4 points, 13.9 rebounds, and 3.5 blocks as a rookie, shooting 56 percent from the floor and running away with the Rookie of the Year award. He brought down backboards and entire basket stanchions and recorded rap albums—Darryl Dawkins's wildest dreams realized.

Barcelona Dreaming

For all of Shaq's accolades, and there are plenty, he wasn't selected to the 1992 Dream Team; Christian Laettner was the sole college representative. The Duke senior got the edge largely for winning the national player of the year award and back-to-back championships with the Blue Devils. As it turned out, it was probably for the best: Laettner played just 7.6 minutes per game, while O'Neal likely would have complicated things for coach Chuck Daly, who already had both Patrick Ewing and David Robinson rotating at the center spot.

The shoes *probably* didn't have anything to do with it. O'Neal was by then Reebok's biggest get, and he'd rankled Nike by wearing Reebok to his campus visit. And while Nike didn't have the entire Dream Team roster — Magic and Larry wore Converse, Ewing wore Ewings, Clyde Drexler wore Avia — they had most of it. That said, Nike took a casual approach to outfitting the Dream Team. Tinker Hatfield didn't have time to create the Olympic color-ups of the four Nike silhouettes, so he dropped them by the desk of fellow designer Tracy Teague, who did them with markers in an afternoon. Meanwhile, the Dream Team spread the gospel of basketball and sneakers worldwide, and of course won gold. Shaq would have to wait another four years for his.

His first signature shoe, the Shaq Attaq, had the Pump on the tongue and featured a highly sculpted midsole, all the more visible on his personal size 20s. Reebok had the brilliant idea of sending Shaq's actual sneaker to select retailers as a display item, allowing would-be customers to try to fill the big man's shoes—usually without having to take off their own first. When Ouellette's son was born, Shaq sent her a rookie jersey and sneaker; she put the baby in the shoe and sent a photo with a note: "Thanks, it makes a great bassinet, too."

BIG PROBLEMS

In the early '90s, word was big men couldn't sell shoes, but Shaq was going to defy that—along with any other unwritten rule he could think of. He'd act in movies and cut records and still try to become the most dominant center of all time. He used Reebok to bring together the star big men who'd preceded him. One of his first commercials featured Bill Walton (who'd advised him when he was still in college), Bill Russell, Wilt Chamberlain, and Kareem Abdul-Jabbar. There were jokes—Chamberlain offered O'Neal a broom and dustpan after Shaq shattered a backboard—but it was also an unofficial welcome to the pantheon of great centers, just as the rookie was getting started. There haven't been many true, can't-miss superstars throughout the course of NBA history, but young Shaquille was certainly one of them.

Though the "big men can't sell shoes" truism predominated, the '80s and '90s were rife with big-men shoe salesmen, from Hakeem to Patrick and David to Shaq. Dikembe Mutombo got an Africa-themed adidas signature shoe with his number 55 as shields, and Shaq's Reeboks peaked with 1995's Shaqnosis. The black-and-white sneaker somehow made his huge feet look even bigger and featured Instapump tech (which used an external pump powered by a CO_2 canister) not included in the retail models.

But big-man shoes tended to be, well, big shoes: high and bulky, while contemporaneous Air Jordans were only getting sleeker and faster looking. You were more likely to see a big-man shoe clomping through your local high school smoking area—unlaced with jeans tucked behind the massive tongue—than you were to see them on the local basketball court. Perhaps it would be more accurate to say, "big-man shoes don't sell."

Meanwhile, Nike's second generation of inflatable shoes weren't any smaller, featuring built-in pumping mechanisms (and Visible Air) in a high-top version of the Air Force 180 and, of course, that endlessly tossed away Command Force. David Robinson wore both and starred in Nike's "Mr. Robinson's Neighborhood" commercials, which played up his straitlaced Naval Academy persona. Like the Pump, the Nikes were tall, they were bulky, and they were heavy. Later, the Command Force had a star turn in *White Men Can't Jump*, where Woody Harrelson's Billy Hoyle gets his shoes pumped up for him by Wesley Snipes's Sidney Deane. Unlike Dee Brown, Billy *spoiler alert* doesn't put the dunk down, with significant consequences. (But he does manage a slam by the end of the film, overcoming both his own terminal whiteness and those hefty-ass shoes.)

The oft-cited reasoning for centers not being great endorsers was the perception that they were unrealistic role models—that growing up to be a seven-footer was too unlikely. Someone like Allen Iverson, listed at six feet but more like 5'11", was seen as having a more attainable brand of athleticism. But maybe he sold more shoes because his shoes were just better. Because while the average kid probably wouldn't grow up to be a nimble 300-pound seven-footer like Shaq, they were just as unlikely to become a flyweight water bug with long arms, big hands, and a lightning-quick first step like Iverson. Shaq in particular was more

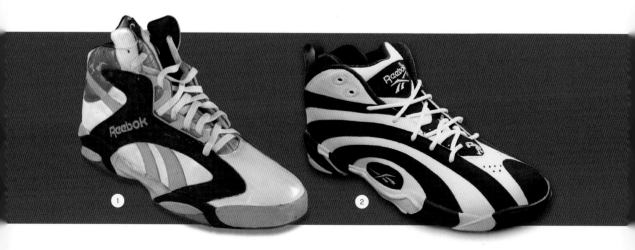

superhero than mere athlete, embracing a Superman alter-ego and tattooing the shield on one massive bicep. And what kid doesn't love a superhero?

Jordan aside, the NBA of the '80s and '90s was still a big man's game: The centers were centerpieces. Offenses were built around them and drafts focused on them—once the obvious college stars were picked, teams habitually looked for the best seven-footer available. Between 1976 (John Lucas) and 1996 (Iverson), every number-one overall pick was a big. Magic Johnson, who went first overall in 1979, may have been a point guard, but he was a 6'9" point guard. When there was no consensus number-one pick, teams erred on the side of size—hence big-time busts like Michael Olowokandi in 1998 and Anthony Bennett in 2013. Even as recently as 2018, the Suns drafted Deandre Ayton over Luka Dončić and Trae Young. As another old axiom goes, you can't teach size.

But outside of Hall of Fame talents like Olajuwon, Ewing, Robinson, and O'Neal, not a lot of bigs panned out as stars. In 1985, just one center was a top-ten scorer. It wasn't until the 1993–94 and 1994–95 seasons, while Michael Jordan was retired, that centers took back command of the scoring charts, with Robinson, O'Neal, and Olajuwon earning the three top spots (in that order in '94, with O'Neal taking the top spot ahead of Olajuwon in '95). A center wouldn't lead the league in scoring again until 2000, when Shaq returned to first.

By the turn of the millennium, O'Neal was wearing his own Dunk.net brand and Pump was no longer new and fresh. Updated versions of the technology would end up in a couple of Allen Iverson's later shoes and on the feet of one of the largest of them all: 7'6" Yao Ming. But Iverson was on his way out, and, unfortunately, Yao would have to retire due to chronic foot problems, playing just five games after he turned 30. All three would reunite in Springfield at their Hall of Fame inductions in 2016.

The Pump had its time, and Reebok wouldn't have achieved their success in basketball without it. But it didn't last. Adidas bought out Reebok in 2005 and the brand was out of performance hoops entirely by 2014. That year they had launched the Pumpspective Omni, a minimalist take on Dee Brown's Omni Zone II. At that point the Pump's time as a basketball performance product was past. The Pump was dead. Long live the Pump.

1. Reebok Shaq Attaq, 1992.
2. Reebok Shaqnosis, 1995.
3. Rookie Shaq, destroyer of backboards.

Chapter Eight

Bad Boys for Life:
Nike Air Force Max

**Converse Chuck
Taylor All Star**
1917

Adidas Superstar
1965

PUMA Clyde
1971

Adidas Top Ten
1979

Nike Air Force 1
1982

Nike Air Jordan
1985

Reebok Pump
1989

**Nike Air Force
Max**
1993

Nike Air Swoopes
1995

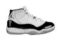

Nike Air Jordan XI
1995

AND1 Tai Chi
2000

**Nike Air Zoom
Generation**
2003

**Nike Zoom
Kobe IV**
2009

**Under Armour
Curry One**
2015

Nike Adapt BB
2019

There were many good reasons for five of the top high school seniors to commit to the University of Michigan in the summer of 1991. For Jalen Rose and Chris Webber, the campus was less than an hour from their Detroit homes. Head coach Steve Fisher had created a winning program and led the Wolverines to a national title in 1989. And for each member of the heralded class who would come to be known as the Fab Five, it was also the shoes.

"When we got to Michigan, we didn't just sign a letter of intent, we signed a shoe deal—we just wasn't getting paid for it," Rose remembered. "So when the gentleman, the [Nike] rep, came and profiled some shoes that they wanted us to rock, we were like, 'Nah, you gotta come correct. I got these Deions that I want, I got these Bo Jacksons that I'm tryin' to check out, what's up with these Barkleys, these Huaraches—you gotta come correct.'"

Some consider the Air Flight Huarache, also worn by the likes of Scottie Pippen, to be the signature Fab Five shoe—understandable, given they all

played in them as freshmen. But as sophomores they wore black Air Force Max, those Barkleys that Jalen mentioned that, along with the team's signature black socks, baggy shorts, and bald heads, defined the Fab Five look. They were the kicks they had on when Webber's panicked, late-game timeout (with none left) sealed their fate against North Carolina in the '93 championship game. That would be their final game together, as Webber declared for the draft in May and became the number-one overall pick in June. He'd go straight from wearing Charles Barkley's shoes to playing against him in the pros.

MAXED OUT

The Air Force Max was a Charles Barkley signature model in practice if not in name, its Visible Air–equipped, mid-cut, strapped-up style built to contain his size 16s on their frequent end-to-end romps. It was just the latest and most extreme evolution of a lower-cut, Velcro-strap style that Barkley had adopted starting in 1987 with the Nike Alpha Force (Moses Malone got the commercial for that one), the Alpha Force II, and the Air Force 180 Low that Chuck had worn with the '92 Olympic team and to begin his MVP-winning 1992–93 season.

Like the Air Force 180, the Air Force Max was designed by Steve McDonald. The former champion skier and Apple designer was simultaneously building Nike's nascent ACG (All Conditions Gear) outdoor line and leading Force basketball. If any one player represented the rugged edge of basketball, where ACG and Force met, it was Barkley.

McDonald never got to speak to the power forward personally about what he liked in a shoe, but higher-ups in Nike basketball passed along Barkley's suggestions. The designer had first included some of them in the Air Force 180 Low—the big heel Air bag, the slightly higher than low cut, the midfoot strap. A neoprene and thermoplastic ankle collar that McDonald had included in his initial 180 sketches from 1991 went into production on the Air Force Max. He put

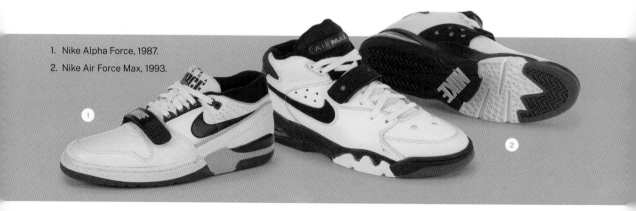

1. Nike Alpha Force, 1987.
2. Nike Air Force Max, 1993.

prominent "teeth" on the outside of the forefoot midsole not only for stability, but for recognition at a distance that he hoped would blossom into greater appreciation the closer one got. "I didn't want to have this real complicated feel," he said, "because people will never remember that." He also had to create a shoe to suit a player who was like no one else.

BOY GORGE

If you were going to build a basketball player exactly like Charles Barkley, well, first of all, you wouldn't. In fact, you *couldn't*. A late-blooming pudgy superball of an athlete, Barkley was born and raised in Leeds, Alabama, and went to college at nearby Auburn, where he destroyed rims and pizzas with equal alacrity. Some of his eating habits were exaggerated both for and by the media, but not by much. He lived his life a Quarter Pounder at a time. It didn't seem to affect him at all on the court. Barkley was built like someone from a planet with heavier gravity than Earth and played like there was no gravity at all.

He was undoubtedly both the best and worst thing to ever happen to Auburn head coach Sonny Smith, who somehow coached both Barkley and equally head-strong Chuck "The Rifleman" Person at the same time without having to be institutionalized. Barkley was good enough to get an invite to the 1984 Olympic Trials and, as it turned out, fortunate enough to be one of the last four players cut—all he really wanted to do was drive up his NBA draft stock, and one more second with Bobby Knight probably wasn't going to end well for either of them.

Keeping It Reel

For evidence of Barkley's dunking prowess, please watch his highlight reel from the epic *NBA Superstars* tape. For many an early '90s basketball junkie, these VHS tapes were in damn near constant rotation. (Yes, Michael Jordan's *Come Fly with Me* was great and all, but eventually you craved variety.) *NBA Superstars* dropped in 1989 as the first official NBA mixtape, with highlights set to music—Barkley to Scandal and Patty Smyth's "The Warrior," Hakeem Olajuwon to Kool Moe Dee's "How Ya Like Me Now," Larry Bird to John Cougar Mellencamp's "Small Town," Michael Jordan set to (sigh) Berlin's "Take My Breath Away" from *Top Gun*. It couldn't have at least been "Danger Zone"?

In those pre-YouTube days, that tape was everything. Not only did you get legit highlight reels of all those players (as well as Magic, Dominique, and Isiah), but you also caught glimpses of magicians past—Cousy, Maravich, Archibald—all on something you could rewind and watch over and over when the NBA wasn't on. It was highlights on demand: MJ dunking from the free-throw line, Magic throwing a full-court bounce pass, Barkley dribbling through entire teams and dunking on whoever was left standing.

Barkley's draft stock went up all right. The 52-win Philadelphia 76ers picked Barkley fifth overall in 1984, and they used their *other* 1984 lottery pick, the tenth overall, on Olympian Leon Wood. The rich got richer. The Sixers were a veteran team just a season removed from a title, fronted by ex-ABA stars and MVPs Julius Erving and Moses Malone and defensive stalwart Bobby Jones. But Barkley wasn't in Alabama anymore, no longer the big man on campus. When he arrived in Philly, the never-at-a-loss-for-words Barkley didn't quite know how he should address the legendary Erving. He was blessedly relieved when the elder statesman introduced himself with, "Hi, I'm Doc." Problem solved.

That was possibly the first and last time Barkley was unsure about anything, as anyone who has seen him pontificating and "gare-on-teeing" on TNT can attest. He quickly emerged as the high-volume frontcourt yin to the taciturn Malone's yang, an ebullient rebounding machine who said more after a game than Malone did in a month and whose on-court nonverbal communication to the opposition was equal parts clear and disrespectful. While Malone was known primarily for his dogged efforts on the offensive end, Barkley used his outsized posterior and logic-defying leaping ability to snatch defensive boards and turn them into coast-to-coast rampages, dribbling through entire opposing defenses before posterizing some poor center with a two-handed hammer.

Young Barkley did this a lot.

Moses and Charles, 1985.

What worked at Auburn also worked in the NBA. Coach Billy Cunningham—who'd won Sixers championships as a player alongside Wilt Chamberlain in '67 and as the coach in '83—was a traditionalist who wanted Barkley to outlet his boards to point guard Mo Cheeks. But why do that when Chuck wasn't likely to get the ball back? And he got plenty of rebounds: Availing himself of Malone's tutelage, Barkley averaged 8.6 boards per game as a rookie, 12.8 the next year, and—with Malone traded to Washington—a league-leading 14.6 the next. Listed at a generous 6'6", he stood closer to 6'4" and played more like 6'10". Barkley was one of the few 1984 rookie signees Nike added alongside Michael Jordan. Unlike Mike, who was very much the anointed one, Chuck had to rise through the ranks the old-fashioned way, waiting a bit longer to land coveted poster shoots and eventually commercials of his own. At first, Nike—like the Sixers—featured him alongside Malone. But by the time Moses was traded and Dr. J retired, Chuck was the clear No. 1 in Philly, as well as the clear No. 2 at Nike.

And in short order, he went from being shouted out by Public Enemy in a song—"Simple and plain, give me the lane / I'll throw it down your throat like Barkley"—to having Chuck D voice an entire stage musical–inspired Nike commercial directed by a music video guy by the name of David Fincher, with music courtesy of the Bomb Squad's Hank Shocklee and Broadway's Don Sebesky. "We had an unlimited budget," remembers Wieden+Kennedy creative director and copywriter Jim Riswold, "yet we still exceeded it." In another spot, a massive, animated, frothing-at-the-mouth Barkley literally threw opponents out of his way and muttered, "Sorry, excuse me" before tearing off the rim and tossing it behind him. In yet another, he went one-on-one against a goggled Godzilla.

ROLE MODEL

The bigger you get, though, the more of a target you become—and not just to irradiated lizards. By the early '90s, hardly anyone was bigger than Barkley, and he'd never been a turn-the-other-cheek type. In 1991 alone there were a litany of incidents both on the court (various and sundry fights and scuffles) and off (spitting at an abusive fan in New Jersey and spraying a little girl instead, breaking a man's nose in a late-night confrontation in Milwaukee). Following his Wisconsin arrest, *Philadelphia Inquirer* columnist Bill Lyon summed up Barkley in two sentences: ". . . he just seems unable to walk away. It is his most obvious asset in basketball and his most obvious shortcoming in life."

Lyon added something else that clearly resonated with Barkley, whether he read it or not (one would lean toward "not," as this was a man who claimed to have been misquoted in his own autobiography). Lyon wrote in soaring prose of the unspoken agreement in which celebrities are asked to give up certain aspects of a normal life in exchange for riches, and Barkley's refusal to do so: "It goes with the territory, just as surely as having to serve as a role model goes with the territory." Barkley, as he would later make resoundingly clear, disagreed.

Too late, Michael: Game 4 of the 1993 NBA Finals.

The Sixers may have lived with Barkley's shenanigans had their fortunes improved, but the team's win totals yo-yoed year to year. After missing the play-offs for the second time, in the summer of 1992 Philadelphia finally parted ways with their 29-year-old six-time All-Star, trading Barkley to the Phoenix Suns for a package of guard Jeff Hornacek, forward Tim Perry, and center Andrew Lang. (That January, Philly had reportedly nixed a trade with the Lakers that would have netted them James Worthy and Elden Campbell.)

The move to Phoenix came right before Barkley took the floor as a member of the gold-medal-winning Dream Team, the most legendary team ever assembled—and one he would lead in scoring. Of course, even that crowning achievement wouldn't come without a Charles-created controversy: During a 116–48 rout of Angola, in the midst of a 46-1 Team USA run, Barkley elbowed 6'7", 170-pound forward Herlander Coimbra in the chest. Afterward, Barkley threw gasoline on the fire: "Somebody hits me, I'm going to hit him back. Even if it does look like he hasn't eaten in a couple weeks. I thought he was going to pull a spear on me."

The Olympics propelled Barkley straight into his Phoenix debut already in midseason form. The Suns had a new coach (Paul Westphal), a shiny new million-square-foot arena (America West), and a new superstar—who was promptly tossed from his preseason debut. No matter. In his first regular-season game, Barkley put up 37 points, 21 rebounds, and 8 assists in a win over the Clippers. The Suns won five of their first six before going 14-0 in December. Barkley made his seventh straight All-Star Game, during which he donned number 23—Hakeem Olajuwon got 34, as back in those days only one All-Star could wear each number—and threw elbows with former Dream Team-er Scottie Pippen in the post. Phoenix finished with the best record in the NBA, with Barkley leading the Suns in points, assists, and blocks.

Yes, you are a role model: Barkley receives his 1993 MVP trophy.

That spring, Nike released a series of inner-monologue-type commercials for Barkley, Jordan, and Alonzo Mourning directed by Joe Pytka. Barkley's spot for the Air Force Max hit as hard as he did. In between clips of Chuck ripping down rebounds and throwing down dunks in an otherwise empty gym, he delivered his lines in tightly cropped closeups: "I am not a role model. I'm not paid to be a role model. I'm paid to wreak havoc on the basketball court. Parents should be role models. Just because I dunk a basketball doesn't mean I should raise your kids." The script was written by Wieden+Kennedy's Jim Riswold but hewed closely enough to Barkley's own views and vocal cadence that the words became his.

It was a controversial message to some—including NBA commissioner David Stern and Jazz forward Karl Malone, who penned a June 14, 1993, *Sports Illustrated* column called "One Role Model to Another" in response. By the time Malone's piece appeared, Barkley was named MVP, and Stern wryly alluded to the commercial in the on-court presentation: "And this year, I guess you would say that if you were looking for what an MVP season is, your season this year is a *role model* for an MVP season." Barkley was also midway through the NBA Finals, his Suns having just pulled out a triple-overtime Game 3 win over Jordan's Bulls.

Phoenix had gotten there in a somewhat roundabout fashion for a team with the best record in the NBA, having dropped the first two games of the opening round to the Lakers and needing seven games to oust the Seattle SuperSonics in the Western Conference Finals. But against the Sonics, the Suns had both home court advantage and the reigning MVP, who posted 44 points and 24 rebounds in 46 minutes in Game 7. Afterward, Barkley was just his normal, understated self: "I'm gonna go out and get really fucking drunk tonight," he said, "and then sit in my whirlpool and celebrate." (Okay, maybe he had a point about the whole not-being-a-role-model thing.)

But the Finals—that was a different story. If you were playing against Jordan, you were the underdog, home or away, better record be damned. The two super-stars were friends, but being pals didn't mean much between the lines. It was hero versus antihero, and Jordan's Bulls beat Barkley's Suns in six.

NEW SCHOOL

Barkley may not have wanted to be a role model, but college hoopers who grew up watching him were taking the NCAA by storm while wearing his sneakers. Take the 1990 NCAA Championship game, where the UNLV Runnin' Rebels lit up the Duke Blue Devils by 30 points. The Rebels were a real-life repudiation of *Hoosiers*, led by the gold-tooth grin of Barkleyesque forward Larry Johnson, the sinewy athleticism of Stacey "Plastic Man" Augmon, and the gritty backcourt of Greg Anthony and tournament Most Outstanding Player Anderson Hunt. They wore baggy shorts and black Nikes and ran you ragged. (Duke would get their revenge the following year with a 79–77 upset over the undefeated Rebels in the Final Four.)

The Rebels were assembled by Jerry Tarkanian, a balding, 59-year-old, towel-gnawing coach who fashioned himself a Hall of Fame career by finding

players on the margins, like Prop 48 nonqualifiers and junior college stand-outs. Sure, his fictional counterpart in the movie *Blue Chips* didn't land Neon Boudeaux or Butch McCrae, but in real life Tark would have gotten commitments from both of them.

Tarkanian wasn't unique in his rough-and-tumble approach. The Rebels had company in teams like Loyola Marymount—whose Paul Westhead–led offense ran other squads out of the gym behind USC transfers Bo Kimble and the late Hank Gathers—and later in Bob Huggins's Cincinnati Bearcats. But that title-winning '90 UNLV team was influential in everything from on-court style to their run-and-gun style of play, and in 1991, a group of blue-chip high school players would come together to build something similar of their own.

It started in Michigan. When Lansing's Earvin "Magic" Johnson entered the NBA out of Michigan State in 1979, he did so as a 6'9" true point guard. His success bred successors, tall playmakers running game at St. Cecilia's gym on the West Side of Detroit and in Magic's footsteps at Michigan State: guys like Steve Smith, Terry Mills, and Derrick Coleman, who was born in Alabama but grew up in the Motor City.

In 1991, Jalen Rose had next. He was 6'8" with handles, dimes, and attitude to spare, a skinny kid with a close-cropped fade who was built like an upside-down exclamation point. Rose's father, whom he never met, was a 6'3" NBA guard named Jimmy Walker who played for the Pistons in the late '60s and early '70s. Walker had been the first-overall pick of the 1967 draft ahead of some guys named Earl Monroe and Walt Frazier. Rose got Walker's DNA and built the rest

Larry Johnson, UNLV.

Jalen Rose, Michigan.

Chris Webber, 1993.

himself on St. Cecilia's proving grounds against returning pros and college players, at Southwestern High School under coach Perry Watson, and on Detroit playgrounds where he literally made opponents cry.

There was another blue-chipper in Michigan, too, a 6'9" power forward with handles and vision who could also post up and finish with authority. He was a kid with a Kenny Walker high-top fade who played with Rose on the Superfriends AAU squad (Rose made him cry, too) but attended Detroit Country Day, a private school in the suburbs. That was Chris Webber.

Rose and Webber were both selected to the 1991 McDonald's All-America game, and there in Springfield, Massachusetts, they planned their future. Together with Chicago big man Juwan Howard and Texas shooting guard Jimmy King, they committed to the University of Michigan. Add in swingman and fellow Texan Ray Jackson and you had the Fab Five, a squad of all-world freshmen who flipped the traditional college team hierarchy on its head. It wasn't even until 1972 that freshmen were eligible to play varsity basketball, and North Carolina coach Dean Smith—who started coaching in 1961—still forbade freshmen from speaking to the media until after their first game. But these freshmen? They would talk before and during their first game and pretty much whenever they wanted.

School Shoes

According to correspondence in their archives, Converse was sending their Non-Skid (the All Star predecessor) to Notre Dame and the University of Minnesota as early as 1916. In return, they got invaluable feedback on their new basketball shoe. By the 1920s, Converse was outfitting basketball programs across the country. Eventually they paid some of the more prominent coaches—Dean Smith at North Carolina and Joe B. Hall at Kentucky—to run clinics with the expectation that the players would wear their shoes.

NCAA rules forbid giving sneakers to players directly, so companies found those kind of workarounds. When Sonny Vaccaro convinced Nike that college teams represented a better value than NBA players, he signed coaches to get the Swoosh onto college squads. His first signing? UNLV coach Jerry Tarkanian. By 1979, more than fifty schools were in Nike. In 1985, Nike creative director Peter Moore used the Air Jordan template to create the Dunk as a college shoe in college colors (from UNLV and Ohio State's gray-and-red to Michigan's maize-and-blue), with the gray-and-blue Legend-based Terminator as a standalone for John Thompson's Georgetown Hoyas.

On February 9, 1992, the Fab Five started as a unit against Notre Dame, scored every Michigan point, and didn't look back. They went into the NCAA Tournament as a 20-8 six-seed and suffered their final loss of the season to the same team that had handed them their first: Duke. That loss, a 71–51 beatdown, came in the National Championship game. Had it been the 2000s or later, Webber, Rose, and Howard would have almost certainly gone pro that summer. But it was the early '90s, and they all came back.

Michigan was a Nike school, one of many that Sonny Vaccaro had signed on his nationwide sweep back in the late '70s. Back then, college programs had long been paying for their own Converse gear and were startled by the idea that a sneaker company would pay *them* instead. But Michigan went from just another Nike school to one of their premier college teams in 1989, when the Wolverines won a national championship. Steve Fisher had taken over as interim coach in the final week of the season when angry athletic director (and Michigan icon) Bo Schembechler fired head coach Bill Frieder for accepting the Arizona State job before the tournament started. Michigan ran the table and Fisher got to keep the position. Add to that title the most heralded recruiting class since, well, ever,

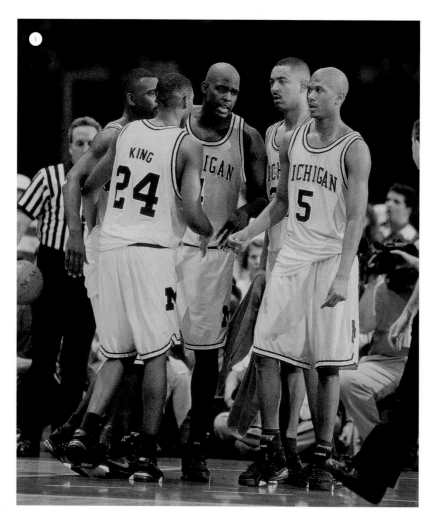

and by 1991, Nike was sending Michigan just about whatever they wanted. They didn't get their own shoe—they got all the shoes.

But the Fab Five learned quickly that even being the elite of the college elite had its limitations. To this day, Rose remembers the name of the team's equipment manager who controlled what sneakers the players received and when. Yes, they wore the shoes on court and got all the styles they wanted, but the team kept tabs on what pairs went where from practices to game days.

All this while they were blowing up Nikes in nationally televised games—1991's Air Flight Huarache became damn near a Fab Five signature model their freshman year. Then the Air Force Max became as much a Fab Five shoe as a Barkley one when the Wolverines wore it in the 1993 Final Four and championship game—the last time the Fab Five would take the floor as a team. Then again, not being able to wear the latest Nike hotness off the court wasn't such a problem for the two Michigan-born guys who grew up idolizing Pistons guard (and Michael Jordan archenemy) Isiah Thomas, who rocked seemingly every brand *but* Nike. Rose, for one, wore PUMA and adidas when he was off the books, saving school-sanctioned Nike for official appearances.

> The Air Force Max became as much a Fab Five shoe as a Barkley one when the Wolverines wore it in the 1993 Final Four and championship game—their last.

The Fab Five were perhaps the biggest bargain in sneakers: five influencers before the term even existed, sporting the latest Nike styles and not making a dime for it. Coach Fisher and Nike profited, but the players themselves didn't even get to keep the gear they were making so popular. Rose and Webber saw their jerseys being sold out of the Michigan bookstore while they were scraping together money for fast food. Rose finally got one of his own

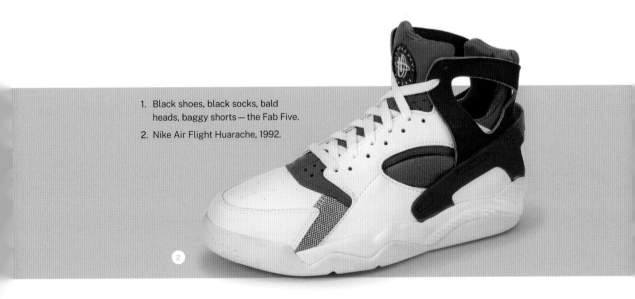

1. Black shoes, black socks, bald heads, baggy shorts—the Fab Five.
2. Nike Air Flight Huarache, 1992.

Michigan game jerseys well after his playing days had ended in Ann Arbor—all that stuff went to coaches and boosters and who knows where else.

As it was, Webber accepted money from a booster named Ed Martin and later lied about it to a grand jury. Eventually convicted of perjury, he was banned from any affiliation with Michigan for a decade, and the university would vacate all the Wolverine achievements of 1992 and 1993. Not only did they forfeit the games and take down the banners, but Fisher was fired and it destroyed Webber and Rose's relationship for years. Of course, had the current NIL rules been in effect in 1992, Rose and Webber would have pulled in considerable earnings and the attention would have stayed on court and not in court.

SEPARATE WAYS

The Fab Five were products of the sneaker-industrial complex long before they even got to Michigan, coming up through elite high schools and AAU programs and showing out in summertime all-star games, all designed specifically to get the best kids in the country wearing specific brands. Sometimes it worked, sometimes it didn't. Even the most heralded high schoolers couldn't always find starring roles on big-time college teams, let alone in the NBA. Webber wound up signing with Nike out of college in 1993, although he didn't stay with them long. Rose, who entered the draft the following year, followed Sonny Vaccaro to adidas, which is why he ended up wearing adidas Ratballs as a rookie instead of, say, Nike Air Ups. Loyalty cuts different ways.

Role Models II

Despite his short stint with the Swoosh, Webber did have one shining NBA moment in Nikes: his sixth-ever game, against the Suns and reigning MVP Barkley. A Latrell Sprewell steal led to a Warriors break that ended with C-Webb going behind the back and dunking on a retreating Barkley, whose posterior ended up crashing directly into a baseline camera. Nike turned the moment into a barbershop commercial, featuring multiple slow-motion replays, N.W.A.'s "Express Yourself" sample, a re-enactment on a Nerf rim, and Webber telling Sprewell, "[Barkley] said, 'I don't believe in role models, but you mine.'"

But Chuck got the last laugh. The Warriors matched up with the Suns in the first round of the '94 playoffs and were swept in short order, with Barkley putting up 36 points and 19 rebounds in the opener and 56 and 14 in the closeout game.

At any rate, Rose was more valuable to the Swoosh as a member of the Fab Five than as an NBA rookie in Denver. Being a lottery pick landed him on a middling Nuggets team whose coach resigned 34 games into a 41-41 season that ended in a first-round playoff sweep. At Michigan, Rose was part of one of the best and

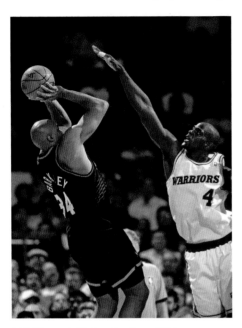

most talked about college teams in the country with games on primetime national TV. For less than the cost of a single rookie endorsement, Nike got Rose and Webber jawing at both each other and everyone else, a steady supply of highlight dunks, and back-to-back Final Fours and national championship games.

Nike paid for a program and got players. All that money was going straight to Steve Fisher; it wasn't a lot, and Nike likely earned it back in sales of black socks alone. The company also collected priceless market research from the exact market they were trying to reach. If the Fab Five thought a shoe was cool, it was safe to say the rest of the American basketball-playing youth would love it, too. The Air Force Max had become more associated with the Fab Five than with Barkley, even though Barkley played in them in the Finals and won MVP. He wore it because it was his shoe. The Fab Five wore it because they wanted to. That makes a difference.

C-Webb guards his favorite player, 1994.

When Webber was inducted into the Basketball Hall of Fame in 2021, he picked two Hall of Famers to come on stage and welcome him in. One was Isiah Thomas, a longtime mentor and friend. The other was Barkley. "Personally, you've shown me the way in life more than once," Webber told him. "I studied your game, I knew your truth, I knew your attitude, and you complimented and encouraged me, and for the first time after seeing you, I thought, 'Hey, maybe I can do this if my favorite player says I can.'" Indeed, Webber got to do something truly rare: He filled his idol's shoes while his idol was still wearing them.

Here's the thing that Barkley got wrong about being a role model: It was never something you could choose to be. Barkley was chosen, just as the Fab Five would be. It didn't have anything to do with championships; neither Barkley nor the Fab Five won any. And it wasn't a question of winning—it was about fighting. They strapped up those big, black Air Max boots and went to war. Barkley and the Fab Five were defiant rulebreakers and trash talkers, going up against the best and more than holding their own. Just performing on those Final Four and NBA Finals stages was enough, making it that far and on their own terms, uncompromising to the very end. That's what the Air Force Max stood for. That's what it stands for still.

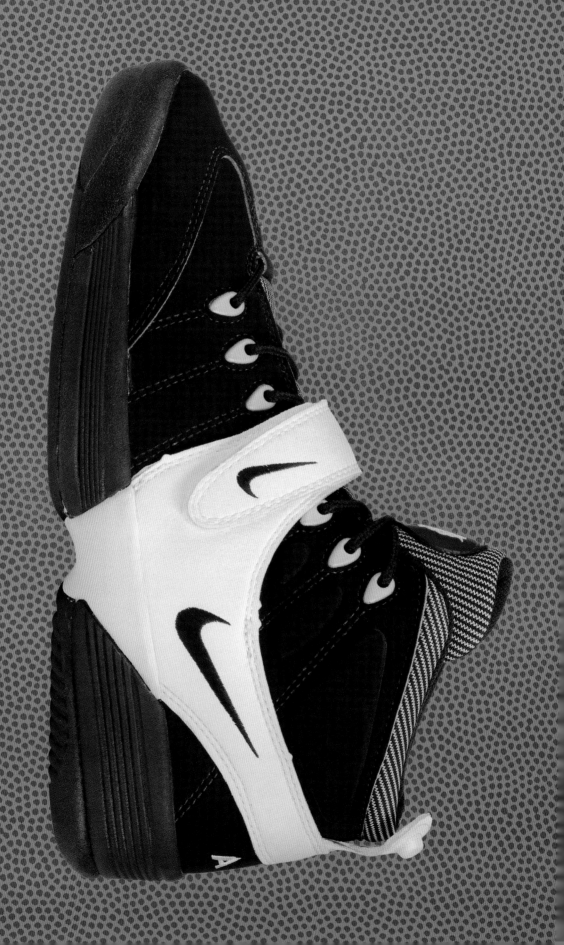

**Converse Chuck
Taylor All Star**
1917

Adidas Superstar
1965

PUMA Clyde
1971

Adidas Top Ten
1979

Nike Air Force 1
1982

Nike Air Jordan
1985

Reebok Pump
1989

**Nike Air Force
Max**
1993

Nike Air Swoopes
1995

Nike Air Jordan XI
1995

AND1 Tai Chi
2000

**Nike Air Zoom
Generation**
2003

**Nike Zoom
Kobe IV**
2009

**Under Armour
Curry One**
2015

Nike Adapt BB
2019

Chapter Nine

All Hail the Queen:
Nike Air Swoopes

Like many hoopers of her generation, Sheryl Swoopes grew up wanting to be like Mike. "I never got an opportunity to watch women play on TV," she said. "I didn't know women could do this. So I watched Michael Jordan. Anytime the Bulls were playing, I had to find a way to get in front of the TV." Swoopes tried to emulate her role model's game. Dubbed "the female Jordan," she graduated from Texas Tech having singlehandedly laid waste to the entire 1993 NCAA Women's Tournament. Nike then signed her to a four-year deal despite the star not even having a US-based professional league to compete in. Swoopes played just ten games in Italy before returning home to Texas, where she got a job as a bank teller and satisfied her basketball cravings by playing pickup at a local gym.

Born and raised in Brownfield, Texas, Swoopes grew up playing against her older brothers. She got good. Really good. She committed to the University of Texas, but Austin was just too far from home and she ended up at Tech in nearby Lubbock. As a senior in 1993, the 6'0" shooting guard showed UT what they missed out on, exploding for 53 points in a game against the Longhorns.

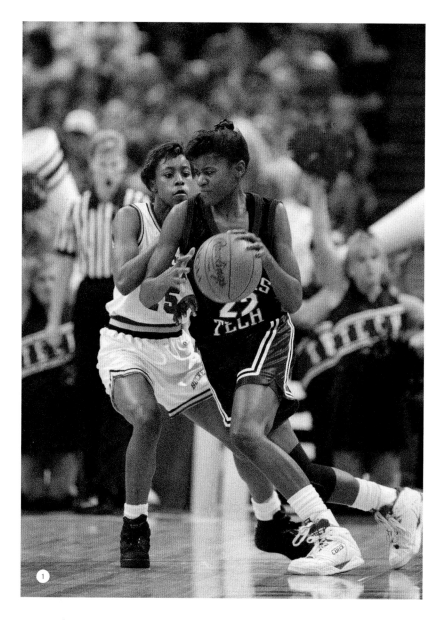

In the '93 Tournament, she scored a record 177 total points in five games. She dropped 31 on Vanderbilt to reach the final and the very next day poured in a championship-game-record (for men or women) 47 on Ohio State. The Red Raiders needed every one of those points, squeaking out a two-point win and earning Texas Tech their first national championship in any sport. Sonny Vaccaro, by then working for adidas, was asked who was more marketable: Swoopes or George Lynch, a national-champion Tar Heel who was also turning pro. "Definitely, Sheryl Swoopes," Vaccaro said. "Her name is meaningful in basketball circles. Swoopes as in hoops: It flows off the tongue."

"Swoopes as in hoops: It flows off the tongue."

LIKE MIKE

The summer Nike signed Swoopes, MJ himself invited "the female Jordan" to work at his camp and challenged her to a game of one-on-one. Swoopes airballed her first three shots but went up 4–3, then down 7–4. He won the game; she got his UNC shirt. She felt good enough afterward to talk trash to his face on camera: "He was tired. Old, out of shape . . ." Jordan interjected with a smile, "I didn't see any challenge. I just wanted to cut it short before someone got hurt."

More was coming. Nike designer Marni Gerber went to Lubbock to learn what made Swoopes tick and find out what she liked in a sneaker. The result was 1995's Air Swoopes, the first-ever signature women's basketball shoe—and one crafted to fit Swoopes's narrow size-10 foot perfectly. Nike's list of signature athletes in basketball that year was a short one: Michael Jordan, Charles Barkley, Penny Hardaway, Chris Webber. Swoopes was just the fifth.

The mid-cut Air Swoopes featured a mid-foot strap, a pull tab on the heel that was long-fingernail compatible, and Swoopes's own logo, a stylized "S" on the tongue. It even got one of Nike's minimalistic print ads featuring a shoe and a 1-800 phone number that people could call to hear Sheryl talk about her own sneaker. The Air Swoopes was a serious hoop shoe designed by women, marketed by women, and marketed *to* women, with sneakers only in women's sizing. It was something completely different.

"That [shoe] made everybody stand up and take notice," said former AND1 and Nike exec Jeffrey Smith. "You mean the girl's version doesn't need to be just pink and light blue?" Quite to the contrary: The $85 release version was basic black with a white strap, and Swoopes got her own red, white, and blue makeup to debut as a member of the US National Team. And it wasn't just any US National Team, but one with vengeance on its mind.

1. Sheryl Swoopes at Texas Tech.
2. The original Air Swoopes, 1995.

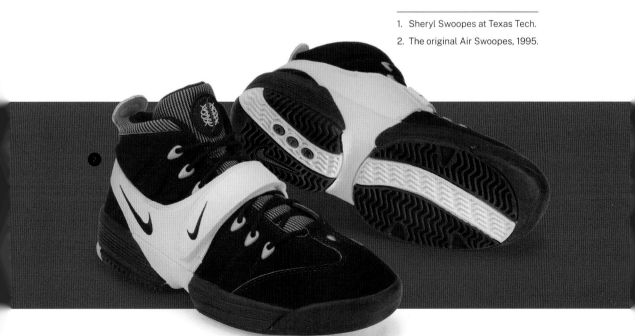

OLYMPIAN

After third-place finishes in the '92 Olympics and the '94 World Championships, nothing less than gold would be acceptable at the '96 Games in Atlanta. Stanford's Tara VanDerveer stayed on as coach, and the week-long Olympic Trials began in Colorado Springs with 24 players in May 1995. By the time practices started, that 24 had been whittled down to 11, including Swoopes, former Virginia point guard Dawn Staley, and former USC center Lisa Leslie. UConn center Rebecca Lobo was the youngest player at 22, and the two oldest—31-year-old Teresa Edwards and 30-year-old Katrina McClain—were both from nearby in Atlanta. Swoopes was able to lace up her own shoe for the first practice—"That's cute," VanDerveer remarked about the signature sneakers.

Starting on Halloween, the squad embarked on a grueling, globe-spanning 52-game exhibition schedule. The primary goal was for the players to coalesce into a true team. But along the way, as they racked up win after win (after win after win after win), they accomplished something more. For starters, they showed just how much better they were than even the best college teams. Louisiana Tech lost 85–74, the closest that any NCAA squad would get. The next closest was Tennessee, who lost by 34. The Olympians beat Stanford 100–63, Kansas 101–47, George Washington 110–37, and Ohio State 118–49, finishing that initial leg of their tour with a 107–24 drubbing of Colorado.

From there they went to Russia, Ukraine, China, and Australia, with some more domestic sellouts in between. Fans kept coming and Team USA kept winning. There were a few close calls: a three-point win over Cuba in Ningbo, China, then a one-point squeaker against Russia in Chicago in their second-to-last game. But when they closed out the final game, an 86–46 victory over Italy before a

1. Undefeated: Team USA, 1996. 2. The Swoopes II, 1996.

crowd of 10,643 in Indianapolis, the Americans were 52-0. A little over a week out from the Olympics, they were more than ready.

After all that dominance, the Atlanta Games were almost an anticlimax—except for the crowds. They had drawn well on their world tour, but this was something else entirely. Team USA averaged 25,000 fans per game, with nearly 33,000 packing the Georgia Dome to watch them dismantle Brazil in the gold medal matchup. Swoopes finished as the team's third-leading scorer, averaging 13.0 points per game, shooting 55 percent from the floor, and ranking second in assists.

She had already transitioned into her second shoe, the Swoopes II, by the start of the Games in 1996. The new sneaker featured off-to-the-sides lacing, a big Swoosh up front and a tiny one at the ankle, and a prominent shank plate in the middle of a thick midsole that was far ahead of its time. Maybe, like the first Air Jordan, Nike should have given the first Air Swoopes more time to breathe and let the legend build before releasing a next sneaker. Then again, Sheryl never even lost a game in her first shoe. Even Mike couldn't say that.

Talk had begun early in the world tour of forming a new women's professional league called the American Basketball League (ABL), whose founders hoped to sign up as many Olympians as they could. Many tentatively agreed to join; with the new possibility of earning a real salary to play at home in the United States rather than finding a scarce spot overseas, the decision was a no-brainer. But before the pre-Olympics tour concluded, the NBA had announced a second professional option, one with even more solid backing. The best women players would have a choice of American pro leagues, something their predecessors had never enjoyed.

BEGINNINGS

From the start, women's basketball was separate and unequal. It took root in the Northeastern United States just a year after James Naismith had invented the game in 1892 and soon spread across the country and then throughout the world. Thriving primarily in colleges and high schools, the women's game originally featured a court divided into three sections with players stationed in each who couldn't cross lines. "We . . . found that allowing the players to run all over the gymnasium led to several bad things," wrote Senda Berenson of Smith College in 1894. "It encouraged individual playing, discouraged team work, overworked the ambitious ones, and gave comparatively no work to many."

Berenson, who wrote out the first rules for women's hoops and was the first woman inducted into the Basketball Hall of Fame in 1985, viewed the game more as self-improvement than competition. Not all the pioneers felt that way, though. Barnstorming women's pro teams like Canada's Edmonton Grads and later the All-American Red Heads played by men's basketball rules and took

on all comers, including men's teams. They posted tremendous records and drew huge crowds. (The Grads even went undefeated in the Olympics from 1924 to 1936, when women's basketball was an exhibition sport with no medals awarded.)

The women's court was eventually divided into just two sections rather than the original three, with five-on-five full-court games not being adopted until 1971. Which is when things really started to move. Title IX, an addendum to the Civil Rights Act of 1964, passed in 1972 and addressed sex discrimination in federally funded institutions. Women's university sports programs would now require equal funding with their male counterparts, and the number of women participating in school sports vastly expanded. Women's basketball finally became an official medal sport in the 1976 Olympic Games in Montreal. Six teams competed, and

Old school: High school ballers circa 1903.

the Soviets—who had dominated the world championships for the previous quarter-century—beat the United States in the gold medal game 112–77.

In a precursor of what would occur twenty years later, an American women's pro league formed following the Olympics. The Women's Professional Basketball League (WBL) launched in 1978; the eight-team association would quickly expand to 15 and hold an All-Star Game at Madison Square Garden in 1979. But when the United States boycotted the 1980 Olympics in Moscow, momentum fizzled for the already fading league and the WBL folded after just three seasons. Other women's pro leagues would prove even more ephemeral.

It's not like the talent wasn't there. Men's teams even occasionally pursued the best female players. The New Orleans Jazz drafted Lusia Harris of Delta State in 1977. Ann Meyers, a four-time All-American at UCLA, signed a one-year, no-cut, $50,000 contract with the Indiana Pacers in 1980 (the average NBA salary was $173,500 at the time), although she didn't make the team. In 1985, Lynette Woodard debuted for the Harlem Globetrotters, and in 1987, Nancy Lieberman—an 18-year-old on the '76 Olympic team who a year prior had played with the USBL's Springfield Fame—joined the Washington Generals, the Globetrotters' historic foils.

The best player of her generation didn't play professionally at all. Cheryl Miller—Reggie's older sister—scored 105 points in a high school game, led her team to a 132-4 record, was a three-time College Player of the Year at USC, and won an Olympic gold medal in 1984. Knee injuries ended her pro career before it could even get started, but even if she had remained healthy, there weren't many options in the '80s. She was inducted into the Naismith Hall of Fame in 1995.

GOING PRO

The success and immense popularity of both the 1996 Olympic team and the undefeated 1995 UConn Huskies changed everything. Once the Olympics concluded, both the brand-new ABL and NBA-partnered WNBA were set to launch. NBA commissioner David Stern had long wanted to establish a women's league— he was just waiting for the right time. This was it, and Swoopes became the league's first signee in October 1996. The WNBA's introductory press conference that month featured three Olympians who would be the faces of three franchises: Swoopes in Houston, Lobo in New York, Leslie in Los Angeles.

The ABL's founders, despite being true fans of the women's game who sought to capitalize on its popularity, were also relative front-office amateurs. By contrast, the WNBA had far more business experience and infinitely more financial stability. Their eight teams would be owned by NBA franchises and play in their arenas (hence a summer schedule rather than the ABL's fall slate of games). They even got a prized TV deal with NBC. The ABL launched first, but the WNBA launched better. It was clear enough from the beginning, basketball talent aside, which league was going to last.

The underfinanced ABL would fold midway through just its third season. But in that brief span from 1996 to 1998, there was a women's pro basketball bonanza in a country that had long been starved for it. The dueling, eight-team leagues reintroduced multiple generations' worth of talent to American audiences all at once. (Imagine ten years of NBA drafts all arriving in a single season.)

There were players like Cynthia Cooper, who won back-to-back NCAA titles at USC alongside Cheryl Miller before heading off to Europe. At 33, she had led

New school: (left to right) Swoopes, Lobo, and Leslie, the WBNA original three.

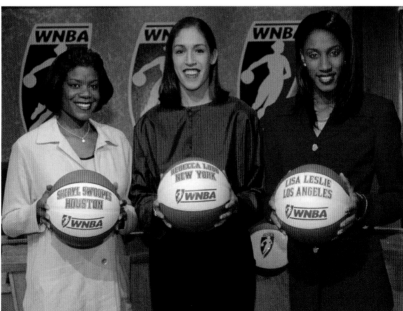

Italy's Serie A—the top European league—in scoring in eight of the previous ten years (she came in second the other two). Younger players like Rebecca Lobo could transition straight from college and Olympic superstardom to a pro league that wasn't thousands of miles away. Those inaugural-year players, especially the Olympians, were coming into a unique situation in which they not only had more name recognition than their teams, but they were more popular than the leagues themselves.

Lisa & Dawn

They couldn't have been more different. One was a willowy 6'5" center from Inglewood who grew up wanting to pose for *Vogue*, the other a rugged 5'6" point guard from the North Philly projects who wanted to be the next Mo Cheeks. One was glamour, the other grit. One scored 101 points in a single half in high school, the other diced up boys on playgrounds. But Lisa Leslie and Dawn Staley both made it to the top of the sport, with eight Olympic golds (Staley earned one as coach) and 14 WNBA All-Star appearances between them. They got the signature Nikes to prove it.

Their shoes suited each other's respective styles and games. Leslie's luxurious Total Air 9 featured full-length Max Air cushioning and quilted uppers that evoked a Chanel bag long before Chicago's Don C flipped a similar pattern on an Air Jordan II retro. Staley's sleek Zoom S5 had two Velcro straps for a lockdown fit and a low-to-the ground feel. How'd they work out? Well, both Lisa and Dawn are in the Hall of Fame.

Nike Total Air 9, 1998.

Nike Zoom S5, 1999.

Swoopes, the very first player to sign with the WNBA, missed the first portion of the inaugural season because she was pregnant. In 1997, she appeared on the premiere cover of *Sports Illustrated WomenSport*, ball in hand, hand on belly, with the line "Sheryl Swoopes and the WNBA are both due in June." She gave birth to her first son, Jordan, and returned six weeks later, playing limited minutes as the Houston Comets won the first WNBA championship. Behind the triumvirate of Swoopes, Cooper, and forward Tina Thompson, the Comets would win the next three as well, making Houston an instant dynasty.

SHOETIME

As the WNBA picked up steam, there were soon more women's basketball sneakers than ever. Brands had already been making women's versions of certain hoops shoes—sometimes designed on a women's last, which had a narrower heel and wider forefoot—but selection was minimal. They typically just added "Lady" to the shoe's name (e.g. Nike's Lady Blazer). The Air Swoopes changed all that. And within a couple of years, Nike went from having one WNBA signature player to a whole roster of them.

Nike created signature models for Houston Comets teammate Cynthia Cooper (the C14), LA Sparks center Lisa Leslie (the Chanel-inspired quilted leather Total Air 9), and Charlotte Sting guard Dawn Staley (the Zoom S5). They also got the backing of Nike's full marketing might: a Spike Lee–directed commercial featuring Swoopes, Leslie, and Staley playing at Brooklyn's Goat Park, and a series of "Little Rascals" commercials featuring a very young—and very impudent—Kyla Pratt. (Swoopes's spot has her pushing her 11-month-old son, Jordan, in a swing; when Pratt criticizes her jumper, an incredulous Swoopes asks, "Girl, where is your mama?" The response: "Mama can't help your jump shot.")

Nike wasn't alone for long. Reebok had signed Lobo to a multiyear deal in April 1995 before she even graduated from UConn, giving her a signature shoe called the Lobo (a pair of which are now in the Smithsonian). In 1999, FILA signed former ABL MVP Nikki McCray, who jumped to the WNBA after the ABL shut down the year prior, and Nike signed '99 number-one overall pick Chamique Holdsclaw and gave her a signature Shox model—both deals exceeded a million dollars.

That representation mattered. For a young Maya Moore, growing up in Jefferson City, Missouri, the first Swoopes shoe was part of something so much bigger. "My mom and I both had them," she said in 2017. "It was exciting. I didn't know how unique that was as an eight-year-old. I just saw Sheryl Swoopes and Cynthia Cooper and Tina Thompson winning WNBA championships and playing amazing basketball, and I just wanted the shoe." Moore happened to become one of the best basketball players of all time—winning at every

1. Sheryl Swoopes, 2002.

2. Chamique Holdsclaw's signature Nike Shox Mique, 2000.

level and on every continent she played—before leaving the WNBA to fight for criminal justice reform. Of course, every girl who owned a pair of Swoopes did not grow up to be Maya Moore. But it was no less important that many thought they could. If signature shoes are meant to be aspirational, it only makes sense that girls have their own heroes to aspire to be. Swoopes had grown up watching Jordan, but Moore and many others grew up watching Swoopes.

The women's signature market seemed to be growing in the late '90s, but it had already peaked. The brands both thought too big and didn't think big enough. They put out a ton of product before the pro women's leagues really had a chance to take off—perhaps Nike should have let Air Swoopes stand alone for a while longer. At the same time, they were so intent on designing shoes for women's basketball players and selling them specifically to an underserved women's market that they failed to consider that men might want to wear them, too. Or, at the very least, that women playing basketball might need larger sizes beyond a women's 12 or 13. In trying to solve the problem of basketball shoes being primarily a men's product, the brands created entire lines that many women over a certain shoe size couldn't buy. Seimone Augustus, a two-time college player of the year and eight-time WNBA All-Star who graced the cover of *Sports Illustrated for Women* before she played a single high school game, had already outgrown traditional women's sizing by the time the Swoopes was released.

Swoopes Zoom

The Air Swoopes was groundbreaking, but Air Swoopes Zoom—Sheryl's third signature model, which she wore for her first WNBA season—was the sneaker that should have broken through. Designed by Aaron Cooper, it was a fantastically aggressive-looking shoe, featuring what looked like giant teeth rising up from the midsole to wrap the foot, and a tiny Swoosh embroidered on the forefoot. Its design elements would have worked well on any number of men's signature models from the era, like those of Charles Barkley, Penny Hardaway, or Jason Kidd.

Maybe it's time to bring the Swoopes Zoom back. Retroing a shoe not only lets a new generation get a chance to own classics, but it also emphasizes the significance of the sneaker and the player who wore it. Swoopes has a better résumé than a whole lot of NBA players whose shoes come back on a regular basis. Hers should, too.

Most mid-to-late-nineties women's hoop shoes at least avoided the "shrink it and pink it" commandment that had made women's sneakers too girly for years. Some, including Dawn Staley's 1999 Air Zoom S5 and Swoopes's 1997 Air Swoopes Zoom could have easily crossed over to a wider audience. They weren't just cool women's basketball shoes, they were cool basketball shoes, period. Like

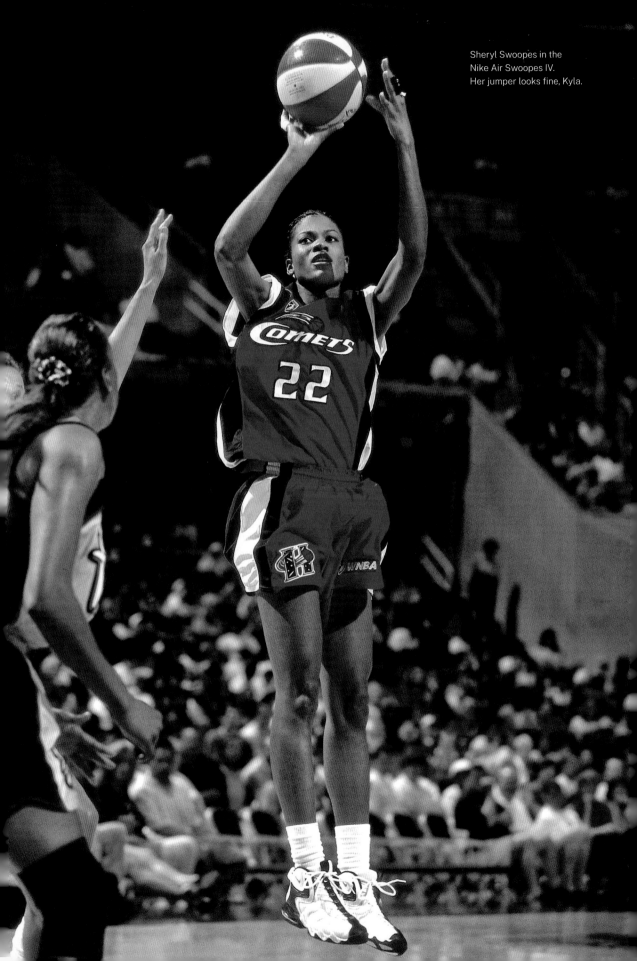

Sheryl Swoopes in the
Nike Air Swoopes IV.
Her jumper looks fine, Kyla.

Mike, Swoopes was winning championships and building a legacy. She was certainly living up to her end of the deal with Nike, going on to win three WNBA MVPs, in 2000, 2002, and 2005.

THE FALL

While Swoopes would wind up going seven signature shoes deep, most of the other WNBA signature sneakers were one-and-done. Since the turn of the millennium, there have been hardly any new WNBA signature athletes at all. Candace Parker got a shoe after signing with adidas in 2008, and Maya Moore became the first woman to sign with Jordan Brand in 2011 (there had been a Women's Air Jordan back when Jordan Brand first launched in 1998, but no specific endorser). The 2004 number-one overall pick Diana Taurasi received a Nike Shox model in 2006 but is best known for her LeBron PEs.

Current players who in the past would have surely landed signature models, from Nneka Ogwumike to Sue Bird to Skylar Diggins-Smith, either got player editions of existing men's models or just team shoes. Put another way, many have gotten sneaker contracts, but not their own sneakers; WNBA superstars haven't received the same perks as their NBA counterparts. It's not unlike the pre-Jordan NBA, back when promotion and endorsement really went only one way.

As viewership and attendance have dwindled over the years, the WNBA itself has become just another upstart league trying to stay afloat. There were indignities that became self-inflicted wounds: The once-great Comets folded in 2008 after Rockets owner Les Alexander sold them to Houston furniture dealer Hilton Koch. Koch then moved them from the Toyota Center to the smaller Reliant Arena, attendance dropped, and they missed the playoffs for the second time in their history. He soon tried to sell the team, and when no one met his $10 million asking price, the WNBA assumed ownership and folded the franchise that won the league's first four titles.

> "Do I think it's time for someone else to have their own signature shoe? Of course I do."

It is difficult to imagine this happening to, say, the Boston Celtics—the last professional basketball franchise before the Comets to win four or more championships in a row. And it's tough to build a proper legacy when you disband the most successful franchise in the league's history. Other original franchises went under, too, including the Sacramento Monarchs, who won a title in 2005 and folded in 2009. Of course, the NBA endured early growing pains of its own, with franchises that moved or went kaput, but there was no need for the WNBA to endure the same struggle, not with the NBA's financial backing.

This is partially a result of the Jordan Effect on basketball as a whole, where highlight-reel dunks and otherworldly athleticism became standard expectations. (Lisa Leslie and Candace Parker could both dunk in games, albeit not quite in Jordanesque ways; Brittney Griner was the first WNBA player to dunk regularly,

starting as a rookie in 2013.) The WNBA was never going to showcase that brand of hoops. Athleticism, yes, but often displayed in different and subtler ways than the NBA game: mostly below the rim and at a slower pace, and more heavily dependent on court vision, team play, and ball movement.

For some people, that's not, and will never be, enough. If you type "lower the rim" into Google, it autofills with "wnba," a suggestion that unfortunately persists, as if dunking would solve the supposed problem of the WNBA not being the NBA played by women. Instead, why not accept the WNBA for what it is? Women's college basketball gained die-hard fans off rivalries and sheer talent, slowly building an audience in their own way from the days of USC and Old Dominion to Tennessee and UConn. Stars became stars not by playing like their NBA counterparts, but by playing like themselves.

REBIRTH

By the early 2020s, things appeared to be headed back in the right direction—at least when it came to sneakers. PUMA signed Seattle Storm center Breanna Stewart to a deal that gave her a signature shoe, the Stewie 1—this after she had won nearly everything possible multiple times. She was a four-time national champion and four-time tournament Most Outstanding Player at UConn, the first overall draft pick and Rookie of the Year in 2016 after winning Olympic gold, and then won MVP, a WNBA championship, and Finals MVP in 2018. After tearing her Achilles in 2019 while playing in Russia, Stewart came back in 2020 and won the WNBA championship and Finals MVP again. She packed in a whole Hall of Fame career by the time she was 26. After Stewart, in 2022, 32-year-old Washington Mystics forward Elena Delle Donne finally received a signature Nike shoe, the DELDON 1, also after having won it all: Olympic gold, Rookie of the Year, a scoring title, a championship, two MVPs.

Sheryl Swoopes didn't get her signature shoe as a result of winning Olympic gold, WNBA championships, and MVPs; she won all those things while wearing her signature shoes. Which makes all the difference. A signature shoe should be less a reward for greatness than a foreteller of it, a way for fans to grow up feeling more connected to their favorite players. The sneaker itself becomes a marker of those moments as they happen, a part of the story rather than just a vehicle to help tell it once it's over.

Swoopes was first—it's past time more up-and-coming women's players get the chance to follow in her footsteps. "Do I think it's time for someone else to have their own signature shoe?" she said. "Of course I do." On the sneaker side, it's better late than never.

Breanna Stewart's PUMA Stewie 1, 2022.

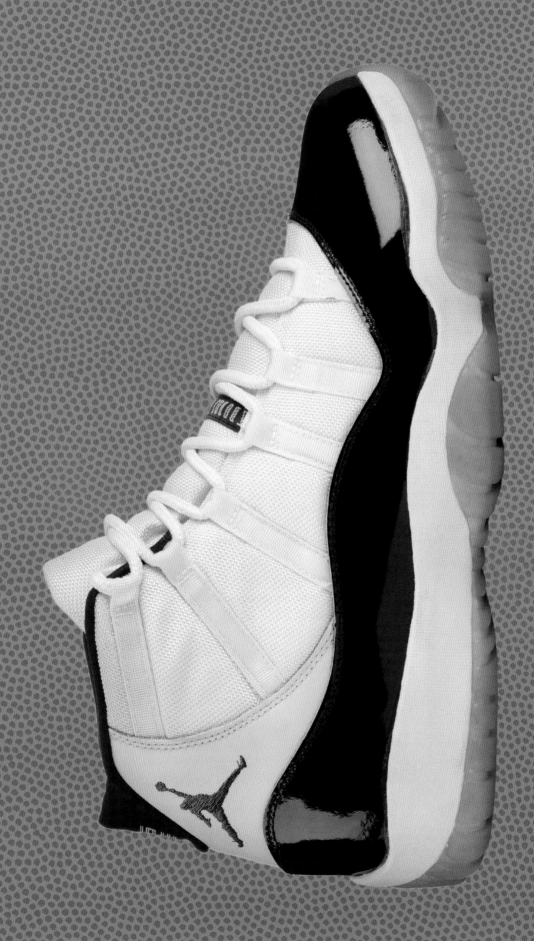

Chapter Ten

A Love Supreme:
Nike Air Jordan XI

Converse Chuck
Taylor All Star
1917

Adidas Superstar
1965

PUMA Clyde
1971

Adidas Top Ten
1979

Nike Air Force 1
1982

Nike Air Jordan
1985

Reebok Pump
1989

Nike Air Force
Max
1993

Nike Air Swoopes
1995

Nike Air Jordan XI
1995

AND1 Tai Chi
2000

Nike Air Zoom
Generation
2003

Nike Zoom
Kobe IV
2009

Under Armour
Curry One
2015

Nike Adapt BB
2019

Even as Michael Jordan sliced and diced the world in Barcelona en route to gold as the undisputed on-court leader of the 1992 Dream Team, he was thinking of other things. Retirement from the NBA and the unlikely pursuit of a professional baseball career were already on his mind, as biographer Mark Vancil noted in *The Last Dance*. But first, Jordan wanted that third straight championship, something neither Larry Bird nor Magic Johnson nor any other modern-day basketball star had achieved.

Jordan did just what he set out to do: He clinched the three-peat, won a third straight Finals MVP, and earned another scoring title. And then, on October 6, 1993, less than a month before the 1993–94 season opener, the 30-year-old walked away. "I just feel at this time that I don't have anything else to prove," he said at his retirement press conference as the world watched in disbelief. But he left an opening for a return: "If I desire to come back and play again, maybe that would be the challenge that I'll need down the road. I don't believe in the word 'never' and I'm not going to close that door."

SAYING GOODBYE

This was the third straight NBA season marked by the retirement of an icon. Magic went first, exiting the league at age 32 after he revealed a shocking (and seemingly life-ending rather than just career-shortening) HIV diagnosis in November 1991. Bird was next in the summer of '92, ten days after the Dream Team won gold, his 35-year-old body finally too broken down to suffer any further indignities. At least Bird's departure was somewhat expected. But Jordan? He had reached the pinnacle once again and found himself like Alexander the Great, with no more worlds left to conquer. Between these three era-defining, league-saving superstars, by '93 they had left with 11 championships, 9 MVPs, and 8 Finals MVPs.

Agent David Falk asked his client to not be so final about staying retired, and Jordan had reportedly made an eventual return sound much likelier to his Bulls teammates and coaches than he had to the assembled media. Falk had projects in the works that would now have to be put on hold, including a movie that paired the star with Looney Tunes characters. Bulls owner Jerry Reinsdorf agreed to keep paying Jordan's NBA salary which, at $4 million per year, was only the fifth-highest in the league (David Robinson enjoyed the top spot that 1993–94 season at $5,740,000).

In the meantime, Jordan wasn't ready to announce his next step. *Sports Illustrated* reported a rumor that he and Phil Knight might go in together on a European pro team and MJ would play on it. This made some degree of sense—whether or not Jordan was in the NBA, the Nike basketball industrial complex would rumble ever on (and Nike's stock price, which had exceeded $90 per share the previous November, had dropped all the way to $45). Could Mars Blackmon learn Italian? *É devo essere le scarpe.*

It was a difficult moment for Nike and the NBA, both of which had by now tied themselves inseparably to Jordan's cult of personality. Nike had built Air Jordan and ridden it beyond their wildest expectations, while the NBA, starting with Magic and Larry in the late '70s, had come to realize that they could successfully market individual players better than any other professional sports league. Team rivalries were all well and good, but a personable icon who dominated individually *and* won championships? That was irreplaceable. At Jordan's retirement press conference, David Falk, Phil Jackson, David Stern, and the Chicago Jerrys (GM Krause and owner Reinsdorf) sat glumly at the press-facing table while only MJ seemed happy. It was the Last Supper sans refreshments.

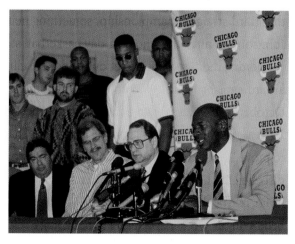

Michael Jordan's first retirement announcement, October 1993.

Unsurprisingly, Jordan and Knight's European basketball dreams never took off—if the NBA no longer held any challenges for Jordan, then European

competition was unlikely to, either. Jordan instead decided to take a whack at major league baseball. And when it became apparent that he couldn't just immediately join the roster of Reinsdorf's Chicago White Sox, he found himself in Birmingham, Alabama, with the Double-A minor league Barons, trading charter flights for bus rides and sneakers for cleats. He wore his brother Larry's high school jersey number 45 and baseball-specific Air Jordan IXs as he resumed a sport he'd last played as a kid growing up in North Carolina. Reaching the major leagues was a dream of his father, James, to whom Michael had been extremely close. The elder Jordan's July 1993 murder, just a month after MJ won his third NBA title, had at least partially led to October's retirement.

The next challenge.

POST-JORDAN

The NBA moved on without their marquee player, and the Bulls didn't miss a fourth straight Finals by much. Scottie Pippen emerged as the alpha dog, won All-Star MVP, and markered a defiant "4-Peat" on the heels of his Nikes at the start of the playoffs. Chicago won 55 games, just two fewer than the year before. The Bulls went the distance in a hard-fought Eastern Conference Semifinal series against the hated Knicks. (And if referee Hue Hollins doesn't make a questionable shooting foul call on Pippen on a late-game Hubert Davis three-point attempt in Game 5, maybe it all goes differently.) Instead, the Knicks reached the Finals for the first time since 1973 and faced the Houston Rockets—themselves making their first Finals appearance in over a decade.

The Rockets won the championship, their first, in a brutal seven games. Five of those games had worse TV ratings than the lowest-rated game of the '93 Finals. Hakeem Olajuwon may have been able to approach Jordan's on-court magnificence, but no one on either team had his transcendent celebrity. It also didn't help that these Finals were a throwback to an earlier age of basketball: low-scoring slugfests where seemingly every game ended 90–83. In the 1993 Finals, the Suns' 92-point output in Game 1 was the series low; a year later, the Rockets' 93-point total in Game 3 was the series high.

As for Jordan, he was turning himself into a legitimate baseball player. What seemed to many like some sort of publicity stunt—as if Michael freaking Jordan needed more publicity—was playing out quite differently from how his critics had

predicted. When *Sports Illustrated*, a publication that had done more than anyone outside of Nike, ESPN, or *NBA on NBC* to build the Jordan mythos, put him on its March 14, 1994, cover, this time flailing at a pitch with the cover line "Bag it, Michael!," he vowed to never speak to them again. MJ put in endless work, both in the batting cage learning to hit the curve and in the weight room rebuilding his NBA-guard body into that of a (hopefully) major league outfielder. "He's trying," as a bunch of legit baseball players from Hall of Famer Willie Mays to cap-flipped-backward Ken Griffey Jr. stated in a baseball-themed Mars Blackmon Air Jordan commercial.

Air Jordan wasn't yet its own standalone brand, but it was trying, too. Air Jordan shoes were the leading edge of Nike Basketball specifically, not a franchise that they could simply transition to another sport—especially one played in cleats that had little influence off the diamond. And pausing the line for the off-chance Jordan might return to the NBA wasn't much of an option, either. After all, Jordan's retirement had only seen Nike through eight models in less than a decade and the line was still quite new. So while they made his personal Air Jordan IXs with baseball bottoms, they also supplied the University of North Carolina men's basketball team with Jordan product and brought some new NBA talent into the fold, players whom MJ himself deemed worthy of the honor.

Among Jordan's chosen ones were Kendall Gill in Seattle and Nick Anderson in Orlando, who had both played at Illinois. There was Anderson's Magic teammate Anfernee "Penny" Hardaway, Mitch Richmond in Sacramento, Latrell Sprewell in Golden State, and Jordan's former Bulls teammate B. J. Armstrong, who would go on to make his first All-Star team in 1994. There was also Miami's Harold Miner, the '93 slam dunk champion as a rookie, who'd been dubbed "Baby Jordan" while still in high school. The roster mostly featured guards in Jordan's own mold, although not with his level of region- and court-transcending charisma. (But they were trying.)

Nike Air Jordan IX, 1993.

Nike Air Jordan X, 1994.

The Air Jordan IX's outsole spelled out various messages in a variety of languages celebrating the superstar's immense global impact; Jordan had gone pre-internet viral during the Dream Team's 1992 triumph. The sneaker's successor, the Air Jordan X, also sent a message via the outsole, listing Jordan's annual achievements from heel to toe, starting with "85 ROOKIE OF YEAR" and ending with a cryptic "94 BEYOND." They, too, were made up for professional basketball players who were not Michael Jordan. And this time, makeups for the different teams—Chicago, Seattle, Orlando, Sacramento, New York (for former UNC guard and new Bulls mortal enemy Hubert Davis)—were even released at retail, albeit as regional drops.

Nike seemed to be resigning themselves to a post-Jordan basketball world.

Jordan himself laced up a pair of Xs in the initial white and steel gray colorway that summer to play in Scottie Pippen's charity game at the newly built United Center in Chicago, stopping to kneel and kiss midcourt on his way out. It felt like a farewell to an arena he had made possible but would never play in as a pro. Jordan was still invested enough in Air Jordan design to tell Tinker Hatfield that the toe reinforcement overlay did not meet with his approval—he preferred a clean toe—so the design was reworked and the reinforcement did not appear on ensuing colorways. But all in all, Nike seemed to be resigning themselves to a post-Jordan basketball world.

Over the course of 1994 and 1995, Nike reissued Jordan's first three shoes in special packaging as a celebration of his career. The first "retro" of the Air Jordan III appeared just six years after it had initially released in 1988. Unfortunately, Nike had done too good of a job convincing people that the latest and greatest were all that would do—the reissues flopped, winding up relegated to sales tables and marked down to $19.99.

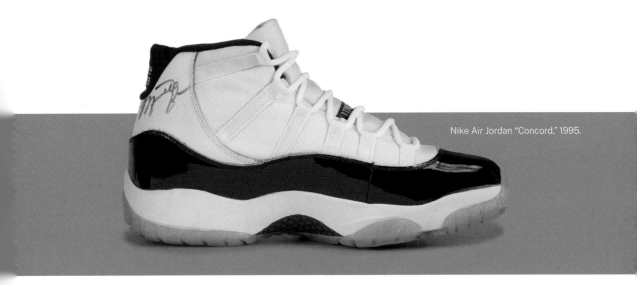

Nike Air Jordan "Concord," 1995.

THE RETURN

And then, midway through this second Jordan-free NBA season, there were rumblings. A baseball labor stoppage derailed Jordan's major-league dreams (MJ, to his credit, refused to scab). Scottie Pippen pointed at the Jumpman logo on the sole of his own Air Jordan Xs during a nationally televised game, grinning and beckoning his running mate with a long finger. A 1993 Corvette ZR-1 with "M AIR J" Illinois plates was seen parked outside the Bulls' suburban practice facility. And finally, on March 18, 1995, Jordan issued a simple two-word statement through David Falk's FAME agency: "I'm back." A year that had started with Jordan destined to play outfield for the triple-A Nashville Sounds ended with Chicago Bulls PA announcer Ray Clay re-introducing him to a packed United Center crowd. This was "Sirius."

Jordan shook off his long basketball absence in record time—after a rusty first game against the Pacers, he hit a game-winner against the Hawks, then the fabled double-nickel 55 points against the Knicks at Madison Square Garden. But it was something of a false spring. Now wearing jersey number 45, he wasn't yet in basketball shape, Knicks stunner notwithstanding, and had only 17 regular-season games to prepare for the playoffs. (And Jordan's new and former teammates had only 17 games to get used to playing with him.)

After dispatching the Charlotte Hornets with relative ease in the first round, his Bulls faced former teammate Horace Grant and the Orlando Magic in the Eastern Semis. Led by All-Star Shaquille O'Neal and All-NBA First-Team selection Penny Hardaway, the young Magic were unburdened by any painful playoff history against Jordan, unlike the Knicks or the Pistons. They didn't feel the same fear.

Orlando faced a different, diminished MJ in 1995—despite a mid-series, league-defying, fine-incurring switch back to his familiar number 23. Nick Anderson stripped him from behind with the Bulls leading in the waning moments of Game 1, snatching victory from the hands of defeat. And afterward, Anderson—who was still wearing Air Jordans—said something about 45 not being the same as 23. Okay then. (Jordan returned to his familiar 23 the very next game, league rules be damned.)

Return of the king.

But the damage was done, that Game 1 loss putting the Bulls in a hole they couldn't climb out of. The will was there; the wind and the legs were not. And when the series ended with a triumphant Grant hoisted on his Magic teammates' shoulders, Jordan swore that such a thing would not happen again. The Rockets would win their second straight title, sweeping the Magic. Before that Finals series even started, Jordan was back in the gym.

New Jack Swing

Building a winning NBA team is hard. Building a championship-winning NBA team is even harder. By the mid-nineties, the Orlando Magic had become a talent-stacked contender; a title was only a matter of time. They made the Finals in 1995, and their ECF sweep at the hands of Michael Jordan and the 72-win Bulls in 1996 should have just been a temporary setback. Instead, Shaq was off to Los Angeles, and the Magic wouldn't return to the Finals for more than a decade.

As one of four NBA expansion franchises in 1989 — along with the Miami Heat, Charlotte Hornets, and Minnesota Timberwolves — the Magic were expected to struggle, having built a young roster through the expansion draft. With their first-ever regular draft pick, they grabbed Flyin' Illini guard Nick Anderson, followed by Georgia Tech marksman Dennis Scott in 1990. Then, with back-to-back number-one overall picks in '92 and '93, they landed Shaquille O'Neal followed by Chris Webber, whom they swapped to the Golden State Warriors for 6'7" Memphis point guard Penny Hardaway and three future first rounders. In their fifth season, Orlando made the playoffs for the first time. In their sixth, they made the Finals.

At that point most of the hard roster work was done, particularly after signing away three-time champion Horace Grant from the Bulls. All the Magic needed was patience and luck. But Shaq was a free agent in the summer of '96. The Orlando Sentinel polled readers on whether the Magic should offer him a $115 million deal and 91 percent of respondents said no. Jerry West and the Lakers said yes. And — poof — just like that, both he and the Magic's best chance at a title were gone.

It was fun while it lasted.

THESE GO TO 11

Jordan didn't just change his number in the 1995 playoffs. He also broke out a new shoe, the Air Jordan XI, a futuristic patent leather–wrapped model that resembled spats, or baseball socks. It was a mid-cut sneaker with a carbon spring plate elevating the arch and sculpted clear rubber outsoles that made it look like he was barely touching the ground. NBC analyst and Jordan confidant Ahmad Rashad even wore a pair on camera during a baseline report. Jordan was fined for wearing the white-and-black pair, breaking the same uniform rule as his original black-and-red shoes back in 1985, so for the following game he switched into a pair of Penny Hardaway Air Flight Ones before Nike supplied him with an all-black pair of Jordan XIs with blue accents. He'd wear a similar pair later that summer while finally filming that Looney Tunes movie along with other Falk clients, including Patrick Ewing and Shawn Bradley.

XIs bore an Air bag inside and Nike Air logos on their insoles, but they were really the passion project of longtime Nike designer and Air Jordan whisperer Tinker Hatfield, who believed Jordan would return to the NBA when few others did. Even Phil Knight was unsure whether the Air Jordan brand could survive without its namesake dominating the NBA (or at least playing in it), and there were reportedly internal conversations about discontinuing the line. Yet Hatfield persisted, reworking elements of the Jordan X into a new formation by retaining the ghillie lace loops but switching from leather to ballistic mesh and patent leather.

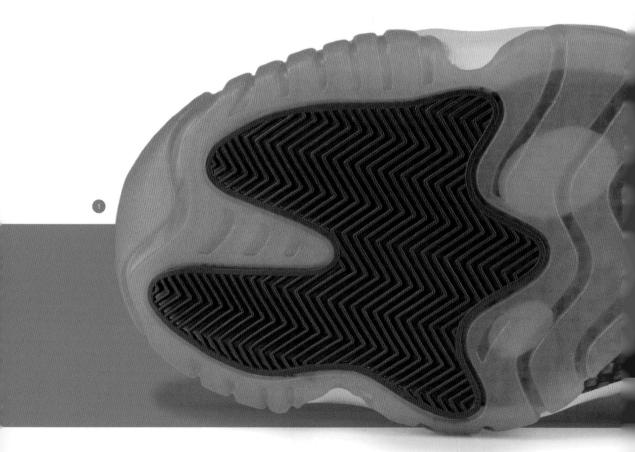

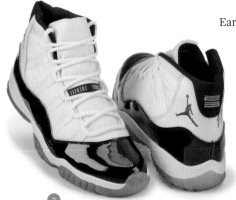

Early sketches of the shoe from mid-August 1994 had ambitious elements—Hatfield wanted to make the shoe laceless—but the general shape and ingredients were all there.

Jordan had requested patent leather as early as the IX, but it took some time to make it work. The inflexible patent wrap on the XI was inspired in part by Jordan's own elegance and, in a more functional sense, by the design of a lawn mower's protective shield, of all things. Hatfield added a carbon plate to the sole to provide support and spring, inspired by the steel plates Bruce Kilgore had incorporated into his Air Force 1 prototypes, and a high-pressure, low-profile Air bag that provided extra bounce while allowing for the low-to-the-ground feel that Jordan always preferred.

Hatfield inherited the Jordan line back in 1987 when creative director Peter Moore and executive Rob Strasser left Nike to start their own business. Hatfield followed the traditional early path to Nike: He was a track athlete at the University of Oregon under coach Bill Bowerman, the company's co-founder. Originally hired as a corporate architect for Nike's campus, Hatfield had some experience with shoe design via Bowerman's home-cobbled creations and became a sneaker

1. Herringbone and carbon fiber.
2. Patent no longer pending.

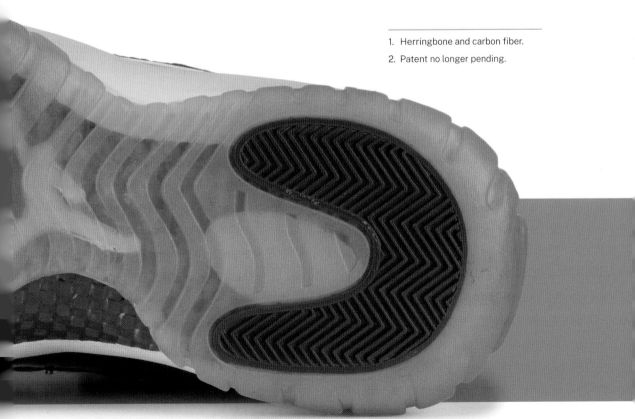

designer by winning an in-house contest. He brought architecture sensibilities to his new job, but also a sense of whimsy. When first faced with the Air Jordan project, he took a new approach: What if the athlete was a true co-designer? His first Jordan—1988's mid-cut, elephant-print Air Jordan III—had helped keep the superstar with the Swoosh when many worried he'd follow Strasser and Moore out the door.

It was this close relationship they had developed over the years that gave Hatfield unique insights into whether Jordan would one day return to basketball. The designer continued working on a striking sneaker that others at Nike thought Jordan would never wear on an NBA court. It's the same sensibility that continues to drive the flagship Air Jordan even now—designing a game shoe for the sport's ultimate player, even though Jordan is now in his sixties with all of his NBA comebacks (presumably?) behind him. That he could step right into this Hatfield creation after a year and a half away and play the game at the highest level was the ultimate testament to the process.

It was also a deceptively simple shoe. Despite a century of technological advances, the Air Jordan XI was like a modern Chuck Taylor All Star: a minimalist sneaker with everything you needed and nothing you didn't. Even the patent leather had a protective purpose. Again, architecture. And an accurate reflection of Jordan's game; while spectacular, it never devolved into the baroque. MJ did things out of necessity, only highlighting their beauty.

THE ART OF THE GAME

The elegance embodied in the Air Jordan XI was a reflection of where basketball itself had been going: a sport that could be seen as an art form. For a long time, the game's artistry had materialized in spots—Dr. J's sweeping dunks, George Gervin's finger rolls, Kareem's skyhooks, Hakeem Olajuwon's impeccable footwork—but more as the exception than the rule. Jordan's game, and Nike's creative packaging of his greatness via advertising and the shoes themselves, brought that elegance to the forefront.

The brand had tried this artful approach before with 1986's Air Jordan II, a shoe made in Italy that did away with the garish colors and prominent logos. It had Jordan's ball-and-wings logo on the tongue but no Swoosh, just NIKE in block letters across the heel tab and molded into the exposed polyurethane on the outsole. The ads were different, as well—slowed-down dunks

1. Air Jordan II, 1986.

2. Two GOATs.

with Jordan clad in billowing white, like renaissance paintings in motion. But the shoe's $100 price point and sleek design were a bit ahead of their time and hard to square with the gym rat appeal of the original Air Jordan line. The world wasn't ready.

A lot changed in the ensuing decade. Basketball had mostly done away with the blue-collar pretenses (not to mention the blue-collar salaries), and high-dollar, high-tech basketball shoes had become the norm. Plus, Jordan wearing the XI in the 1995 playoffs gave them a long launch window before they'd be available in stores. He would do much more than lose a playoff series in them before it was all over. That summer, Jordan filmed the back-on-again *Space Jam* in Los Angeles, a Warner Brothers product tie-in that co-starred longtime Chicago sports fan Bill Murray and *Seinfeld* mailman Wayne Knight along with the whole animated Looney Tunes gang, from Bugs Bunny to Elmer Fudd to the Tasmanian Devil.

> *After 12-hour shooting days, he'd run full-court to get back into basketball shape.*

Jordan had worked with Bugs—and director Joe Pytka—before, in commercials dreamt up by Wieden+Kennedy's Jim Riswold. But this was a much bigger operation. Jordan relocated to California for the shoot and spent most of his downtime in the Jordan Dome, a regulation-size NBA court complete with a gym, built on the studio lot at his request. He worked out with longtime trainer Tim Grover during breaks; after 12-hour shooting days, he'd then run full-court, working himself back into basketball shape. A virtual who's who of college and pro players turned out for games, from young Chicagoans Antoine Walker and Juwan Howard to established stars Reggie Miller and Dennis Rodman, allowing Jordan to get a closer look at future foes—or, as it turned out, future teammates. Even Pytka got into games.

REVENGE SZN

By the start of the 1995–96 season, the Bulls had reshaped themselves, both individually and on the roster sheet. In the gym, Jordan, Scottie Pippen, and Ron Harper formed a "breakfast club" that got in tough morning workouts and meals from Jordan's chef before practice. Over in the front office, some deft Jerry Krause dealmaking meant the only Bulls remaining from the 1992–93 championship team were Jordan and Pippen. Euro star Toni Kukoc, a 1990 Bulls draftee, had finally come over from Croatia; Harper went from defending Jordan in Cleveland, to replacing him, to complementing him; and Steve Kerr now filled John Paxson's former sharpshooting role. The last preseason move would prove to be the most crucial. Having been convinced that Rodman, who'd become a pariah with the Spurs, would be a perfect fit in Chicago, Krause shipped center Will Perdue off to San Antonio for the mercurial forward, locking in the final key piece for a historic season.

If the world of Air Jordan had expanded during MJ's retirement, the brand snapped back to its original form upon his return. All those guys who had gotten Air Jordans in team colors the year before? Well, that was over—there would be no team-specific Air Jordan XIs for the likes of Nick Anderson and Kendall Gill. Of course, some prominent players still wore the Air Jordan XI in meaningful games, but few dared wear them on the court against the man himself. One notable exception: Straight-outta-high-school rookie Kevin Garnett laced up a pair of all-white Columbia XIs against a Concord-clad MJ in Minnesota in 1996. ("He was like, 'Nice shoes,'" Garnett remembered many years later. "And that was the only thing he said to me.")

> *Some prominent players still wore the Air Jordan XI in meaningful games, but few dared wear them on the court against the man himself.*

And then there was Allen Iverson, a blue-chip recruit from Hampton, Virginia, a stellar all-around athlete who the AP named High School Player of the Year in both basketball *and* football as a junior in 1992. The following year he was imprisoned after a bowling alley brawl, and all the schools recruiting him dropped away. His mother, Ann, had to convince Georgetown coach John Thompson to give him a chance. Iverson responded by winning Big East Rookie of the Year and earning a first-team All-American selection as a sophomore.

That second season, his last in college before leaving to be the first overall pick of the 1996 NBA draft, he played in white-and-black Air Jordan XIs, black ankle braces peeking over the top. For Iverson, who'd come up when Jordans were already a status symbol and saw what his mother had to sacrifice to buy them for him, this was success all by itself.

But that was just extra. The 1995–96 Bulls scorched and stomped their way through the regular-season schedule, going 72-10 and setting a new NBA

standard. They were barely slowed in the playoffs by the Magic, whom they swept—reminiscent of their dismissal of the Detroit Pistons in 1991—on their way to a Finals matchup with the Seattle SuperSonics. The Bulls went up 3-0 before taking their foot off the gas for the first time all season, finally dispatching Gary Payton and Shawn Kemp's squad in six games. Meet the new world order, same as the old world order. The Bulls won it all on Father's Day, and following the close-out game Jordan collapsed to the floor in the trainers' room, clutching the game ball and overcome by tears.

The Question

While he was at Georgetown, Allen Iverson did as much for the Air Jordan XI as anyone not named Michael Jordan. The young point guard wore his with black ankle braces, which did little to slow his hyperkinetic game. When he declared for the draft as a sophomore, it seemed clear he would be selected first. And there was no question — as he was represented by David Falk — that he would sign a huge sneaker deal of his own.

Reebok wanted him badly. Designer Scott Hewett had been tasked with sketching out an Iverson shoe even before they made their pitch for what became the Question. Nike still could have signed him, but ultimately passed. Reebok offered a $60 million deal — the richest sneaker deal in terms of guaranteed money up to that point — and Iverson was theirs. When the Question dropped in Philly and AI's home state of Virginia in 1996, it sold out immediately.

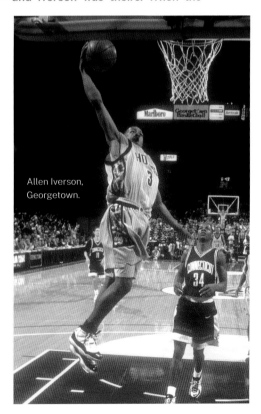

Allen Iverson, Georgetown.

"I think Allen, other than Michael, is the most marketable shoe guy in the last forty years," Falk said. "Because he's so unique. He created the whole hip-hop element of basketball, which is what kids want — a great style. He was fearless. He was small. Allen was amazing." And Allen was real, unfiltered, always saying what he meant. Reebok, to their credit, let that all shine through. They knew that it wasn't the coaches or the media he had to connect with, it was the kids. The Answer always had answers, even if they were ones people didn't want to hear.

Then, after all that, *Space Jam* was released in November 1996. A Jordan-starved public, who'd barely gotten a couple dozen NBA games out of MJ over the prior two seasons, suddenly had a glut: a record season, another championship, and now a whole-ass movie. Jordan on the big screen was a can't-miss, whether the film had a coherent plot or not. Made for $80 million, *Space Jam* earned $230 million to become the highest-grossing basketball movie of all time. And that wasn't including the profits extracted from a dizzying array of tie-in merchandise. When the movie was released, the "Space Jam" Air Jordan XIs got a lot of attention, but they wouldn't hit stores until 2000.

THREE FOR ALL

The NBA had changed considerably in the short time Jordan was gone. In the 1994–95 season, three-point attempts jumped to a record 15.3 per game, up from 9.9 in 1993–94; the line was moved in from 23 feet, 9 inches and 22 feet at the corners to a uniform 22 feet all the way around, driving the biggest single-season increase in attempted threes in NBA history. (Two seasons later, the line would move back to its original distance and attempts would fall from a high of 16.7 per game before starting to rise once again.)

Jordan was a middling and mostly unwilling three-point shooter. (His famous shrug after sinking his sixth three-pointer in the first half of Game 1 of the '92 NBA Finals partly referred to the then-record's unlikeliness.) He shot a career-high 43 percent from three in the 1995–96 season, tying him for tenth with Allan Houston. Jordan also hoisted a career-high 3.2 per game, which he broke again with 3.6 per game the following season. Those were the only two seasons of his career that he made more than 100 threes, connecting on 111 each year. When people wonder how Jordan would have adapted to the far more three-heavy present-day game, those two seasons should give them an idea.

But for the most part, Jordan was still the same Jordan. Despite the increase in shots beyond the arc, he led the NBA in two-point makes in 1995–96, just as he had every season from 1989–90 through 1992–93 and would do again in 1996–97 and 1997–98. Jordan's mastery of the mid-range had been so thorough and so successful that even a league-wide shift toward outside shooting—and that tempting shorter three-point line—couldn't help defenders fare any better.

Jordan's first retirement, an interstitial in a Hall of Fame career, only made his presence shine that much brighter once he returned. In that second stint he played three full seasons and won three scoring titles, three championships, and three Finals MVPs. He didn't miss a single game. And the Air Jordan XI catapulted all things Air Jordan to new heights, too. In 1994, the product line's future was in question; in 1997, Nike launched the Jordan Brand which, as a standalone, immediately became the second-largest brand in basketball behind only Nike itself. When Princess Diana died in 1997, Jordan's business manager Estee Portnoy told him, "You're the most famous person on the planet now." A quarter century later, he might still be.

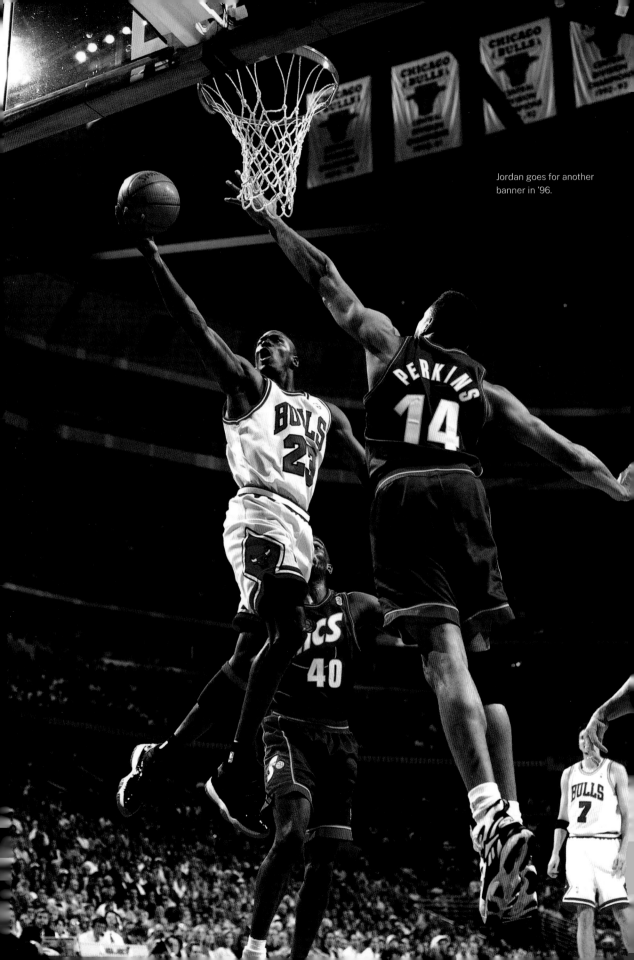

Jordan goes for another banner in '96.

Chapter Eleven

The Strength of Street Knowledge: AND1 Tai Chi

Converse Chuck
Taylor All Star
1917

Adidas Superstar
1965

PUMA Clyde
1971

Adidas Top Ten
1979

Nike Air Force 1
1982

Nike Air Jordan
1985

Reebok Pump
1989

Nike Air Force
Max
1993

Nike Air Swoopes
1995

Nike Air Jordan XI
1995

AND1 Tai Chi
2000

Nike Air Zoom
Generation
2003

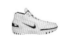

Nike Zoom
Kobe IV
2009

Under Armour
Curry One
2015

Nike Adapt BB
2019

Imagine this: It's the fall of 1996. You are a marketing executive with Philadelphia-based basketball brand AND1, a company that started in 1993 selling T-shirts and just three years later is launching their first sneaker on the feet of a top-five NBA draft pick. You have bought billboards in major cities, a three-story-high ad outside Minneapolis's Target Center, and promotional T-shirts for the 18,109 fans filling the seats. Your heralded rookie point guard is making his NBA debut in your new shoes—your *first* shoes—as the centerpiece of your new marketing campaign: BREAKING ANKLES. The company founders are courtside; you are in a suite with the team owners. This is going to be great. What could go wrong?

TRASH TALK

Rewind. How big did sneakers and basketball—and basketball sneakers—get in the '90s? Try this for a timeline: AND1, which started as the grad school project of a couple of Wharton Business School friends, went from being a T-shirt brand to producing the sneaker worn by half the NBA in less than a decade. The company expanded into shoes in 1996 upon signing Brooklyn-born point guard and fourth-overall pick Stephon Marbury to be their first signature athlete; it took just five years from getting their shoe on one NBA player to outfitting well over 100 of them. But when Jay Coen Gilbert, Seth Berger, and Tom Austin founded AND1, the face of their brand wasn't an NBA player. The face of their brand didn't even have a face.

The message behind AND1 was that your game did the talking, but your T-shirt could get a few words in, too. Back in '93, the sayings that blared from AND1 tees were presented as the utterances of a nameless, faceless, raceless baller with a Schwarzeneggerian build. He was dubbed "The Player," a Silver Surfer–like character who wore cutoff shorts and generic shoes and talked nonstop shit (e.g., "If I Let You Score, Will You Go Home?").

At the suggestion of Foot Locker, AND1 increased their initial product line from one Player shirt with five slogans to five separate tees, each with their own saying. The T-shirts and game shorts—double-mesh with pockets, long before Nike or Mitchell & Ness thought of it—were hits, and they signed Hornets forward Larry Johnson (still under shoe contract with Converse) to an apparel-only deal so they could feature an NBA player in their ads. Sneakers were the logical next step for a company so rooted in hoops. They went back to Foot Locker not with a sample, but with a sketch. Which, given their momentum, was enough to get them started. But to enter the shoe game properly, they needed a star to wear them.

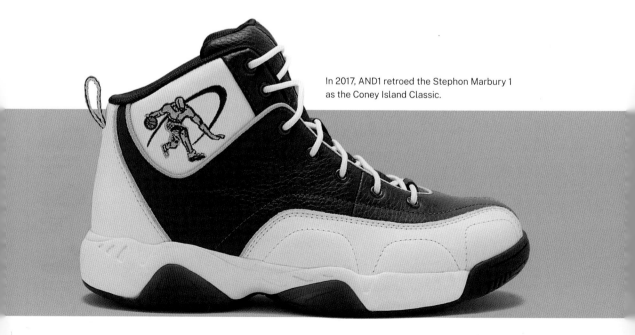

In 2017, AND1 retroed the Stephon Marbury 1 as the Coney Island Classic.

Heading into the 1996 NBA draft, Jeffrey Smith, AND1's first marketing director, wanted to sign Allen Iverson, just like every other brand. But AND1 knew they couldn't afford the 21-year-old Georgetown point guard. The 76ers selected Iverson first overall and he signed with Reebok in the richest rookie sneaker deal ever. AND1 instead inked a deal with their 1a, Stephon Marbury.

AND1 went from being a T-shirt brand to producing the sneaker worn by half the NBA in less than a decade.

Like Iverson, Marbury combined streetball sizzle with fundamental steak, a star from nearly the moment he learned to dribble. He had kept a high school diary for the then-new *SLAM* magazine before decamping to Georgia Tech—a.k.a. "Point Guard U"—for a single season to play for Bronx-born coach Bobby Cremins. Marbury was already a household name among hoops diehards before he ever shook David Stern's hand on the NBA draft stage as the fourth overall pick by the Bucks. But in a previously worked out deal, Milwaukee shipped the guard to the Minnesota Timberwolves for Ray Allen and a future first-rounder.

Minneapolis was a cold basketball outpost, a city that hadn't produced an NBA champion since George Mikan's Lakers in 1954. But the Wolves had Kevin Garnett, the prep-to-pro seven-footer who'd moved into the starting lineup at the end of January and never left. He and Marbury had gotten to know each other through the high school all-star circuit, and it was Garnett who convinced Wolves GM Kevin McHale that Marbury was the guy to take the team to the next level.

The much-hyped rookie started his November 1, 1996, pro debut against the Spurs and notched some personal NBA firsts: first rebound, first assist, first turnover. And then, with 6:47 to go in the first quarter, the dream turned into a nightmare. Marbury went down with a badly sprained ankle. He hadn't even scored yet. The AND1 contingent had planned for everything but this. As AND1's marketing manager (and Jeffrey Smith's wife) Errin Cecil-Smith put it: "I don't even remember [what happened]. I just know we're up in the suite. I was just like, 'Oh my fucking god. Are you kidding?'" What a way to launch your first shoe. Marbury would go on to miss the next seven games, but all was not lost: He returned to average 15.8 points and 7.8 assists and make the All-Rookie First Team.

IN YOUR FACE

Steph's injury may have caused chaos and heartbreak, but it didn't slow AND1's rise. The clunky Stephon Marbury 1 would gain something of a cult following. The sneaker featured bold graphics, including a stylized "S" with arrows on either end that served as Stephon's logo, and utilized tried-and-true structural elements: a leather upper, steel eyelets, a closed-cell foam midsole, and herringbone traction. AND1 wasn't trying to reinvent the basketball shoe; they just

wanted to get in the game. "It weighs a ton, it's got this big Player logo stitched onto the side, and it's all leather and super puffy," said then-VP of Footwear Ryan Drew. "The logo was probably like a 500-stitch count, but we thought it was the greatest thing ever."

Years before Nike introduced the stretchy Presto with its XS–XXL T-shirt-inspired sizing, AND1 had launched a basketball shoe that was essentially a T-shirt for your feet; it was sneaker as logo delivery system. If real technical progress required expensive and time-consuming testing and other expenditures, why not just stand out via color blocking and branding? This was something the company would refine and perfect four years later with the iconic Tai Chi, where the color blocking *was* the branding.

The original.

Even as AND1 introduced Marbury's shoe, they were thinking past it. The brand grew so quickly (with sales doubling every season) because they were always planning multiple steps ahead—often to the detriment of their overall financial health. "We had to make a shoe that had the value of $90 or $85 even just to ask $75 or $80 for it because no one had heard of us," Smith said. Spending money before they even had it, they partnered with retailers like FootAction and Foot Locker to secure a big enough store buy for the math to work. "We were doing a shell game," Smith said. "We didn't have any of the money we were pitching. It was like you can have our athlete and this shoe and a million dollars of TV buy, but you have to buy this many shoes—we didn't have the money in the bank at the time."

The company took off, but not everyone came with them. Marbury was gone from AND1 by the summer of 1998 and out of Minnesota the following spring, dealt to the Nets in a nine-player deal. He was supposed to be AND1's Jordan; he instead became a cautionary tale against building a brand around just one player. Lacking the money to sign superstars, the company went for sheer volume. They produced more shoes and expanded their roster with young players, having added the likes of Rex Chapman, Derek Fisher, and Darrell Armstrong, and—around the same time they released Marbury—lottery picks Larry Hughes and Raef LaFrentz. The Iversons of the world were still beyond them, but as it would turn out, they didn't need to sign superstars to get to the next level.

A true game-changer for AND1 was the Mixtape. It all began when a grainy highlight reel of a skinny Queens kid named Rafer Alston with unbelievable handles and court vision began circulating throughout AND1's offices. It became known as the "Skip Tape," in reference to Alston's Rucker nickname, Skip to My Lou. AND1 creative Set Free, a DJ, took the Skip Tape home and spun records while it played. "I was just practicing matching the beat to the basketball," Free remembered. "And that moment I said, 'I got something special.'"

Starbury

Stephon Marbury's NBA road was long and winding. Upon leaving Minnesota, where he and Kevin Garnett were expected to be the hip-hop generation's John Stockton and Karl Malone, Marbury became the NBA's Pied Piper — only instead of children he attracted detractors. He wore his emotions plainly, and too many interpreted his despair as status-seeking (and stat-seeking) self-ishness, but all he really wanted was to win.

Eventually Marbury came home to New York, where short-lived celebration gave way to the worst experience of both his NBA career and his life. He joined a Knicks team in turmoil and was ill-suited to ride the waves, feuding with head coaches Larry Brown and Isiah Thomas. Marbury did accomplish one thing in New York: partnering with discount retailer Steve & Barry's to launch his Starbury line of sneakers and clothes, with a game shoe that retailed for just $15. The Starbury One claimed to be every bit as good as shoes that retailed for ten times more, and while that was a bit dubious, Marbury did wear them in games. He even went so far as to get the logo, a stylized star-shaped 3, tattooed on his head.

It all came to an end in 2009. The Knicks waived Marbury and Steve & Barry's declared bank-ruptcy, effectively ending the Starbury brand. He made a brief cameo with the Celtics before leaving the NBA entirely and finding a second basket-ball life in China, where he won three championships and was immortalized with statues and a museum. The Hall of Fame should be next.

Stephon Marbury, 2006.

The result was the AND1 Mixtape, a collection of streetball highlights set to hip-hop beats that hit VCRs in the summer of 1999. Within just three weeks, the company had sent out 50,000 copies to their connects in the basketball world and gave away another 200,000 free with purchases at FootAction (where it played on a loop on in-store TVs). This unconventional marketing approach opened up a whole new world. It spawned an entire series of AND1 mix-tapes, as well as the Mixtape Tour, which the brand used as a launchpad to turn streetballers into worldwide stars. But soon before the Mixtape hit, AND1 dropped the Latrell Sprewell commercial.

AND1 Tai Chi

FIRE, WATER, AIR, EARTH

ASSYMMETRICAL DESIGN:
DUALITY OF ONE

MOLDED EYELET

MID-CUT SILHOUETTE:
UNRESTRICTED MOVEMENT

LATERAL SIDE VIEW

HIDDEN LACING

TUMBLED CALF

AND1

AND1

SUEDE

EXPOSED MOLDED SHANK STABILIZER

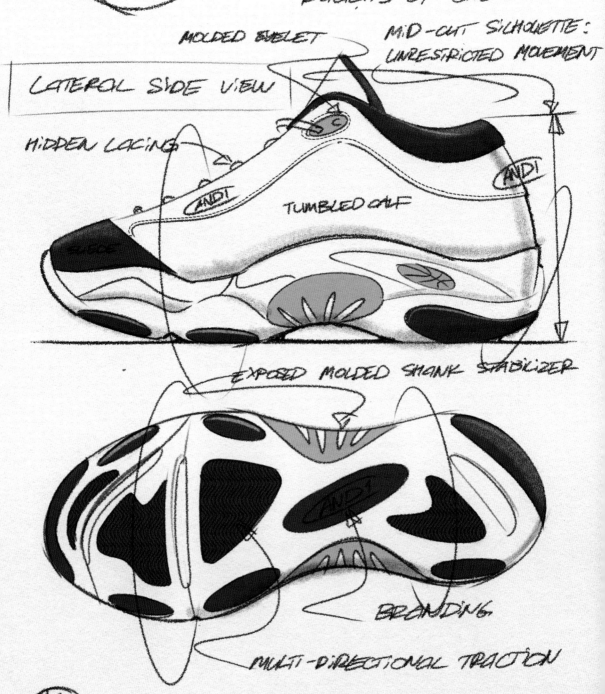

AND1

BRANDING

MULTI-DIRECTIONAL TRACTION

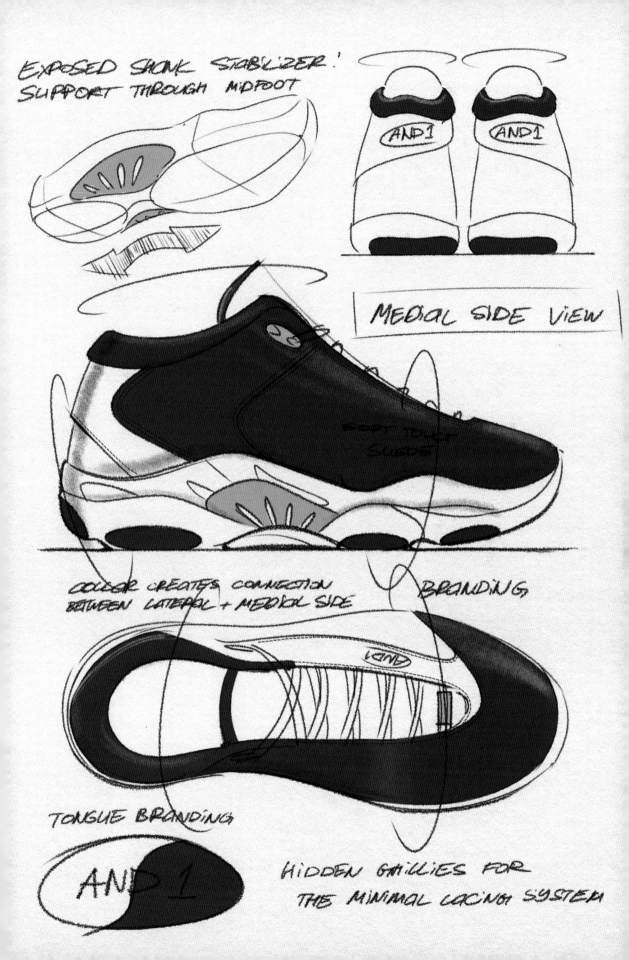

EXPOSED SHANK STABILIZER:
SUPPORT THROUGH MIDFOOT

AND1 AND1

MEDIAL SIDE VIEW

SOFT TOUCH SUEDE

COLOR CREATES CONNECTION
BETWEEN LATERAL + MEDIAL SIDE

BRANDING

AND1

TONGUE BRANDING

AND 1

HIDDEN GHILLIES FOR
THE MINIMAL LACING SYSTEM

THE AMERICAN DREAM

"The Sprewell spot," Jeffrey Smith said, "changed the whole trajectory of AND1." Sprewell had established himself as an All-Star guard in Golden State, then choked and threatened to kill coach P. J. Carlesimo during a December 1997 practice. The NBA suspended him for a year, the Warriors voided the remainder of his $30 million contract, and Converse dropped him. An arbitrator then reinstated his contract and reduced his suspension to just the remainder of the 1997–98 season. In January 1999, with the lockout-shortened season about to start, the Warriors traded Sprewell to the Knicks. AND1 signed him in April, and at the start of the playoffs, they rushed to put together a commercial that barely showed his Crossover Mids.

The 30-second spot begins with Spree getting his hair braided as a distorted Hendrixian national anthem blares. The mercurial player declaims three lines that Smith can still recite from memory: "I've made mistakes, but I don't let 'em keep me down. People say I'm what's wrong with sports, I say I'm a three-time NBA All-Star. People say I'm America's worst nightmare, I say I'm the American dream." It was "I am not a role model": the remix.

"For me," Kevin Garnett said years later on his *Area 21* show, "that was like—I don't want to put it on levels of Muhammad Ali, but it was a rebel moment where all young players was feeling that." After all, what young player hasn't wanted to choke their coach? The 27-23 Knicks squeaked into the playoffs by one game and made it all the way to the NBA Finals, Sprewell leading the way. With the double-tap of

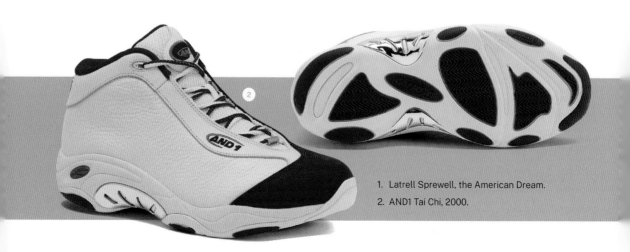

1. Latrell Sprewell, the American Dream.
2. AND1 Tai Chi, 2000.

the Spree commercial and the first Mixtape, AND1 had the attention. Now all they needed was the shoe that would break through in a major way.

It was coming. AND1 designer Tuan Le had sketched up a new model he dubbed the Tai Chi, a three-quarter-height yin-yang–inspired sneaker with contrasting panels on the lateral and medial sides. Further simplified from those first drawings, the sampled-up Tai Chi took color well, generally including a white or black full-grain leather paired with a colorful nubuck and a shiny midsole shank plate. If the first Marbury shoe was a graphic tee, then this was AND1's high-quality blank—easy to match up with an NBA uniform yet still instantly recognizable as an AND1 sneaker. The company sent Tai Chis in team colors with embroidered numbers on the heels to an ever-growing list of NBA endorsees, from Sprewell in New York to Jamal Crawford in Chicago to Marbury in New Jersey, who was temporarily back in the fold. And, of course, to Rafer "Skip to My Lou" Alston, by then a Milwaukee Buck.

Tai Chis retailed for $75, so you could get two pairs for the price of one pair of Jordans—important in the days when you wanted your sneakers to match your outfit. This was the era of throwback jerseys and pinwheel fitteds, baggy jeans, and tall tees. Fitted hats were chosen not based on any team allegiance but rather on whether the color scheme worked. There was even cross-sports, cross-city matching—an Atlanta Falcons jersey with a Chicago Bulls hat, or vice-versa. No one cared as long as the colors worked. The Tai Chi was the perfect shoe to cap a fit off.

And it made colors pop without breaking the NBA's still-strict uniform rules regarding sneakers. Up until the late 2000s, NBA game shoes needed to be at least 51 percent white or black to pass muster, and the Tai Chi walked that line as well as, if not better than, any other shoe. Rather than utilizing blatant side branding like adidas's three stripes or Nike's Swoosh, entire panels were solid colors. They popped in a world still dominated by sneakers that were mostly white or black. Even on the bench they stood out. AND1 wasn't paying everyone who wore them, either, having signed plenty of players to product-only deals. They even sent pairs to players not under contract at all, which is how some size 16s with embroidered number-15s found their way to a budding superstar named Vince Carter.

VINSANITY

Carter came out of the University of North Carolina as the latest in a line of "next Jordans," his absurd athleticism and Tar Heel pedigree placing him on the same heirwave as Jerry Stackhouse, a UNC lottery pick just a few years earlier. Drafted fifth overall by the Golden State Warriors, Carter was dealt on draft day to the Toronto Raptors for college teammate Antawn Jamison.

Going to the Raptors was the best thing that could have happened to him. "I had some great teachers," he remembered. "I had six veterans on my team—five of them played with the best players in the world: Charles Oakley played with Jordan, Kevin Willis played with Dominique, Doug Christie played with Magic,

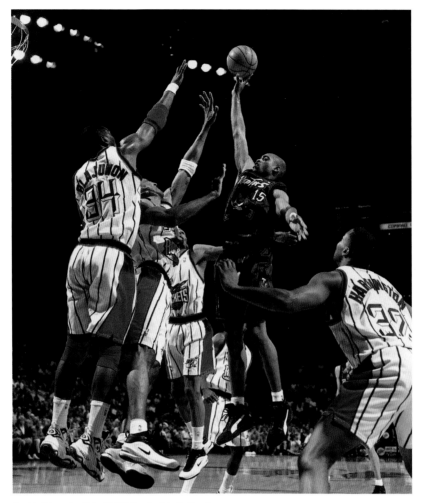

Rookie Vince (and his PUMAs) got a lot of attention.

Dee Brown played with Larry Bird, Antonio Davis played with Reggie Miller. So I was taught how to play the game the right way and prepare so it made it easier. I remember Oakley . . . the second day of camp he put his arm around me and was like, 'I'm gonna help you be a star in this league,' and I was like, 'Okay.'" He laughed. "You don't tell *him* no."

Coming out of college, Carter had multiple sneaker company suitors and signed a big deal for a signature shoe with PUMA, which had been out of the NBA since Suns forward Cedric Ceballos rocked the Disc System Weapon in '93. Carter had a great first year despite a lockout-shortened season, averaging 18.3 points per game and running away with the Rookie of the Year award. But just a year into the sneaker deal, things went sour with PUMA; reports indicated either his signature Vinsanity shoes hurt his feet or he was frustrated with the product's release date. Either way, getting out of the contract was complicated, what with an eight-figure buyout and his being barred from signing with another company until the next season was over. So Carter entered his second season as a restricted sneaker free agent.

CORONATION

Carter's high-flying, death-defying, 360-degree-slam-dunking game put him in rarefied air. Maybe he wouldn't be the next Jordan, but MJ himself was retired (again) and someone had to fill those highlight reels. Carter's seeming quest to dunk on everybody in the NBA made him a natural choice. And there were more places to see his on-court exploits than ever. "Air Canada" became a *SportsCenter* staple and brought extra TNT to *Inside the NBA*. YouTube was still in the future, but NBA TV launched on opening night of the 1999–2000 season, and there were GIFs on GeoCities pages and ESPN.com (still called ESPNET SportsZone).

David Stern's massive marketing push and the global appeal of both the 1992 Dream Team and Jordan's Bulls had sown, and Carter was there to reap. His second season—in new Raptors uniforms that did away with the cartoon dinosaur—got off to a blazing start. When the final balloting came in for the 2000 All-Star Game, Carter was the leading vote-getter, with the second-highest total ever.

But forget the All-Star Game—there was finally going to be a Dunk Contest again after a two-year absence. In 1998, the contest had been scrapped and replaced with Two-Ball, a short-lived experiment to incorporate WNBA players into All-Star Saturday Night, and in 1999, All-Star Weekend was canceled due to the lockout. While Kobe Bryant would not be defending his 1997 dunk title, Carter, his Raptors teammate Tracy McGrady, and high-flying Rockets point guard Steve Francis would headline the 2000 event. After a lack of star power in recent years, Carter would be the first leading All-Star vote-getter to participate in the Dunk Contest since Jordan in '88.

Sneakers had featured prominently in Dunk Contests since MJ broke out the black-and-red Jordan 1s in 1985. There was Dee Brown pumping his Reeboks in '91, and Kobe flaunting his player-exclusive purple adidas in '97. But Carter's contractually obligated sneaker free agency had also come during something of a lull in sneaker madness. Late 1999 and early 2000 was a time before the All-Star Game became a showcase for wild player-edition sneakers and limited-edition drops. Regular-season on-court footwear was largely nondescript. Jordan was a few years into retirement and Jordan Brand had just started to enjoy some success bringing back older styles, but retro hadn't yet really taken off. Carter had spent part of the season in generic-looking black

Kobe Bryant, 1997 Slam Dunk champion.

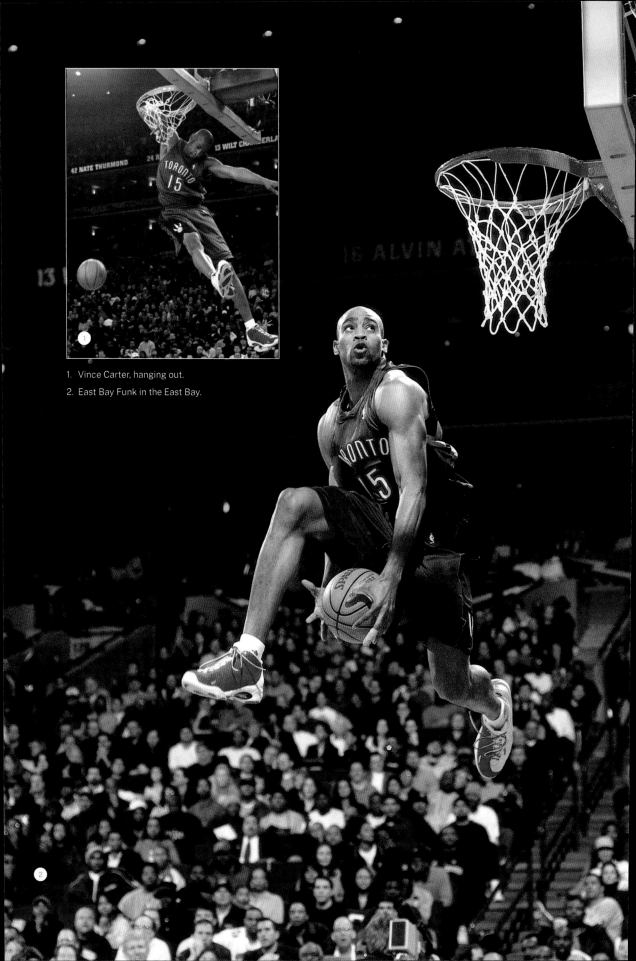

1. Vince Carter, hanging out.
2. East Bay Funk in the East Bay.

adidas before trying out the Tai Chi, as AND1 was already treating him like one of their endorsers. "They would overdo it," he remembered. "They would send so much stuff."

But sheer volume wasn't the reason he chose to wear AND1s in Oakland, rocking white-and-red in the Dunk Contest, then black-and-red in his All-Star Game debut the following day. Carter had learned in the weeks prior that the Tai Chi was the one shoe that didn't need any breaking-in time. "I could take those things out of the box right before the game and they're good to go," he said. "You didn't want to have shoes that were worn down on All-Star Weekend—nobody does that."

Carter came out for the most highly anticipated Dunk Contest in years in his fresh Tai Chis and proceeded to blow everyone's minds.

Carter came out for the most highly anticipated Dunk Contest in years in his fresh Tai Chis and proceeded to blow everyone's minds. In college and in his rookie NBA season, Carter had shown himself to be less Dominique or Michael than a blend of both, a savage mix of the former's power and the latter's grace. But a dunk contest is different from in-game dunking, as Shawn Kemp could attest. Kemp, one of the best in-game dunkers ever, competed in four NBA Slam Dunk Contests but never won; the Reign Man found out the hard way that dunking on would-be defenders was one thing, open-court creativity another thing entirely. Carter excelled at both. He had worked out an entire routine in advance, but the night before he decided to scrap it, thinking it wouldn't be enough.

It didn't take long for Carter to prove he was no Shawn Kemp—exactly one dunk, as it turned out. His first slam was a spring-loaded, two-dribble, opposite-rotation 360-windmill that ended with Carter bouncing on the balls of his feet like Muhammad Ali, NBA All-Stars falling all over themselves on the sidelines, and TNT analyst (and former contestant) Kenny Smith excitedly repeating, "Let's go home! Let's go home!" Not a bad idea. Steve Francis and Tracy McGrady both made valiant efforts, but this contest was no contest.

Carter did things no one had seen or imagined before. Yes, he went through his legs—a Dunk Contest staple since J.R. Rider first unleashed the "East Bay Funk" in 1994. But he also hung from the rim by his elbow after a one-handed slam, dangling long enough to make sure the crowd realized what he had done. Long before the end it wasn't a question of how he'd beat everyone else—just how he'd top himself.

THE AFTERMATH

Carter hadn't told anyone from AND1 about his sneaker plans, and no company execs were in the building for what turned out to be the brand's biggest NBA moment. They found out the same way as everyone else: by seeing it on TV. The

Carter effect took AND1 to new heights, that single All-Star Weekend appearance doing more for the Tai Chi than any of their official endorsers ever could.

"Him wearing those shoes and performing the way he did was like a crowning of the brand," Cecil-Smith said. "You know, like, 'This is a legit footwear company. And this was a choice I made out of all of the choices I could have made.' That was a pretty ringing endorsement without actual endorsement." Along with the slip-on Tochillin sneaker, the Tai Chi sold near-platinum numbers, driven by Carter's feats, the Sprewell spot, and the now-ubiquitous Mixtape.

In the fairy-tale version, Carter signs with AND1 and everyone lives happily ever after. But that didn't happen—Carter never became an AND1 athlete. He continued to wear the Tai Chi for more of the 2000 season, as well as on the cover of *SLAM* #41 (headline: "The Greatest Show on Earth"). But the PUMA buyout meant the next brand to sign him would have to not only pay the leading All-Star vote-getter and reigning Slam Dunk Champion, but recompense PUMA to the tune of $10 million or more. And there was no guarantee that Carter would ever top his 2000 All-Star Weekend exploits.

By this point, AND1 had received tons of free publicity, their only expenditures being a couple of boxes of gear. Sure, they couldn't further capitalize on the moment with ad campaigns featuring Carter, but you could already buy the shoes he wore in the Slam Dunk Contest—just without his number on the back or his name attached. And, as it turned out, he'd never enter another dunk contest. Once was enough.

Of course, by the end of the season and the end of his PUMA-mandated sneaker limbo, Carter had done more than just win a dunk contest. He'd averaged 25.7 points per game, finished tenth in MVP voting, and led the Raptors to their first-ever winning record and playoff appearance (a first-round sweep by the Knicks). He then bounced to Sydney, Australia, for the 2000 Olympics, where he leapt clear over a seven-foot Frenchman en route to gold. That moment came in Nike Shox, which Carter had worn on and off throughout the Games as his agent worked out a Nike deal. He signed for $30 million, roughly half of which went to PUMA, and became the face of a whole new cushioning technology—the antithesis of what AND1 had done with the low-tech Tai Chi.

The Tai Chi democratized the player-exclusive shoe from superstars all the way to the guys at the end of the bench. AND1 wisely prioritized quantity over quality with their signings, figuring it was a better deal to get their shoes onto six players on a given team rather than put all that money and then some into signing a single superstar. The company had learned well from their Marbury experience and spread the Tai Chi far and wide, putting its aesthetic versatility on full

display—and adding splashes of color where before there were none. They paid plenty of players to wear it, but of all the guys who wore the Tai Chi, the player who made the biggest impact was the one who didn't have to.

Boing

Nike Shox technology was a long time coming. It started in the 1980s, when Bruce Kilgore added metal hinges and springs to existing running shoes, an idea that would have given sports regulatory agencies fits. The success of Air, however, put mechanical cushioning on the back burner. But by 2000, a new version with spring plates and foam pillars had emerged, one that looked like the business end of a NASA rocket.

Shox launched like a government project, with futuristic tech given unassuming names like the R4 runner, XT cross-trainer, and BB4 basketball shoe. The latter had four Shox pillars in the heel (hence the "4"), Zoom Air in the forefoot, and minimal branding—just a tiny Swoosh molded into the external heel counter and the five discrete dots of Nike's Alpha Project (for their most technologically forward designs) on the lateral side. The Shox pillars themselves were branding enough. And there was just the right player available to show and prove its on-court worthiness.

Shox wasn't designed for Vince Carter, but Vince Carter was designed for Shox. Wearing the BB4 in the gold medal game of the 2000 Olympics, he launched up and over poor French center Frederic Weis, then ran through an array of Shox-equipped signature shoes, starting with the front-and-rear Shox VC1, whose synthetic upper was encased in a form-fitting zip-up shroud. No one else had more bounce to the ounce.

1. The Tai Chi yin and yang.
2. Nike Shox VC, 2001.

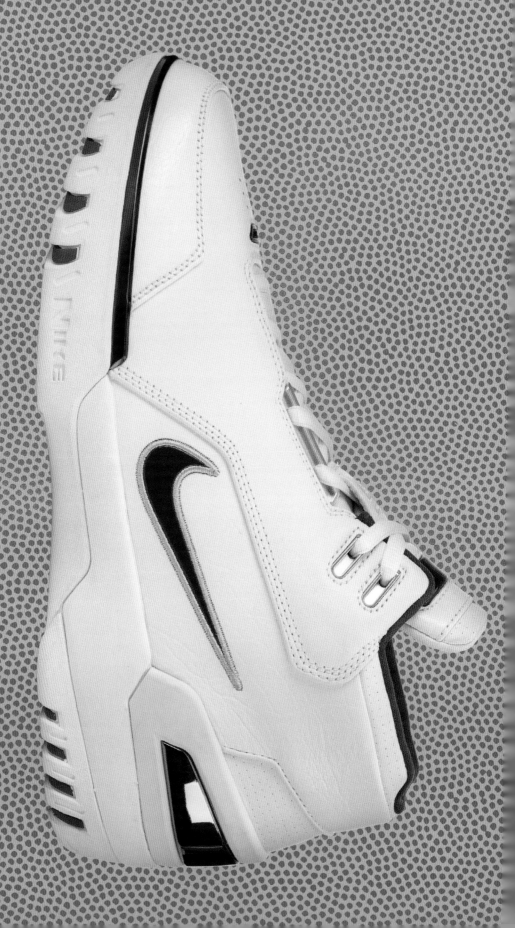

Converse Chuck
Taylor All Star
1917

Adidas Superstar
1965

PUMA Clyde
1971

Adidas Top Ten
1979

Nike Air Force 1
1982

Nike Air Jordan
1985

Reebok Pump
1989

Nike Air Force
Max
1993

Nike Air Swoopes
1995

Nike Air Jordan XI
1995

AND1 Tai Chi
2000

Nike Air Zoom
Generation
2003

Nike Zoom
Kobe IV
2009

Under Armour
Curry One
2015

Nike Adapt BB
2019

Chapter Twelve

Watch the Throne: Nike Air Zoom Generation

LeBron James was never going to college. Well, that might be a slight overstatement, but by the time he led Akron's St. Vincent–St. Mary to a second-straight state championship and was named Ohio's Mr. Basketball and earned a *USA Today* first-team selection as a sophomore— both unprecedented achievements—his turning pro out of high school was a foregone conclusion. SVSM had to find bigger gyms for the growing crowds, which included eager NBA scouts. James officially torched his NCAA eligibility the summer after his senior season by playing in three high school all-star showcases instead of the allowable two, but by then he was already gone. David Stern's ping-pong balls would determine his NBA future; he'd have to determine his sneaker future for himself.

THE CHOSEN ONE

That was a lot to put on an 18-year-old, especially one who'd grown up in poverty and whose sneaker deal would eclipse his rookie NBA contract. With Michael Jordan retired for real for real this time, it was a big moment for sneaker companies, too. The recruiting had started early, with both adidas and Nike supplying James with exclusive product for years. SVSM was officially an adidas school thanks to Sonny Vaccaro, but LeBron still occasionally wore the Swoosh in games. He was careful not to show a preference, one year sporting Nike at adidas's ABCD Camp and adidas at Nike's All-American Camp. And brands weren't just sending product. His closest Akron confidant, Maverick Carter, had scored an internship at Nike and was in Beaverton learning all he could about the business from the inside. Both companies had advantages.

When it came time to present, Reebok went first and rolled in with a Godfather offer in excess of $100 million. Reebok exec and rap impresario Steve Stoute had the idea of giving LeBron a $10 million check on the spot if he would agree to forgo meeting with any other brand. But James couldn't do that. When adidas didn't come correct with the numbers—much to Vaccaro's chagrin—Nike came back with an improved offer of close to $90 million over seven years, including a $10 million signing bonus of their own. Reebok was still offering the most money, but Nike was Nike—LeBron knew what they could do for him. There was a reason he wore number 23.

The 2003 Converse All-Stars

There was one legacy company missing from LeBron's sneaker suitors: Converse. It was for good reason. Converse had declared bankruptcy in 2001, and even after selling their factories in the United States and Mexico, they didn't have the kind of money it would take to sign LeBron. But that's not to say they didn't sign *anyone* in 2003.

In fact, Converse signed just about everybody else, scooping up top-ten lottery picks Dwyane Wade, Chris Bosh, Kirk Hinrich, and Michael Sweetney. The signing frenzy more than doubled their roster, which at that point consisted of Ron Mercer, Rodney Rogers, and Andre Miller — decent players, but a far cry from the glory days of Magic, Bird, and Dr. J. The hope was to revive that era, even evoking the Weapon with the all-new, questionably named Loaded Weapon (there was immediate backlash).

Before the summer leagues kicked off, Nike bought Converse outright for $300 million in July 2003. Converse would survive, much to the relief of Chuck Taylor fans everywhere, and Nike got itself a farm team. Bosh ended up with Nike proper while Dwyane Wade moved to Jordan Brand in the summer of 2009 — joining fellow Class of 2003 alumnus Carmelo Anthony.

A NEW START

Once LeBron was in the fold, a dream team of Nike Basketball designers, including Tinker Hatfield, Eric Avar, and lead designer Aaron Cooper, worked on what would become the Air Zoom Generation. It not only had to perform on court for an athlete with a unique combination of size and speed, but it also had to appeal to off-court wearers and kick off Nike's most significant signature line

The young King.

since, well, Air Jordan. The shoe's technical specs wouldn't have been unfamiliar to any early aughts Nikehead: Zoom Air (a lower-profile and springier version than the original Air), carbon fiber plate, nubuck or synthetic leather, and nylon upper, with a breathable Sphere textile lining (dimpled like a golf ball, increasing surface area and creating space for cooling) as the only "new" development.

Since LeBron's first shoe released in 2003 rather than, say, 1996 or 1985, it was not only crafted to his performance specifications, but it said a little about who he was as a person. Previous rookies with signature deals hadn't gotten that specialized design treatment. Yes, Jordan had the black-and-red "banned" legend, but that came after the fact. And the design for Iverson's Reebok Questions, with their giant Hexalite windows and array of brightly colored pearlized and suede toe caps—a smooth update of the OG Chuck Taylor All Star's rubber toe caps—had begun before AI had even signed with Reebok. By contrast, the Zoom Generation had a backstory, one that showed James's shoe was truly his.

Each of the Zoom Generation's primary designers was familiar with this personalized approach, but Hatfield had pioneered it. He had not only designed many of Nike's most recognizable models, including the Air Jordan III, but he reinvented what a "signature shoe" truly was. Rather than a sneaker that simply bore an athlete's name, Hatfield's designs were meant to reflect the athlete themselves, with details drawn from that person's life. Avar and Cooper later brought that same concept to signature lines for players like Scottie Pippen, Penny Hardaway, and Kobe Bryant.

Mining the life of an 18-year-old prodigy wouldn't be simple. But James wasn't your usual teen phenom. His entire high school career was national news. The Zoom Generation's details were inspired in part by LeBron's Hummer H2, which his mother, Gloria, had purchased with a loan against his future earnings. (That was just one of the controversies that tailed him through the end of his

high school years.) Lions were another design inspiration—James had long been fascinated by them—and the first Zoom Generation print ads featured LeBron lounging on a throne in kingly garb with three big cats at his feet. He had also cultivated a "soldier" persona, having worn fatigues to games for his California-based AAU team called the Soldiers. Combine all those elements with his overriding desire for comfort, and you had something to work with.

Car Stories

LeBron's Zoom Generation was far from the first signature sneaker to be inspired by a player's ride. Tinker Hatfield was way early on that, too, sculpting the heel tab of 1991's Air Jordan VI to flow like the rear wing on Jordan's Porsche 911 Turbo. But that was only the beginning of car-sneaker synergy. The Air Jordan XIV took cues from MJ's Ferrari 550 Maranello, and the Air Jordan XVII from his Aston Martin (he went through cars like he went through sneakers). Both the Air Jordan XXI and the Nike Shox VC2 were inspired in part by Bentleys. And it wasn't just Nike/Jordan—in 2000, adidas worked with the designers of the Audi TT to create Kobe Bryant's KOBE shoe.

The designers had a head start when it came to the comfort part. LeBron had worn an incredible number of different shoes already—from Nike Shox VC2s to Nike Zoom 2K3s, adidas Pro Model 2Gs to adidas T-Macs—and had a pretty good idea of what suited him. The design process went quickly; he signed with Nike in May 2003 and was wearing his own signature shoe by the end of October. Priced at $110, the Zoom Generation eventually released in just five colorways over 2003 and 2004 (with several more produced as promo- or LeBron-only), along with three low-tops. Nike produced Zoom Generations with green and gold accents for SVSM, pink-accented pairs for Gloria, and a makeup with lasered details for LeBron to wear in his first Christmas Day NBA game.

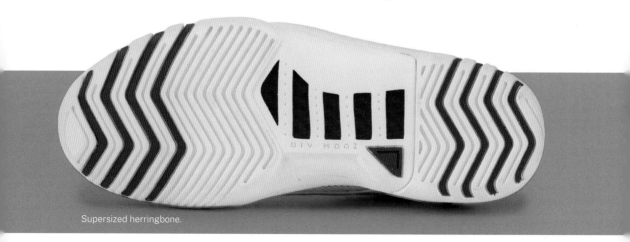

Supersized herringbone.

And that wasn't the only way the whole process was fast. Most signature athletes get their own shoes later in their careers—think Stephen Curry and Kyrie Irving, or Scottie Pippen and Charles Barkley. Players typically earn their signature shoes *after* making the NBA (and maybe a couple of All-Star teams). But LeBron? He got the same thing as Michael Jordan and Allen Iverson: a signature shoe he could wear in his very first NBA game. What's more, he was the first high schooler to receive that honor.

STRAIGHT OUTTA HIGH SCHOOL

LeBron was the most NBA-ready high schooler anyone had ever seen. It had taken some time for the best prep-to-pro players to reach superstardom, but they were clearly worth the wait. Tracy McGrady, who hadn't averaged double digits until his third season, became the first player drafted out of high school to lead the NBA in scoring, a feat he'd repeat in LeBron's rookie year. Also in 2003–04, Kevin Garnett became the first prep-to-pro player to win MVP since Moses Malone back in 1983. By 2003, Kobe Bryant was a three-time champion, and Jermaine O'Neal was a two-time All-Star. Less than a decade earlier, the thought of taking a high schooler first overall was absurd. Now it made a hell of a lot of sense.

Garnett, the new-generation prep-to-pro pioneer in '95, thought guys like Bryant and himself had paved the way for LeBron. He was right. KG explained: "It's almost like this, man—if you in fifth grade, and you know some kids that's in ninth grade, you get enough stories and you see enough things that when you get to ninth grade you know how to be. This is how you gotta walk, this is how you gotta talk. . . . So by the time you get to high school, you know, you might know how to talk to the girls, you might know how to dress—what bookbag to have, what hat to match what kicks. I look at LeBron as sort of being like that young kid who's been able to see us and how to be."

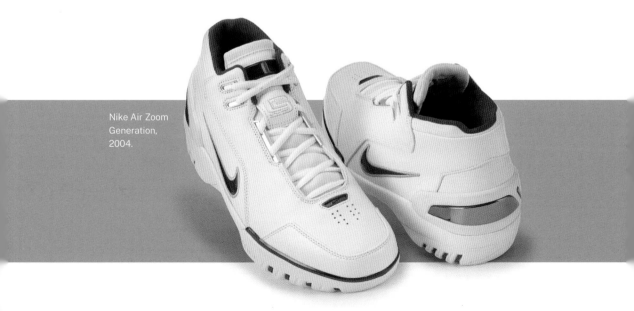

Nike Air Zoom
Generation,
2004.

For James, there was also a downside to being the next one rather than the first. Neither Garnett nor Bryant had to perform under the enormous magnifying glass that hovered over LeBron in high school. The media environment had completely changed. The internet alone had grown in leaps and bounds between 1995 and 2002. Before LeBron even entered the draft, out-of-touch old men like Charley Rosen (a Phil Jackson co-author and confidant) were writing stuff for ESPN's Page 2 that everyone saw and you can still search, like "Here comes another narcissistic young man who has been conditioned to believe that celebrity equals money equals power," and "A note to long-suffering Cavaliers fans: Don't get caught in the LeBron James pipe dream. The best King James can ever be is an average NBA player." Read that last one again.

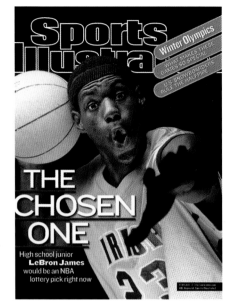

The hype was very real.

And then LeBron was drafted by the Cleveland Cavaliers, his hometown team (or as close to Akron as he could get). The Cavs were stacked with former McDonald's All-Americans—guys like Ricky Davis, who thought James was just going to help him score; Darius Miles, still just 21 years old and not far removed from his head-bopping Clipperdom; and Dajuan Wagner, the previous year's lottery pick, a high school phenom himself who had once scored 100 points in a game. Until Cleveland traded for Eric Williams in December, they didn't have a single player over 30. LeBron came down from NBA draft heaven in a gleaming white suit and was heralded as the would-be savior of the Cavaliers while half the roster was thinking, "Wait, I thought I was."

On October 29, 2003, LeBron went to Sacramento's Arco Arena—a deafening cowbell-clanging bandbox—for his NBA debut. Was the game televised on ESPN? Of course. "Probably the most anticipated debut of any first-year player in any sport," said announcer Brad Nessler. No pressure, kid. Less than two minutes in, he pulled up at the free-throw line and tossed a perfect lob to Ricky Davis. The rookie hit his first three shots, with his first dunk so photogenic it became his "Dunkman" logo. And did Jim Gray hold up the new Zoom Generation for the camera and riff on it? Very much so. LeBron wore the general release white-and-black "home" pair and put up 25 points, 9 assists, 6 rebounds, and 4 steals. And afterward, all he

Rookie LeBron in Nike Air Zoom Ultraflights.

could talk about was not doing more to come away with the win for his team. He was 18 going on 30.

His home opener, against Carmelo Anthony's Nuggets, didn't go quite as well for him. Forgivable, considering the 18-year-old drafted to be a franchise savior was playing in front of a capacity crowd that included Nike founder Phil Knight and Jay-Z. Even for LeBron, this was a lot to take in. Nike had made up a whole shoe for it—the First Game, a limited-edition pre-launch colorway with white leather and Cavaliers wine and navy accents, along with the date of the game (11-5-2003) embroidered in gold inside the ankle collar. He ended up shooting 3-for-11 and scoring 7 points—along with 11 rebounds, 7 assists, 3 blocks, and 2 steals, of course. The Cavaliers dropped to 0-4.

The shoes officially launched in December alongside all kinds of tie-ins, as Nike slapped his LJ23 logo on everything from shorts and jerseys to headbands, bags, and watches. It wasn't just because they paid so much to sign him. With Jordan Brand having launched in 1997, Air Jordan was no longer part of Nike Basketball. Longtime endorsers had either faded (Barkley) or fizzled (Penny), Shox lost some of its initial gold-medal luster, and Nike Basketball needed a new standard bearer. (It wasn't really a coincidence that the first widely available Generations were made in Air Jordanesque white, black, and red.) The LeBron launch was reminiscent of the initial Air Jordan release: just straight-up flooding the zone with LeBron-branded product, only this time you had a kid barely removed from high school being marketed to those who were still there.

The LeBron Effect

Anyone who's ever missed out on buying something they really wanted knows what happens next. In your brain, that money has *already* been spent, so why not just spend it on something else? When Reebok and adidas whiffed on LeBron, that budget was going elsewhere.

Reebok diversified beyond hoops, adding 50 Cent and Pharrell to a lifestyle roster that already included Jay-Z, whose S. Carter shoe had dropped in April. Sonny Vaccaro also came on to revamp their basketball roster (he had left adidas shortly after failing to sign LeBron). The problem was that another LeBron wasn't coming. They signed high schooler Shaun Livingston in 2004, and by 2005, Reebok had become an adidas subsidiary.

Adidas regrouped in a hurry. After LeBron turned them down in May, they signed 27-year-old six-time All-Star Kevin Garnett—adding him to a roster that included Tim Duncan and Tracy McGrady—to a "lifetime deal" in August. (He would leave at the end of the 2009–10 season.) Garnett won MVP in 2004 and an NBA title in 2008, but adidas's Shox-like a3 line was a literal and figurative brick. They went heavy on the high schoolers in the 2004 draft—signing Dwight Howard, Sebastian Telfair, Josh Smith, and J. R. Smith—as Nike mostly sat it out. They already had their guy.

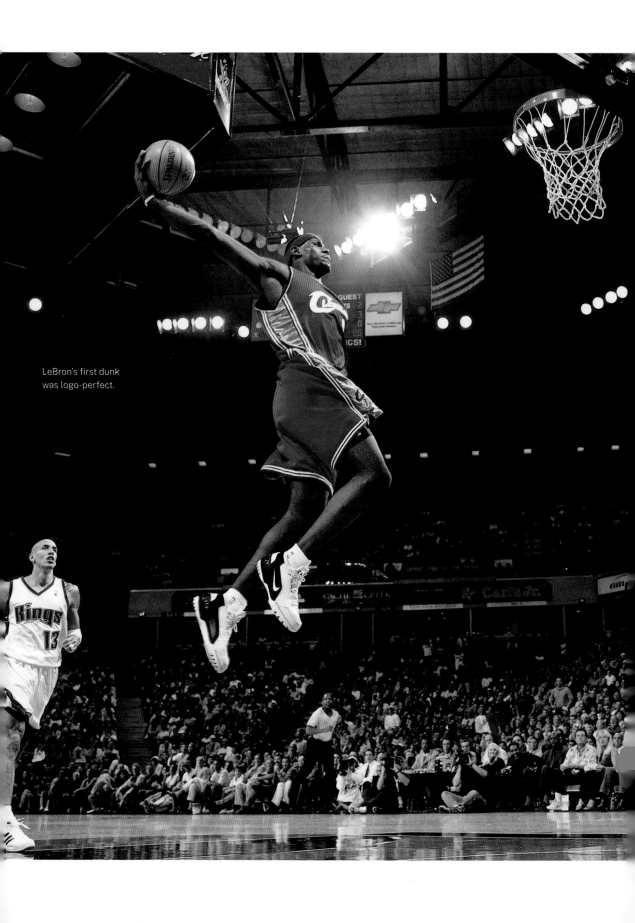

LeBron's first dunk
was logo-perfect.

EXCEEDING EXPECTATIONS

Unlike Mike, LeBron didn't make the All-Star team in his first year. He was relegated to the Rising Stars game, where he led the rookies with 33 points and threw down a dunk contest's worth of slams, several off lobs from Carmelo Anthony. They lost to the sophomores by 24, and Amar'e Stoudemire was named MVP. But LeBron was the sneaker MVP. His "Wheat" Zoom Generations were all-tan nubuck with matte gold accents and gum bottoms, bringing a Timberland work boot aesthetic to the hardwood. (Adidas, for their part, had already done a virtually identical color-up of the All Day All Night streetball shoe in 2001.) The game wasn't competitive but it was a lot of fun, leading former Georgetown coach John Thompson to say of Bron and Melo on the call: "The interesting thing about both of those kids, they remind me a lot of the attitude Magic Johnson had in playing: Not only could he play, he enjoyed playing."

Melo and LeBron were Magic and Larry on fast-forward. They'd played each other in a highly touted high school matchup—James, a junior, outscored senior Melo 36–34 but lost to Anthony's Oak Hill Academy 76–66—and joined the league at the same time. And while they played for different NBA teams in different conferences, their connection was obvious from the start. They didn't need to film a commercial together to become friends.

Both joined 17-65 teams, and both had an awful lot of work to do. Melo's Nuggets improved to 43-39 and made the playoffs; LeBron's Cavs finished 35-47 and didn't. James averaged 20.9 points, 5.5 rebounds, and 5.9 assists as a rookie—an accomplishment that would be marked by a 2005 outdoor-use shoe called, yes, the 20-5-5. He became just the third rookie to hit those numbers. (The other two? Oscar Robertson and Michael Jordan.) LeBron won Rookie of the Year, with Carmelo as his only real competition, and everyone knew this was just the start. "He silenced the critics early and often," said Julius Erving at the award ceremony, calling it James's "first step to going to the Basketball Hall of Fame."

LeBron exceeded first-year expectations and then flipped on the afterburners. The Cavs missed the playoffs again his second season—they were still calibrating the rest of the roster, and Brendan Malone replaced Paul Silas at coach. But James dropped 56 points on the Raptors—"I probably played the best game of my life, but it means nothing when it comes with a loss," he said afterward—and averaged a Jordanesque 27.2 points, 7.3 rebounds, and 7.2 assists, making his first All-NBA team. That season he turned 20.

His third season, LeBron led the Cavs to the playoffs, and in his fourth, the 22-year-old dragged an otherwise subpar team to the NBA Finals. For some, the fact that the Cavs lost that Finals (in a Spurs'

sweep) meant LeBron could never equal, let alone surpass, Jordan as the GOAT—never mind the fact that at age 22, Jordan had only just finished his rookie season. In Game 5 of the Eastern Conference Finals, LeBron utterly annihilated the Pistons, scoring 29 of the Cavs' final 30 points in a double-OT win. His fifth season, he won his first scoring title, and in his sixth, the first of back-to-back MVPs.

There is a level of greatness that few reach, where superlatives cease to function and putting that brilliance into words only seems to diminish it. Bill Russell, Wilt Chamberlain, and Michael Jordan reached that level, as did LeBron, stacking accomplishments and "youngest to . . ." every step of the way. From the start, you couldn't compare him to one player but many—he combined Karl Malone's size, Magic Johnson's court vision, and Jordan's scoring. And the easiest route to criticism was to call him out for things he hadn't done yet. Jordan went through that, too, being questioned for not having won a title through his first seven seasons; a December 1990 *Sports Illustrated* cover asked, "Can Michael Jordan and Chicago Finally Make It to the Top?" We all now know the answer to that question.

No player should be beyond criticism, but sometimes it reaches a point in which searching for things to criticize is to expect nothing less than perfection. Sure, Wilt and Shaq could have been better free-throw shooters. But if they were, they would have had zero weaknesses and become gods. LeBron sometimes passed at the end of games if a teammate had an open look and, if they missed, well, damn—clearly LeBron didn't have enough of a killer instinct to do it all himself. Sports talking heads—particularly one whose name rhymes with "slip payless"—seemed to dedicate entire media careers to denigrating one of the greatest players in the history of the game. Whatever makes you happy, I guess.

It was all there from the very beginning: the physicality, the selflessness, the ability to take over a game. LeBron's very first game was a microcosm of all the countless moments to come, everything right there for everyone to see. And his first sneaker did all it needed to do, too. As time goes on and technology advances, his shoes have evolved, but they are always a means to the same end: protecting LeBron from himself.

BUILT LEBRON TOUGH

The bootlike construction of the Zoom Generation had to contain the physicality of a man with the size of a power forward and the moves of a point guard. There was a lot of stress and strain on his sneakers. Michael Jordan made a sort of ritual out of wearing a new pair of shoes every game, but there were valid reasons for players to never use the same pair twice: Leather stretches, foam breaks down, and sharp edges wear off, even over the course of a single 48-minute game. Freeze-frame a player making a sharp cut and you'll see sneakers rolled into shapes the manufacturer never intended. Someone like LeBron could run through a pair of shoes fast; wear them too long, and you get Zion Williamson tearing through his midsole. You don't want to lose a billion-dollar player because of a hundred-dollar sneaker.

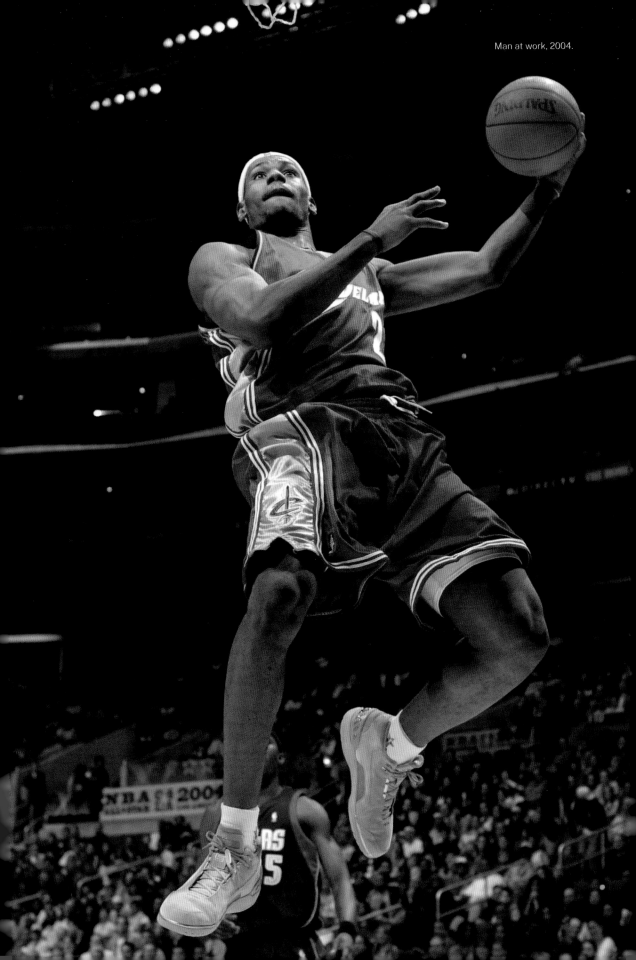

Man at work, 2004.

For the Zoom Generation, what could be built was overbuilt. There were multiple layers of material, double- and triple-stitching, a carbon fiber plate in the midsole, and an exposed heel counter designed to keep LeBron locked down in something that players from Dr. J's era would still be able to recognize as a basketball shoe. Like sneakers of yore, there was still leather and rubber, just with a seamless bootie and pressurized air cushioning to keep things smooth on the inside and bouncy on the bottom. It was a shoe designed from the inside out. They were light for a player of LeBron's size, too—though perhaps it became evident later on that a few ounces either way weren't going to keep the King down.

Ensuing LeBron models changed stylistically, first under designer Ken Link and then Jason Petrie, but still served to prevent wear and tear on James himself. The LeBron 2 was a double-stack Zoom Air, strapped-up, laser-etched football shoe for the hardwood (appropriate since James was also an All-American on the gridiron). The 3 and 5 were sleeker while the 4 and 6 were overbuilt monstrosities designed for him and hardly anyone else. The LeBron 4 was a virtual Coney Island sideshow attraction, a foam-encased, carbon-reinforced brick that mere mortals could barely flex with their bare hands (yet didn't slow down James in the slightest), while the 6 was like an Air Force 1 built for the Incredible Hulk.

Signature lines tend to evolve in one of two ways: dramatic change with every model (Jordan) or incremental evolution toward an ideal (Kobe). LeBron's split the difference with radical year-by-year designs all focused on comfort and containment. With 2009's LeBron 7, Petrie flipped the script with an all-new full-length Air Max midsole bag and a sleek, Flywire-reinforced upper that gave the line an entirely fresh look. And then in 2017, Petrie reinvented everything again with the 15, combining a new articulated Air Max bag with a beefed-up knit upper.

CALL IT A COMEBACK

The Zoom Generation, including the Wheats, returned as a retro in 2017 (at $175 rather than $110), as have several of LeBron's other signature models. It was still a perfectly viable basketball shoe, and several NBA players wore it on court. Even

Nike Zoom LeBron 2, 2004.

Nike Zoom LeBron 4, 2006.

as the retro cycle gets shorter, sneaker technology advances incrementally rather than in leaps and bounds. In 1998, Michael Jordan wore a pair of 1985 Air Jordans in his final Madison Square Garden appearance as a Bull and it was huge news. In 2023, an NBA player wearing a sneaker from 2010 doesn't even bear mentioning, assuming anyone even notices.

Retros tend to fall short, mostly because buying a shoe you loved when you were 18 doesn't magically make you a teenager again. The most interesting consumer for an AZG retro was, of course, LeBron himself, who was 18 when they first released. It's just that the memories LeBron made in this shoe are ones that we all happen to remember, too.

The Zoom Generation will always hold a special place in LeBron's heart.

As the first shoe LeBron wore in the NBA, the Air Zoom Generation piled up its share of firsts: first All-Star Weekend, first Olympics, first 30- and 40-point games. Other milestones would have to wait for other sneakers: first 50-point game, first triple-double, first playoff appearance, first championship. But as likely the last thing that LeBron put on before stepping onto an NBA court for the first time (save maybe his headband), the Zoom Generation will always hold a special place in his heart.

LeBron was closing the circle early, with more still to come. He entered the NBA with the highest of expectations and exceeded just about all of them. As of 2023, he was continuing to do so, having signed a $97 million extension and broken Kareem Abdul-Jabbar's all-time scoring record. He went from "youngest to . . ." to "oldest to . . ." without ever even slowing down. By the time he's done, he'll have rewritten all the all-time lists, worked himself into all the GOAT conversations, and, if all goes as planned, played in the NBA alongside his oldest son, Bronny. Back in 2003, "Air Zoom Generation" was a strange name choice for a signature shoe—why not just call it the Zoom LeBron 1? Now it all makes sense.

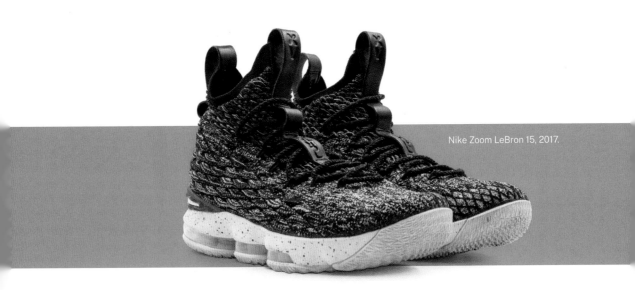

Nike Zoom LeBron 15, 2017.

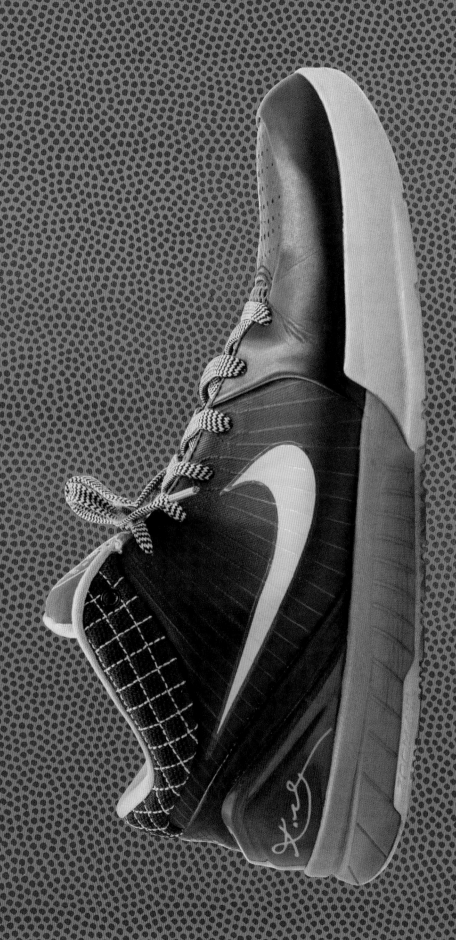

Chapter Thirteen

The Low-Cut Theory:
Nike Zoom Kobe IV

Converse Chuck Taylor All Star 1917

Adidas Superstar 1965

PUMA Clyde 1971

Adidas Top Ten 1979

Nike Air Force 1 1982

Nike Air Jordan 1985

Reebok Pump 1989

Nike Air Force Max 1993

Nike Air Swoopes 1995

Nike Air Jordan XI 1995

AND1 Tai Chi 2000

Nike Air Zoom Generation 2003

Nike Zoom Kobe IV 2009

Under Armour Curry One 2015

Nike Adapt BB 2019

Before the start of the 2006–07 NBA season, Los Angeles Lakers guard Kobe Bryant changed his jersey number from 8 to 24. It was a period of massive change in his career. Shaq had been traded away in the summer of 2004, Phil Jackson returned after a season away, and Bryant was now the unquestioned alpha dog in LA.

A chapter was ending, a new one beginning. He led the league in scoring for the second consecutive year, the last time he would do so. In 2007–08, he led the Lakers back to the NBA Finals, where they fell to the Boston Celtics, capped off by a 39-point blowout loss in Game 6 in Boston. Kobe scored just 22 points on 7-of-22 shooting and walked off the court through a flurry of green and white confetti. Later that summer came a triumph: Team USA's romp through the Beijing Summer Games, culminating in an 11-point gold-medal-game win over Spain. The victory washed away the bad taste of 2004's bronze medal and established Bryant as the star among stars.

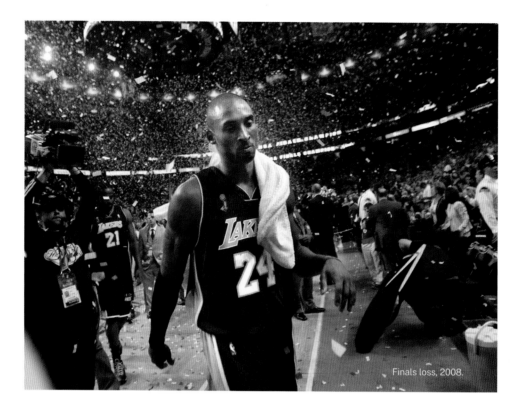

Finals loss, 2008.

There was something else, too. By 2008, Bryant had been a Nike athlete for five years, signing with the Swoosh after a break with adidas and a year of sneaker free agency in 2003 that saw him actively courted by everyone from Jordan to Reebok to AND1. He wore the all-new Hyperdunk in the '08 Olympics, as did many of his Nike labelmates, and had tried a variety of approaches with his first three signature models. For his fourth, he wanted to go in a completely different direction—one that, if successful, would define his signature line for years to come. So he told designer Eric Avar that he wanted the lowest and lightest shoe that Nike Basketball had ever made. A genuine low-cut. A soccer boot for the hardwood.

GOING LOW

Bryant's request had not come out of nowhere. His vision for the Zoom Kobe IV was rooted in the same sense of relentless reduction and refinement that would come to define his playing career. Bryant's game was a carefully assembled repertoire of moves, countermoves, and preparations for any and every eventuality that he had built through endless repetition. His offensive approach disregarded defenses and was instead based primarily on getting to his spot. If he got there, the shot was going up. He'd proved that ability as early as his first Lakers

pre-draft workout, when GM Jerry West pitted the 17-year-old Bryant against former Lakers defensive stopper Michael Cooper.

Since then, Bryant had added a lethal turnaround and a dizzying array of post moves—Kobe 2.0—while still at his get-to-the-rim athletic peak. "My high school coach told me a long time ago, you don't build a house without blueprints," he said in Spike Lee's *Kobe Doin' Work* documentary. "You gotta know what you're doing coming in."

But in 2008, Bryant was turning 30, his three titles a speck in the rearview. He hadn't followed Michael Jordan's career blueprint so much as remixed it. His early struggles had barely faded before he started winning championships—three rings by age 23—and then only after that came the highest individual accolades (an MVP award; All-NBA First-Team selections). He'd accomplished many things since the 2004 Finals loss to the Pistons and Shaquille O'Neal's ensuing exit, including historic scoring barrages (62 points in three quarters against the Mavericks in 2005; 81 points against the Raptors in 2006). But now it was time to refocus, starting with his new shoe—he needed to figure out what worked best to get him where he wanted to go.

"That's what me and Avar discussed at length—how do we minimize, minimize, minimize," Bryant remembered in 2019. "And I didn't want any clunk. If there was any material there that didn't need to be there, it's gotta go. The material that's there serves for the first intention, which is the performance of the shoe, the performance of the product. I didn't want to create any shoe that had something on there just for pure aesthetic pleasure. That made no sense to me. I wasn't in it to create a shoe that looks good, I was in it to create a shoe that performs at the highest degree. And then from that, if it checks those boxes, now we can work on the aesthetics."

> ## "I was in it to create a shoe that performs at the highest degree."

Read that quote again and apply it to Bryant's game instead of his shoe and it still makes perfect sense. He was forever paring down, figuring out his spots on the court and how to get to them as quickly as possible. He wasn't the most efficient player statistically, but he was efficient in his movements. There was no clunk in his game; he learned to control what he could. The rest? That was someone else's problem.

Every situation Bryant found himself in, he attacked the same way. "My approach to the game, designing sneakers, building an animation studio—it's all the same thing," he said. "It's being patient, focusing on small things, making sure those small things are just right. And then you move on from there." For the Zoom Kobe IV, he wanted the lightness and freedom of a low-top with the support of a high-top, something that could be achieved through fit and foundation. It was going back to the principles Chris Severn used when developing the adidas Supergrip and Superstar, only in a far more high-tech world.

They would have to literally build it from the ground up. Luckily, Nike's in-house sports science labs had already developed some of the relevant

technologies, from outsole outriggers to prevent rollover to Zoom Air bags that provided low-profile cushioning. A big task was perfecting the heel counter, which would enhance stability and protect the ankle. But the advantages of a low were many—lighter weight, more freedom of motion. Back in the '80s, Falk wanted to market Jordan like a tennis player. Now Bryant wanted the footwear of one.

Performance aside, Bryant also wanted a sneaker that was specifically for him. "Even at an early age I understood if a shoe looked like something that you could slap on anybody, then it wasn't doing its job the right way," he said. "It must be an extension of yourself." Bryant drew a comparison to samurai swords: "Each samurai warrior had his own sword and his own sheath. And if you had your sword, it would not fit into the sheath of another warrior, because that sheath has been made personal for that warrior. That was the aesthetic that I wanted with every single one of my products. This is a story; this is *my* story. This is personal." He wanted an old-school touch, too: a perforated and burnished leather toe, adding a handcrafted look. And when Foot Locker had reservations, Bryant took on the role of marketing manager and helped convince the retailer himself.

Paying Homage

Kobe wasn't the first to incorporate storytelling into his sneaker designs, but as a storyteller himself, he was the most willing partner in that phase of the design process. It got even deeper with the Zoom Kobe V, the ZKIV's lighter and lower successor. (Off went the molded leather toe, down went the ankle collar.) Bryant had a wide variety of muses, and he honored a select few of them—Bruce Lee, Miles Davis, Batman—with distinct colorways. And both the Kobe IV and Kobe V landed on Nike's custom program, NIKEiD, where you could create your own colorways.

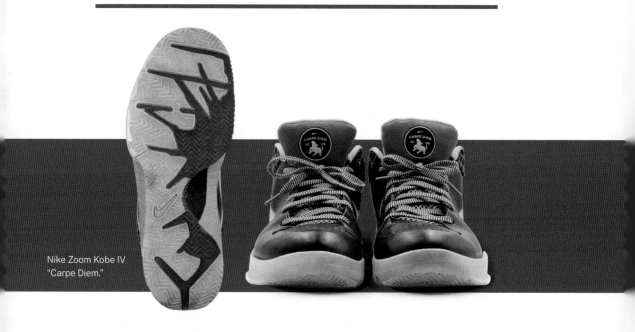

Nike Zoom Kobe IV
"Carpe Diem."

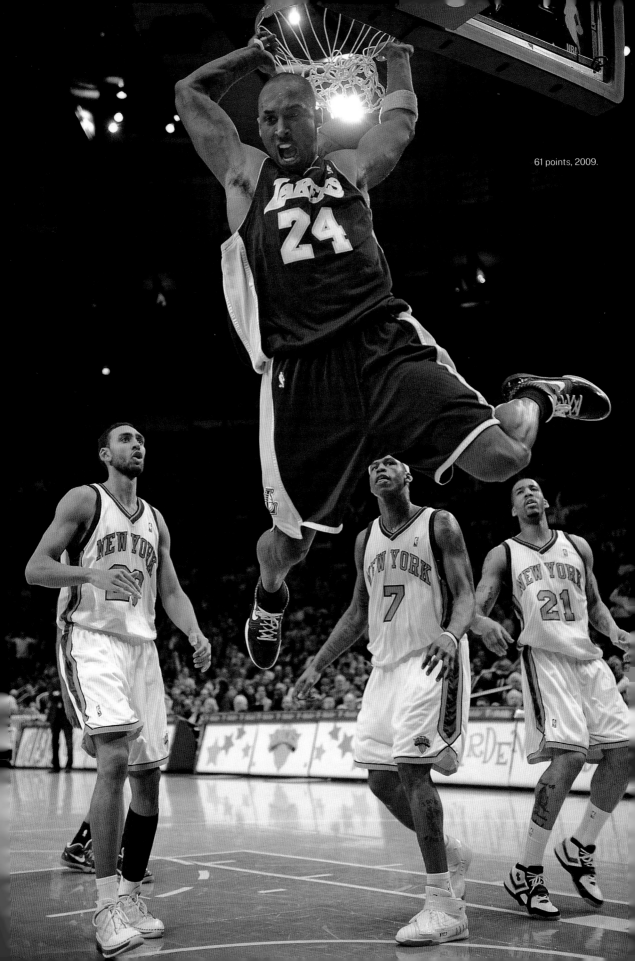

61 points, 2009.

When Bryant debuted the Zoom Kobe IV on December 19, 2008, in Miami, the Lakers lost 89–87; it was just their fourth defeat of the season. Dwyane Wade's game-high 35 points overshadowed Bryant's 28, but much of the attention was on Kobe's new black low-tops with purple accents and gold Swooshes. He'd deliver his signature performance in them less than two months later.

GARDEN PARTY

The current Madison Square Garden, New York's fourth iteration of the World's Most Famous Arena, opened on February 11, 1968. In its fifty-plus years it has borne witness to the Knicks' only two NBA championships, one Rangers' Stanley Cup, and an ever-growing number of Billy Joel sellouts. It has undergone two major renovations: a $200 million job in 1991 and a $1.1 billion facelift twenty years later. For visiting superstars, trips to the Garden have always been just this side of sacred, and everyone from Michael Jordan to LeBron James have praised the old gym effusively (leading to constant, unrequited speculation from long-suffering Knicks beat writers about how great it would be for said superstars to play there on a nightly basis). They also tended to light the place up—Jordan many times, most notably with his 1995 "double-nickel" 55-point performance.

The February 2, 2009, game was only Bryant's 12th time playing at the Garden, given his Western Conference Lakers visited just once a year. In 2007, he missed a trip to MSG serving a one-game suspension, and in 2008, two days before Christmas, he put up 39 points, 11 rebounds, and 8 assists. He'd come a long way since his first appearance on November 5, 1996, when he played three minutes and scored one point in just his second-ever NBA game.

The '09 game launched a horror of a homestand for the Knicks—Kobe, LeBron, then the world-champion Celtics all in one week. Bryant came out firing and didn't stop. He had 18 points at the end of the first quarter, 34 at the end of the second, 46 at the end of the third, and a Garden-opponent-record 61 when he went to the bench for the last time with 1:48 to go in the fourth. He shot 3-of-6 on threes, 19-of-31 from the floor, a perfect 20-of-20 from the line, and somehow did not corral a single rebound in the Lakers' 126–117 win.

> If any game was proof of concept of the Kobe IV, it was this one — he got to his spots at will and was as efficient as he could be.

If any game was proof of concept of the Kobe IV, it was this one—he got to his spots at will and was as efficient as he could be. He scored on breakaways and over double teams. It was his highest-scoring game of the season. Afterward, Kobe was scheduled to meet up with Spike Lee to do his voiceovers for the *Kobe Doin' Work* documentary. Safe to assume Spike didn't have much to say.

1. Job's not finished.
2. 2009 Finals, Game 1.

BACK TO THE FINALS

A decade later, Bryant's strongest memory of the Zoom Kobe IV was less of the shoe itself than of his biggest accomplishment while wearing it. It wasn't the 61 points he hung on the Knicks, or the fact that he played all 82 games for the second season in a row. "Orlando," he said without hesitation. "Orlando, and the journey to get to that championship, that first championship, that's what I think of." Along with the so-called first championship (in reality his fourth, but his first of two as the Lakers' undisputed alpha dog), Bryant called that 2008–09 team the most fun one he had ever been on—sorry, Shaq.

The Lakers weren't supposed to play the Magic in the Finals. Everyone hoped Kobe would either finally match up with LeBron, who'd led the Cavaliers to an NBA-best 65 wins, or get another shot against Boston's Big Three, who'd won 62. Instead, the Magic—who'd surrounded 23-year-old center Dwight Howard with an array of three-point shooters en route to 59 wins of their own—knocked off the injury-hobbled Celtics in the Conference Semis and LeBron's Cavs in the Conference Finals and were now making their first Finals appearance since getting swept by the Rockets in 1995.

The Magic were in for another rude awakening. The Lakers ran out to a 20-point lead in Game 1, and during a time-out in extended garbage time, the ABC cameras focused on Bryant's Kobe IVs. The white-and-purple pair was covered in gold "graffiti" commemorating a multitude of his achievements, including a big "61 points" visible on his inner ankle, honoring his recent Madison Square Garden record.

Underbite on full display, Bryant was aggressive from the start, driving straight into the teeth of the defense, shooting over the outstretched hands of Magic players, and eluding shot blockers by holding his release until the last moment. "Help has to come quickly," said broadcaster Mark Jackson after Kobe took Mickael Pietrus to the hole ahead of a late-arriving Dwight Howard. "You cannot allow Kobe Bryant to play one-on-one on the block." Not that it made much of a difference one way or the other.

After going up 2-0 in the series, a somber, suited Bryant took to the press-conference podium and was asked, basically, why the long face? "Job's not finished," he replied, a three-word dismissal that would become a mantra a decade later as LeBron James's Lakers battled in the bubble to the 2020 title. "Job finished? I don't think so," Kobe continued. He went out for Game 3 like the Lakers were the ones in an 0-2 hole. In the first quarter, he fired up a heavily contested 20-footer. Double-team? Yeah, whatever. "Oh my god," exclaimed Jeff Van Gundy, "those are impossible plays." Fourteen minutes into the game he had 20 points.

It all ended in Orlando in Game 5, the Lakers exorcising at least some of the demons of the year prior. As the clock wound down, the lead insurmountable, Bryant stood excitedly in the frontcourt waiting to explode in celebration. When the final buzzer sounded, he leapt one, two, three times before being enveloped by giddy teammates. He pulled on his championship shirt and hat and took the stage with his wife and two daughters to receive the Bill Russell Finals MVP trophy, his first, from Russell himself. The chapter concluded. The job was finished. But the story continued.

The following season saw a lighter, lower shoe (the Kobe V) and another championship—this time in seven games over the Celtics. It was a slog, and Bryant struggled through a 6-for-24 final game (0-for-6 from three) that the Lakers won despite shooting just 32 percent from the floor. This was the real exorcism of 2008, Bryant standing tall once again with both trophies rather than trudging through the opposition's celebration. Kobe's fifth ring would be his last, the 2010 Finals ending a chapter of NBA history, the next beginning later that same summer when James announced he would be taking his talents to South Beach.

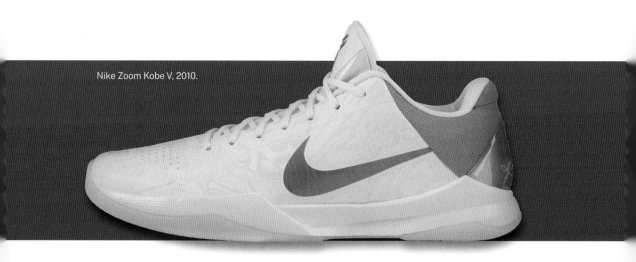

Nike Zoom Kobe V, 2010.

The legacy of Bryant's fourth shoe is as inseparable from the game as Bryant's own. Its story was personal, but it resonated with others. Countless players wore it ten years later in the 2018–19 season, brought back as a "Protro"—a retro updated with modern tech. Not that a sneaker from 2009 need much upgrading. Luka Dončić wore them, as did Giannis Antetokounmpo. And Kobe took pride in the next generation of stars wearing his shoe. It was just further proof of concept for a sneaker that did more for basketball low-cuts than any since the adidas Superstar.

"Some products are much more radical than others," Eric Avar told ESPN in 2019. "Some are much more traditional. The IV was a little in the sweet spot. It was just enough classic, just enough modern, that it has stood the test of time." Kobe's shoes had come a long way since the "Feet You Wear" adidas he started his career wearing. For that matter, so had Bryant himself.

HEIR JORDAN

In the summer of 2000, Kobe was insistent. Not even a month after he'd won his first NBA championship, the then-21-year-old wasn't having it with the Michael Jordan comparisons. At all. "It's completely different," he said, enunciating each word very carefully. "Our timetable is completely different, our style of play is completely different. We're diametrically opposed." Even back then, one could have pushed back against that questionable assertion in all kinds of ways. Sure, the whole "next Jordan" thing was a lot to lay on anybody—especially for a bud-

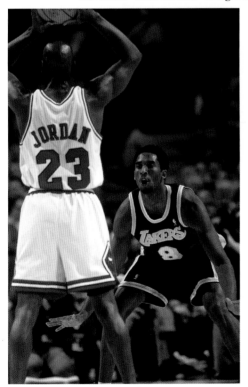

Mike and Kobe, 1998.

ding star who was just coming into his own. But Bryant's game had so much Jordan in it you could almost taste it. He'd grown up idolizing No. 23 and come as close as anyone to becoming Jordan 2.0.

Even so, Bryant's disdain for all the Jordan talk is important for understanding his psyche. To any other NBA-bound high schooler, being compared to His Airness would have been the ultimate honor. But not to Kobe—he wanted to transcend comparisons to *anyone*. From the start, he sought not to merely equal Jordan but to surpass him. And Bryant wanted what Jordan himself had enjoyed: a limitless future defined only by his own capabilities.

Now, were there differences? Absolutely. Bryant was correct regarding the timing—he went straight to the NBA from high school and won his first championship at 21, the same age that Jordan played his first NBA game. Kobe had won a Slam Dunk Contest, endured painful playoff losses, and seen his

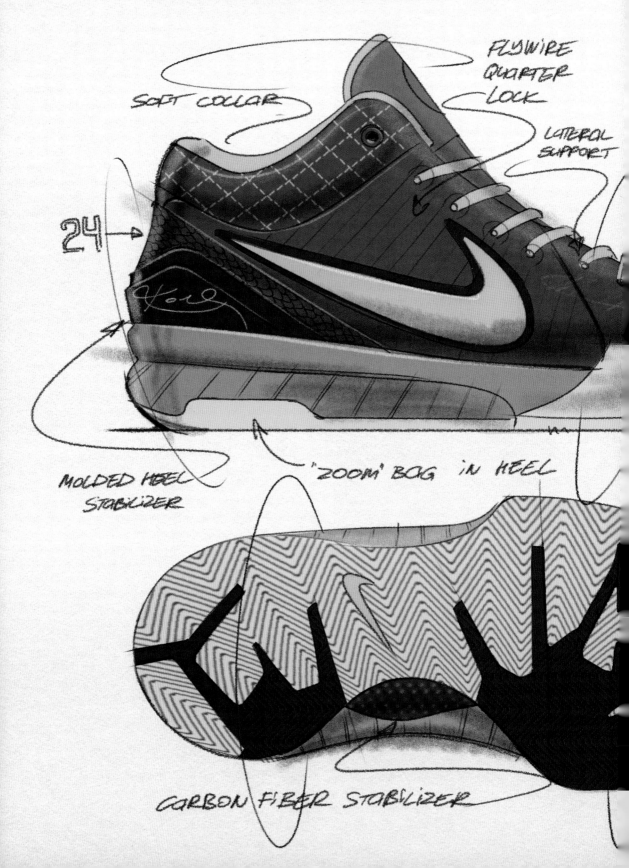

Nike Zoom Kobe IV

SOFT COLLAR

FLYWIRE QUARTER LOCK

LATERAL SUPPORT

24

MOLDED HEEL STABILIZER

"ZOOM" BAG IN HEEL

CARBON FIBER STABILIZER

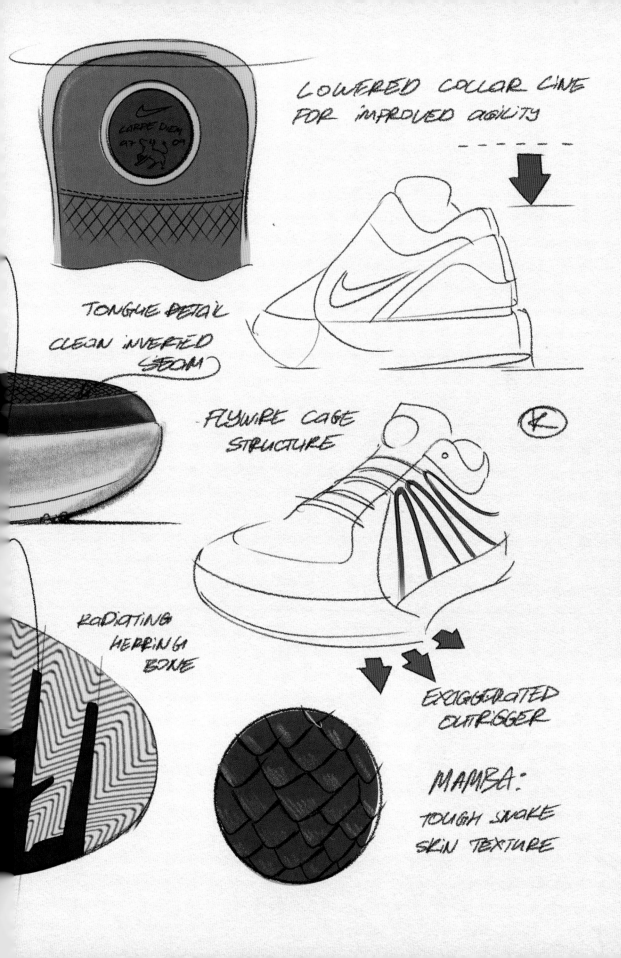

LOWERED COLLAR LINE
FOR IMPROVED AGILITY

TONGUE DETAIL

CLEAN INVERTED SEAM

FLYWIRE CAGE
STRUCTURE

RADIATING
HERRINGBONE

EXAGGERATED
OUTRIGGER

MAMBA:
TOUGH SNAKE
SKIN TEXTURE

team hire Phil Jackson all in his first three seasons, running MJ's first NBA decade on fast-forward. Even their sneaker deals contrasted: Jordan entered the NBA dreaming of adidas and wound up with Nike while Bryant, who'd grown up in Air Force 1s and Air Jordans, signed with adidas. Then again, while the two wore different logos on their feet, the same fingerprints were on their respective deals—those of Sonny Vaccaro.

Since advising Nike to sign Jordan back in the summer of 1984, Vaccaro had moved on to adidas. Depending on who tells it, the stories differ on the circumstance of that departure. But no one doubts that Vaccaro's connections vastly increased Nike's influence in basketball, and that his eye for talent had not diminished since his days picking rosters for his Dapper Dan high school all-star games back in the '60s. He'd been absolutely right about Jordan, and he'd prove absolutely right about Bryant, as well.

ELEVATION

Bryant started out in adidas sneakers featuring their licensed Feet You Wear technology (whose rounded-off soles worked on the same principles as Rick Barry's Top Tens) that adidas's youthful stable of NBA athletes like Antoine Walker and Jermaine O'Neal also wore. Bryant then moved to the Equipment Elevation, a signature sneaker in all but name, before he laced up his proper signature KB8 in 1998, a bulbous shoe with aggressively canted stripes wrapping around its leather upper. The KB8 II carried the design forward in nubuck with clear plastic windows set into the lower portion of the upper. Then things started to get a little weird.

Sneaker designers had long been inspired by car design, but in 1999, adidas decided to take it a step further: What if they worked with a car company itself to design Bryant's next sneaker? Adidas was still very much a German company, and designer Eirik Lund Nielsen worked with Bavaria-based Audi to develop what would become the KOBE, a sleek, synthetic, monochrome shoe based on design cues from the TT roadster.

The ads placed a huge sneaker next to a diminutive Bryant in matching gear. In one he gazed up at the shoe from a chair, in another he wore a black leather

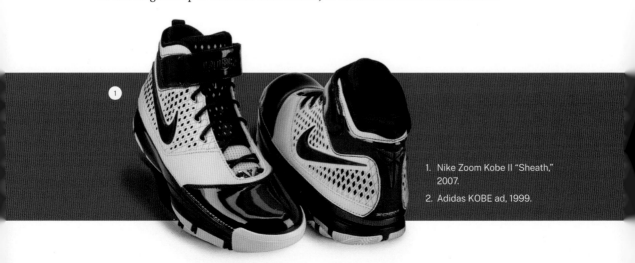

1. Nike Zoom Kobe II "Sheath," 2007.
2. Adidas KOBE ad, 1999.

motorcycle getup and held a helmet. This departure from the earlier, more basketball-centric ads was a mistake. Maybe it would have flown in *Vogue*, but it was far too high-concept for basketball and rap mags. The shoes were pretty cool, though: They featured a vestigial shell toe, embossed stripes, and his "Frobe" (Kobe with a 'fro) logo on the heels. Bryant wore them on the road to his first title, shining in a "Sunshine Yellow" pair at the 2000 All-Star Game in Oakland.

The design director on the project was none other than Peter Moore, who had designed the original Air Jordan as Nike's creative director in 1984.

As Moore could have told all involved, the toughest part of having a hit is coming up with a sequel. (The hugely popular Air Jordan 1 was followed by the $100, Italian-made Air Jordan II, a shoe that was stripped bare of all the garishness that made the original Air Jordan pop. It was a polarizing design choice and probably just too ahead of its time.) In 2000, adidas followed up the KOBE with the KOBETWO, a similarly synthetic model, only this time with the stripes moved to the midsole and the laces fully covered. With its vast blank panels, it looked like a futuristic toaster. Despite the Kobe imprimatur, sales languished, and even Bryant himself abandoned it, going back to the KOBE in the NBA Finals. This was the beginning of the end of Bryant's time with adidas.

In 2003, Bryant went through a full season as a sneaker free agent, wearing anything and everything that caught his eye, from AND1 Tai Chis to Reebok Questions to Air Jordan retros, all with accents of Lakers purple and gold. He eventually signed with Nike, only to have what would have been his first signature shoe with the Swoosh released as a general basketball model following his arrest on rape charges in Colorado. The case was eventually settled out of court, with Bryant contending that while he still thought the encounter was consensual, he understood that the victim—whose name had since been published in the press—felt otherwise. He paid a settlement, held an incredibly uncomfortable press conference, and famously bought his wife a $4 million ring.

That first shoe with Nike, released as the Zoom Huarache 2K4, established a new design process for Bryant and empowered him as an equal in its creation. The sneaker boasted a dream team of Nike designers, including Tinker Hatfield, Mark Parker, and Eric Avar, who would eventually become Bryant's de facto sneaker partner. As Bryant got used to a new company, new technologies, and new designers, the shoes changed dramatically. His line evolved from the fairly straightforward Zoom Kobe I to the Zoom Kobe II's situationally tuned three-shoe collection (dubbed "Sheath," "Strength," and "Lite") to the futuristically caged synthetic Zoom Kobe III. But the Zoom Kobe IV was where he really found his stride, as well as a true design collaborator in Avar. It's no coincidence that was the same season he rediscovered his championship form.

DEDICATION

Bryant grew up a student of the game. His father, Joe "Jellybean" Bryant, played for the Sixers and later in Italy, where young Kobe spent his formative years and got his first experiences competing as a boy against men. He'd been steeped in NBA culture and history almost since birth—Joe Bryant played against Magic Johnson in the latter's first NBA game when Kobe was just barely one year old. Once the family moved to Italy, Kobe received VHS tapes of games from relatives and obsessively watched Magic, Larry Bird, and, later, Jordan. When the Bryants moved back to suburban Philadelphia, Kobe arrived stateside with a ready-made game birthed outside of the AAU circuit that others of his age and abilities had traveled.

Looking back, it's easy to see how Bryant's path differed from the prep-to-pros players who followed him. His ultimate goal wasn't a guaranteed contract and a starting spot or, later on, a max contract and All-Star appearances. All those were mere plateaus where others might stop and take a breath. For Bryant, the mountain continued ever upward. There was no stopping. There was always something else to learn, something else to achieve. The only championship, the only game, hell, the only *basket* that mattered was the next one. It was a single-mindedness that did not go unnoticed by opponents.

Kobe on Generations

My own personal history with Kobe was long. I first met him at the McDonald's All-America Game in Pittsburgh when he was 17 years old and I was 25. We saw each other nearly every year thereafter. I talked to him for this book in December 2019, and the last thing I ever said to him was that I'd see him at his Hall of Fame induction. Kobe made his own mark by studying the game's past and watching the present closely. He also had thoughts on its future.

"Do you ever think about what it would be like if you were in your prime in this era?" I asked.

"To be honest with you, I preferred the era I played in," he replied, "and actually I probably would have preferred playing in the era before mine because of the physicality that was allowed and the tenaciousness that the game was played with. That physicality was something I thoroughly enjoyed and I think made the game better. Today the game is much more loosey-goosey."

"Where does the game go from here?"

"I think it's cyclical. So it will all come back eventually to the physical game, the slowdown game; this is just the era that we're living in. So we'll fast-forward years from now and historically we'll look at the numbers that Harden's putting up, Westbrook's put up, LeBron's put up, we'll have a historical context to it. . . . Eventually the game will circle back to what it used to be and then it'll go through that evolution all over again."

"He is a guy that all of the clichés were actually legitimate," Jalen Rose said. "The most discipline, the hardest working, killer instinct, not fraternizing and being friends on the court. Not caring what the public said, not caring what the media said, not caring what his *teammates* said. Like straight up. And the way most people like breathing and money and sex, that's how he liked basketball. For real." Quentin Richardson told *SLAM*, "I lived in LA for the first four years of my career and I never saw him anywhere outside a basketball gym. Ever. Not one time. Nothing."

Bryant's career was always more about opportunity than achievement. Achievements just made for more opportunities. Playing the All-Star Game in his second season not only gave him the chance to go at Michael Jordan himself, but to pester Gary Payton—then in his trash-talking defensive prime—with questions about his craft. Kobe learned post footwork from Hakeem Olajuwon and reached out to Jordan for knowledge time and again. In turn, he mentored others once he became a veteran of the game, teaching the likes of Kyrie Irving and DeMar DeRozan. He understood that the best thing we can do with lessons we receive from our elders is to pass them down.

Kobe's last six seasons were a difficult coda, his massive salary preventing a full-on Lakers rebuild and his body finally breaking down. Before his final game at Staples Center in 2016, Shaq told him to go get 50. Bryant went out and got 60—on 50 shots—every one of them necessary to hold off the Utah Jazz. He left it all on the floor, finishing the way he started as a 17-year-old in summer league at Long Beach State: never satisfied, always hungry.

On January 26, 2020, Kobe Bryant died in a helicopter crash on a foggy Calabasas hillside. He was 41 years old. All nine people on board, including his 13-year-old daughter, Gigi, were killed. This was not how the story was meant to end. And even as it came to a tragic close, Kobe had been rewriting and reinventing. His 2015 poem "Dear Basketball," which he had published in The Players' Tribune, was adapted into an Oscar-winning short film in 2017. He had also started coaching his daughter's team and redirected all the dedication he used to pour into his own game toward that of Gigi and her young teammates. The future was female. He was seen at more WNBA than NBA games, although he was on hand at Staples Center on January 25 as LeBron passed him for third all-time in scoring. The next day he was gone. His legacy remains.

Bean and Jellybean Bryant, 2000.

Chapter Fourteen

Three the Hard Way: Under Armour Curry One

Converse Chuck Taylor All Star
1917

Adidas Superstar
1965

PUMA Clyde
1971

Adidas Top Ten
1979

Nike Air Force 1
1982

Nike Air Jordan
1985

Reebok Pump
1989

Nike Air Force Max
1993

Nike Air Swoopes
1995

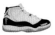

Nike Air Jordan XI
1995

AND1 Tai Chi
2000

Nike Air Zoom Generation
2003

Nike Zoom Kobe IV
2009

Under Armour Curry One
2015

Nike Adapt BB
2019

When Stephen Curry was a junior in high school, a coach from Virginia Tech called to arrange a meeting. It wasn't much more than a courtesy—Steph's father, Dell, was a VT alum who played 16 years in the NBA. But, hey, it was better than nothing. Calling Stephen "lightly recruited" would have been an overstatement. In fact, he wasn't being recruited at all. Forget wearing his own signature shoe someday—all he wanted was a scholarship. So they met in the school cafeteria, and the coach invited him to walk on. Maybe he could redshirt. Well, that wasn't happening. Stephen instead committed to mid-major Davidson, whose coach, Bob McKillop, had first seen him play as a 10-year-old. The rest is *SportsCenter*.

THE POWER OF BELIEF

The annals of sports history are filled with superstars who claim to have defied the odds, to have conquered the haters, to have silenced doubters—which often turn out to be something like their third-grade gym teacher quite reasonably citing the slim chances of becoming an NBA player. "No one believed in us!" shouts the championship team that nearly everyone believed in. All it takes is one doubter—in the age of social media they are *so* easy to find—and that single grain of sand becomes the seed of a pearl of motivation. Michael Jordan didn't make varsity as a high school sophomore and he was still citing the slight at his Hall of Fame induction.

Stephen Curry wasn't a McDonald's All-American. He wasn't recruited by North Carolina—or NC State or UNC Charlotte. Heck, UNC wouldn't have bought him McDonald's. Sure, he was the son of an NBA player, and yes, he would go on to be a lottery pick following his junior season at Davidson. Everything in between, though? It wasn't that he was doubted so much as people didn't even know who he was. But from an early age, Stephen decided it didn't matter who believed in him as long as he believed in himself.

Curry wound up at Davidson College in the Southern Conference, where he'd get to play *against* a lot of those blue-chip teams instead. A magical sophomore year saw him take the Wildcats all the way to the Elite Eight, where they lost by just two points to eventual champion Kansas. The following season, the Wildcats played in the NIT, but Curry was a consensus first-team All-American, Davidson's first since Fred Hetzel in 1965. Hetzel was the NBA's first overall pick that year—by the San Francisco Warriors.

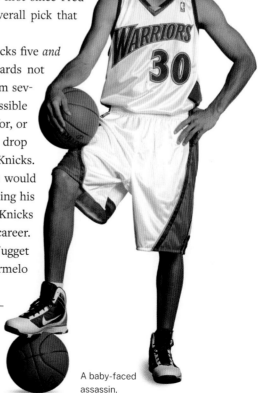

The Minnesota Timberwolves, who had picks five *and* six in the 2009 draft, used both on point guards not named Stephen Curry. Golden State drafted him seventh, even though he had done everything possible to dissuade them. Curry declined to work out for, or even speak to, the Warriors. He had hoped to drop to eighth and join the Mike D'Antoni–helmed Knicks. Curry playing in D'Antoni's up-tempo offense would have been terrifying. On the other hand, spending his injury-plagued early seasons with the lowly Knicks would have been even more terrifying—for his career. He very well might have ended up a Denver Nugget as part of 2011's roster-emptying trade for Carmelo Anthony. We'll never know.

By then others believed in the young guard—you don't get drafted in the top ten otherwise—but few could imagine his becoming a transformational figure. It wasn't so much his talents were in question as simply undervalued. In the 2008–09 NBA season, just one

A baby-faced assassin.

Rookie Steph, 2009.

player attempted more than 500 threes and made more than 200: Orlando's Rashard Lewis. The Magic reached the Finals that year, and much of their success stemmed from surrounding center Dwight Howard with shooters like Lewis, Hedo Türkoğlu, and JJ Redick. But accumulating stars was still the prevailing team-building method, and the ball still primarily went through the post. A slim, 6'3" shooter who would probably be a defensive liability was considered a risk.

Some of Curry's new Golden State teammates certainly thought so. Stephen Jackson requested a trade before the season started. Monta Ellis proclaimed that a starting backcourt of Curry and himself would be too small. On November 13, 2009, the Warriors went to New York, but Curry didn't get the chance to show the Knicks what they'd missed out on. Four Warriors scored 20-plus in a 121–107 win—Curry wasn't one of them. Coach Don Nelson played him for just 2:45; he took no shots and scored no points.

Rolling Thunder

The Warriors weren't the only big winner in the 2009 NBA draft. Sure, they had Steph Curry fall into their lap at number seven. But the Oklahoma City Thunder, who selected Arizona State guard James Harden at three, had just completed what might be the best three-year run by any team in draft history. Starting in 2007, when they were still the Seattle SuperSonics, they got Kevin Durant at two, followed by Russell Westbrook at four in 2008.

Only KD won Rookie of the Year, but they've all been MVPs (Durant in 2014, Westbrook in 2016, Harden in 2017), all won scoring titles (Durant four times, Harden three times, Westbrook twice), and all got signature shoes. Each of them started in Nike — only Durant, 16 signatures deep as of 2023, remains, while Westbrook moved to Jordan Brand in 2019 and Harden signed a 13-year deal with adidas in 2015. None stayed with the Thunder — Westbrook was the last to go in 2019 — and Durant won two Finals MVPs playing alongside Curry in Golden State.

But Curry had already shown what he was made of following the previous game, a loss to the Pacers in which he scored six points. Curry—who had yet to score even 15 points in a game—tweeted out: "Promise to all the Warrior fans . . . we will figure this thing out . . . if it's the last thing we do we will figure it out." Curry was willing to take responsibility, and the Warriors were willing to give it to him. In his last game before the All-Star break, a win over the Clippers, he recorded his first NBA triple-double—36 points, 13 assists, 10 rebounds—and he rode that achievement into a strong second half, making All-Rookie First Team.

Monta Ellis happened to be right that the Curry-Ellis backcourt was too small. But he guessed wrong about who they'd keep. In March 2012, the Warriors traded the high-volume-everything Ellis to the Milwaukee Bucks for center Andrew Bogut. This paired Curry in the backcourt with rookie Klay Thompson, another lottery-pick son of a former NBA player (Mychal Thompson, from the Air Force 1's "Original Six").

Only Curry's fragile ankles were holding him back, as injuries limited him to just 26 games in his third season. He bounced back in his fourth year to play 78 games and scored 22.9 points per game, marking his first season averaging over 20.0. It was also the first time in his NBA career he'd played for the same coach for more than one season. He was an elite shooter on a not-so-elite team. And he had a decision to make.

DECISIONS, DECISIONS

Curry could have been, should have been, Nike for life. He signed a four-year deal with the company as a rookie and had grown up with the brand. His godparents, Shelly Bain-Brink and Greg Brink, were Nike executives; his father, Dell, wore Nike toward the end of his long NBA career; and Stephen himself rocked the Swoosh from high school onward. In the summer of 2013, with his deal ending, Nike had the inside edge to retain him. Only they didn't.

At the outset of their pitch meeting, Curry's first name was mispronounced as "Steph-*on*" and things only got worse from there. Kevin Durant's name, rather than his own, popped up onscreen during the presentation, and that was the ballgame. It was an honest mistake, but certainly not one they would have made with, say, LeBron James or Kobe Bryant. (Or Durant, for that matter.) Curry wasn't a superhero athlete like LeBron or Kobe, or even a traditional playmaking point guard like Chris Paul. He wasn't going to get a signature shoe from Nike right away, or even his own summer camp. He would have had to wait in line. And Curry was done waiting.

With Nike, Curry had been part of a predetermined hierarchy, stuck behind not only their current signature athletes (LeBron, Durant, Kyrie Irving) but also retired legends (Bryant), Jordan-Branded affiliates (Westbrook), and each year's new crop and not-yets (Paul George, Anthony Davis). Signature shoes aren't quite a zero-sum game, but it's not an everybody-gets-one scenario, either. An up-and-coming company like, say, Under Armour, had no such player hierarchy,

no line for him to join. They didn't even have a retro program. With no real past, the future was limitless.

Curry's sneaker-free agency would be his only chance to shop around—he had already re-upped with the Warriors on a four-year, $44 million extension in the summer of 2012, coming off that injury-plagued season in which he averaged career lows in minutes and points. Even so, his shooting percentages had continued their upward arc, and the Warriors had faith. Curry was locked in and had no need to visit other teams. But the sneaker thing—that was different. He was going to see what else was out there.

In the meantime, Under Armour was looking to expand their footprint. Established in 1996 by former University of Maryland football player Kevin Plank, the company started out selling sweat-wicking workout gear. They'd made footwear attempts with a running shoe line and basketball sneakers crafted expressly for prep-to-(Italian)-pro guard Brandon Jennings, but neither made a big splash. The runners ended up at discount chains and Jennings's shoes—even once he joined the Milwaukee Bucks in 2009—weren't even sold at retail. (This maybe seemed like a poor choice when Jennings exploded for 55 points in just his seventh NBA game, against Curry and the Warriors, no less.) Yet the company was growing fast and in 2010 exceeded a billion dollars in sales for

Even as late as the 2013 All-Star break, it wasn't at all clear that Curry was a sure thing to become the face of a brand and warrant a signature shoe.

the first time. They'd tried to sign Curry as a rookie, but that Swoosh connection was too solid. Now it wasn't.

Even as late as the 2013 All-Star break, though, it wasn't at all clear that Curry was a sure thing to become the face of a brand and warrant a signature shoe. He was a good young player on a bad West Coast team that most people in the East had barely seen play. The Warriors had ten nationally televised games in the lockout-shortened 2011–12 season, starting with an opening-day Christmas matchup with the Clippers. Tip-off was at 10:30 p.m. EST; the Warriors lost by 19, and Curry scored just four points on 2-of-12 shooting. For the 2012–13 season, they lost their Christmas Day spot and played only eight games on national TV. It's hard to become a household name if you're not getting into households.

Then, on February 27, 2013, Curry detonated for a career-high 54 points on 28 shots at Madison Square Garden. He played all 48 minutes and shot 11-of-13 from three. He broke both basketball Twitter—a month earlier they had launched a video app called Vine, whose constantly looped six-second clips were tailor-made for Curry's pop-a-shot style—and the game of basketball itself. (And all this the night after he'd dropped 38 points on 70 percent shooting in Indiana.)

At MSG, Curry established himself early with buckets in the paint and three-pointers when he had time to get set, slowly building to a crescendo of deeper and deeper threes and pull-ups on the break with nary a concern for rebounders or defenders. It was the Sorcerer's Apprentice of games. Afterward, reporters asked Carmelo Anthony if there was anything his Knicks could have done to stop Curry. Melo succinctly summed up the decade to come: "No, no, there's nothing nobody can do. Nothing nobody can do. Just hope he miss."

Despite Curry's theatrics, Golden State lost the game. But that 2012–13 season was building toward something—both for Curry and the Warriors. It was the surge before the wave. The Warriors won 47 games, made the playoffs, and upset the 57-win Nuggets before losing in the conference semis to the Spurs. And thanks to Curry, they'd become a League Pass favorite, as obsessives and basketball Twitter tuned in nightly to see what Curry would do—or where he would shoot from—next.

The 2015 NBA MVP.

THE NEXT STEP

Curry signed with Under Armour in the autumn of 2013—an apocryphal (and adorable) story has his daughter Riley tossing away two other brands' shoes in agent Jeff Austin's home before holding the Under Armour shoe over her head. Of course, there were other, more substantive considerations. Nike had offered Curry $2.5 million per year, but he signed with Under Armour for $4 million—a number Nike had the right to match but didn't. "Under Armour always talks about that underdog mindset that follows them in the basketball world," Curry said at the time, "and that's how I've been my whole career."

There were any number of reasons Under Armour was able to sign Curry, from Nike's carelessness to UA's ability to immediately make him the face of their basketball brand. But they also had a not-so-secret weapon: Curry's Warriors teammate Kent Bazemore. In an outside-the-box move that paid off, Under Armour signed the undrafted guard out of Old Dominion not so much for his own talents but for his proximity to Curry and Klay Thompson. The company sent Bazemore enough gear to outfit an entire franchise, and he became both an NBA influencer and UA's biggest proponent. Curry couldn't help but wonder: If they were treating Kent Bazemore that well, what could they do for him?

The answer was "a lot." Under Armour hoops director Kris Stone remembers telling Curry at their initial meeting, "Go make an All-Star team, go start for an All-Star team, and next year you'll have a signature shoe." Curry went out and had the best year of his career. He averaged a then-career-high 24.0 points per game as the Warriors won 51 games, their first 50-win season since 1993–94. That July, Drake name-dropped him— "I been Steph Curry with the shot / Been cookin' with the sauce, chef, curry with the pot, boy"—on "0 To 100 / The Catch Up," which ended up being one of the summer's hottest songs and earning a Grammy nomination.

Signature shoes are a step beyond mere All-Star status and into cultural zeitgeist territory.

The 2014–15 season was even better. Curry started the All-Star Game and earned his first MVP award. The Warriors went 67-15 under rookie coach Steve Kerr and won their first NBA title since 1975, beating LeBron James's Cavaliers in six games. Curry took 65 threes in the Finals all by himself—making 25—as the Warriors hoisted 186 as a team. They shot more threes than free throws. Andre Iguodala won Finals MVP, but Curry easily could have instead, averaging a team-high 26.0 points to go with 6.3 assists, 5.2 boards, and 1.8 steals. Oh, and he debuted the all-new Under Armour Curry One in January. He'd most definitely earned it.

SIGNATURE

Before designer Dave Dombrow started work on the Curry One, the first person he talked to was Curry's trainer. Dombrow wanted to see what the guard needed most for his ankles and make sure everything started from a stable base. It was all about building confidence—or rather, transferring the confidence Curry had in

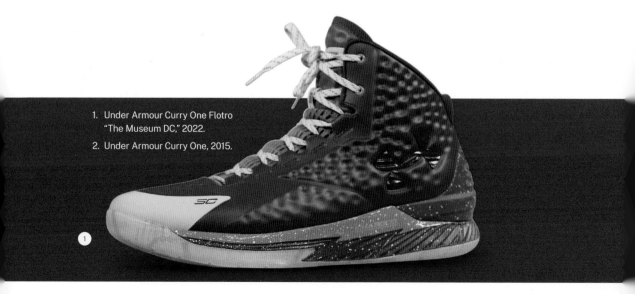

1. Under Armour Curry One Flotro "The Museum DC," 2022.
2. Under Armour Curry One, 2015.

himself to his shoe. Dombrow had learned valuable lessons on the practical limits of minimalism while working for PUMA and designing spikes for the fastest man on earth. "I remember Usain Bolt saying that you needed a certain amount of support on a spike, which meant it wasn't necessarily going to be the lightest," Dombrow said, "because he needed enough support to harness his power."

What mattered most about the Curry One was who it had been designed for. The shoe itself combined innovations with proven elements. A $120 high-top with a sloping front-to-back cut, it featured a new foam-based cushioning developed in conjunction with Dow Chemical and the same traction pattern as UA's earlier, higher-cut ClutchFit Drive (the shoe Curry had started the season wearing). The upper was made from Anafoam, an anatomically molded foam fused with mesh. Most important, there was room for Curry's ever-present ankle braces. Curry's mantra from Philippians 4:13, "I can do all things . . . ," which he'd written on his shoes since Davidson, was incorporated into the Curry One and all his signature models since. At the launch, UA had six colors ready, including a basic black, a Warriors blue and gold, and a bright camo based on the stash of Sour Patch Kids that Dombrow had found at Curry's house.

Signature shoes represent a new achievement level unlocked, a step beyond mere All-Star status and into cultural zeitgeist territory. Curry's shoe made him even more Jordan-like than most; as Under Armour's first signature athlete, he became the foundation for their entire basketball business. It didn't hurt that in the time between the Curry One's design and launch, Curry himself became one of the best-known and most-loved athletes on the planet.

Perhaps the easiest way to define Curry's widespread appeal is that he embodies both Michael Jordan *and* Mars Blackmon, the superstar athlete and the relatable pitchman rolled up into a 6'3" package. It's like if Lil' Penny could actually hoop. Curry is both cuddly and lethal, a wolf in sheep's clothing, Gozer the Gozerian as the Stay-Puft Marshmallow Man. Michael Jordan was a superstar who could pick out the exact spots for you to try to deny him and beat you from there anyway. Kobe Bryant followed that blueprint. But Curry? He began to

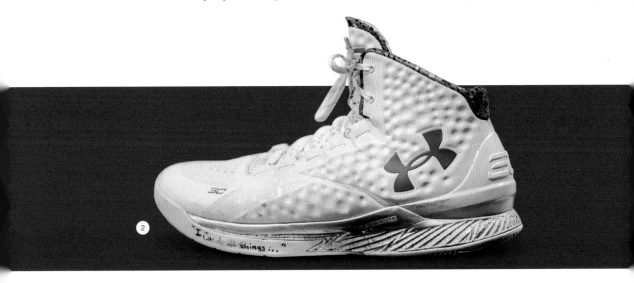

operate in spaces that defenses were not even aware they were supposed to be defending. Jordan was an apex predator, Curry an invasive species. Either way, their opponents were headed for basketball extinction.

THREEDOM

A famous photo from 1992 shows a young Steph sitting courtside with his dad at All-Star Saturday, extending a hand to high-five Kings guard Mitch Richmond. Curry, like Bryant before him, was born into basketball and grew up around professionals. Dell Curry was a masterful shooter in an era when the most prized shot in basketball was one taken at the rim—his All-Star invites were strictly for the three-point shootout. He took part twice, in 1992 and 1994, losing to Craig Hodges in Orlando and Mark Price in Minnesota.

Feeding the post was the priority in the '90s game, with kickouts seen as mostly a last resort. Dale Ellis, who shot 40 percent from three over a 17-year career, made just one All-Star team—as a reserve in 1988–89, when he hit a career-high 48 percent from long distance. (Ellis did at least get a great Costacos Brothers poster, featuring Air Force 2s on his feet and Air Jordan IIs in his gym bag. It was titled "The Silent Assassin.") But even the best three-point shooters of the time didn't get signature shoes, and offenses weren't built around them. Shooters, especially undersized ones, were expendable.

Disposable Heroes

Craig Hodges was one of the best three-point shooters of all time. He led the league in three-point percentage twice, in 1986 with 45.1 percent and 1988 with 49.1 percent. In the summer of 1992, he was the two-time defending three-point shootout champion (and a two-time defending NBA champion) when the Bulls declined to re-sign him. His NBA career was over at 32. Hodges has long believed he was blackballed from the NBA due to his outspokenness on political issues—notably, during the Bulls' 1991 post-championship visit to the White House, he handed George H. W. Bush a letter urging the president to do more to address injustices toward the Black community.

That certainly may have played a role in his career ending so abruptly, but it was also just how things worked for shooters. You need only look as far as his replacement: The Bulls signed former Knicks sharpshooter Trent Tucker, whose 1990 three-point game-winner against Chicago with 0.1 seconds left caused the NBA to change the rules (you now need at least 0.3 seconds to get a shot off). Tucker bettered Hodges's numbers across the board, played in all six games of the 1993 NBA Finals, and he too was not re-signed in the summer of '93. His NBA career was over at age 33.

Stephen grew up in the game.

Curry the elder, who also shot 40 percent from three for his career, spent much of his time in the NBA as a reserve. He was a beloved original member of the Hornets, playing ten seasons there and returning to the Charlotte area upon retirement. In Dell's final season, in 2001–02, teams attempted 14.7 threes per game. In 2012–13, the last season before Steph signed with Under Armour, that number hit 20.0 for the first time, and it's only risen from there. In 2021–22, teams took an average of 35.2 threes per game.

Steph, meanwhile, had obliterated the single-season record with 886 three-point attempts in 2015–16, a record that James Harden soon re-obliterated with 1,028 in 2018–19. Curry's other record of 402 made threes (set that same MVP season) has yet to be eclipsed; in comparison, Dell's 2002 Raptors made 387 threes as a team.

Steph Curry's immediate spiritual predecessor was another Golden State Warrior, if only for two seasons. In 2001, the Warriors used their second-round pick on Gilbert Arenas, a sophomore guard out of Arizona. By his second year with the Warriors, he was an everyday starter—and, as it turned out, too good for the Warriors to afford to keep. After signing with the Washington Wizards, he led the NBA in minutes played in 2005–06 and three-point makes and takes in 2006–07, and became a perennial All-Star and cult favorite. He dropped 60 points on Kobe Bryant and 54 on the Phoenix Suns, launching absurdly deep threes whenever he got the chance (and yelling "Hibachi!" as he did so).

Curry took Arenas's bug and made it a feature. In any other generation, from any other player, a Steph Curry shot would have resulted in an immediate benching. He shot off the dribble from 35 feet, always with a hummingbird-quick release. Through endless repetition, he

Curry shot off the dribble from 35 feet, always with a hummingbird-quick release.

became so attuned to what a make felt like off his fingers that he could turn around and head back upcourt while the ball was still in the air, confident it would go in. Curry was free to unload at any moment in the game and at any point in the shot clock, forcing defenders to decide whether to faceguard him at midcourt and risk a blowby or lag back and risk giving up an instant triple. It resulted in games that were more past-versus-future than Warriors-versus-whomever, with an opposing team battling to score two and then giving up three points on a ludicrous shot just seconds later.

Agent Zero

Gilbert Arenas wasn't just ahead of his time with his Curryesque long-range shooting. He was the original NBA player-blogger, he wore low-tops before Kobe, and he displayed his many interests and inspirations on his shoes. In 2007, Arenas got a signature sneaker from adidas — the TS Lightswitch Gil II Zero — with dozens of limited-edition makeups dedicated to *Halo*, *SLAM* magazine, and his hometown of Los Angeles. They included a "Watch Me Not TV" pair, a "Vote Gilbert" pair, and a "Black President" pair, and he intended to wear a different version in nearly every game. But real life intervened.

Watch him, not TV.

Arenas tore up his knee eight games into the 2007–08 season and played just seven more games over the next two years. He was never the same player, and after a free-agent sneaker run like Kobe's (in which Arenas even wore a pair of Dolce & Gabbana shoes in a game), an unfortunate locker room incident involving guns, and cascading injuries, he was out of the NBA at age 30.

BREAKING THE GAME

It is difficult to compare Curry's rise to anyone else's save perhaps Bill Russell. When Russell joined the Celtics in 1956, his shot blocking dominated a league that had known no such thing. The previous generation of NBA bigs, virtually all accustomed to one style of play, found themselves tested in unseen ways. Shots

that had hitherto gone unchallenged were swatted back, sparking the Celtics break. Red Auerbach parlayed that singular skill from a singular player into 11 championships in 13 seasons.

Russell may have won 11, but Curry's four rings have come in a league of 30 teams (instead of eight) that are all much quicker to adapt. Of course, Curry didn't invent the three-pointer. But he broke the NBA, and the league has stayed broken—there is no way for a five-man team to guard 35 feet out for 24 seconds with the same intensity once used to guard 10 feet and in. A three-pointer off a kickout as the shot clock expired had been something you lived with. A three-pointer launched from 35 feet in transition—that's now something you die by.

As the Warriors fortunes rose, so did Under Armour's. The company's net revenue soared from $2.3 billion in 2013 to $4 billion in 2015. By March 2016, a Morgan Stanley analyst noted that Curry's signature sneaker business was larger than anyone's not named Michael Jordan and posited that Curry could be worth as much as $14 billion to Under Armour's bottom line. Perhaps Steph should have renegotiated his deal. Meanwhile, the kids who watched Curry play and pestered their parents for his shoes didn't know or care that he started his NBA career in Nikes or that UA didn't even exist as a brand until Michael Jordan was four championships deep. Under Armour had always existed for them, just as Steph Curry had always been a star.

Curry was well aware of that lack of company history and saw it as more of an advantage when he signed. "[Y]ou can't really talk about their past, it's more about their vision going forward and how things will come out as we go on for the next five years of my deal," he said in 2013. "To be a part of that process and see it grow and every year it be something new, will be fun." He wasn't kidding.

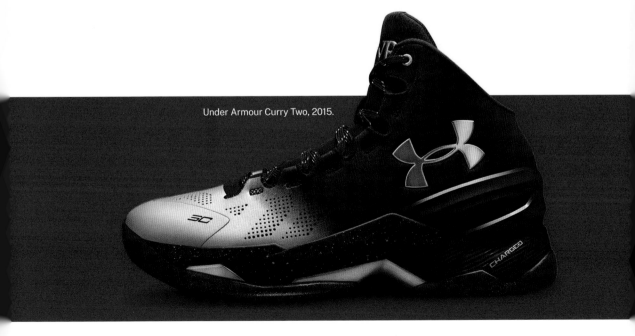

Under Armour Curry Two, 2015.

Under Armour didn't sign a true second NBA star until Joel Embiid in 2018, which gave the Curry line years to grow without UA's focus fragmenting to launch another player's shoe. Steph had laid the foundation and helped shape Under Armour as a basketball brand. They brought out his Curry One in Lux and low versions, and then gave it an encore at the end of the following season. The "B2B" pack paired a graffitied-up makeup of the One with the Curry Two to celebrate his back-to-back MVPs.

UA also tried out new styles, like the all-white "Chef" Curry Two low-top, which, after the release of an unflattering promo shot, was clowned unmercifully on social media for being bland and swagless—but it got noticed. And given how well the Curry One sold, Under Armour could laugh, too. According to an Undefeated story at the time, UA profited to the tune of $264 million off Curry's line in the first quarter of 2016 alone. And in 2020, the superstar finally got the full brand treatment. Curry Brand launched seven years into his Under Armour partnership, five years quicker than Nike had launched Jordan Brand.

To some, this approach wasn't anything novel. "Everyone's trying to create their own brand," David Falk said. "All they're trying to do is replicate what Michael did forty years ago. Why is it that no one's come along with the next new thing in forty years?" The reasoning seems pretty simple: What Falk did with Jordan represented a complete paradigm shift, and every basketball player since then has existed in that new paradigm. It validated the idea that superstar individuals can be marketed in a team sport. Air Jordan built a new world, one where Curry Brand would be an inevitability for a player so talented and broadly popular.

There is no need for every ensuing generation to reinvent the wheel—or the signature shoe model. It has endured for a reason. Signature shoes can both reflect and enhance a player's personality, allowing fans to share in it. But if basketball sneakers aren't based as much on personality, then what will the future look like?

Steph rocks Under Armour Curry 4 Flotros in the 2022 NBA Finals.

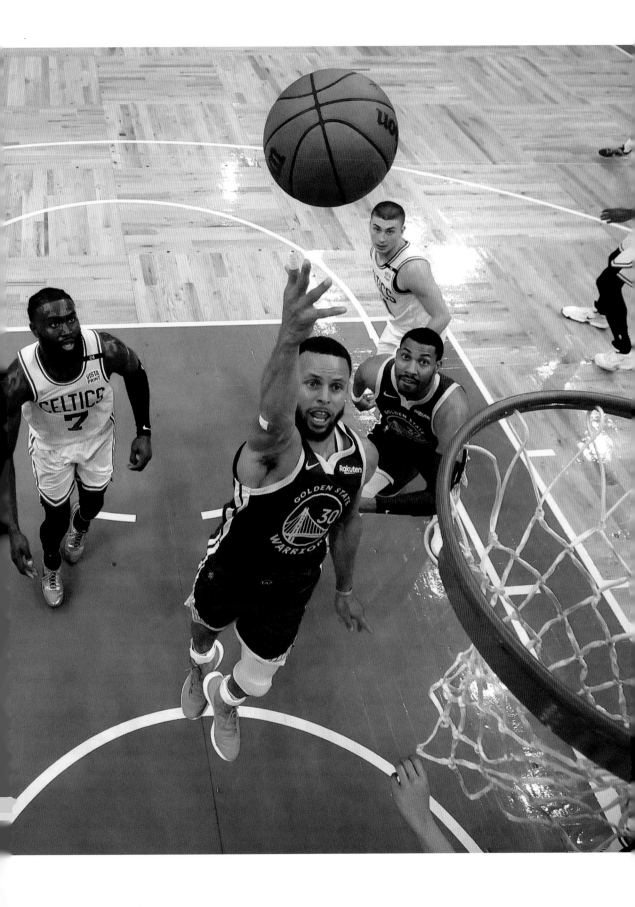

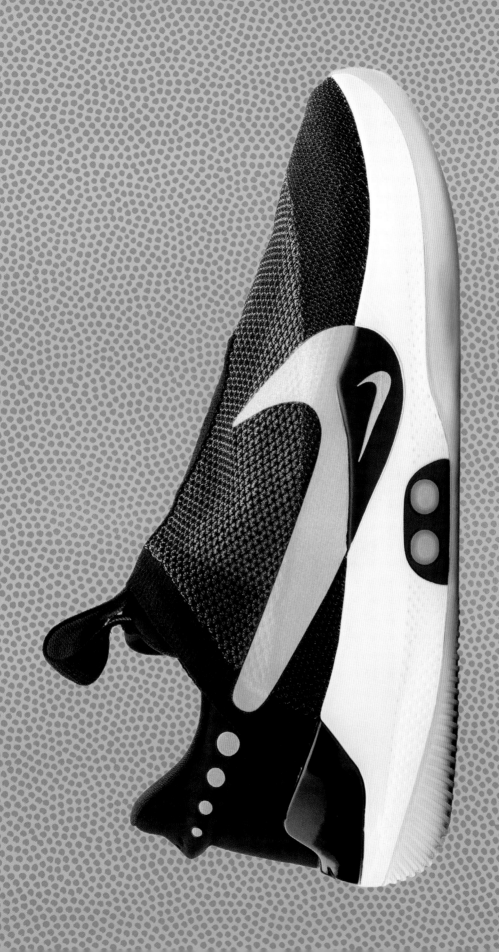

Future Shock:
Nike Adapt BB

Converse Chuck Taylor All Star
1917

Adidas Superstar
1965

PUMA Clyde
1971

Adidas Top Ten
1979

Nike Air Force 1
1982

Nike Air Jordan
1985

Reebok Pump
1989

Nike Air Force Max
1993

Nike Air Swoopes
1995

Nike Air Jordan XI
1995

AND1 Tai Chi
2000

Nike Air Zoom Generation
2003

Nike Zoom Kobe IV
2009

Under Armour Curry One
2015

Nike Adapt BB
2019

Back in 1988, Nike designer and futurist Tinker Hatfield created a sneaker for the year 2015. The original Robert Zemeckis and Bob Gale script for *Back to the Future Part II* introduced the fictitious Nike MAG, so named for its "magnetic" feature that would allow the wearer to walk up walls. When Hatfield was invited to weigh in, he thought that idea was pretty weak and could do better. What he came up with instead was a super-high-cut shoe with the same MAG name but different features: The sneaker lit up as "power laces" tightened themselves with a servo whine. His idea was that you put your foot in the sneaker and it came alive.

Not only did Hatfield design the shoe (which had a familial resemblance to the yet-to-be-released Air Pressure, Nike's 1989 inflatable basketball sneaker), but he also wrote and storyboarded the scene. It was just one of those things that was a fun project even if the shoe's power lacing wasn't for real. Hatfield and his fellow designers were always looking into the future, and 27 years was a lot, even by their standards. But that's where things got confusing—and more interesting.

MAKE IT REAL

The movie debuted at number one and a self-lacing sneaker designed in 1988 for a fictional future started to influence, well, the actual future. It went from something dreamed up by one man at Nike to a part of the collective consciousness, becoming one of those things where you asked yourself, "Could this really work someday?"

Whether you were a kid or a professional sneaker designer in the '80s and '90s, you wanted it—and soon, not decades later in 2015. You became nostalgic for something that didn't even exist yet. And sometimes you just have to wonder, had Hatfield designed something different, or had he not been asked to work on the movie at all, would the present be the same? Think of it this way: A sneaker that Hatfield designed in the past to define the future ended up changing the present. And you thought that kind of thing happened only in the movies.

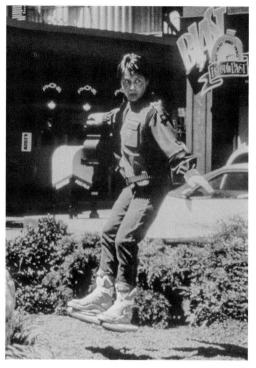

Marty McFly in the Nike MAG.

What About 2015 Basketball, Though?

It's kind of a bummer that *Back to the Future Part II* never really touched on hoops in 2015, seeing that *Grays Sports Almanac*—which admittedly only covered up to *Conan O'Brien voice* the year 2000—played such a major role in the plot. It's likely, of course, they would have gotten everything wrong.

Back in 1989, when *BTTF2* was shot, it was the time of the Bad Boy Pistons—a Biff Tannen team if there ever was one, the Pit Bull Hoverboard of basketball. Detroit was enjoying their first championship run, a 63-win team with Bill Laimbeer punching, Vinnie Johnson microwaving, and Isiah Thomas smirking. They were slow, dead last in pace, first in your face.

By the real October 21, 2015, the regular season was about to start. Stephen Curry, who had been a year old in 1989, was set to lead his Warriors to a record 73-win season, earn his first MVP, and blow a 3-1 series lead to LeBron's Cavaliers in the 2016 NBA Finals. No one could have predicted that result during the Finals, much less 26 years in advance. Still, maybe Marty McFly should have stuck around.

Of course, laceless basketball shoes weren't unprecedented. Back in 1991, PUMA introduced the Disc Blaze runner, which tightened and loosened wires overlaying the foot via, yes, a disc mounted above the tongue. By 1993, laceless tech reached the NBA in the form of the Disc System Weapon on the feet of PUMA's primary endorser: defending Slam Dunk champion and Suns forward Cedric Ceballos, a.k.a. Discman. (How did PUMA not get sued by both Sony and Converse for the shoe's name?) But it didn't last. Ceballos couldn't defend his title in the '93 Dunk Contest and broke his foot before the Suns reached the Finals. By '94, Ceballos was back with Nike while PUMA dropped out of the NBA until signing Vince Carter in '99.

Based on archaeological discoveries, shoelaces were first in use roughly 6,000 years ago and the basic concept has hardly changed since. Laces are simple, cheap, easy to replace, and do their job well. They can fail in only two ways: They can break, and they can come untied. If a shoelace breaks, you get a new lace. If something like PUMA's Disc System broke, you got a new shoe. But back in the early '90s—the halcyon days of the Reebok Pump and ever-expanding Nike Air windows—every brand was looking for a way to stand out.

Even into the mid-2000s, brands were minimizing and hiding laces. In 2004, the Air Jordan XIX had its thin, vestigial laces covered with a structural mesh shroud (the original intent was to go laceless, but they couldn't get the lockdown fit they wanted). The following year, Reebok did something similar with Allen Iverson's Answer IX, except with two Velcro straps and an auto-Pump setup. Yes, both pairs technically had laces, but you didn't have to tie them—or see them.

The MAG was something much different. The push for Nike to make a real power-lacing shoe came from the sneaker community, who had come to think of Marty McFly's shoes as less of a prop than a promise. There were grassroots petitions from collectors asking for an auto-lacing Nike MAG release by the date indicated in the movie—October 21, 2015. The future, as it turned out, had a deadline. This was going to be a bit more difficult than mass-producing something that had already existed as a one-off.

1. Puma Disc System Weapon, 1993.

2. Jordan Brand Air Jordan XIX, 2004.

Enter: Tiffany Beers. The designer grew up an athlete, with Nike posters on her wall and Nike NDestrukts on her feet. She found her way to the Swoosh in 2004, and one of her first Nike projects was designing interchangeable cushioning pods for the Air Jordan XXI. But the thing about working for Nike is you can find yourself pulled into just about anything. Introduced to Tinker Hatfield in 2005, she was asked whether she could make an old movie prop a reality. Not having the slightest idea how much work it would require, Beers did the only thing you can do in a situation like that: She said yes.

Beers began her quest at a nondescript building called DNA, the Department of Nike Archives, on the fringes of Nike's Beaverton campus near the vaunted Employee Store. The clandestine DNA contains all sorts of artifacts from the brand's past. One of those is an original Nike MAG prop, now crumbling as most polyurethane-based shoes from that era tend to do (and as any collector of vintage Nike, including this author, can attest). As Beers would discover at DNA, the original MAG was not a self-contained unit; it existed as a "self-lacing shoe" only on the screen. The Hatfield-penned scene was moviemaking magic, not technological wizardry.

This was about an experience, not performance, the future driven by nostalgia.

"I fully expected to see pictures of old pattern files and all the details," Beers said. "Like, I thought Nike has this all—all I have to do is get this packet out, turn the machine on, and start making it, right?" She laughed. "Man, was I sorely shocked there." Even before trying to get "power lacing" to work, it was a monumental task just recreating the shoe and packing in all the electronics for the lights. A limited MAG would release in 2011—complete with a 3,000-hour battery—but you had to tighten the laces yourself.

With power lacing, Beers was developing something entirely new from the ground up. She needed to source tiny electric motors—she first tried the ones

The Nike MAG
was a prop . . .

that power toy trains, but there wasn't much room to spare in the low-profile sole. It had to work just right; after all, this was about an experience, not performance, the future driven by nostalgia. It took a lot of trial and error and a lot of trips to Asia, but they made the deadline. Michael J. Fox put on the new, power-lacing MAG on *Jimmy Kimmel Live!* on October 21, 2015—the date Marty received them in the movie. A year later, Nike auctioned off an 89-pair run that raised $6.75 million for the Michael J. Fox Foundation.

MAKE IT USEFUL

Nike being Nike and Hatfield being Hatfield, making a mere movie prop real wasn't enough. The intent from the beginning was to use power lacing in a shoe that people could and would wear. Like most other technology, it would be prohibitively expensive at first, but as refinements came and production scaled up, the cost of entry would fall.

Nike's first auto-lacing performance shoe was dubbed the HyperAdapt 1.0, or E.A.R.L. (Electro Adaptive Reactive Lacing), and was intended not as a hoops shoe but rather a do-anything sneaker, much like the Chuck Taylor of the '50s and '60s. Of course, at $720 a pair, it was a mite expensive for something just to kick around in. But that's the price you pay to be first. The HyperAdapt featured the same servo whine as the MAG, something that could have easily been eliminated. But, thanks to *BTTF2*, the whine was considered an essential part of the self-tightening experience. It stayed.

Even before the HyperAdapt 1.0's debut in 2016, Hatfield was considering the next application: basketball. He may be best known for his sneaker designs—he created the original Air Max runner, the Huarache, and every shoe Jordan wore as a Bull from the III onward—but he remains a futurist and fantasist at heart, Nike's Willy Wonka right down to the hats. Sure enough, hoops was the most promising fit for the new basketball Adapt project helmed by Eric Avar and Ross Klein, and the designers were well on their way.

. . . but the Nike E.A.R.L. was an all-purpose shoe.

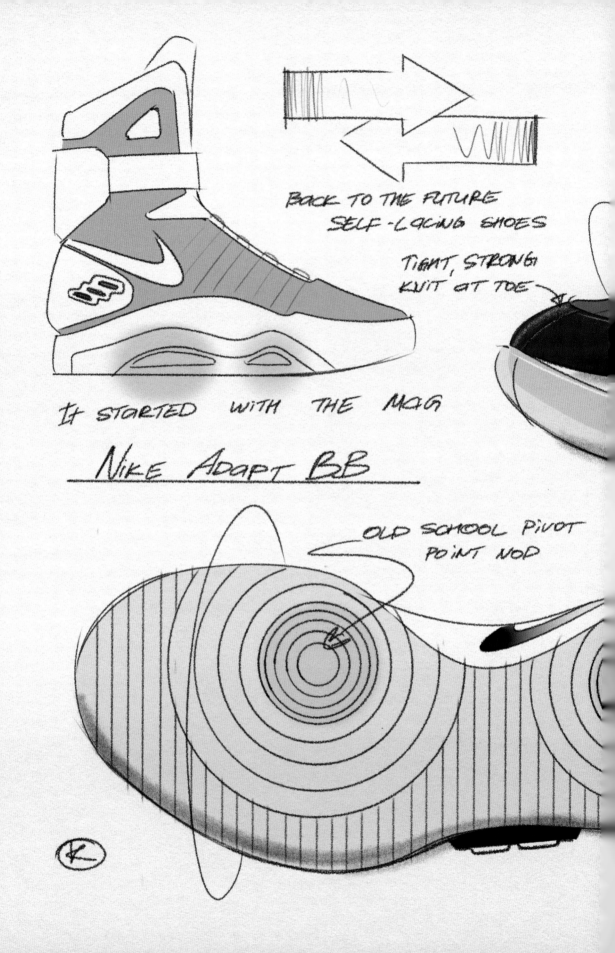

BACK TO THE FUTURE
SELF-LACING SHOES

TIGHT, STRONG
KNIT AT TOE

It STARTED WITH THE MAG

Nike Adapt BB

OLD SCHOOL PIVOT
POINT NOD

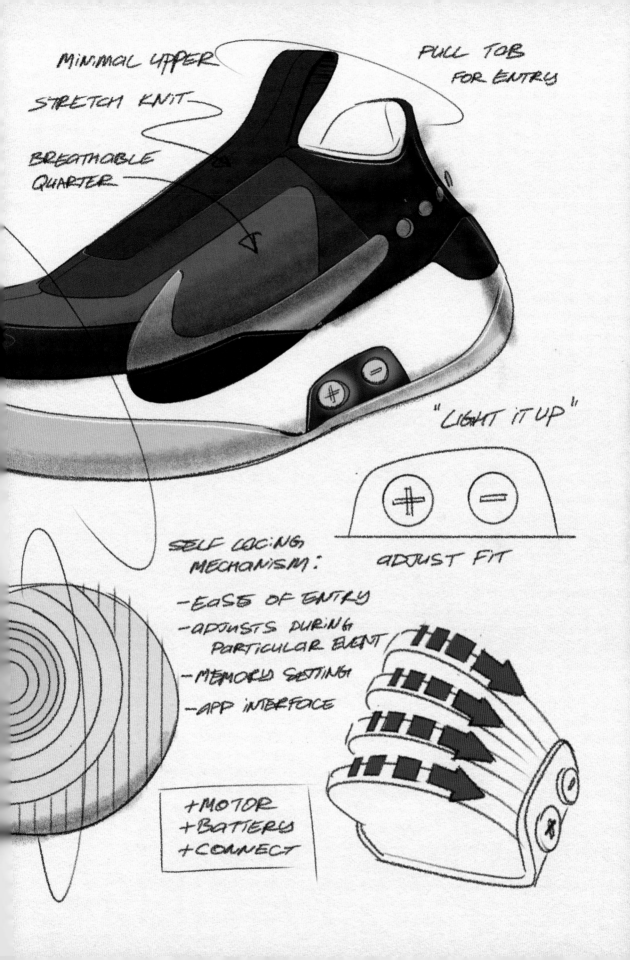

MINIMAL UPPER

STRETCH KNIT

BREATHABLE QUARTER

PULL TOB FOR ENTRY

"LIGHT IT UP"

SELF LOCING MECHANISM:

ADJUST FIT

- EASE OF ENTRY
- ADJUSTS DURING PARTICULAR EVENT
- MEMORY SETTING
- APP INTERFACE

+MOTOR
+BATTERY
+CONNECT

Basketball players tend to lace their shoes tightly, and while that makes sense during play, hoopers also spend a lot of game time *off* the court, where they benefit from loosening their shoes to allow for better blood flow. For evidence, go into any NBA locker room while guys have their shoes off and look at their feet. (On second thought, don't. It's not pretty. Toes somehow wind up in places where toes really shouldn't be.) Dennis Rodman, who was excoriated for petulantly taking off his shoes while on the bench with the Spurs, actually had the right idea. What if, Hatfield speculated, you could loosen your shoes at the press of a button, then retighten them the same way? It was the same basic concept as the Reebok Pump, only without all that pumping.

The third self-lacing Nike shoe, 2019's Adapt BB, was, like Hatfield's Air Jordan III from decades earlier, a game-changing mid-cut. The advanced tech was all in the lacing, powered by a small electric motor and a charging pad to rest your shoes on when not wearing them. You could tighten or loosen the shoe via a pair of glowing, light-up buttons on the midsole, and there was still that signature whine. The present had finally caught up with the future—and surpassed it. Maybe they should have called it the MAG 2.

> *The present had finally caught up with the future— and surpassed it.*

The sneaker didn't have quite the same cultural impact as its elephant-print forebear, owing in part to its $350 retail price and limited production. The Adapt BB also wasn't a signature shoe with a superstar athlete driving sales. But beyond that, performance basketball sneakers were no longer the off-court status symbol that they once were in the '80s and '90s. The use of synthetic materials has made modern-day hoops shoes less street-worthy, just as the perpetual availability of retro models from every era has satisfied all the needs of status-seeking consumers.

Adjusting the fit of the Adapt BB.

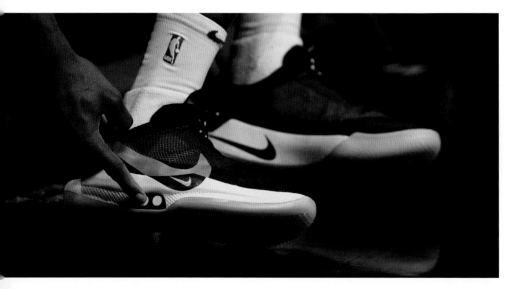

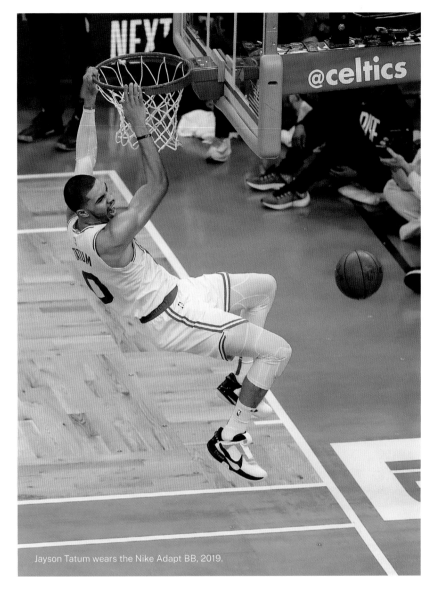

Jayson Tatum wears the Nike Adapt BB, 2019.

On January 16, 2019, Adapt BB made its NBA debut on the feet of 6'8" Boston Celtics swingman Jayson Tatum, who scored 16 points in a home win over the Raptors. The young forward had worn Nike in high school in St. Louis, in college at Duke, and in the Olympics for Team USA. Drafted third overall by the Celtics in 2017, Tatum signed with the Swoosh and started out in Paul George's signature PGs in rookie league before playing the games that really mattered in the newest Kyries. In his second season, he became the Adapt's earliest NBA adopter, a player defined more by his abilities than his size. By his sixth season, he'd break the All-Star Game scoring record and be an undisputed MVP candidate. The future had arrived in the NBA via a movie from the past, a self-fulfilling sneaker prophecy debuted on court by a player who was born ten years after *BTTF2*'s initial release.

REIGN OF TECH

There has since been an Adapt BB sequel, the Adapt BB 2.0—one pair was even done up in a MAG-inspired colorway of silver shades with an array of bright lights. The impact of Adapt, despite the clamor for the MAG, has been muted. Power lacing has yet to replace old-fashioned shoelaces—only PUMA has thus far introduced their own takes on auto-lacing with AutoDisc and Fit Intelligence—and the price of entry remains high enough that they remain out of reach for many. Tatum himself wore the shoe for only a single season before joining Jordan Brand.

It's still too early to tell whether power lacing represents a real step forward or just another evolutionary dead end.

It's still too early to tell whether power lacing represents a real step forward or just another evolutionary dead end. A lot of times with sneakers, futuristic tech hasn't had a future. Some concepts painted themselves into corners. Back in 2011, adidas introduced the Crazy Light, which they claimed was 15 percent less heavy than the lightest performance basketball shoe ever. The sequel, released the following year, needed to be even lighter than that. You see where this is going.

The history of basketball sneakers is littered with technological detritus, from LA Gear's Catapult to adidas's a3 to Converse's React Juice, most of which promised to make you jump higher, land softer, or, as Larry "Grandmama" Johnson would have it, let you dunk on fools while wearing a dress. Converse even put helium in a shoe once. Nike had made these sorts of wild technological leaps before, too. In 1997, they launched the $180 Foamposite One, a molded foam shoe inspired by a similarly constructed sunglasses case. Made in royal blue for Penny Hardaway, they were another learn-as-you go design that rewarded early adopters with a flashy product but were heavy with a so-so fit. Ensuing evolutions were both better and cheaper.

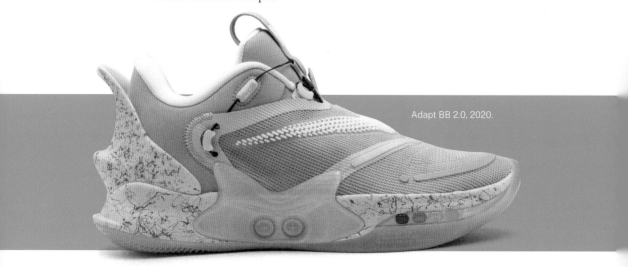

Adapt BB 2.0, 2020.

Puma RS-Computer, 1986.

The Adapt wasn't the first computerized shoe. That started with adidas's Micropacer runner in 1984, a sleek sneaker that measured the running basics—elapsed time, distance traveled, calories burned—and displayed them on a unit set in the middle of the tongue. Two years later, PUMA released the RS-Computer, a running shoe with a bulbous protuberance at the heel that recorded the same data, which was retrievable by plugging the shoe itself into your Apple, IBM, or Commodore computer. In 2006, Nike teamed up with Apple for Nike+, in which you placed a wireless transmitter in the midsole of your shoe that communicated information to an iPod. Nike+ started with the Zoom Moire runner before expanding throughout the running line and later into basketball with the Hyperdunk and LeBron 10.

But those were all just ways to collect data. Computerization didn't come to performance until 2005's $250 adidas_1 runner, which used a microprocessor to monitor and constantly adjust "intelligent cushioning" in the heel. In 2006, they released a basketball version, which Tim Duncan wore in the All-Star Game—a

smart shoe for a smart player. Soon-to-be adidas brand president and CEO Erich Stamminger had sky-high ambitions for the adidas_1: "This product will change the entire sporting goods industry," he predicted. "It is a true first and establishes adidas as a clear leader in the field of innovation." Suffice it to say that a decade-plus later, there has yet to be an adidas_2.

ANALYTICS

The Adapt BB was the perfect shoe for the high-water mark of new basketball analytics taking NBA front offices by storm. Here was footwear for the Revenge of the Basketball Nerds. The 2010s marked the time of MBA GMs like Daryl Morey and Sam Hinkie, the MIT Sloan Analytics Conference (which Morey founded), Nate Silver's FiveThirtyEight, and blogs like Wages of Wins. Team personnel and fans alike now followed a plethora of advanced stats, from PER (Player Efficiency Rating) to WARP (Wins Above Replacement Player—not to be confused with VORP, Value Over Replacement Player), and RPM (Real Plus-Minus) to LEBRON (*deep breath* Luck-adjusted player Estimate using a Box prior Regularized ON-off).

Basketball is a dynamic sport—unlike baseball or football, the players do not restart from the same positions after a play concludes. As such, basketball analytics have always been best utilized as supplemental tools, pointing out patterns and skills that don't show up in a regular box score. A major inflection point was Michael Lewis's 2009 *New York Times Magazine* cover story on then-Rockets forward Shane Battier, "The No Stats All-Star." It served to introduce casual fans to Morey (hired at age 33 to transform the Rockets), Philly's Sam "Trust the Process" Hinkie, and the idea that a player could be a star without being, well, a star. (Never mind the fact that the game framing the story ends in a Rockets loss, with Kobe Bryant—Battier's man—hitting the winning shot.) Lewis also showed that there are things you can never predict: In that same game, Rockets journeyman guard Von Wafer filled in for an injured Tracy McGrady and shot 10-of-14 and 3-of-4 from three for a career-high 23 points. The real moral of the story seemed to be that you could do all the studying and preparation possible, but the team with the best player was still likely to win.

Analytics are great, but it's possible to take them too far. With so much basketball data now at our disposal, you can develop tunnel vision. Offensive and defensive efficiency—good. True shooting percentage weighed for three-pointers and free throws—great. But they became a way for people only capable of thinking in numbers to quantify elements of the game that standard statistics cannot address. It's worth noting that even the Sixers themselves eventually lost trust in their data-driven rebuilding strategy. Neither Hinkie—out of the NBA since he resigned from Philadelphia in 2016—nor Morey has yet to assemble a championship team. It's possible for a front office to focus too much on the numbers, just as it is for a shoe company to focus too much on the technology.

Peak Performer

Shane Battier gets defensive.

Shane Battier, who was not only a smart basketball player but an actual genius, had no illusions that he'd be a conventional superstar. He was willing and able to do the dirty work—guard his man, stay involved, spread the floor—while others did the bulk of the scoring. But as a four-year Duke player who won the consensus national player of the year as well as the Most Outstanding Player of the 2001 Final Four, he got a lot of endorsement opportunities as a rookie, including a shoe deal with Oakley—yes, that Oakley, the one that makes the sunglasses. Later he signed with adidas, then entered a long-term partnership with Chinese brand Peak—it's good to be Yao Ming's teammate—whose Battier signature line lasted longer than Battier's NBA career. Basically, the "No Stats All-Star" was a better P. J. Tucker with far worse taste in shoes.

Y, THO

Would loosening one's Adapt BB shoes every time a player leaves the floor be better for the feet? The studies say yes. But will any player be diligent enough to do that, even if it's as simple as pressing a button? Or be willing to do away with laces and rely on a high-tech system for something that can be effectively duplicated with a Velcro strap? In 2016, three years before the Adapt BB's launch, Nike released the LeBron Soldier 10, a laceless high-top with three massive Velcro straps. James wore it in the 2016 NBA Finals as his Cavaliers became the first team in NBA Finals history to overcome a 3-1 deficit, beating the 73-win Warriors in seven games. With designer Jason Petrie focusing the Soldier line on minimalist lockdown, the 10 took a huge step forward—here was Nike's first true laceless basketball shoe, proven by their biggest player on the NBA's biggest stage.

But despite all that, it wasn't a game-changer. While Petrie experimented further with straps in subsequent Soldier sneakers, LeBron's primary signature shoes kept their laces. Just because something works better doesn't mean it takes over. And the shoelace won't be replaced that easily. It's simple, it works, and it's cheap. Maybe, like the Pump, the ultimate application of Adapt would be the ability to tighten and loosen one's shoes at the press of a button while still having laces. As adidas discovered when going for pure lightness, sometimes good design requires balance. Kind of like a team *only* taking threes or dunking: Maybe mixing some midrange in there would be smart.

Basketball shoes have been around for well over a century, and rather than having traced a continuous evolutionary line, it has been more like a bell curve, starting and ending minimalist, with a baroque peak in the '80s and '90s. When Converse relaunched their basketball program in 2019 with the All Star Pro BB, they incorporated the same mesh that Nike (now their corporate owner) used on the Adapt, all while revisiting many of the concepts and features that had originated with the original All Star a hundred years earlier. There were no steel eyelets, but the reinforced mesh upper and tongue were thin, ensuring a snug fit. The sole, with its Chuck-inspired diamond outsole pattern, was fused to the upper rather than stitched, and cushioning was delivered via a proprietary foam.

Retail for the Pro BB was $140—admittedly quite a bit higher than even the inflation-adjusted price of an original pair of All Stars. But despite the material and construction advancements, it was a shoe that Marquis Converse would have recognized. Chuck Taylor, too. Red Auerbach would have balked only at the price. His players may have had to make do with just one pair per season.

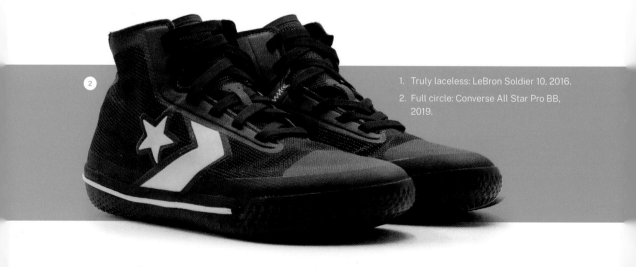

1. Truly laceless: LeBron Soldier 10, 2016.
2. Full circle: Converse All Star Pro BB, 2019.

Pon de Replay: What About Retro?

Until the turn of the Willennium, sneaker history was linear. That's not to say that old sneaker designs never coexisted with new ones: The Chuck Taylor All Star, the adidas Superstar, and the Nike Air Force 1 all stayed in production with nary a pause (well, AF1s had a little pause). But they were continuations, not rereleases. The few rereleases that brands attempted didn't sell so well. It wasn't for lack of effort. When Nike brought back the first three Air Jordans with deluxe packaging and informational postcards in 1994 and 1995 to celebrate MJ's retirement, the world responded with a collective yawn. An industry that had always pushed the new found few takers for the old.

By the time of Jordan's *second* retirement in 1998, however, attitudes had changed. More people were seeking out old styles or at the very least were aware of them. The Beastie Boys had revived interest in the PUMA Clyde and the adidas Campus. Outkast rocked Mitchell & Ness throwback jerseys in 1998's "Skew It on the Bar-B" video, and Allen Iverson wore one on an iconic 1999 *SLAM* cover. Old wasn't just old anymore, it was nostalgic. Jordan Brand—by then its own entity—rereleased Air Jordan Is, IVs, Vs, and XIs in 1999 and 2000, and this time they were massive hits.

Retro became a category unto itself, a shift that created unintended consequences. For many consumers, it offered a shortcut. Rather than take a flier on a new model that might not be perceived as cool, you could spend your $100 on a pair of sneakers that were *already* cool. If you weren't going to play basketball in them—and 90-plus percent of basketball shoes sold never see a court—then why not stick to the classics? While new basketball shoes had always been compared to their predecessors, now they were getting sold right alongside them. There were still compelling new options, but sometimes it was easier to just relive your past—or someone else's.

Even NBA players—including Jordan himself, by then adding an epilogue to his career by suiting up for the Washington Wizards—embraced retro styles. MJ wore current Air Jordans (along with lower-cost Jumpman models) in Washington but also Air Jordan IIIs, VIIs, and XIs, revisiting earlier stages of his career. For decades, sneaker brands had touted advancements in technology as reasons for basketball players to stay up to date. There were always outliers—like Rasheed Wallace in Air Force 1s—but for the most part, players played in the newest shoes that their respective brands had to offer. Not anymore. And if *Michael Jordan* could play NBA games in sneaker technology from 1988, maybe you didn't need the latest shoes, either.

While Jordan's presence looms over the sneaker world, he has cast an even wider shadow over the game. Any GOAT argument seems to start and end with Michael, his six-of-six Finals record used to dismiss any would-be challengers. The base of the Jordan statue outside the United Center in Chicago reads, "The best there ever was. The best there ever will be." But Jordan isn't the ultimate standard bearer in everything: Bill Russell won more championships, Kareem Abdul-Jabbar earned more MVPs, LeBron James has scored more points, Dr. J flew just as high. Every generation stood on the shoulders of those who came before. One essential difference, though, is that Jordan became omnipresent in ways his predecessors couldn't—through highlights, through video games, and, of course, through sneakers.

The rise of retro meant you could buy just about any Air Jordan. But a tectonic shift came to the NBA in the summer of 2018, when the league finally lifted the uniform rule that required players to wear white- or black-based sneakers similar to those of their teammates. The NBA had finally become a world that a sneaker like the original Air Jordan could no longer disrupt. Adam Silver wouldn't need to send any threatening letters.

But if something was gained—players being able to wear whatever they wanted whenever they wanted, free to express themselves with

their footwear—something was lost, too, and not just any semblance of team unity through footwear. Suddenly every game was the All-Star Game, every day was Christmas. Certain shoes from the past were special because of when they were worn and how they stood out against everything else; they become less special when they're worn all the time. Take the "Grinch" Kobe 6, a shoe that Kobe Bryant wore for the Lakers' Christmas Day game in 2010. Nike reissued it on Christmas Eve in 2020, and the lurid lime-green shoe has seemingly been worn by at least one player in every NBA game since.

Had the entire basketball sneaker market settled fully into retro, and had Michael Jordan been universally accepted as the forever GOAT, the story of both basketball and basketball sneakers would have effectively ended there. A century-plus–long evolution would have reached its conclusion. But retro has only partially eclipsed new performance models, providing on-shelf and on-court context and competition, just as the NBA has entered an era more stacked than ever with young, transcendent talent. Incredibly, the first NBA game Jordan ever saw was the first one he played in; now players grow up with unprecedented on-demand access to the game's past and present. Today's superstars have their own heroes. Kobe grew up wearing Air Jordans and watching tapes of Magic and Bird; Luka Dončić and Giannis Antetokounmpo started off in Kobes and now have signature lines of their own.

Retro allows you to look back even while both sneakers and the sport continue to move forward. Virtually every featured shoe in this book has been made available again—or should be—allowing new generations to experience and put their own spin on what came before. Anyone can go back and watch not just highlights but entire games. Put them together and you get the fullest historical view that any generation has ever had. With the entirety of the past at everyone's fingertips, the future is wide open.

Even MJ couldn't resist retros.

SNEAKER ANATOMY

CUPSOLE: A stitched or glued on one-piece sole unit that the foot sits down in instead of on top of.

EYESTAYS: A typically U-shaped portion of the upper where the eyelets are.

FOXING: A strip of material on a vulcanized shoe that helps secure the upper to the sole.

HEEL COUNTER: A stiff piece of material (generally plastic) that holds the heel in place.

INSOLE: A thin piece of padding, often removable, that the foot rests on.

LATERAL SIDE: The outer side of the shoe.

MEDIAL SIDE: The inner side of the shoe.

MIDSOLE: The part of the sole that does not touch the foot or the ground.

MUDGUARD: The wrap around the toebox.

OUTSOLE: The portion of the sole (usually rubber) that touches the ground.

SHANK PLATE: A stiff insert — generally plastic, carbon, or steel — in the midsole that adds flex and prevents twisting.

SOCKLINER: A fabric or leather inner lining that the sock (or foot) comes into contact with.

TOEBOX: The entire forward part of the upper.

UPPER: Everything above the sole.

VAMP: The portion of the shoe over the forefoot/toes.

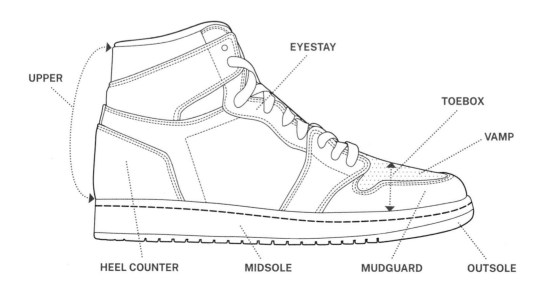

UPPER

EYESTAY

TOEBOX

VAMP

HEEL COUNTER MIDSOLE MUDGUARD OUTSOLE

BIBLIOGRAPHY

Abdul-Jabbar, Kareem. *Coach Wooden and Me: Our 50-Year Friendship On and Off the Court.* New York: Grand Central Publishing, 2017.

Abdul-Jabbar, Kareem, and Peter Knobler. *Giant Steps.* New York: Bantam, 1983.

Abrams, Jonathan. *Boys Among Men: How the Prep to Pro Generation Redefined the NBA and Sparked a Basketball Revolution.* New York: Crown Archetype, 2016.

Albom, Mitch. *Fab Five: Basketball, Trash Talk, the American Dream.* New York: Warner Books, 1993.

Axthelm, Pete. *The City Game: Basketball from the Playground to Madison Square Garden.* New York: Pocket Books; 1971

Barkley, Charles, and Roy S. Johnson. *Outrageous! The Fine Life and Flagrant Good Times of Basketball's Irresistible Force.* New York: Simon & Schuster, 1992.

Barkley, Charles, and Michael Wilbon. *I May Be Wrong but I Doubt It.* New York: Random House, 2002.

Barry, Rick, and Bill Libby. *Confessions of a Basketball Gypsy: The Rick Barry Story.* New Jersey: Prentice Hall, 1972.

Berger, Phil. *Miracle on 33rd Street: The NY Knickerbockers' Championship Season.* New York, Simon & Schuster, 1970.

Bird, Larry, Earvin "Magic" Johnson, and Jackie MacMullan. *When the Game Was Ours.* Boston: Houghton Mifflin Harcourt, 2009.

Bird, Larry, and Bob Ryan. *Drive: The Story of My Life.* New York: Doubleday, 1989.

Bondy, Filip. *Tip-Off: How the 1984 Draft Changed Basketball Forever.* Boston: Da Capo Press, 2007.

Bradley, Bill. *Life on the Run.* Chicago: Quadrangle, 1976.

Chamberlain, Wilt, and David Shaw. *Wilt: Just like Any Other 7-Foot Black Millionaire Who Lives Next Door.* New York: Macmillan, 1973.

Coles, Jason. *Golden Kicks: The Shoes That Changed Sport.* London: Bloomsbury, 2016.

Corbett, Sara. *Venus to the Hoop: A Gold Medal Year in Women's Basketball.* New York: Doubleday, 1997.

Cousy, Bob, and Al Hirshberg. *Basketball Is My Life.* New Jersey: Prentice Hall, 1957.

Cousy, Bob, and Bob Ryan. *Cousy on the Celtic Mystique.* New York: McGraw-Hill, 1988.

Croatto, Pete. *From Hang Time to Prime Time: Business, Entertainment, and the Birth of the Modern-Day NBA.* New York: Atria Books, 2020.

Erving, Julius, and Karl Taro Greenfeld. *Dr. J: The Autobiography.* New York: HarperCollins, 2013.

Frazier, Walt, and Ira Berkow. *Rockin' Steady: A Guide to Basketball & Cool.* New Jersey: Prentice Hall, 1974.

Frazier, Walt, and Joe Jares. *Clyde: Walt Frazier Tells about Himself, Pro Basketball and the World Champion New York Knicks.* New York: Holt, Rinehart and Winston, 1970.

Fury, Shawn. *Rise and Fire: The Origins, Science, and Evolution of the Jump Shot and How It Changed Basketball Forever.* New York: Flatiron Books, 2016.

Garcia, Bobbito. *Where'd You Get Those? New York City's Sneaker Culture: 1960–1987.* New York: Testify Books, 2003.

Greene, Bob. *Hangtime: Days and Dreams with Michael Jordan.* New York: Doubleday, 1992.

Greene, Bob. *Rebound: The Odyssey of Michael Jordan.* New York: Viking, 1995.

Halberstam, David. *The Breaks of the Game.* New York: Ballantine, 1981.

Halberstam, David. *Playing for Keeps: Michael Jordan and the World He Made.* New York: Random House, 1999.

Jackson, Phil, and Charles Rosen. *Maverick: More than a Game.* New York: Playboy Press, 1975.

Jackson, Robert "Scoop," *Sole Provider: 30 Years of Nike Basketball*. Brooklyn: powerHouse Books, 2002.

Johnson, Earvin "Magic," and Richard Levin. *Magic*. New York: Viking, 1983.

Katz, Donald. *Just Do It: The Nike Spirit in the Corporate World*. Holbrook, MA: Adams Publishing, 1994.

Klein, Naomi. *No Logo*. New York: Picador, 2000.

Knight, Phil. *Shoe Dog: A Memoir by the Creator of Nike*. New York; Scribner, 2016.

Krugel, Mitchell. *Jordan: The Man, His Words, His Life*. New York: St. Martin's, 1994.

Lazenby, Roland. *Michael Jordan: The Life*. Boston: Back Bay Books, 2014.

MacMullan, Jackie, Rafe Bartholomew, and Dan Klores. *Basketball: A Love Story*. New York: Broadway Books, 2018.

McCallum, Jack. *Dream Team: How Michael, Magic, Larry, Charles, and the Greatest Team of All Time Conquered the World and Changed Basketball Forever*. New York: Ballantine, 2012.

Osborne, Ben, et al. *SLAM Kicks: Basketball Sneakers that Changed the Game*. Bloomington, IN: Universe, 2013.

Pearlman, Jeff. *Showtime: Magic, Kareem, Riley, and the Los Angeles Lakers Dynasty of the 1980s*. New York: Gotham, 2014.

Pelé, and Robert L. Fish. *My Life and the Beautiful Game*. New York: Doubleday, 1977.

Peterson, Robert. *Cages to Jump Shots: Pro Basketball's Early Years*. New York: Oxford University Press, 1990.

Pluto, Terry. *Loose Balls: The Short, Wild Life of the American Basketball Association*. New York: Simon & Schuster, 1990.

Pluto, Terry. *Tall Tales: The Glory Years of the NBA, in the Words of the Men Who Played, Coached, and Built Pro Basketball*. New York: Simon & Schuster, 1992.

Pomerantz, Gary M. *Wilt, 1962: The Night of 100 Points and the Dawn of a New Era*. New York: Crown, 2005.

Pomerantz, Gary M. *The Last Pass: Cousy, Russell, the Celtics, and What Matters in the End*. New York: Penguin, 2018.

Russell, Bill, and Taylor Branch. *Second Wind: The Memoirs of an Opinionated Man*. New York: Random House, 1979.

Russell, Bill, and Alan Steinberg. *Red and Me: My Coach, My Lifelong Friend*. New York: HarperCollins, 2009.

Ryan, Bob. *The Pro Game: The World of Professional Basketball*. New York: McGraw-Hill, 1975.

Salzberg, Charles. *From Set Shot to Slam Dunk: The Glory Days of Basketball in the Words of Those Who Played It*. New York: E. P. Dutton, 1987.

Smit, Barbara. *Sneaker Wars*. New York: Ecco, 2008.

Smith, Nicholas. *Kicks: The Great American Story of Sneakers*. New York: Broadway Books, 2018.

Smith, Sam. *The Jordan Rules: The Inside Story of a Turbulent Season with Michael Jordan and the Chicago Bulls*. New York: Simon & Schuster, 1992.

Smith, Sam. *Second Coming: The Strange Odyssey of Michael Jordan—from Courtside to Home Plate and Back Again*. New York: HarperCollins, 1995.

Strasser, J. B., and Laurie Becklund. *Swoosh: The Unauthorized Story of Nike and the Men Who Played There*. New York: HarperBusiness, 1993.

Telander, Rick. *Heaven Is a Playground: A Season on the Inner City Basketball Courts*. New York: St. Martin's Press, 1976.

Thompson, Marcus II. *Golden: The Miraculous Rise of Steph Curry*. New York: Touchstone, 2017.

Windhorst, Brian. *LeBron, Inc.: The Making of a Billion-Dollar Athlete*. New York: Grand Central Publishing, 2019.

Wolff, Alexander, and Armen Keteyian. *Raw Recruits: The High Stakes Game Colleges Play to Get Their Basketball Stars—and What It Costs to Win*. New York: Pocket Books, 1991.

PHOTO CREDITS

Front cover: jacket graphic from photo: Courtesy NIKE, INC. **Inside back flap:** (graphic from photo) Courtesy PUMA. **Back cover:** Left (graphic from photo) studio waldeck/Adidas; middle (graphic from photo) Courtesy Reebok; right (graphic from photo) Courtesy Under Armour. **Case cover:** Sneaker graphics based on photos Courtesy AND1, PUMA, Reebok, studio waldeck/Adidas, Under Armour.

© **studio waldeck/Adidas:** 20, 25, 26 (right), 34 (bottom), 35, 50, 52, 54, 55 (both). **Alamy Stock Photo:** MARKA 222, United Archives GmbH 153, xMarshall 112, ZUMA Press, Inc. 213. Courtesy **AND1:** 158, 160, 166 (bottom left), 166 (bottom right), 172. **AP Photo:** Bob Galbraith 170 (inset), Fred Jewell 29, Bill Kostroun 135, Marty Lederhandler 84, Amy Sancetta 130, Paul Shane 30. Courtesy **Converse/NIKE, INC.:** xii, 2 (both), 4 (silo), 5 (both). **Getty Images:** BRIAN BAHR/AFP via Getty Images 148; Andrew D. Bernstein/NBAE via Getty Images 75, 88, 90, 105, 116 (right), 118, 119, 169, 195 (bottom), 197, 203, 211, 215; Bettmann 6, 12, 83 (bottom); John Biever/Sports Illustrated 108; Nathaniel S. Butler/NBAE via Getty Images 106, 166 (top); Lou Capozzola/NBAE via Getty Images 144; Jerritt Clark 110 (right); Rich Clarkson/Sports Illustrated via Getty Images 9, 62, 83 (top); Anthony J. Causi/Icon SMI/Corbis/Icon Sportswire via Getty Images 193; Lachlan Cunningham 212; Scott Cunningham 237; Brian Drake/NBAE via Getty Images 19 (inset), 116 (left); James Drake/Sports Illustrated via Getty Images 53; Garrett Ellwood/NBAE via Getty Images 170 (full); Garrett Ellwood/WNBAE 137 (left); Focus On Sport 18, 27, 56, 60, 65, 73, 145; Sam Forencich 127; Steven Freeman/NBAE via Getty Images 132; Jesse D. Garrabrant/NBAE via Getty Images 180 (bottom); George Gojkovich 33; Barry Gossage/NBAE via Getty Images 111, 157; John D. Hanlon/Sports Illustrated via Getty Images 44; Andy Hayt/NBAE via Getty Images 99; Heritage Art/Heritage Images via Getty Images 110 (left); Kent Horner/NBAE via Getty Images 185; Glen James/NBAE via Getty Images 168; Nick Laham 163; Mitchell Layton 155; Michael J. LeBrecht II/Sports Illustrated via Getty Imagesa 180 (top); Neil Leifer/Sports Illustrated via Getty Images 38; David Liam Kyle/NBAE via Getty Images 139; Library of Congress/Corbis Historical 4 (left); George Long/Sports Illustrated via Getty Images 40–41, 77; Walter Iooss Jr./Sports Illustrated via Getty Images 45; Richard Mackson/Sports Illustrated via Getty Images 122; Ronald Martinez 234 (top); John W. McDonough/Sports Illustrated via Getty Images 121 (left), 124, 233; John McMullen/Historic Photo Archive 134; Fernando Medina/NBAE via Getty Images 149; Maddie Meyer 229; Manny Millan/Sports Illustrated via Getty Images 121 (right); Layne Murdoch/NBAE via Getty Images 207; NBA Photos/NBAE via Getty Images 26 (left); New York Daily News Archive 16–17; Rich Pilling 76; Popperfoto via Getty Images 22; Dick Raphael/NBAE via Getty Images 19 (full), 94–95; Mitchell B. Reibel 39; Robert Riger/Getty Images 15; Brian Rothmuller/Icon Sportswire via Getty Images 228; Ezra Shaw 209; Wally Skalij/Los Angeles Times via Getty Images 190; Jon Soohoo/NBAE via Getty Images 195 (top); Lane Stewart/Sports Illustrated via Getty Images 31; Kyle Terada/USA TODAY Sports–Pool 218–219; Al Tielemans/Sports Illustrated via Getty Images 177; Rocky Widner/NBAE via Getty Images 183–184, 206, 216; John G. Zimmerman/Sports Illustrated via Getty Images 23. Courtesy **NIKE, INC.:** xi, 66, 68 (both), 69 (both), 78 (both), 80, 85 (right), 86, 92 (both), 93 (both), 114 (both), 125, 128, 131, 133, 136 (both), 137 (right), 142, 146 (both), 147, 150–151 (bottom), 151 (top), 152, 173 (both), 174, 178, 179, 186 (both), 196, 200, 220, 223 (right), 224 (all), 225. Courtesy **PF Flyers:** 13. Courtesy **PUMA:** 36, 42 (both), 46, 48, 49, 141, 223 (left), 231. Courtesy **Reebok:** 96, 100 (right), 101 (both). © **Mike Schreiber:** 244. **Shutterstock:** Mike Flippo background image for pages xii, 20, 36, 50, 66, 80, 96, 112, 128, 142, 158, 174, 188, 204, 220; MSPT viii; Vasilixa 238. Courtesy **Under Armour:** 204, 217.

Sneaker time line on pages 1, 21, 37, 51, 67, 81, 97, 113, 129, 143, 159, 175, 189, 205, 221: 1st Courtesy Converse/NIKE, INC., 2nd from top © studio waldeck/Adidas, 3rd from top Courtesy PUMA, 4th from top © Studio waldeck/Adidas, 5th from top Courtesy NIKE, INC., 6th from top Courtesy NIKE, INC., 7th from top Courtesy Reebok, 8th from top xMarshall/Alamy Stock Photo, 9th from top Courtesy NIKE, INC., 10th from top Courtesy NIKE, INC., 11th from top Courtesy AND1, 12th from top Courtesy NIKE, INC., 14th from top Courtesy Under Armour, 15th from top Courtesy NIKE, INC.

ACKNOWLEDGMENTS

Now what are you supposed to say at the end of books? The thing about writing one is you realize very quickly that you have no idea what you're doing. Or at least I didn't. So one of the first things I did after making the tremendous error of convincing (a) myself, (b) my soon-to-be agent, Daniel Greenberg, and (c) Workman Publishing and my tremendous editor, Danny Cooper, that I could write this book was to reach out to anyone I knew—or had a Twitter connection to—who had written one (or more) to see exactly what I had gotten myself into. So thank you to my old roommate Jeff Pearlman, the inimitable Susan Orlean, longtime friend Jonathan Abrams (who pitched, researched, wrote, and released an entire 500-page book while I was struggling with this one), and last but by no means least, the *And Other Things* god, Shea Serrano. Thank you all for talking me off the ledge.

I've essentially been reporting this book since I was a kid—which means the list of people I am indebted to is damn near endless. I could start with Chris Bowe, a kid in my homeroom at Smithtown High School East who worked at The Athlete's Foot and always had the newest, flyest shit. If there was Instagram back in the '80s, he would have been huge. And also Chad Powers, with whom I made my earliest LIRR trips to Madison Square Garden to watch Michael Jordan and Dominique Wilkins from our 400-level seats.

In the time it took to get through the interviewing and writing process, four people who were instrumental in the book's creation passed away: first and foremost my dad, Leslie Bengtson, to whom this book is dedicated. The three others were legends in their fields who were generous with their time and memories: Hall of Fame Celtics player/coach/announcer Tommy Heinsohn, Air Jordan co-creator Peter Moore, and—still unbelievably—Kobe Bryant.

My formative basketball work happened at *SLAM*, where I was brought on by Dennis Page, Tony Gervino, and Anna Gebbie, had my eyes opened by the writing of Scoop Jackson, and continued on through the years with—and I'm gonna miss some people here—Ryan Jones, Susan Price, Ben Osborne, Lang Whitaker, Khalid Salaam, Bonsu Thompson, Alan Paul, Don Morris, Melissa Medvedich, Jenny Aborn, Ronnie Zeidel. . . . If your name ever appeared in a masthead with mine, I thank you. *SLAM* remains fam.

Thanks to those who helped facilitate NBA interviews, including Jeff Twiss with the Boston Celtics and Jelani Downing with the Atlanta Hawks. Samuel Smallidge of the Converse Archive was instrumental in breaking down the early days of the Chuck Taylor All Star (and Chuck Taylor himself)—and Ariana Joharjian, formerly of Converse, was instrumental in linking me with Samuel.

I first met Sonny Vaccaro—actually, I'm not even sure when I first met Sonny, likely at ABCD Camp in Teaneck, New Jersey, maybe in the summer of 1997 when a Florida kid named Tracy McGrady went from unknown to NBA lottery lock

over the course of a week. His memories and phone calls were most welcome, as were those of David Falk, who called from a number so protected that I'd never even seen that particular notification before.

Rick Barry was a pleasure to speak with—as opinionated as ever—and I'd also like to thank Kevin Grevey, Marques Johnson, Michael Cooper, Micheal Ray Richardson, Mychal Thompson, Michael Cooper, Mickey Johnson, Walt Frazier, Dominique Wilkins, Jalen Rose, Kevin Garnett, and Vince Carter, among all the other NBA players and former players with whom I've spoken about sneakers. Gilbert Arenas once told me he might lace up a pair of Chuck Taylors in a game, and it will gnaw at me endlessly that he never got a chance to do it.

On the sneaker side, thanks to all those who shared their expertise and experience from all angles, including Chris Severn, Steve McDonald, Dave Dombrow, Tiffany Beers, Joanne Borzakian Oullette, Tracy Teague, Jeff Smith and Errin Cecil-Smith, Kris Stone, Aaron Cooper, and Jim Riswold. Also to Eric Avar and Tinker Hatfield, both of whom I've gotten to speak with at length at various sneaker launches over the years.

An extra-special shoutout to digital archives, without which this would have been much dustier work, including the *Sports Illustrated* Vault, the *New York Times* TimesMachine and the neverending glory that is newspapers.com. Many rabbit holes were explored thoroughly, some of which even had to do with the topic at hand.

Thanks to anyone to whom I sent chapters while panicking over whether they were any good or not, and for your reassurances and suggestions, including Gerald Flores, Elena Bergeron, and Alex Wong.

Shout-out to my man DJ Cucumber Slice aka Bobbito the Barber aka Kool Bob Love aka Bobbito Garcia for not only penning the foreword, but also kicking off all this sneaker writing shit. Also thank you to some other sneaker OGs: DJ Clark Kent, Alex "Retrokid" Wang, Adam "Air Rev" Leaventon, and Chris Hall.

Thanks to all those at Workman Publishing, including Becky Terhune, Janet Vicario, Beth Levy, Elissa Santos, Julie Primavera, Sofia Khu, and Aaron Clendening (the last for her tireless photo research and endless back-and-forths with sneaker companies to secure the best possible images), and to illustrator Nick Maloy, who absolutely killed it with his spreads.

Thanks to my agent Daniel Greenberg of LGR Literary for helping turn my first-ever book pitch into something palatable and publishable (and guiding me through the process every step of the way). Danny Cooper was more than just an editor: He talked me through walls and even more daunting obstacles to get through this, and he turned clunky sentences into more streamlined versions (any echoes that remain are strictly the author's fault—or intention).

My parents deserve the most thanks, not only for introducing me to the joy of reading and raising me in a house full of books (and for buying me that long ago first pair of Nike Bruins that set me on this path), but for their constant support in every sense of the word.

About the Author

Russ Bengtson (top, in 2003) is the former editor in chief of *SLAM* magazine and was the longtime sneaker editor at *Complex*. He wrote a monthly sneaker column for *Mass Appeal* and contributed to the books *Agents of Change: The Story of DC Shoes and Its Athletes*, *SLAM KICKS: Basketball Sneakers That Changed the Game*, and *Nike SB: The Dunk Book*. He lives in New York and wears a size 10.

Bobbito Garcia (bottom) is an NYC native, world-renowned DJ, and the critically acclaimed author of *Where'd You Get Those? NYC's Sneaker Culture: 1960–1987*.